THE
HOT TROD

Hot-trod: Noun (plural hot trods – obsolete) the legal pursuit of Border Reivers across the English-Scottish border, in order to recover stolen goods.

Here are two peoples almost identical in blood – the same language and religion; and yet a few years of quarrelsome isolation – in comparison with the great historical cycles – have so separated their thoughts and ways, that not unions nor mutual dangers, not steamers nor railways, nor all the king's horses nor all the king's men seem able to obliterate the broad distinction.

Robert Louis Stephenson

THE
HOT TROD

A HISTORY OF
THE ANGLO-SCOTTISH BORDER

JOHN SADLER

AMBERLEY

Dedicated to the memory of my grandfather, James Sadler (1890-1960) and also of my father, Matthew Soulsby Sadler (1920-1998); it's all their fault.

This edition published 2024

Amberley Publishing
The Hill, Stroud
Gloucestershire, GL5 4EP

www.amberley-books.com

British Library Cataloguing in Publication Data.
A catalogue record for this book is available from the British Library.

ISBN 978 1 3981 1962 8 (paperback)
ISBN 978 1 3981 0543 0 (ebook)

1 2 3 4 5 6 7 8 9 10

Typeset in 10.5pt on 13pt Sabon.
Typesetting by SJmagic DESIGN SERVICES, India.
Printed in India.

Contents

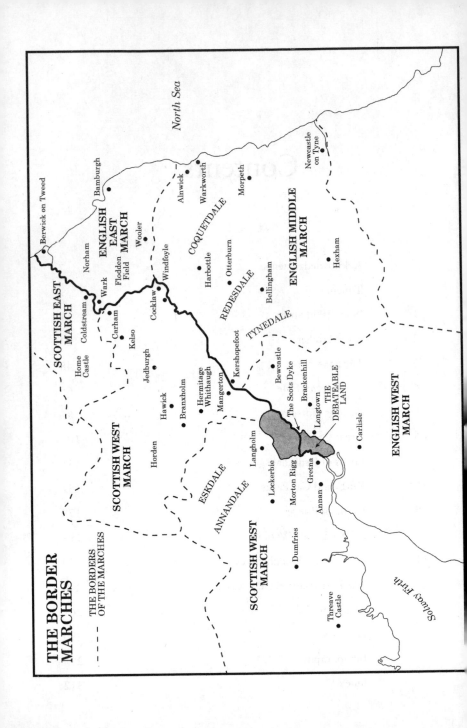

THE BORDER MARCHES

- - - - THE BORDERS
OF THE MARCHES

North Sea

Newcastle on Tyne

Berwick on Tweed

Bamburgh

ENGLISH EAST MARCH

Alnwick
Warkworth
Morpeth

SCOTTISH EAST MARCH

Norham
Wooler

Coldstream
Wark
Flodden Field
Windfoyle

COQUETDALE

ENGLISH MIDDLE MARCH

Carham
Cocklaw
Harbottle
Otterburn

Hexham

Kelso
REDESDALE
Bellingham

Home Castle
Kershopefoot
TYNEDALE

Jedburgh

Bewcastle
Brackenhill

The Scots Dyke
Longtown
THE DEBATEABLE LAND

Hawick
Branxholm
Hermitage
Whithaugh
Mangerton

SCOTTISH WEST MARCH

Horden
Langholm
Carlisle

ENGLISH WEST MARCH

ESKDALE
Lockerbie
Morton Rigg
Gretna
Annan

ANNANDALE

SCOTTISH WEST MARCH

Dumfries

Threave Castle

Solway Firth

Acknowledgements

My thanks to staff at the following institutions for their courtesy and assistance throughout the writing and research processes: Alnwick Castle Archives, Alnwick; Johnnie Armstrong, Museum of Border Arms & Armour, Teviothead; Bamburgh Castle; Berwick Museum & Art Gallery; Bellingham Heritage Centre, Bellingham; British Library; Cumbria's Museum of Military Life; Douglas Archives, Drumlanrig Tower, Hawick; Durham County Record Office; East Lothian County Archives; English Heritage; the Explore Programme, Newcastle; the Friends of Harbottle Castle; Fusiliers Museum of Northumberland; Hexham Old Gaol Museum, Hexham; Hexham Partnership; Historic Scotland; Green Howards Museum, Richmond; King's Own Scottish Borderers Museum, Berwick-upon-Tweed; Literary and Philosophical Society, Newcastle; Ministry of Defence (Otterburn, Redesdale & Spadeadam); the National Archive, Kew; National Museum of Scotland, National Records of Scotland, Edinburgh; National Trust for Scotland; Newcastle Central Library; Glendale LHS; Coldstream & District LHS; Remembering Flodden Project; Flodden 500 Project; Northumberland Archives, Woodhorn; Northumberland National Park Authority; Royal Armouries, Leeds; Society of Antiquaries, Newcastle upon Tyne; the UK Battlefields Trust; Tullie House Museum, Carlisle; Tyne and Wear Museums & Archives, Newcastle.

I have a great many people to thank, many who have knowingly and many others un-knowingly contributed to this book, which has been a long time in the making. These include: Max Adams, Dr Lyndsay Allason-Jones, Fiona Armstrong, the late Alec Bankier, Adam Barr, Margaret Baxter, Stan Beckensall, Alix Bell, Barbara Birley, Peter Blenkinsopp, Chris Berendt, Steven Bogle, Liz Bregazzi, Robert Brooks, Colin Burgess, Chris and Barry Butterworth, Dr David Caldwell, Ronnie Campbell-Smith, Dr Tobias Capwell, Geoffrey Carter, Doug Chapman, Beryl

Charlton, Andrew Cochrane, the late Ian Colquhoun, April Common, Eric Common, George Alan Common, John Common (senior), Marjorie Common, the late Tom Corfe, John Dale, John Day, Terry Deary, Ruth Dickinson, Andrew Dineley, Gordon Dixon, the late Wilf Dodds, Keith Douglas, Ulfric Douglas, Pat Dunscombe, Colin & Lindsay Durward, Margaret Eliott, Flora Fairbairn, Janet Fenwick-Clennel, Ann & John Ferguson, Tony Fox, Alistair Fraser, Jane Gibson, Bobbi Goldwater, David Goldwater, Dave Grey, Alan & Julia Grint, Anna Groundwater, Jane Hall, Tony Hall, Clive Hallam-Baker, the late Robert Hardy CBE FSA, Jim Herbert, Rob Horne, Philip Howard, Andy Jepson, the late George Jobey MC FSA, Chris Jones, Terry Kowal of the Scottish Assembly, Jennifer Laidler, Sue Lloyd, Stephen Lowdon, Paul Macdonald, May McKerrell, John Malden, Kath Marshall-Ivens, Paul Martin, Dr Xerxes Mazda, Major Sam Meadows 2 RGR, Margaret Mitchinson, Brian Moffat, Glenda Mortimer, Peter Nicholson, John Nolan, Colm O'Brien, Geoff Parkhouse, Harry Pearson, Phil Philo, Aiden Pratt, Baroness J. Quinn, Stewart Rae, Sarah Reay, Julian Reynolds, Joe Ann Ricca, Peter Ryder, Pearl Saddington, John Scott, Rosie Serdiville, Trevor Sheehan, David Silk and colleagues at Newcastle Keep & Black Gate, Barbara Spearman of English Heritage, Alex Speirs, Lord Steel of Aikwood, Derek Stewart, the late Jock Tate, Anne Telfer, Paul Thompson, Neil Tranter, Graham Trueman, Anne-Marie Trevelyan MP, The Honourable Christopher Vane Chester Herald, Jenny Vaughn, Philip Walling, Sir Humphrey Wakefield, Charles Wesencraft, Bob Widdrington, Peter Woods and Dr Paul Younger.

My heartfelt thanks to all of those who took time and trouble to offer a viewpoint when asked to do so; I am deeply obliged for your contributions and apologise for having had to edit some of these down, due entirely to space constraints. Thanks also to April Jackson for the original drawings, Chloe Rodham for the map, another fruitful collaboration, to Julia Grint for copy editing, to Beverley Palin for the indexing, to Shaun Barrington, Nicola Embery, Alex Bennett and the team at Amberley Books, and as ever to my wife Ruth for yet another bout of writer's self-absorption. All errors remain my sole responsibility and should any agency, organisation or individual find they have not received accreditation or have been accredited in error, please let the publishers or me know and I'll ensure future amendment.

John Sadler

Timeline

1296	Sack of Berwick by Edward I
1314	Battle of Bannockburn
1328	The Treaty of Northampton, the 'Shameful Peace'
1332	Battle of Dupplin Moor
1333	Battle of Halidon Hill
1346	Battle of Neville's Cross
1388	Battle of Otterburn
1402	Battle of Homildon
1464	Battles of Hedgeley Moor & Hexham/Siege of Bamburgh
1488	Battle of Sauchieburn
1502	Treaty of Perpetual Peace
1513	Battle of Flodden
1523	Siege of Cessford Castle
1542	Battle of Solway Moss
1544	Hertford's devastating raid on Leith and Edinburgh
1545	Battle of Ancrum Moor
1547	Battle of Pinkie
1560	Treaty of Berwick
1575	Raid of the Redeswire
1596	Buccleuch's raid on Carlisle
1603	Union of the Crowns
1603–10	Pacification of the Border

1

'Sod off' in Stone

The landscape here is one of gently rolling hills of great natural beauty, and the area is rich not only in scenic attractions but also in great houses with an amazing store of literary, legendary and historic associations. This was the front line of the centuries-old struggle between two warring nations, one comparatively rich and aggressive, the other poor and struggling to maintain her independence. It was the source of a great heritage of ballads, telling stories of feats of valour, love and betrayal, and of supernatural forces. And it was the home and inspiration of such figures as Sir Walter Scott, James Hogg, John Buchan and Andrew Lang.[1]

On a very warm Mediterranean afternoon in September 2017 we drove along the main road in eastern Cyprus, which links the two cities of Larnaca and Famagusta – the latter is the setting for both *Othello* and an epic siege of the Venetian fortress by Ottoman armies in 1570. There's a fine hint of historical irony here because our journey involved far more than just bowling over well-laid tarmac; it meant crossing an armed frontier. I hadn't done that in Europe since the fall of the Berlin Wall, but this one showed no sign of going away. It had been in place since 1974 (and it's still there); its origins go back to the long and very bitter siege, ending in wholesale massacre and atrocity, that set the tone for Greek/Turkish Cypriot relations to this day. Our borderer ancestors here in the north of England would have fully understood.

In July 1974, Turkey launched the well-named Operation *Attila*. This was a dynamic response to a deteriorating situation on the island where a Turkish minority was being violently oppressed by a Greek majority. Now, when in doubt, blame the Brits and, to be fair, we did employ the old 'divide and rule' trick when we took over from the faltering Ottomans in 1878. After the Second World War a groundswell of Greek Cypriot

opinion wanted independence from the UK, and union (*enosis*) with Greece. We weren't too keen: Cyprus was perceived as being strategically vital in the Cold War. It may even be that Britain helped Turkey in 1974.[2]

Driving along the UN-policed Green Zone – with the silent observers in their rival watchtowers scanning each other across the narrow, dried-up defile – is an eerie experience, but you can't get to Famagusta without crossing the border at the atmospherically named 'Black Knight' checkpoint, Cyprus's Checkpoint Charlie. In the nineties a couple of British gunners were wounded there in an exchange of fire.

Back up the dusty road, and very easy to miss, is what's left of Fort Bravo: just a forgotten sign by the verge, almost lost among the scrub and the remains of a platoon outpost. My friend and guide, who'd served on the island with UK forces in the eighties, grew quite excited, as you would; the place still has a real feel to it – it's a forgotten slice of history that virtually none of the modern army of British tourists would begin to understand. But this was Europe's last fighting frontier until the invasion of Ukraine and anyone over forty in Cyprus will remember what happened. Sporadic talks about re-unification get lost among the chatter of cicadas and those watchtowers remain, sentinels to history's unfinished business.

Now *our* frontier war went on for three centuries and the issue of Scottish nationalism is still very much alive.

On 9 September 2013, the 500th anniversary of the Battle of Flodden in North Northumberland (see Chapter Nine), I was taking a tour group up to the monument on Piper's Hill.[3] New paths had been laid in anticipation of a big turnout. We trudged along to the base of the conical mound where a rather nervous young community policewoman informed us that there were a number of 'Scottish people' already on top and she hoped there wasn't going to be any 'bother'. The folk in the group with me were all of pensionable age, so I was able to reassure her that we could either climb the hill or start a fight – but not both at once. She seemed reassured and, as it turned out, the Scots bore no grudges; they proffered whisky.

George MacDonald Fraser pithily described Hermitage Castle in Liddesdale as 'shouting "Sod off" in stone'. As a one-sentence summary of the Anglo-Scottish border, that's pretty hard to beat. The men and women who inhabited this desolate *threap* (wasteland) during three centuries of endemic warfare and sustained inter-tribal hatreds make ISIS seem almost cordial. They didn't just cut off your head, they hacked you into *pieces sma'* so whoever was left to tidy up wouldn't have much to work with. Borderers on both sides of the line were targeted by many

and loved by few. When their era passed in a fury of Stalinist suppression, there weren't many mourners. Yet, just look in the phone books for Liddesdale, Tynedale, Redesdale or the Eden Valley and you'll still see the old 'riding' names flourishing. They're hard to kill off.

I've lived on these marches all of my life, studied and read about their wilder inhabitants (or those who were perceived as wild), traversed every inch and studied every castle, bastle, tower and battlefield (there's an awful lot of all those). I've taught about them, written about them and played at being them for the last half century. I've dug their traces and obsessed about their lives, read their ballads and collected their weapons. The good news is that there's always something new to discover: the story has never actually ended. The Union of the Crowns in 1603 might have been a watershed, but the river still flows.

It begins with landscape, and mine is unique to Britain. In the summer of 1946, as the long shadow of world war lifted, *Journal* correspondent Paul Brown[4] visited the remote steading of Blawearie in North Northumberland. Twenty years later I went there as a boy, and ten years after that visit my first foray into writing was an article about the place written for the late Roland Bibby, editor of *Northumbriana*. Over four decades later, I went back again.[5]

You get there from the B6346, north from Alnwick or off the A697 at Wooperton. When Paul Brown walked up the track from the tiny hamlet of Old Bewick it was summer. The shepherd's house at Blawearie was still inhabited by the Rogerson family, as it had been for some time. The tenant's wife had lovingly crafted a rock garden on the wooded rise just east of the buildings, a tended oasis in the remote and wild grandeur of the hills. A great lump of glacial moraine squats directly in front, forming a small enclosure of the sort you would imagine reivers putting to good use.

Blawearie has never been inhabited during my lifetime; originally a roofed stone shell, it has steadily collapsed over the years of abandonment. The rock garden's gone: only the lines of stone-fringed borders are still discernible, and you really have to know what you're looking for. It has an air of deep melancholy, echoing not just tales of recent lives now forgotten but much older resonances. As a lad, I was hooked. I still am. This is an ancient landscape, the sort of scenery Malory or even Tolkien might have created. It's somewhere you might see in dreams, what some might call a *thin* place, where the veil between this world and the next, past and present, becomes very flimsy and you might feel you can just reach out and touch the past.

Local journalist and writer Tony Henderson recalls talking to Stan Beckensall, *doyen* of Northumbrian rock art, about a Bronze Age burial cairn just before you reach the house, investigated in 1865 by the busy Canon William Greenwell.[6] His style was more Indiana Jones than

Time Team, yearning for hidden treasure, though much earlier tomb robbers had beaten him to it. I met Stan there, and we reflected on the place and the people who had lived there over many centuries... by and large we know nothing whatever about them.

Beyond the forlorn heap of tumbled stones, the land dips away down to the course of the Harehope Burn, bisecting bleak Bewick Moor. Above the stream, a couple of hundred metres south, are the remains of an Iron Age settlement holding a commanding position above the gorge. It's a good defensive site and one occupied by the Home Guard during the Second World War. A pal and I once found some spent brass .303 cases there; digging expectantly we recovered many more, including a good number of live rounds where someone had worked the bolt on his SMLE without pulling the trigger. I won't say what we did with them, but anyone who says a .303 will penetrate a brick wall isn't wrong.

Now, walk back in a westerly direction above the track leading up from the settlement, skirting the steep drop down the flank of Old Bewick, and you come to a large, bi-vallate[7] hill fort. Most of these originated in the Bronze Age but were given significant makeovers in the Age of Iron when the old élites who controlled that precious supply of copper and tin seem to have been shoved aside by a new democratisation. More iron, readily available and easily worked, meant more tools and also more weapons – lots of them – and so more internecine feuds, tribal wars and raids. Hill forts had facelifts and Old Bewick received another one in the war, with a concrete pillbox constructed inside the ancient ramparts. It's not the only ancient site to boast a Home Guard redoubt.

This place is timeless. Through half-closed eyes you can 'see' the barren expanse filled by rearing palisades built to surround and protect the timber houses that stud the interior, alive with the everyday sounds of a noisy local population. Echoes still hover on the wind. As much as anywhere this was what ignited my lifetime's fixation. There aren't many locations on this overcrowded island where you can feel yourself completely removed from modernity, but along the Anglo-Scottish border there are still quite a few.

I've always been interested in the armour and weapons of the Steel Bonnets. Some time ago Brian Moffat started up a museum of Border arms and armour at Teviothead,[8] a wonderfully eccentric ensemble of sixteenth-century kit; it was world class, if on a smaller scale. He fell out with his local planning authority when they got windy about his displaying a pair of live machine-guns. I've a feeling the Armstrongs and Eliotts would have been on his side.

In my case, it's been a family obsession. I toured the marches as a boy in my father's ageing Series IIA diesel short-wheelbase Land Rover, which had the speed of a rocking horse. For literature, I started off with The Reverend Borland's *Border Raids & Reivers* plus D. L. W. Tough's seminal

Last Days of a Frontier and then the late, great, George MacDonald Fraser wrote *Steel Bonnets* and brought the reivers into twentieth-century perspective: goodbye Walter Scott and welcome Quentin Tarantino.

Hermitage Castle sums it up for me; it's one of the two most instantly atmospheric sites I've ever encountered (Culloden battlefield being the other). It resonates in its very remoteness, its uncompromising and unique starkness; exuding menace, it reminds us of a very dark and violent past and, at the same time, a kind of freedom.

In the early 1990s as the walls came down, some half-witted pundits were proclaiming the death of the old Soviet Bloc as the 'end of history'. That's nonsense, obviously; we've had an awful lot of history since then. It's not something under which you can ever draw a neat line. And that, in part, is the essence of this book because I suggest that the past still has a particular and unique currency on the Anglo-Scottish borderlands. It's not a cohesive identity, this *threap*; it's still localised and tribal. Our ancestors here didn't call themselves 'borderers' or define their core identity as English or Scots; they could be neither or both to suit, and loyalties were always fluid and frequently cash-dependent.

This tribalism sprang back to life in 2014 with the Scottish referendum and independence debate. It wasn't always pretty. As an Anglo-Scottish borderer I feel I've got a pretty fair dual perspective. That's partly what this book is all about: not just about *then* but about *now*, and how *then* influences *now*. I'm anchored in history without (I trust) being marooned there, and I've visited quite a few frontiers: Berlin, US/Mexico, the Middle East and Cyprus as well as our own, and I hope I have an insight into to how they operate.

Our border is far older than any of those others and has endured much longer, had more blood spilt and has witnessed regular destruction on a biblical scale. Though the old border disappeared in 1603 – officially anyway – it remains in spirit. Drive up the A697 past Wooler and you come to the Northumbrian hamlet of Millfield. It's fairly typical: classic four-square sandstone and some between-the-wars infill. It's very much 'us' to Northumbrians. Cross the Tweed, over that stunning bridge, and you're in another country. Actually, it's only Coldstream … but it's different. They talk differently; the houses are taller, more crowded, with distinctive crow-stepped gables. It really is another realm; you could be in Brittany. You tend not to find that in Europe anymore. Drive from France to Belgium or on into the Netherlands and you barely notice the shift; there's no real frontier as such. In order to find it you have to motor east from Berlin, past the atmospheric Seelow Heights, the vast memorials to Russian soldiers and Zhukov's Bunker, and then cross *that* border into Poland. Here there's still a palpable shift, from east to west. Poland is still very distinct from Germany.

What I'm aiming to discover is what our border means to the people who live here, not just to the many with ancient roots, but to newcomers. I'll be going coast to coast, from Northumberland's lordly strand and smugglers haunts to the wide sweep of the Solway, Scott's *Redgauntlet* territory; moving from lush river valleys such as the Tweed through the upland dales and debatable lands, from yeoman's blockhouse bastles to gentry towers and great lords' castles.

In July 2010, a latter-day outlaw named Raoul Thomas Moat,[9] vicious petty criminal and murderer, holed up in Rothbury as hundreds of police tried to flush him out. Vile as he was, he became a kind of instant folk hero, Coquetdale's Robin Hood (but without the philanthropy). It was a mix of farce, tragedy and media frenzy that even Scott couldn't have invented. Four centuries ago, Moat would barely have been noticed on the border and he wouldn't have lasted five minutes.

To an extent it is the 2014 Scottish independence debate and the re-ignition of the SNP's call for a second vote in the wake of Brexit, and indeed Brexit itself, that opens the window for a re-appraisal of what nationality/frontier and borderer identity actually mean in the twenty-first century, along with a chance to ponder on how the past affects this.

> Wha daur meddle wi' me?
> Wha daur meddle wi' me?
> My name is little Jock Eliott
> And wha daur meddle wi' me?[10]

From Carter Bar, the high watershed that divides the two kingdoms, the view stretches northward over the rolling crests of Philip Law, Woden Law and Whitestone Hill, a sea of harsh grass and heather, plucked and furred by the winds in winter, a carpet of green in spring and summer. Secretive still, and unspoilt, the border country offers the visitor unique insight into a troubled past.

Though the plough has tamed those fearsome marshes or mosses where reivers skulked, and man-made forests have replaced the dense canopy of wild wood, it is still possible for us to get an impression. This area has been militarized since the days of the Roman occupation; it still is when you consider the MoD ranges at Spadeadam, Otterburn and Redesdale. As you might perhaps expect, King Arthur apparently spent some quality time up here as well: Sewingshields on Hadrian's Wall has distinct Arthurian connections. At least one contemporary author asserts that the Arthurian legends are firmly rooted in the post-Roman era along the northern frontier, with Roxburgh as the 'real' Camelot.[11] I do like that idea, even though it mightn't be too popular in the south-west of England.

Legend asserts that Sewingshields Castle, Scott's 'Castle of the Seven Proud Shields', existed somewhere in the vicinity of the present

farmhouse; most probably, though no one can prove it, the nineteenth-century building stands on the same ground. In the Victorian era, a shepherd sitting down to enjoy his lunch, or *bait* as we might call it, dropped a ball of wool among the tangled stones, which promptly disappeared. As he searched for his wool he shifted a few lumps of masonry and uncovered a passage leading down into what must have been the old castle vault. With only a lighted match he gingerly stepped down and into a long, dark passage. Drawn by an irresistible impulse he kept going until he found himself in a vast cavern lined with men at arms, frozen in enchantment. Standard advice in these Indiana Jones-type stories is, *Don't pick anything up!* But he couldn't resist: he helped himself to a silver-decorated horn, an outrage that galvanized the whole sleeping army into furious reaction. He fled and escaped unharmed but could never find that stairway again. Nor could anyone else – I've tried.

Ironically, these hills still reverberate to sounds of war as the Ministry of Defence continues to utilise the Otterburn and Redesdale training areas. A vast treasure was disbursed to widen the A696 to accommodate a monstrous new generation of self-propelled guns (the SS20), steel leviathans that could wreak destruction on a scale that our reiver ancestors could not even begin to comprehend. Just as well they weren't around at the time.

Having sampled the unique splendour of the Wall, the visitor could detour, initially via the A68, heading north to West Woodburn before branching left toward Bellingham, the market town of the North Tyne. From Bellingham, head westwards to Kielder, a great man-made lake, and follow the valley towards the border line at Riccarton. You are now in Liddesdale, of evil repute, although the inhabitants are a good deal friendlier these days.

Border Ballads are justly famous, and Scott collected many of them in the early years of the nineteenth century. It has frequently been lamented that no one from an earlier period thought to compile a collection of the ballads of his day, so many may well have been lost altogether. The earliest ballads, *The Battle of Otterburn* and *Chevy Chase*, are probably from the fifteenth century, though the majority appear to belong to the sixteenth. Many may have originated on the Scottish side, though some are clearly Northumbrian. These ballads deal with subjects both violent and romantic: women left widowed, tragic love affairs that end in death, battles, duels, skirmishes and general bloodletting. All very dramatic! Cattle raiding, the reivers' main occupation, also gets its fair share of attention as in *Jamie Telfer of the Fair Dodhead*:[12]

> It's I Jamie Telfer, o' the fair Dodhead
> And a harried man I think I be!
> There's naething left at the fair Dodhead
> But a waefu' wife and bairnies three.

The unfortunate Jamie was relieved of his cattle, and indeed everything else, by the English captain of Bewcastle. In the sixteenth century the fort there, now a ruined shell, was a very important garrison. Jamie sought the aid of his neighbours to recover the cattle, which they duly did after a sharp fight:

> O mony a horse ran master-less,
> The splintered lances flew on hie,
> But or they wan to the Kershope ford
> The Scottes had gotten the victory.

The ballad exults in the tumult of battle and lingers on the ghastly injuries sustained:

> The captain [of Bewcastle] was run through the thick of the thigh
> and broken was his right leg bane,
> If he had lived this hundred years
> He had never been loved by woman again …

Some readers might remember a BBC TV series, *The Borderers,* with Michael Gambon and Iain Cuthbertson, from the late sixties.[13] It really wasn't very good and the fight scenes were rather uninspired, but along with The Reverend Borland it fired my interest. So much so that my dad and I used to bounce along half-hidden tracks to discover forgotten and wonderfully romantic towers like Kirkhope and Fatlippes, Neidpath, Hollows and Dryhope; bastles like Black Middings, Bellingham Hole and the Combe. It's only when you start looking that you realise just how extensive the traces are – and most are in a largely unchanged setting.

This history has soaked into the very canvas of the upland dales – the troublesome valleys of Coquetdale, Redesdale, Tynedale, Liddesdale and Teviotdale. Shocked southern chroniclers of the Wars of the Roses shuddered in distaste as they learned about their more rapacious ways. Scott gave the 'roaring borderers', *bobinantes boreales*, their first literary makeover by creating Young Lochinvar: pure Errol Flynn – dash, fire and total tripe – but he sold an awful lot of copies.

The Three Hundred Years' War, as it's called, between England and Scotland, began properly in 1296 and kept going until 1603 when, with fine historical irony, a King of Scots, James VI, also became King of England. The whole blood-soaked business had been about whether the King of England also ruled Scotland. Edward I ('Longshanks') had razed Berwick (then Scottish) in the opening moves and that more or less set the tone. In fact, Berwick changed hands fourteen times before Richard of Gloucester finally won it back in 1482.

It was always seriously brutal. After Bruce had wrested Scotland back, he conducted a systematic reign of terror through northern England; the hills and upland valleys became well-nigh uninhabitable, and climate change and the plague didn't help. Edward III, replacing his useless father and with bigger fish to fry across the Channel, bolted the back door by creating a militarized zone filled with men who held their land by the sword rather than the plough. These hobilars (so called on account of the sturdy ponies they rode) became the border horse and then the reivers. They weren't nice people; being nice was a luxury they could never afford.

National wars were punctuated with local raids; the thieving of small black border cattle was the principal form of economic activity. These forays could involve anything from a handful to several thousand men. Livestock was generally taken, but other goods were also at risk: during 'Kinmont' Will Armstrong's notorious raid on Haydon Bridge in 1587, his many thieves cleared the place like locusts: children's clothes, shrouds, pots, pans and even doorframes were lifted.

If local and international wars weren't enough to sate anyone's bloodlust, there was always the feud or 'feid' – murderous vendettas that ploughed on for decades. It was fairly simple: one family steals from another so you have to steal twice as much back; next time they double the ante and kill a couple of your herdsmen... and so it escalates. The most notorious feud between the Maxwells and the Johnstones reached its dramatic highlight in 1593 near Lockerbie in the savage Battle of Dryfe Sands. The Maxwells had genocide in mind, but the Johnstones got there first and at least a thousand died in the fight, mainly Maxwells. It was still going on in 1610 (see Chapter Two).

Most of it is still there, the landscape and historic environment, even if Hawick lads exercise their brawn more on the rugby pitch than on the battlefield (the two can be difficult to distinguish at times). Enjoy it though, it's your heritage. My first published book, over thirty years ago, was *Battle for Northumbria* – a history of conflict in the county, or rather the wider county area. At that time, the idea of 'heritage tourism' around historic battlefields was fairly new, and most sites in the region were poorly signposted and interpreted. The visitor was obliged, in most instances, to turn detective with map and guide in hand.

When King James VI crossed the Tweed southwards by a new bridge built for the occasion, he was the first Scottish ruler to do so with peaceful intentions. Two of his predecessors (Shakespeare's Malcolm and James IV) came too often and were felled.[14] William the Lion and David II were both captured; William had immolated the entire population of Warkworth inside their own parish church. Bruce's hobilars even dug up the rabbit warrens at Bamburgh to deny the locals any sustenance. Nor was it one-sided: time and again English riders, wardens and armies crossed the line to wreak havoc.

Long before, Hadrian had drawn his line over the stark crags of the Great Whin Sill to mark a boundary between 'us' and 'them'. I've encountered southerners who believe that this is the current border. The early Saxon overlords of Bernicia had chosen the high citadel of Bamburgh for their capital (legend insists that Lancelot and Guinevere were earlier residents). Successive periods of defensive building witnessed waves of recycling. Thirlwall Castle, near Gilsland, built to seal the strategic Irthing Gap, employed stones lifted from the Wall. The builders of an adjacent Victorian farmhouse robbed those same stones from the tower.

Since 1988, a number of our better-known border battlefields have received attention. Flodden is a good case. In recent years, mainly due to the efforts of local volunteers, a first-rate battlefield trail has been laid out and there is good, accessible interpretation. Oswald's victory at Heavenfield, Hotspur's failed gamble at Otterburn and a later Percy's 'Waterloo' at Hedgeley Moor have also been given limited makeovers. The pre-Civil War clash at Newburn has benefited from some attention – yet others have not.

A spectacular example is Homildon, a unique tactical success for the vaunted longbow and where Hotspur avenged his earlier defeat and capture, very ably advised by the Scottish Earl of March who had defeated him thirteen years previously. The site has been shamefully neglected, although in the wake of the work done on the Flodden site, a highly commendable effort is underway – again led by volunteers. Borders military heritage doesn't stop with the end of Civil Wars: we have traces from the Jacobite era, and there was a very nasty incident in Hexham Marketplace when dozens of local people were mown down, leaving over forty dead, by nervous North Yorks Militia during anti-conscription rioting in 1761. This region may not be able to boast of any spectacular Victorian coastal forts (bar Heugh Battery at Hartlepool) but it has some superb coastal defences from both world wars. North of the Wear, the best of these is Blyth Battery, an extensively restored Second World War installation (though earlier in origin). Again, this has been brought back to life, interpreted and managed by volunteers.

There's also the matter of language/dialect. There is no such thing as a border dialect; each region, each county, and even areas within those counties, have marked variations. Old Northumbrian with its rolling 'R' sound is fast dying out; it's often confused with 'pitmatic', the distinctive patois of the Northumbrian coalfields. Geordie is unintelligible to most Scots, and the folk south of the border can have the same difficulty in comprehending those just north of the line. Christopher Vane, Chester Herald in Arms Ordinary, is a successful barrister turned herald (his office dates from the time of the Black Prince). His family, the Fletcher-Vanes, were granted the baronetcy of Hutton as far back as 1786 and in 1931

the then incumbent became Baron Inglewood. Richard, Christopher's older brother and also a barrister, is now the 2nd Baron Inglewood. The family have long roots in Cumberland. Christopher recalls the dialect difficulty:

I was born in Carlisle 67 years ago to the day. I now live about twelve miles south of that city. On a clear day we can see Scotland from our garden. I have some cousins, who are farmers at Moniaive near Thornhill. One year, about the time when I was at university (in other words nearly fifty years ago), my cousin contacted me asking if I could come up and help him with his clipping. Obviously, I was not going to be doing any actual clipping myself, but there were various tasks associated with clipping which needed to be done and which could be done by overeducated Englishmen. For instance, in this part of Scotland fleeces were packed into long jute sacks which were suspended from a horizontal bar fixed between two vertical poles. The fleeces were handed up to someone standing in the sack who packed the fleeces down by standing on them. This was smelly work.

The evening before the clipping I went with my cousin in his van to pick up a couple of sheep which had strayed over the hill into the next glen and which had been rounded up by a farmer there, who was preparing for his own clipping. On arrival there we found that he had with him a young Australian shearer, who gave us a demonstration with some new-fangled electric shears.

The clipping the next day lasted most of the day. In addition to my cousin, his shepherd and me, there were a number of shepherds from neighbouring farms. Not all the shepherds sheared in the same way; the elder ones sat on stools while the younger ones knelt on the ground, but none used electric shears. When the work was finished, we all went to my cousin's shepherd's house for a supper. The shepherds were very friendly to me, but after a while their conversation turned exclusively to farming matters: at least that is what I assume they were talking about. No doubt many dialect words were being employed, but I soon realised that, although I was no more than sixty miles from where I had lived all my life, they might have been talking Romanian for all I could tell: they were speaking another language![15]

2

The Marches

What though in the halls of the great we may meet
With men of high rank and braw order,
The heart sighs for hame and nay music's sae sweet
As the soft lowland tongue of the Border.

Common riding song

In Olivia Manning's *Levant Trilogy*, her heroine, Harriet, is wandering in the hot frenzy of an Egyptian bazaar when she suddenly has a vision of herself alone on an English lane during a blustery autumn afternoon.[1] The juxtaposition is immediate: it's not simply a recollection of a changed environment but also a tug of conscious identity. However exotic and exciting the bazaar may be, it's essentially alien and she an alien in it. We borderers have similar moments: I've had a few and I haven't ever been to Egypt. I didn't coin the phrase, but for a northerner the best view of London is from the rear window of the train as it pulls out of King's Cross. I might enjoy the capital's many attractions, but I don't, and never will, belong there.

Compared to King's Cross, Newcastle's magnificent Central Station has the feel of another country, very *northern*. Prior to the outbreak of civil war in the 1640s, lively writer and traveller Celia Fiennes described Newcastle as 'the fairest and richest Town in England, inferior for wealth and building to no city save London and Bristol'.[2] She wasn't exaggerating: the city's population was fast approaching that of Bristol, its commercial rival; probably around 13,000. The North was different and the wild lands beyond Newcastle, Northumberland up to the border, very different again. Southerners (those rich enough anyway) were building beautiful and ornate country houses; Northumbrians were hunkering down in bastles – crude, defensible blockhouses.

Somewhat later, three centuries and more, the city of Newcastle formed a backdrop for the seventies cult gangster movie *Get Carter*.[3] So successful was Michael Caine's performance as the hardman Jack Carter that a whole 'Get Carter Heritage' was begotten. Forty years on and the city looks very different, although the *Get Carter* connection to Gateshead's towering, squalid sixties monstrosity of a municipal car park was of sufficient weight to grant it numerous stays of execution.

Actually, the original setting of the book by Ted Lewis[4] was Scunthorpe, with Hull as the initial choice for the film location. Director Mike Hodges gives his reasons for the change of setting:

> We passed on and came to Newcastle. The visual drama of the place took my breath away. Seeing the great bridge crossing the Tyne, the waterfront, the terraced houses stepped up each side of the deep valley, I knew that Jack was home. And, although the developers were breathing down the Scotswood Road, they hadn't yet gobbled it up; we'd got there in time but only just.[5]

Some might say, 'Typical condescending southerner'.

By the term 'borders' I'm referring to the northern English counties of Northumberland in the east and Cumbria in the west – this latter is an amalgamation (much resented by locals) of the ancient shires of Cumberland and Westmorland. North of the border it's even worse: the Scottish counties of Berwickshire, Roxburghshire, Selkirkshire, Peeblesshire and Dumfriesshire have been re-packaged simply as Scottish Borders in the east, with Dumfries & Galloway in the west. The fine historical and cultural nuances of the ancient shires have been wiped out with a blank, dystopian flourish.

In geological terms this is an ancient landscape, over five hundred million years old: 'Here are rocks that tell the tale of the convergence and collision of the ancient Laurentian, Avalonian, Baltican, Armorican and Gondwana tectonic plates and the compressive and extensional forces that resulted.'[6] Those distant seismic upheavals have formed a distinctive landscape, or set of landscapes, with bony ridges of high ground, the Cheviots humped in the centre of the English side, the Southern Uplands over on the Scottish. These are old, high hills, endlessly rolling and rounded, usually still, with only the wind that scours from chilled lands north and east and the lamenting lilt of curlews haunting the emptiness.

South of Cheviot you find the altogether sharper edges of Simonside and further south again the hard rampart of the basalt Whin Sill that carries Hadrian's Wall and – much further east – the great bulk of Bamburgh Castle. These uplands are slashed by the dales – North Tyne, Rede and Coquet – that spill out onto the coastal plain and former coal

measures. Old mining towns and villages like Ashington and Bedlington survive, though robbed of their original purposes; Aldi and Lidl flourish where once the winding gear stood, and scars left by the Miners' Strike of 1984 still fester. Borderers are good at allowing grudges to foment; we've centuries of solid form.

Further west into England and the Eden Valley is very different. Cumberland is softer somehow, mellower. The sandstone here is a pleasing shade of red and the small villages between Brampton and Longtown look nothing like their Northumbrian counterparts. In February 2020, after monsoon rain, the river swelled to a mini-Amazon, its great red waters spreading over flat alluvial fields. Carlisle – badly flooded in 2015 – rightly trembled, and though some areas did suffer damage it wasn't even close to the havoc of the earlier inundation.

Just over the line, in the west, lies the old 'Debatable Land', synonymous with outlaws, mosstroopers[7] and 'divers broken men'. This micro-region has been recently and brilliantly written up by Graham Robb[8] and may not necessarily have been quite the Wild West of its legend. And then, over Bewcastle and Spadeadam Wastes, is Liddesdale, which definitely *was* wild, the epicentre of the reiver culture along with its neighbour, Teviotdale. Across in the east, on the Scottish side, the Merse was frequently a target for English raids and full-scale invasions, bounded by the cold North Sea, sealed in by the Lammermoor Hills to the north.[9] No landscape in the world has seen so much systemic violence; nowhere else have so many done so much harm to so many for so long and with such gusto.

I'm going to look at the borders as a sixteenth-century March Warden might have seen them.[10] By Elizabeth's day there were three rather than two on both sides of the line: an East, Middle and West March. Each one differed from its neighbours, with several especially unruly districts, like Liddesdale and Tynedale, having their own mini-wardens or 'keepers', inferior in status to wardens proper but notably potent in their own fiefdoms. We will look at each one in turn.

Great border valleys such as those of the Tweed, Teviot, Till and Eden are deeply fertile, some of the best farming land in Europe. When the bad old days were put aside and the reiving habit robustly suppressed by James VI and I after the Union of 1603, the badlands swiftly became carpetbagger lands, but before then the Tweed marked the border as it had done since that black day of the Northumbrian clergy at Carham in 1018 (see Chapter Five). Later, after Longshanks, Berwick-upon-Tweed became a frontier post or *bastide*, guarding the English East March.

Berwick used to be Scottish – in character it still is – taken and retaken until 1482 when as previously mentioned Richard of Gloucester (he of car-park fame) took it back for the last time. In 1296, Longshanks easily overcame the tatty palisade during his first *blitzkrieg* and the

place had a series of makeovers culminating in the construction of the massive Elizabethan Walls in the 1560s (state-of-the-art Italian design, still intact though never actually completed). At that point the defences actually shrank: Edward's, Bruce's and Henry VIII's walls had extended a good third to the north, and the castle was originally adjacent to the north gates. This was a great border fortress but today very little survives except a section of the battered curtain wall and lower Watergate; the rest was thoroughly purged in the mid-nineteenth century to make room for the railway station. Still, the wondrous and elegant span of the Royal Border Bridge, which soars like a living sculpture over the river, offers significant compensation.[11]

The old town has retained much of its character, complemented by splendid barrack piles built by Sir John Vanbrugh after the failure of the 1715 Rebellion and, until recently, HQ for the King's Own Scottish Borderers (KOSB). Walking the walls with its vast bastions, topped by cavaliers (raised earth platforms with flanking casemates ready to enfilade any attacker who got close enough to the curtain wall) is a great experience, with the sheer drop exhilaratingly free of health and safety. Berwick is unique and could be another York or Bath, but locals have little appetite for cultural tourism and the retail offer is as dowdy as it was in the 1950s. Like legions of besieging Scots, caravan sites ring the walls, awaiting a Caledonian invasion which is now primarily limited to school holidays.

This was the hub and anchor of the English East March; a 'forward operating base'. Its governor was a man of some standing, 'one of the wisest and most approved of the nobility of England'.[12] For much of Elizabeth's reign, Sir Henry Carey, Lord Hunsdon, did the job. A tough, no-nonsense and bluff soldier, he held the fort even when the rebellion of the Northern Earls burst into brief, doomed flames in 1569. He and Middle March Warden Sir John Forster stood fast, holding the line then and in the following year, dealing with 'Crookback' Leonard Dacre in the west.

To the west this march was bounded by the foothills of the Cheviots, the highly evocative 'Hanging Stone',[13] encompassing the valley of the Till; its southern edge was marked by the Aln, so while quite small in area, it covered vital ground. Hunsdon declared the march was twenty-four miles (39 kilometres) in length and sixteen miles (26 kilometres) wide,[14] 'that part of Northumberland which is next to Scotland and the east side of England.'[15] The Tweed was guarded, aside from Berwick itself, by mighty Norham and (now largely vanished) Wark. The first of these, a grand northern bastion, plus a fringe of land around, 'Norhamshire' with 'Islandshire', was part of the Bishopric of Durham, and remained so until 1844. While there were no bridges, at least half a dozen fords allowed reasonably safe crossings between Norham and Berwick.

Manorial castles at Heton, Etal and Ford covered the line of the Till. Hethpool stood as an outpost at the junction of Bowmont and College Burns, where a narrow pass leads up to the bleak and bare Cheviot massif. Sturdy forts studded the ground at Haggerston, Barmoor and Chillingham, with strong towers or *peles* at Duddo, Kyloe, Doddington, Lilburn, Hepburn and Crawley (home to Bastard Heron, see Chapter Nine). This was the 'Pale', a defended and defensible landscape, successive lines of resistance designed to take the sting out of invasion; it was what in the Second World War would have been known as a *Pak Front* – defence in depth.[16]

The long and exposed east coast with its miles of marvellous sands was dominated by Olympian Bamburgh and the equally impressive fortress of Earl Thomas of Lancaster down a way at Dunstanburgh. Now, if on a darkening evening beneath leaden skies, you walk along that stretch of coast where the blank windows of the gatehouse keep stare out at you, keep an eye open for one lonely knight: Sir Guy was on his way home from a crusade when he was locked into a hopeless quest by perverse magic and has wandered the shore ever since.

Directly opposite the English East March lay its Scottish counterpart, the fertile belt of the Merse (from the ancient English *mæres*, or border) which was made up of the old county of Berwickshire. This was named after the town while it was part of Scotland. After Berwick-upon-Tweed was lost, from 1596 to 1890 the county town was Greenlaw; now and since then it's Duns. Bounded by the rise of the Lammermoors to the north, this is a rich and fertile plain, its principal misfortune being that it lies so close to England and was thus very handy for raiding. An English fleet could sail up the east coast to victual the armies, and for a long period the Scots lacked equivalent naval resources.

Here the powerful Humes dominated (and still do, to a degree). Hume Castle once commanded a vast tract of land from its rocky hilltop; what's left now is just a rather bland, eighteenth-century folly. Another strength of the march was thrilling Fast Castle, a borders Tintagel, standing on a high, exposed pinnacle some seven miles (11.3 kilometres) east of Cockburnspath. Its dramatic ruins cling to the steep slopes of the promontory; there is nowhere else quite like it. Originally, the tower was linked by a timber causeway, long since rotted; subsequent land spill has partially filled in the void which would have yawned like a frothing cavern, straight from Edgar Allen Poe. Indeed, the coastline here is a complete contrast: no long, lordly strands but looming cliffs, studded with such joys as the fishing settlement of Cove – a real smugglers' haven – and Eyemouth, which, bolstered by the French, became a counterpart to Berwick with much skirmishing between contesting garrisons.

Generally, a Hume occupied the role of warden. It wasn't hereditary, but they considered it to be so. Alexander, the 3rd Earl, was a key player during the reign of James IV and a heavyweight at Flodden in 1513 (see Chapter Nine). The taint of treachery followed him like a gangrenous stench and he was executed by the regent of the time in 1517. Serving Scotland at that time was the influential French knight Antoine d'Arcy, Sieur de la Bastie-sur-Meyland, who had jousted during the festivities celebrating James IV and Margaret Tudor's wedding in 1502. He was called the 'White' Knight, possibly on account of the scarf he wore as a favour from Anne of Brittany, and he returned to Scotland in the aftermath of Flodden as French ambassador. He provided much sound military and diplomatic advice before being appointed Deputy-Governor and Warden of the Marches.

His patch included the Merse and he was based at Dunbar. The Humes didn't take too kindly to the killing of their earl, an insult made worse by having this foreigner foisted on them. They showed their dislike by murdering the nearest Frenchman and defying D'Arcy. He sallied out from Dunbar on 18 September 1517 but ran into an ambush led by George Hume and Davy Hume of Wedderburn. The knight rode for it, but his horse floundered in what became known as 'Batty's Bog' in posthumous memory. George neatly lopped off the Frenchman's head, tied it by the hair to his saddle bow, Celtic style, and rode boldly into Duns, where he fixed his trophy to a pole to show you didn't mess with the Humes.[17]

Up the coast is lovely Eyemouth eight miles (13 kilometres) north of Berwick, located at the mouth of the Eye Water, which creates a break in the steep and lofty bluffs that otherwise dominate this stretch of coast. It's very much a fishing port and the population is rarely above three thousand. Fort Point – aptly named – was where competing English and French military engineers threw up defences, either to augment or threaten Berwick.

Taking ostentatious pride of place in the harbour is Gunsgreen House, a vibrant Palladian concept, very pleasing in its proportions, built by John and James Adam. It occupies one of the finest locations on the whole north-east coast and was the seat of John Nisbet who, disingenuously, styled himself as a 'merchant'. Indeed he was a merchant ... but Nisbet was primarily a smuggler. His house incorporates some bespoke features, and I don't mean acanthus leaf cornices. A network of wide cellars provides discreet access to the sea. Nisbet worked with a Scottish clique in Gothenburg, men like John Sibbald and Henry Greig, who channelled luxuries into Britain. Tea, for example, was taxed at 119 per cent, allowing agents and smugglers comfortably wide margins.

In the centre was the Middle March. On the English side this was the great heap of Cheviot, a near impassable barrier for the movement of any large, conventional force, but the territory curled around south of the Aln to take in Northumberland as far down as the Tyne. The river systems of North and South Tyne, Rede, Coquet and Wansbeck all flowed through it. The hills themselves aren't very high or even particularly steep; the border fence marches across the spine with little or nothing to show where one country ends and another begins. The terrain is primeval; endless peat hags drag a walker's feet down and fill even the stoutest boot; steep-sided burns like Trows and Usway feed through narrow, hidden glens, bare of trees, into the rivers. Nothing there tells you which century or even which millennium you're in. You can easily experience all four seasons in a day, even in summer, and go from middling bleak to near-tundra in half an hour.

In the shadow of Harehope, Cheviot's smaller brother, an old track leads west from Ilderton off the A697 to Three Stone Burn, arguably one of the remotest habitations in the borders. A long-time friend of my father (and my boyhood mentor) Alec Bankier had the place, which was best reached by four-wheel drive. A courtyard with a house on one flank, barns and outbuildings around, what remains of it dates from the nineteenth century but it still looks like another Rorke's Drift, ready for improvised defence. With no mains electricity, water or any of that softie suburban stuff, Three Stone Burn made *Cold Comfort Farm* seem palatial. Needless to say, I loved it.

Harbottle Castle was the cork in Coquetdale's bottle, and I've a lot more to say about that in Chapter Seven. South-east of the westerly, upland end of this long, lovely valley there are towers at Hepple, Tosson, Cartington, Rothbury and Longframlington. Whittingham Vale is secured by peles at Alnham, Ryle, Eslington, Callally and Edlingham – Northumberland's answer to Pendle where the witches (allegedly) hung out.

Go west and you enter Tynedale. After the river splits north and south, the northerly arm winds past Chipchase, Simonburn and Wark to Bellingham. The heritage centre has some great exhibits, but by and large the locals aren't interested in history; I was curator there for a while and the townsfolk were often more resentful than grateful. If anywhere in the borders keeps the reiver spirit alive, it's North Tynedale. In 2005 we had a go at re-enacting the Raid of the Reidswire at the North Tyne Heritage Centre, and it went off rather well. The original combatants would have felt perfectly at home and my enthusiastic novice swordsmen and women had no interest in 'pulling' blows as we normally tend to in the hope of avoiding life-threatening injuries.

It's no wonder that there is a plethora of defensive buildings. There are bastles at Tarset and Dally, once held by the Red Comyns but now

largely demolished. Bellingham's Hole Bastle is still intact and part of a farm complex; past Tarset are the neighbourly bastles at Gatehouse, then Black Middings, with the Combe and numerous others within the modern forest. The regular conifers look far more Hawkeye than Steel Bonnets and it's easy to imagine these blockhouses being intended to deter Iroquois! And castles ... heading south, noble Chipchase still has its medieval core. Simonburn, its stump lost in the woods, was the keeper's residence; then you gave Haughton near Humshaugh. Privately owned and still inhabited, Haughton was originally built in the thirteenth century; it suffered much at the hands of the reivers before being re-imagined for the Smith family by John Dobson in the nineteenth.

Long after the Union, Tynedale was still wild: the old ways died hard. In the depths of the bitter winter of 1723, the occupier of Lee Hall in Tynedale, Colonel Ridley, who had amassed a great fortune through military service in India, was absent. He had entrusted the care and security of the place to a skeleton staff of servants – Alice, Old Richard and Young Edward.

In the gathering darkness of a winter's afternoon, a pedlar knocked at the door and begged a night's lodgings. The maid, Alice, was alone, working at her loom. This visitor was well enough turned out, although Alice found his dark good looks and confident manner anything but reassuring: he went to great lengths to persuade the girl to let him stay. All the while Alice was conscious that the hall would be an obvious target for any organised criminal gang.

After some cajoling, however, the stranger was permitted to set down his heavy, elongated pack, ostensibly containing his wares. Alice, however, was unhappy with its presence in the low parlour. While it appeared outwardly innocuous, though oddly shaped, 'a monstrous great pack', it seemed that, as she stared, she detected a flicker of movement from inside. She fled the room and sought out her fellow servants working in the barns.

In the parlour, Old Richard inspected and passed his hands over the recumbent pack. As he had expected, he could detect nothing untoward. At this point young Edward, aged no more than sixteen at the time, and drawn by the voices, came into the parlour. The boy was from yeoman stock, his kit more workmanlike than grand, but he was hefting one of his master's old guns – 'Copenhagen'.

Edward, too, thought that he could see a faint stirring within the pack and, and being young and impetuous decided that it would be good sport – and entertaining – to fire into the canvas. He let fly. The crack of the blast reverberated round the narrow chamber; there was a pall of sulphurous black powder. Worse, blood gouted from the pack ... there was shuddering and writhing. Seized by panic, both Edward and Alice fled the parlour and ran from the house. Only the older man remained.

Calmer than the younger pair, he cautiously approached the pack and lifted the external wrapping.

There were no wares inside. He saw only the body of a young man, twitching in his death agonies, eviscerated by the full charge of shot. The lad had been carefully fitted into the interior and only the movement of his breathing had betrayed his concealment. Around his wrist was a cutlass to hack his way out, and a brace of pistols, loaded and primed. The corpse had a silver whistle around its neck. So this was the supposed pedlar's game! Clearly the accomplice was to remain hidden till the servants had retired, then sneak out from the pack to unbolt the doors and, presumably, to summon his confederates with the whistle. The young man's death did not remove the threat ... somewhere outside, lurking in the bitter dark, was an armed gang.

Edward wasted no time in summoning an armed posse of his master's tenants and neighbours, some twenty-five in all. Of these, sixteen had firearms, the remainder carried edged weapons and implements. Edward, recovered from his initial shock and dismay, appears to have taken command, posting shooters at windows on all levels, with the rest as a tactical reserve. At midnight, Edward decided that it might be interesting to use the silver whistle, and he blew a long blast, with trusty Copenhagen clenched in his other hand. A party of mounted bandits rode into the courtyard, heavily armed. A classic gun battle, such as the American West would see in the following century, now raged.

Young Edward, who by then was getting the hang of gun-fighting, shot the leading raider from the saddle while most of the rest were still behind the outer wall. As the defenders regrouped, the thieves sneaked back and managed to drag away their casualties and escape. The gang was never identified. The Long Pack grave still exists in Bellingham churchyard.

Redesdale is equally spectacular and just north of Otterburn a great battle was fought on St Oswin's Eve, 19 August (sources vary) 1388 and commemorated in the great *Ballad of Chevy* [Cheviot] *Chase*. Much work is being done by 'Revitalising Redesdale', looking both at the history and ecology of the battlefield – or *presumed* battlefield, as there is significant dispute. In 1988, I was one of those who organised a re-enactment of the battle for the 600th Anniversary. Besides the usual suspects we had a company each of English and Scottish junior leaders offered by the MoD. Young, fit and trained for aggression, thankfully they only had wooden weapons – it was very nearly as exciting as the original. The local women formed the Scottish camp-followers, who fought hard and died well.

Back in the day, two of the leading local names were Hall and Reed; rough customers. The particularly grim fate of 'Parcy' Reed remains a special case among border atrocities, despite stiff competition (see Chapter Ten).[18] 'Mad Jack Ha' who lived in what is now the Otterburn Towers Hotel, was a notorious character, even in a region where

colourful and aberrant behaviour was often the norm. He fought and won a celebrated duel with one of the Widdringtons at Stagshaw Fair and was 'out' with the rebels of 1715. On trial for his life, he claimed he had been coerced and effectively kidnapped. Nice try, but he swung for it anyway.

The present A68 follows the line of Roman Dere Street that led up from Corbridge (Corstopitum) and Halton Chesters (Hunnum) and joined the road north from Newcastle just south of the outpost fort at High Rochester (Bremenium), which features so vividly in the action of Rosemary Sutcliffe's *Frontier Wolf*.[19] From there it was on to the borders and Melrose (Trimontium). During the medieval era, the valley, then a convenient invasion route, was far more densely populated than it is now; each farm today would then have been its own hamlet. Otterburn Tower, an Umfraville hold, was the ckoke point, reinforced by Elsdon [20] which covers the passage into Coquetdale by way of the Grasslees Burn. Once you are over the dreach rise of the Ottercops and Aid Moss,[21] dark and lowering even in summer, the next significant wet gap is the west-east course of the Wansbeck.

Morpeth has a finely elevated castle – two in fact. The second shifted from the first motte to a later one – although only the gatehouse really survives (currently well restored and managed by Landmark Trust). More castles at Mitford and Bothal held the line. The road south from Redesdale towards Newcastle was guarded by Little Harle, then Shortflatt, Belsay and West Beechfield, Ogle and Ponteland. I live in Belsay, where the manor has been in the hands of the Middletons since the late eleventh century. It was forfeit in the early fourteenth when Sir Gilbert, who also held Mitford, went rogue and defected to Scotland, going so far as to kidnap the Prince Bishop Elect for ransom. He paid the price and his estates were confiscated for a generation. Like many other places, including Chipchase (which bears traces of the same masons' marks), a Jacobethan wing was added to Belsay after the Union: 'Thomas Middleton and his wife Dorothy built this house, anno 1614.'[22] The new and entirely domestic wing was tacked onto the flank of the old tower – just in case.

Up the road towards Wallington is Scots Gap, previously Scot's Gap. During the border wars (date uncertain), Scots reivers dropped in to relieve the inhabitants of their flocks. In anticipation of just such an event, their sheep were gathered in a natural saucer-shaped depression (the '*ba hollow*' or 'Villain's Bog'), which lay to the east of the settlement, secure – or less insecure – in marshy ground, fortified by a rampart and palisade and with only one way in. When the Scots attacked, the locals summoned reinforcements by lighting a beacon on Rothley Crag, presumably where Blackett's eighteenth-century folly now stands. The attackers were cut to pieces, no doubt *hewed into pieces sma'* as Northumbrians were wont to

do, and were buried in a mass grave nearby. To commemorate the fight a stone was set up by the roadside, but this was swept away when the track was widened into a turnpike.[23]

Alnwick, the warden's HQ, became, thanks to the bent bishop (see below), home to the Percies and despite many vicissitudes they've hung on – and in some style. The current duchess's development of Alnwick Gardens has really put the county town back on the map and the place attracts tens of thousands of visitors every year – or it did until Corona Virus struck. J. K. Rowling has helped Alnwick as a principal location for the *Harry Potter* movies, and broomstick training is still *de rigueur*. Not just Hogwarts either: two *Downton Abbey* Christmas Specials were filmed there. I was able to gate-crash the cast and crew lunch one day as I was in full Great War brigadier's kit doing living history at the excellent Fusiliers Museum. Why not? I easily outranked the rest.

It was the most flamboyant, not to say venal, of the Prince Bishops – Anthony Bek – who sold the Barony of Alnwick to Lord Henry Percy in 1313. Bek negotiated the sale in his capacity as trustee on behalf of the de Vesci beneficiaries, though he failed to account for the proceeds, which were diverted to fill the Episcopal coffers and never subsequently transferred (a fraud which rankles even today).

These Percies became very important in Northumberland's history and in the wider narrative of the border wars; at times their stories are closely interwoven. During the wars of the fourteenth century, successive raids and climatic changes depopulated the upland dales and many a gentleman looked elsewhere for a living. The Percies bought up everything that was going, virtually at clearance prices, while these despoiled and barren uplands were re-settled by a harder and purely martial breed. The Percies would grow into the over-mightiest of over-mighty subjects, together with their emerging rivals, the Nevilles. Endemic border conflict helped build a power base and a level of northern hegemony that none of the other magnates could boast.

Henry Percy, the 1st Earl (they're all called Henry), acted as kingmaker when Henry of Derby unseated his cousin, Richard II. The choleric Hotspur, something of an aristocratic thug, fought Glendower in Wales and the Scots wherever he could. Finally, they over-reached themselves: the son died a traitor's death at Shrewsbury in 1403, followed five years later by the old fox himself. The Percy star was eclipsed by that of the Nevilles, whose loyalty saw them elevated to Earls of Westmorland. This was not the end of their feud, however: Percy bounced back and increasing tension between these two rival families sparked a gang-war that finally blossomed into the Wars of the Roses in 1453.

One of my more bizarre experiences at Alnwick was filming one cold and sleeting February day for *Strictly Come Dancing*. I have not watched the show, but the crew wanted 'a knight in shining armour', I

don't know why, but at least I had the kit. All went well until someone asked me at the end who I supported. I looked totally blank, but I was saved from embarrassment by effervescent page-girl Alix, who was a fan and knew who was who. (The only contestant I could think of was Ann Widdecombe – she'd been on years before, apparently.)

East of Alnwick towards the mouth of the Coquet stands Warkworth, despised by Shakespeare, who described it as 'a worm-eaten hold of ragged stone' (Henry IV, Part II), but loved by many, including me. It's the real deal ... proper medieval. With Alnwick and Bamburgh, grand and imposing as they are, most of what you see is nineteenth and early twentieth century; Warkworth is authentic, just ruined enough to heighten the romance and with the wonderfully enigmatic Hermitage just a stone's throw up the river.[24] This is a very different landscape, almost a different country: flat and fertile, alluvial and giving. South of Amble, you pass over the fault line between rural and industrial into a region that's all very different ... not much scope for *Homes & Gardens*. Then there's the 'toon', marking the southern flank of the march.

During the nineteenth and early twentieth centuries, Newcastle upon Tyne became the industrial powerhouse not just of the north but of England and indeed (as we Geordies like to think), the world. Dan Jackson in his recent illuminating study, *the Northumbrians*,[25] links the industrial revolution to the warrior past; hardness, courage, steadfastness, self-belief and a sense of community link the two. Perhaps, then, it's no coincidence that much of the city's great wealth derived from the manufacture of armaments, and that wars were generally good for business on Tyneside.

What did the Romans ever do for us? Well, they built a bridge over the Tyne and created a fortified crossing, their fort of Pons Aelius guarding the passage. The medieval castle stands more or less on the site of the original fort, on a knoll that falls away sharply on three sides to form a reassuringly defensible mound. The view is virtually obscured by the rail network, constructed with no regard for heritage. The keep itself, like Berwick, was under threat until rescued by antiquarians and prettied up by famous local architect John Dobson who, in partnership with developer Grainger and fixer Clayton, created a superb Victorian city. Grey Street, with its elegant curve, is still one of the finest cityscapes in England.

Formerly, the medieval town rose from the river where timber-framed merchants' houses crowded the heaving quayside. Coal, post-Reformation, made the place and its mercantile élite fabulously wealthy. Before that, during the long Scottish Wars, it was a frontier town,[26] the largest in the north, probably rather bigger than its more upmarket neighbour Durham, seat of the omnipotent Prince Bishops.

A readiness to fight has long been identified as a border characteristic, and the fierce, not to say fanatical, aggression which is still seen as a defining trait has a long provenance. The *feid* (feud) or vendetta was a long-established Northumbrian and border custom, and one of the most notorious encounters between gentlemen of the better sort took place by the old White Cross on Newgate Street in the eighteenth century.

John Fenwick of Rock and Ferdinando Forster of Bamburgh (an MP) were both men of substance; in August 1701 they were guests at a grand jury luncheon held in the Black Horse Inn on Newgate Street. A drink-fuelled altercation followed, each seemingly encouraged by the raucous company. Next morning, when heads should have cleared and blood should have cooled, a chance encounter sparked a resumption of verbal abuse followed by swords. Both men were skilled at arms and for a while the blades bickered and parried without hurt. Forster suddenly lost his balance, slipped and stumbled, and his enraged opponent delivered a killing stroke. Inevitably, Fenwick was caught, tried and hanged: a duelling fatality was murder. The White Cross and Black Horse Inn are long gone, though Forster's impressive tomb survives in the chancel of Bamburgh church.[27]

Much of the city's heritage was bulldozed in the sixties and seventies. T. Dan Smith, socialist worker hero, icon/iconoclast and crook, ripped much of the heart out of the place in his egomaniac quest to raise a Poundland Brasilia of the North. He went to gaol but inflicted far more damage than the *Luftwaffe* could ever have dreamt of in their worst Wagnerian fantasies.

On the other side of the line it's different: there's no major urban centre, but a series of very fine and very *Scottish* towns. During the industrial revolution it was the wool trade that dominated; Hawick, Selkirk, Galashiels and Peebles were crowded with mills. Most of these are now outlets for wool and cashmere jumpers that employ only a handful each. Echoes of the distant past would be easy to miss, and while there might be a general awareness of it, there's not necessarily very much interest, although there are the Ridings of course and the Reivers Festival in Hawick during early spring. The town has not changed much during my lifetime; there are a few more bars and cafes, but most of the shops are dowdy with a rash of charity outlets. While I like a decent charity shop as much as anyone, too many on a high street indicates decline. Heritage assets like the well-restored Drumlanrig's Tower,[28] with the lovely museum set in a charming park[29] are fine, but they don't bring many jobs. In tourist terms, the Middle Marches ought to rival the English Lakes but they have not quite managed it. I was once driving through Teviotdale during a bank holiday and heard, on the car radio, that police had stopped traffic leaving the M6 to visit the Lakes owing to excessive congestion. The road I was on was empty.

Derek Stewart, well-known border historian and writer and a leading light of the festival, explained to me its importance:

> Living in Hawick, a market town in the centre of what was once the old Scottish Middle March, it is impossible to not be aware of the long history of the town and the wider area. Hawick was shaped by conflict and feudalism – to understand the town is to perceive history. Travelling around the borders, peel towers and abbeys are visited on weekend outings – ruins which excite the imagination and transfer knowledge of a harsh heritage.
>
> Growing up, knowledge is developed of the Borders as a battle ground, and one of destruction and loss. All the border abbeys have been burned down, all castles turned into ruin, and the battlefields are all Scots defeats. A perception is built up of the Scots trying hard, being brave and heroic –ultimately losing – but bouncing back to do it all over again. Looking at the reivers however, here was a people who co-existed side by side during the border wars and did not do too badly from it ... living like petty princes ruling over all the land they surveyed.
>
> As a 'Teri' [someone born in Hawick; probably Norse in origin] we are taught at school about how a group of Hawick boys and old men in the years after the Battle of Flodden had to rise up and take on a company of raiding English soldiers. A skirmish was fought a few miles to the east of Hawick at Hornshole, in which the English were ambushed and slain to a man, with the Hawick men returning in triumph with a captured flag as a trophy. The town was saved from destruction and a local tradition was born. Hawick, as with many other border towns, has its annual Common Riding. Held in June, the tradition combines two events in the town's past – the marking of the town's Common Land and the skirmish of Hornshole in 1514. The Common Riding brings deep passions to the locals, something which is 'better felt than telt [told]'. The town comes together, providing a tight community and pride.

* * *

In its day the Scots Middle March faced its English opposite along the high frontier of Cheviot, from the hanging stone west to Kershopefoot, with the last eight miles (13 kilometres), bounding the English West March. It encompassed the sheriffdoms of Roxburgh, Selkirk and Peebles with both Teviotdale and Liddesdale – two highly tricky valleys. It was said of the Teviotdale men, not without justification, that they were 'a warlike nation which by reason of so many encounters in foregoing ages between Scottish and English was most ready for service and sudden invasions.'[30]

Liddesdale was a thorn in the sides of both English and Scots administrations for hundreds of years; it was the haunt of Armstrongs, Elliotts, Scottish Bells, Croziers, Nixons, and Burns – true riding names. Back then it was wild, barren and remote; a Tolkienesque landscape devoid of roads, towns or any visible trace of civilisation. Fearsome Tarras Moss – a nightmare marshland, a half world of peat hags and bog myrtle, laced with hidden, part-submerged pathways known only to the locals – was a sure and impenetrable refuge when vengeful English wardens came calling ... which they did, quite often. The reivers used the valley of Bowmont Water to cross the line by Cocklaw and fall upon Coquetdale, one of a number of reiver routes.

It's very different now: Newcastleton is a pleasing and drawn-out nineteenth-century ribbon development, close to forbidding Hermitage and seventeen miles (27 kilometres) south of Hawick. It's more fêted for its lively music festival than for banditry. Like the whole of Liddesdale, several centuries of drainage and husbandry have virtually erased all traces of the bad old days. In its time this was a badlands where outlaws and reivers roamed: remote, lawless, verging on the primeval and as hospitable as a plague pit.

Teviotdale was dominated by Scotts and Kers of Ferniehurst and Cessford, both of which castles still stand. Ferniehurst, just south of Jedburgh, is a classic border tower which remains a family home, close to the magnificent two-thousand-year-old Capon Tree. Cessford's squat, no-nonsense bulk, even though ruined, sits on its mound above Kale Water, six miles (10 kilometres) south-west of Kelso, astride what was then the principal route into England. Scott and Ker contested the Middle March wardenship and feuded enthusiastically. Scotts with Eliotts and Ker, at one point, all feuded with the township of Jedburgh, a novel kind of feud and nobody seems to know quite why. Not that 'why' was ever really the point.

Walter Scott of Buccleuch, 'Bold Buccleuch', was Keeper of Liddesdale in the last decade of the sixteenth century and was the kind of law officer with whom Pablo Escobar could have bonded. Vicious and vengeful, he represented everything that was wrong with the borders. Famous for the daring raid on Carlisle in 1596 to spring his disreputable client Kinmont Will (see Chapter Ten), he maintained a particularly nasty vendetta against Charlton of Hesleyside – though it must be said that the Charltons were perfectly capable of retaliation. Novelist Andrew Greig in his clever re-telling of the story of Fair Helen of Kirkconnel[31] (being a border ballad it doesn't end well) portrays Buccleuch as a ruthless and manipulative Mafioso. Like his equally unpleasant contemporary Ker of Cessford, Buccleuch had a handy epiphany after the Union of the Crowns and became a true zealot in the cause of law and order, even hanging some of those who'd ridden with him against Carlisle.

Jedburgh, its amenity much improved since the A68 bypass was built, is dominated by the Gothic shell of the Abbey and the gaol built above the town.[32] Coffee shops and a very friendly Indian restaurant have arrived alongside David Thomson's traditional gent's tailor and outfitter, whose in-house kilt-maker was working into his nineties.

All of these marcher townships are different. Kelso has a wide central square, reminiscent of Flanders, and the glorious over-the-top sprawl of Floors Castle, home to the Ker Dukes of Roxburghe. Peebles is a little removed from the rest; it's a pretty town that has a feel of gentility. The vast Victorian pile of the Hydro helps: it's one of those great nineteenth-century spas, scene of many a family short break; my own children loved the place. It's gone a bit down-market in recent years which is a shame; it used to have a first-class selection of good single malts and a wine-waiter cum major-domo who was never troubled by standard measures and who well understood his clients' needs. The town is brimming with clothing outlets, good cafés and has a general visitor-friendly ambience that Hawick and dour Galashiels lack: a borders version of Windemere or Bowness but retaining a harder edge.

At the western end of the town, a mile or so beyond, rearing like a cliff above the Tweed, is Neidpath Castle. This is roofed, intact and habitable, and these days is a wedding venue, like so many other ancient buildings. It's exactly what you'd look for in a border tower: the sort of place in which you might expect to find Macbeth and his other half. In fact, the L plan tower was occupied over several centuries by the Frasers, Hays and Douglases. The rubble corners are all neatly rounded and it probably derives its name from the *Nid*, or narrow pass below, through which cattle could pass between fortress and river.

Billy the Kid was described as 'a sure thing killer', but contrary to heroic myth he tended to shoot most of his victims in the back, and only when the odds favoured him. Two of Peebles' leading families, the Tweedys and the Veitches, would have offered him an internship on the spot. These aren't names like Armstrong or Eliott, whom you'd expect to be feuding. Nonetheless, theirs was one of the most pernicious vendettas of all.

Tweedys were lairds of Drumelzier, the name is said to derive from 'spirit of the Tweed', thanks to the ingenious spur-of-the-moment improvisation by the lord's wife during the crusades. He came home after years on foreign service to find his spouse bouncing a healthy newborn son on her knee. Upon his enquiring how this might be, the lady, quick as a flash, replied she had been magically impregnated by the spirit of the river – a borders version of the Virgin Birth. I'm not sure how the story panned out, but Tweedys don't seem like the forgiving kind.

'Wherever a Veitch and a Tweedy met, they fought and fought to kill.'[33] In the 1590s the heidman of the Veitches was known as the 'Dei'l

(Devil) o'Dawyck' and his minder, Burnet, the 'Hoolet' (owlet) of Barns, was every bit as bad. Feuds don't just involve the names themselves: they draw in both sides' wider affinities. On one occasion, nine of the Tweedys jumped Dawyck's son near Neidpath and hacked him to death. The Dei'l responded and the Tutor of Drumelzier was tracked to Edinburgh and murdered on the streets. Not to be outdone, the Tweedys, also in Edinburgh, targeted James Gedder, Dawyck's brother-in-law, and gunned him down at point blank range – 'sure thing killers' all right. As late as 1611, a court proclamation noted 'the deadly feud between Veitches and Tweedys is as yet un-reconciled.'[34]

<p style="text-align:center">* * *</p>

Back into England and the West March. It's huge, covering all of what were Cumberland, Westmorland and the Furness District of Lancashire. While Bruce's raids after 1314 did penetrate as far south, we are more concerned with the top third from Inglewood Forest northwards. The Esk and Liddel Waters with the Kershope Burn run along the frontier with that perennial thorn – the Debatable Land. The road from Newcastle traced much the same line as the modern A69, but it was seriously rough and usually wet. Very wet. It was so bad that Marshal Wade, struggling to move his troops west to counter the Jacobites (who had humbugged him by attacking west rather than east),[35] resorted to doing what he did best in any crisis: he built an all-weather highway – the Military Road (these days the B6318) which now conducts us along the loftiest part of Hadrian's Wall. Regrettably, Wade used a lot of it as hardcore.

The south Tyne Valley was always tempting, lush with pasture and settlement targets. Kinmont's raid on Haydon Bridge in 1587 with a force of thousands is regarded as a masterpiece of the art of banditry, even if the residents did give him a warm reception. This lowland was still well protected: the Umfravilles –we'll meet them again in Chapter Seven – held Prudhoe, which resisted William the Lion in 1174, then Bywell, refuge for Henry VI before the misfortune of Hexham in 1464. Aydon, a stunning fortified hall with a curtain wall (now in the hands of English Heritage) stands above the Cor Burn with Halton Tower just to the north. Halton has been in the possession of the Blacketts for several centuries and there is a sad memorial in the chapel to a pair of young children, brother and sister, who died there in a fire – apparently their ghosts remain.

Further west, near Haydon Bridge, is high Langley Castle, much restored by Cadwallader Bates and now a luxury hotel. Heading south there are peles at Allendale and Staward and just south of Haltwhistle stands Bellister (agreeably haunted) and the wonderful Featherstone. This is one of the real gems in the magical west of the county; in a romantic

location, it is the ancient seat of the Featherstonehaughs – border gentry frequently active in march affairs. Like most Northumbrian knights they were a pretty rough bunch and, in approved local style, they were at feud with their neighbours, the Ridleys. The Ridleys were yeomen from the nearby – and rather more utilitarian – Willimoteswick.[36] This was to have consequences; blood feuds usually do.

In the fifteenth century the baron had a beautiful daughter, Abigail, who was headstrong – as border heroines tend to be. She had formed a liaison with one of the more dashing scions of the rival house of Ridley, which was deemed unsuitable: a daughter was highly valued in the dynastic marriage stakes, a commodity that could provide a welcome cash dividend. Traditionally, it was the mothers of both parties who negotiated the union; this was an art form, a careful pairing and comparison leavened by some sound commercial haggling.

The baron wanted his girl married off quickly: pre-sampled goods only went at fire-sale prices and he needed a good match – and soon. In fact, he chose a cousin, not too close in blood but abundant in acres, an excellent candidate, right age etc. and no doubt she'd get to like him. Abigail didn't have a say in this of course; the wedding was agreed upon and planned. All she had to do was to turn up and look resigned, if not radiant. Featherstone did these things in style: he had a magnificent table laid for the wedding breakfast, groaning with game, choice cuts and gallons of drink.

A family tradition demanded that after the ceremony, the bridal party would change into hunting clothes then walk or ride around the bounds of the estate before partaking. He, the baron, wouldn't take part in this, but would wait to play the welcoming host when they all returned to his great hall.

Off they went in the warm afternoon of a spring day, probably mounted and in the greens and russets of the chase. This was Northumberland, so they would all be armed including the women according to records of the reiving or riding names. All went well, or seemed to; we don't know if the riders had had a drink or two, but again, this was Northumberland, so we can be fairly sure they did. Where the track narrowed into a small ravine, up popped Master Ridley and his gang; they had planned a different sort of wedding. Whether Abigail was party to the plan isn't clear, but there is a good chance she was.

Both sides laid on: maid of honour, bridesmaids, they all went down in the mêlée. Apparently, there were no survivors. In the fray, Abigail interposed herself between her husband and lover to frustrate the former's attempts to impale the latter. She took the fatal blow. Filled with fury and grief, Ridley ran the husband through, then killed himself, adding his corpse to the now completed pile. You can tell this is a borders tale: Webster couldn't have done better.

Meanwhile, back at the hall, the baron waited ... and waited. The servants stayed clear. He was alone in the great empty cavern of his hall, the laden tables and stacked bottles seemed to mock him. The afternoon thickened and faded; none dared approach to light the candles. Not until the dolorous stroke of midnight did the baron, still alone in his chair, hear the sound of returning hoof-beats. The wedding party filed in silently to the sepulchral hall ... but not as they were in joyful, youthful, vigorous life; they were the pale, blood-garnished shadows of their final seconds. The feast was never consumed and when the shaking domestics crept back into the empty space at dawn, there was the baron, still in his high carved seat, but completely mad.

Hexham is the main market town, with Corbridge village, though equally historic, as its rather up-market neighbour. If you can afford Corbridge you've arrived. Hexham is very ancient. It is possible (never proven) that Bishop Wilfrid's great abbey stands on top of a Roman outpost dominating the river crossing, and on the basis of inherent military probability, it's a cert. The undercroft with its Roman masonry is a real gem. When it was built-in Anglo-Saxon times the masonry was taken from the Roman site at Corbridge. Its tight confines may well date back to the late Roman era but it is the medieval abbey, much improved by Dobson, that creates a core and sets the tone.

Across the market square, scene of the dreadful massacre of 1761, is the Moot Hall and Gaol, part of the original castle and the first purpose-built prison in England. This bespoke gaol was built in 1330-1332.[37] If you had the means you might be held on the upper floor, where life could be tolerable; the further down you went, the worse the accommodation. If you were a common thief you went into the deep basement that yawned like the pit of hell. Henry Beaufort, Duke of Somerset, captured after the rout of May 1464, would have spent his last night on earth there before his beheading in the market place the following morning. He wasn't alone: the triumphant Nevilles had a regular clear-out of the opposition. One way and another, Hexham Marketplace has a far bloodier history than its pleasant façade would imply.

Before the English Reformation, the Moot Hall was the court and offices of the Archbishop of York, who controlled the old Regality of Hexham. This was an area of about ninety-two square miles (238 km²) made up of the parishes of Hexham, Whitley Chapel, Allendale and St John Lee, possibly the original land grant from Queen Ethelreda to St Wilfrid in 674, linked to the foundation of the priory. York acquired the area in c.1100, governing both secular and ecclesiastical affairs.

This endured until 1536 when Henry VIII stripped out the lay authority and vested it in the grasping hands of Sir Reynold Carnaby, a gentleman Jack-the-Lad who made the abbey his private residence. Incidentally, his future son-in-law was none other than Sir John Forster,

long-serving (as in self-service) warden of the English Middle March. The lay estate passed first to the Fenwicks and then to the Blacketts. It was only in 1837 that the old Regality was finally scrapped and the parishes were integrated into the Bishopric of Durham.[38]

Westwards from Hexham, both Haydon Bridge and Haltwhistle have been bypassed in recent years, from which both towns have benefitted enormously. Past Haltwhistle the road rises as it leads on towards Brampton. Look to your north if you are driving along the A69 if the rain and mist aren't too bad, and you will be blessed with views the like of which you won't see anywhere else in England. The land stretches away, not a scrap of modernity in sight, north towards Simonburn, then Gilsland, Bewcastle and Spadeadam. Just before Gilsland stand the ruins of Thirlwall, guarding the tempting Irthing Gap as assuredly as its Roman predecessor, Birdoswald (Camboglanna). It was built, tidily, with stone recycled from the Wall.

If you turn off the Military Road or the A69 at Gilsland, and head north towards Bewcastle Waste, you have left the twenty-first century way behind and re-entered the mystical world of the old borderland; little has changed if you ignore MoD Spadeadam on your right. The Romans used the Maiden Way to link Birdoswald to Bewcastle, which began its long history as a forward post. Thomas Dacre, the one who fought at Flodden, built an inner bastion at Askerton, today a marvellous small country house.[39] The garrison here was formed to back up the contingent at Bewcastle but, being borderers, there was never much love lost between the two.

Why did the Romans build a fort at Bewcastle? There's no obvious answer. It was idiosyncratic, which is a good word when you have no real idea. We *all* know Rome built to a bog-standard pattern – boring, perhaps, but highly pragmatic – but this outpost, one of three with Netherby and Birrens, is built to conform to the topography.

It is an old site, most likely sacred to my old friend the native god Cocidius (see Chapter Four), who does get about, so it's very probably *Fanum Cocidi*, and worship certainly seems to have continued after the occupation.[40] It is this religious significance that might be a clue to the location, since Rome practised cultural imperialism, taking over the local gods and integrating local worship. It's not a good defensive site, even though built six-sided to conform to the mini-plateau it stands on. It is overlooked; any major inroad is more likely to come down through the far more strategic Irthing Gap. In the late eleventh century the Normans gave the place a makeover and built a castle there that re-used parts of the old ditches. It was blitzed in 1173 by William the Lion. Rebuilt again in the fourteenth century, Edward IV granted the place to his younger brother, the energetic Richard of Gloucester. It remained, gradually decaying during the following century, as a garrison outpost with a

captain in charge. What was left defensible may have been roughed up by Cromwell during the Civil Wars and then became a convenient quarry.

St Cuthbert's Church is rightly famous as the home of the Anglo-Saxon Bewcastle Cross, an astonishing triumph of art and piety. It is probably dedicated to Aldfrith, son of Oswy and half-brother to the fatally aggressive Ecgfrith, who came to grief in Perthshire. The carving of sacred figures is exquisite, and though the head of the cross is gone, the shaft still stands fourteen feet (4.3 metres) high. Another, just over the border at Ruthwell, shows similar craftsmanship.[41] The church itself is built from recycled Roman stone and was constructed in Longshanks' time, with a substantial makeover in the eighteenth century.

In the churchyard lie three CWGC gravestones; these are the graves of young men of the parish who fought in France and were wounded then repatriated. They died, and their bodies were brought home for burial. I've seen thousands of these Portland Stone markers across many cemeteries in many parts of the world, but there is something particularly poignant about these three, because they are so unexpected in this tranquil place, which looks as though industrial wars might have passed by. They don't of course; they never do. And that is the magic of Bewcastle ... this commemoration still fits.

Past Bewcastle and you're soon in Liddesdale, over the line into 'Indian Country'. But you can feel why Bewcastle was sacred to our ancestors. The membrane between this world and the next seems translucent there. In the borders many such places are untrammeled. For me, Bewcastle, St Mary's Loch with its wonderfully mysterious old hillside graveyard (west of Selkirk along Yarrow Water), Hermitage Castle, the hillfort at Brough Law and a handful of others are compelling, life-affirming, hallowed by history and by the souls of those who went before us. Call it what you will, but it's definitely there.

Carlisle – Roman *Luguvalium* – is as different to its eastern neighbour, Newcastle, as it gets. The red sandstone is softer and the city, despite its industry, never matched Newcastle as an economic centre. It has the aspect of a large and ancient market town; the lofty nave of the Cathedral and splendid undercroft are wonderful. The formidable castle rises like a sandstone bluff, isolated from the city proper by the relatively new moat of an urban highway. Almost in defiance, the Bishop of Glasgow's epic 'Monition of Cursing'[42] hurled at the reivers is etched in stone along the pedestrian underpass that links the rather magical Tullie House Museum to the castle:

> I curse their crops, their cattle, their wool, their sheep, their horses, their swine, their geese, their hens and all their livestock. I curse their halls, their rooms, their kitchens, their stalls, their barns, their cowsheds, their barnyards, their cabbage patches, their plows and their harrows.

I curse all the goods and every building necessary for their sustenance and well-being.

It hurts when even your cabbage patch is cursed! The Bishop *must* have had a visit from the reivers to spark so much venom – and that's just the opening salvo. 'The river of Tweed and other rivers where they ride might drown them, as the Red Sea drowned King Pharaoh and his people of Egypt, pursuing God's people of Israel.'

Unlike Newcastle, you still get the feeling of a more remote historic past in Carlisle and it is not hard to imagine the bold Buccleuch's riders splashing over the river to lift Kinmont Will Armstrong from under the warden's precious nose (see Chapter Ten). In Susan Price's delightful novel *The Sterkarm* (Armstrong) *Handshake*,[43] the sixteenth-century reiver hero Per (who has been seriously wounded while on a raid) is brought via a time portal (run by a twentieth-century corporate villain) into contemporary Carlisle. He doesn't care for it and escapes from hospital via the underpass, where he encounters a dropout who happens to be wearing a T shirt carrying the family crest. Per immediately assumes the lad is a fellow reiver and makes him swear fealty there and then. The boy, hopelessly adrift in the modern world, suddenly finds he has a real place in the sixteenth century and the power of the oath provides an epiphany.

Brooding over the wide sweep of the Solway stands the Lochmabonstane, a megalith and a marker for truce days between the west marchers. Scott, in *Redgauntlet*,[44] has Solway fishermen riding into the waters and spearing salmon with tridents; it must have been great fun but more common was, and indeed is, the 'haaf' net. *Haaf* is the Old Norse word meaning channel, and the practice clearly goes back centuries; you might still see fishermen using a haaf net on the Solway itself or on the rivers Nith, Annan or Eden. It consists of a rectangular timber frame, eighteen feet long, which both secures the net and separates it into two sections or *'pokes'* (pockets). The frame has three legs and the central post is extended to allow the fisherman to both heft and tip the beam to trap fish. Traditionally, the anglers draw lots for who should have the best pitch on any given day. Once that's decided they walk out into the shallows and set up the haaf so it is facing into either the ebb or flood tide; either will suffice. Once the quarry swims into the net, the legs are allowed to float upwards to the surface, trapping the fish. The season is normally from about April to September. It is both skilled and potentially dangerous work. The knack has been passed down through the generations and some, not many, keep this venerable skill alive.[45]

Near Carwinley, the blank bulk of the Liddel Strength or Moat crowns a bluff overlooking the south bank of the Liddel, near its union with the Esk, the last scrap of high ground before the river spills out onto coastal flats. Seat of the Anglo-Norman Barony of Liddel, the timber

motte was trashed by David II in 1346, en route to his own *Ragnarok* at Neville's Cross, and it is possible a later pele was thrown up on the site. Some authorities, such as the influential nineteenth-century antiquarian William Forbes Skene, presented a persuasive case for a much earlier origin, as far back as the Roman era. He links Carwinley to a native ruler of the Selgovae, Gwenddolen ap Ceidio, who died during the fight at Arthuret in 573 AD.[46]

Across the shallow tidal reaches of the Solway lies the Scottish West March comprising Galloway, Nithsdale, Annandale, Eskdale, Ewesdale and Wauchopedale, the Stewartries of Kircudbright and Annandale and the Sheriffdom of Dumfries (which generally marked the western flank of the wardenry). Like all the marches, this is a very distinctive province, with Dumfries as the main urban centre, and Annan perhaps the poorer relation. Unexpectedly though, this was a hub of Britain's munitions manufacturing during the Great War, with the immense and utterly astonishing 'Devil's Porridge' factory, said to be the biggest in the world, employing some 30,000 men and women. (Devil's Porridge was a lethally explosive mix of nitro-glycerine and gun-cotton).

Before you get to Dumfries, just off the M74, is Ecclefechan and above that the mound of Birrenswark. We found pieces of a Roman sword hilt there during several seriously wet and windy seasons of digging in the sixties under the inspiring aegis of the late Professor George Jobey. It was *very* wet and *very* windy and even at sixteen that hill felt damned steep and as exposed as it gets, a high plateau above the flat plain. You can see why the tribes built a settlement here: it controls a vast swathe of ground and overlooks the Roman Way laid down to link Carlisle with the Clyde Valley. The hill rises above the meeting of the Mein Water with the Middlebie Burn and the outpost fort Blatobulgio, built during Agricola's time by XX Legion and then garrisoned by a Germanic auxiliary cohort.[47]

Although it was first dug in 1898, in the sixties we found loads of lead slingshots. The theory was mooted that the place had been part of a training complex, and that the (by then) abandoned hillfort had been used for target practice and mock assaults. George Jobey had the MC and bore scars from notably active service with 16 DLI in Italy during 1943/1944. His soldier's instinct (which I'm still prepared to trust) told him there hadn't been a battle here, that this was a site of mock warfare, for training purposes only. Having said that, much more recent archaeology, conducted by a highly respected team, suggests that this may not have been the case, that it may in fact mark the site of a real military operation.

One of the most celebrated border ballads features Helen Irving (or Bell), the beautiful daughter of the Laird of Kirkconnel in Annandale I touched on previously. Naturally, she didn't lack for suitors. Her favourite was dashing young Adam Fleming of Kirkpatrick, but her father, for the usual dynastic or cash reasons, preferred another, also called Bell. This was a real *Lorna Doone* scenario, but since it's the borders with no hope of a happy ending.

The lovers met secretly in Kirkconnel churchyard, swept around on three sides by the pretty river Kirtle. They were discreet but not discreet enough, and Fleming's rival decided to clear the path for his own suit by bumping off his rival with a well-placed shot. Helen saw the flash in the pan and nobly threw herself in front of Adam, taking the fatal round. Enraged, as well he might be, her distraught boyfriend did the usual thing and hacked his rival into barbecue-size chunks before disappearing into a lifetime's exile. As I've mentioned, Andrew Greig re-imagines this poignant tale in his recent *Fair Helen,* putting the scheming Buccleuch into the frame as arch manipulator.

> I wish I was where Helen lies,
> Night and day on me she cries;
> Oh that I were where Helen lies,
> On fair Kirkconnel Lee.[48]

Dumfries is a port, very old, a royal burgh and now county town. It is located by the mouth of the Nidd at the Solway end of one of the lateral valleys that slash through the uplands in the west. These secret dales are not like the much-visited and much-heralded glories of the English Lakes; they're barer, more subtle and they feel far more remote. The derivation of Dumfries may be from the Gaelic *Dun Phris* – 'the fort of the thicket' – and its original people may have come from the Selgovae. In the heyday of Northumbria *Northymhymbre* (north of the Humber), the Angles were in charge; later it came to be part of Strathclyde. It was a major centre where William the Conqueror and Malcolm III, Shakespeare's Canmore, met to deal with the irritant of Edgar the Atheling, King Harold II's potential English successor and a thorn in the Normans' side.

Later, Alexander III (before his fatal tumble) used Dumfries Castle as a forward operating base for his bid to recover the Isle of Man from Norway, though it has now gone. In February 1306 Robert Bruce met and killed, or at least his minders did, John, the Red Comyn, an erstwhile ally, who Bruce was sure had betrayed him to Longshanks. The murder happened in Greyfriars Church. Killing your rivals was to be expected, but knives in church weren't allowed: this was hallowed ground and murder was very bad form. The future King of Scots was promptly excommunicated.

Much later, the town became home to Rabbie Burns, who moved there in 1791 and stayed until his death five years later. There is a Burns Museum and I went there thirty years ago. The interpretation there, rather blandly, blamed Burns' early death on physical exhaustion brought about by long, hard hours of work in the fields as a boy. Oddly, there was no mention of the two bottles of whisky a day he consumed.

An RAF base was built in the town during the run up to 1939, and it received a visit from a *Luftwaffe* Dornier Do 217 on 25 March 1943; the aircraft shot up the aerodrome, strafing the beacon before crashing. The German pilot did not survive and was interred with full honours in Troqueer cemetery. Of course, by this time the Scottish West March was no stranger to violent death, and on a grand scale. Seventeenth-century dramatists such as Webster and Ford (both of whom enjoyed a seriously gratuitous bloodbath) could never have written the plot for that most murderous of all border feuds, the war between Maxwell and Johnstone.

Caerlaverock, Clan Maxwell's impressive pile, stands by the Solway. It's been used many times as a location for television programmes. Its red-faced ashlar and unusual triangular floorplan, fronted by a wide moat, may seem familiar to the visitor. Much of the drum towers defending the gate and later barrack pile buildings survive. It was certainly besieged as recently as 2002 when Tony Robinson was having fun with trebuchets. The Maxwells were the leading name in the west; their rivals and nemesis the Johnstones were never quite a match – or not until the end, anyway. Quite what the source of the quarrel was nobody seems to have been able to recall, but Lord Dacre, writing to Wolsey in 1528, reported that the feud was bubbling along nicely. This suited England: keeping the Scottish West March in foment was tactically useful and cost-free.[49]

It heated up during the uncertain decade of the 1580s, the prize being the office of March Warden. John 8th Lord Maxwell and Johnnie Johnstone slogged it out with the honours changing hands. King James could do nothing, it seemed, to stop the mayhem, which was characterised by constant forays, burning, murder on a near industrial scale and widespread larceny. Nobody ever said a feud couldn't be lucrative. When, in July 1584, Johnstone gained the coveted office of Provost in Dumfries, Maxwell hired the Armstrongs to drive him out. At various times, one or both of them was outlawed and Maxwell did himself no favours by clinging to the old religion and fraternising with Spain.

Generally, despite his blatant recusancy, Maxwell held the upper hand. He ravaged Johnstone lands, killed them by the score and torched his rival's main hold at Lochwood, flames leaping into a night sky 'so that Lady Johnstone might have a light to put on her hood'.[50] Johnstone clung to the warden's official seat at Lochmaben ... but only just. At this point, to add a truly Jacobean twist, Maxwell was betrayed by his own half-brother, Robert the Bastard, and found himself in gaol.

This wasn't the first time and he soon bounced back. Nonetheless, this respite gave Johnstone a chance to strike back, which he did with interest, but his resilient enemy was soon back in office, his many sins overlooked. Johnnie died, a broken man, in 1587. Maxwell was firmly in charge.

He might have been ahead on points but he didn't learn; he was soon doing his bit to facilitate the Armada[51] and again spent time imprisoned while James VI executed twenty-two of his affinity by way of a caution.[52] Ever the rurvivor, he was reinstated and this time for life. Maxwell could fancy he'd done rather well, all things considered, and even brokered a dynastic marriage for young James Johnstone – the surest way to cap a feud. This might just have settled it, and Maxwell was actually reluctant to take up arms when things flared again in the summer of 1593. The spark was horse theft – one miserable nag – and neither the owner nor the thief was from either name, but vengeance cried out as it always does, and the Crichtons, allies of Maxwell, sparred with Johnstone and lost fifteen of their number in the skirmish.

Dragged into the refreshed vendetta, Maxwell set to work assembling a force nearly two thousand strong; this was no mere gang fight, but a planned campaign of annihilation. He outnumbered Johnstone by at least four to one. Both names dragged in as many hired lances as possible; one of those who followed Jamie Johnstone, Robert of Raecleuch, was all of eleven years old, up for his first and last fight.

Maybe Maxwell was losing his touch or maybe he was just too confident (he'd never lost yet) but on 6 December he allowed his vanguard, ranging ahead in approved manner, to be seduced into an unsupported charge against a knot of Johnstone riders. Classic ambush tactics, Maxwell's riders whooped straight onto a line of spears and were routed, disordering the main body as they struggled to come up. Johnstone now launched his own disciplined charge, which broke the warden's line. Untidily, the fight spilled into the narrow streets of Lockerbie, where Johnstone foot 'loons' wielding heavy-bladed Jeddart staffs dealt fearsome strokes, 'Lockerbie Licks', against their mounted opponents. Slashing and hacking down scores of Maxwell riders, they felled the warden himself, whose long run of remarkable good luck came to an end. Nearly a thousand died and the Johnstones, if bloodied and depleted, were saved.

That should have finally been that, but old enmities die hard, especially on the border. Fifteen years later the king brokered a reconciliation between James Johnstone and the then Lord Maxwell. They met under solemn undertakings, but Maxwell nonetheless managed to smuggle in a brace of pistols with which he shot Johnstone twice. Jamie died on the spot and Maxwell went to the block for his murder.[53]

Welcome to the marches.

3

The Marchers

Last night a wind from Lammermoor came roaring up the glen
With the tramp of trooping horses and the laugh of reckless men,
And struck a mailed hand on the gate and cried in rebel glee:
"Come forth, come forth, my Borderer and ride the March with me!"
I said, "Oh! Wind of Lammermoor, the night's too dark to ride,
And all the men that fill the glen are ghosts of men that died!
The floods are down in Bowmont Burn, the moss is fetlock-deep;
Go back, wild Wind of Lammermoor, to Lauderdale – and sleep!"

Will H. Ogilvie[1]

Though the plough has tamed the fearsome marsh and moss where reivers skulked, and man-made forests have replaced the dense canopy of old, wild wood, it's still possible for us to glean an impression of how things were. When England and Scotland were at last united under a single crown in 1603, these two countries had been at war, outright or simmering, for three hundred years – since the time of William Wallace and the Wars of Independence, beginning in 1296.[2] During the sixteenth century there were times of intense, open warfare between the two.

Scotland had long been an ally of England's old enemy, France. Indeed, in 1512 the 'Auld Alliance' between the two countries was extended, and all nationals of Scotland and France also became nationals of each other's countries, a status not repealed in France until 1903. In the following year this allegiance obliged James IV of Scotland to attack the English in support of his French allies, who had been attacked by Henry VIII. The result was Flodden, in which the Scottish King, many of his nobles and perhaps ten thousand men were killed – *The Flowers of the Forest* of the folk song (see Chapter Nine).

And things did not improve during the century. After a period of regency, James V of Scotland succeeded his father and married a French

noblewoman, Mary of Guise, mother of his only daughter, Mary. In 1542, James's rag-tag army was soundly and humiliatingly trounced at the Battle of Solway Moss (see Chapter Ten) in another disastrous campaign.[3] He died shortly afterwards, he *turned his face to the wall.* Henry VIII failed in his ensuing diplomatic and then military attempts to win the hand of James's young daughter Mary (to be Queen of Scots) for his son Edward (to be Edward VI); the so-called 'Rough Wooing' – and rough it certainly was – continued into the regency that followed Henry's death in 1547. Mary was sent to France a year later, aged five, as intended bride of the French Dauphin (see Chapter Ten). She might have fared rather better had she stayed there...

> The Border country ... was the ring in which the champions met; armies marched and counter-marched and fought and fled across it; it was wasted and burned and despoiled, its people harried and robbed and slaughtered, on both sides, by both sides. Whatever the rights and wrongs, the Borderers were the people who bore the brunt; for almost 300 years, from the late thirteenth century to the middle of the sixteenth, they lived in a battlefield that stretched from the Solway to the North Sea.[4]

This harsh land north and south of the Border was a region of 'riding names', groups held together by the most powerful of all bonds – blood. Not only was Northumberland subject to cross-border incursions from Scots, but also to inter-clan bickering. The border line itself meant little to the reivers:

> The raiders from Bewcastle, from Tynedale and from Redesdale were as much a nuisance to their compatriots as was anyone from over the border. Indeed, at the time compatriot meant nothing and the border did not count for much, for men who had made the place too hot to hold them on one side would flee to kinsmen and friends on the other, being 'Scottish when they will and English at their pleasure'.[5]

Reivers (from the OE *rēafian* – to rob) were not all outlaws, although some of them most certainly were. They came from all classes and backgrounds, having in common the ability to ride and to fight and the need to survive in a hostile environment. It was an accepted way of life. Practising systematic thievery and wholesale destruction, they have the dubious distinction of bringing the word *bereaved* into the English language, as indeed they did *blackmail*, another innovative reiver practice: 'By the sixteenth century, robbery and blood feud had become virtually systematic, and that century saw the activities of the steel-bonneted Border riders – noble and simple, robber and lawman, soldier and farmer, outlaw and peasant – at their height.'[6]

We aren't talking here about a set of regular villains who were perpetually attacking their peace-loving countrymen; in fact, theft was the significant occupation of the sizeable majority. It was a way of subsisting during the reiving 'season' from August (Lammas) to February (Candlemas) whenever weather and moonlight allowed:

> A foray might involve a dozen riders or half a thousand, with the *graynes*[7] active every night the weather allowed, the bright reivers' moon their guiding star. So important was this lunar conspiracy that the image appears in border heraldry – the Scotts' badge was a star and two crescent moons; mottoes such as 'we'll have moonlight again' were popular among riding names.[8]

Safe as tower houses – the Scottish tower-house, as distinguished from the 'pele' of Northumberland, is a four-square stone keep, perhaps three or four storeys high with crow-stepped gables flanking a pitched stone-slated roof with parapet walk. The entrance, usually a single narrow opening at ground level, leads to a barrel-vaulted basement with hall and apartments above. The whole was surrounded by a palisade or 'barmkin', often studded with loopholes for guns. Many examples still survive, such as picturesque Smailholm, near Melrose, or Newark, whose barmkin bears the imprint of gunfire – a legacy of the slaughter of Montrose's men after defeat at Philiphaugh. Gilnockie or Hollows, near Canonbie, is reputed to have been the hold of the infamous Johnnie Armstrong,[9] whose colourful career was cut short by James V; the king did not baulk at violating a truce to string up the posturing bandit and his crew, all of whom had dressed lavishly for the occasion.

More powerful marchers built themselves far grander bastions, such as Hume Castle in the Merse, distinctive three-sided Caerlaverock by the Solway (which we encountered in the preceding chapter), and not forgetting grim Hermitage in Liddesdale. This wonderfully gaunt and forbidding fortress has a history that matches its appearance: a medieval castellan, 'wicked' Lord Soulis, reputed to practise the black arts, was according to legend dragged off by his disgruntled tenants, rolled in a sheet of lead and melted at the Ninestanerig, an ancient stone circle nearby. He never re-offended. Mary Queen of Scots nearly died of influenza contracted when she rode out from Jedburgh, struggling through appalling weather, to tend her wounded lover, Bothwell; he was Keeper of Liddesdale so resided at Hermitage, and had been cut up pursuing a notorious reiver.[10]

Bamburgh must be one of the most photographed of all our great castles. With good reason. It sits supreme on its stark outcrop of hard basalt, the last flourish of the Whin Sill that carries Hadrian's Wall before it marches off into the North Sea. What we see is largely a late Victorian

makeover created for William, Lord Armstrong, an industrial rather than medieval magnate, but one whose wealth still came from war – by making other people's weapons rather than wielding his own.

Bamburgh may well have been an Iron Age fort, but it certainly formed the kernel of Saxon warlord Ida's fledgling kingdom. His grandson and successor Aethelfrith ('The Destroyer', well-named), gave it to his queen Bebba from whom the place gets its name. Happily for the Northumbrians, St Aidan (from his cell on the Farne Islands) was able to summon God's assistance for a timely shift in wind direction when fearsome Penda of Mercia, formerly a client of Aethelfrith, attempted to burn down the palisade. Bamburgh was the capital of the growing kingdom of Northumbria and housed such important relics as the head and hand of St Oswald, which he had mislaid in battle.[11]

Inevitably, the place was hammered by the Vikings and the core of what we see today is Norman. Before then, before even Ida, it might have been called, in Old English, *Dinguardi*. Those attuned to Arthurian romance may see that Malory anglicised, or rather Gallicised, this to 'Joyous Garde'. We're way beyond history here, firmly into myth, but we do know that numerous Iron Age forts had a second lease of life after the end of the Roman occupation.

It was entrusted to 'First Knight' Lancelot, who was in love with Guinevere. Evil Mordred and his second in command Agravain kept a close watch on the pair, grassing them up to a saddened King Arthur who ordered Mordred with a dozen men at arms to bring them both in. Honest Bors spilled the conspiracy to Lancelot who, though he didn't wear mail, kept a sword hidden in the folds of his cloak when he went to pay an evening call on the queen.

Mordred turned up mob-handed but Lance was ready and did for Agravain and all of the rest, except Mordred who took to his heels. Lancelot fled Camelot but without the queen, sure the king would show mercy. He didn't: Guinevere was condemned to the stake, with Mordred as MC. The generally unlamented Agravain was Gawain's brother who now, understandably, turned against Lancelot. Everyone thought Lancelot would try to rescue Guinevere ... He did, and Mordred bottled it again, and another two of Gawain's brothers were cut down in the mêlée. Gawain was now really *very* irritated and spearheaded Arthur's retaliatory strike against *Joyous Garde* where Lancelot and Guinevere were holding out.

It was a full-blown siege, a mini civil war, just what the creep Mordred was hoping for. Gawain was a man possessed by demons of revenge, thus the many fights before the walls were hard and costly for both sides. Arthur himself was in serious trouble at one stage, but Lancelot, a really good guy, saved him. This was the sign for a truce and then cease fire: Guinevere was sent back to her husband, though not as a sacrifice, and

Lancelot accepted exile back in his native Brittany. It's not history as we know it, but it's a cracking story which has kept poets, novelists and filmmakers in business ever since.

When we were at school we were taught to think of history as episodic. In this vein we learned that the Romans left here in 410 AD[12]: on one day in that year they all packed up and went home (wherever that was). We know they didn't, history is a continuum, and few places illustrate that as well as Thirlwall Castle, a thirteenth-century hall-tower, first mentioned in 1255. (I touched on the place in the last chapter.) It is set on a rocky knoll ten metres or so above the Tipalt Burn, covering the strategic Irthing Gap, which lay between the wall forts of Aesica and Camboglanna. In fact, the hall-tower is constructed from stones lifted from Hadrian's work, and by a fine stoke of historical irony the old tower was quarried to provide masonry for the adjacent nineteenth-century farm.

Longshanks appears to have bivouacked there. The owners were the de Thirlwalls, Anglo Normans it seems and a fairly robust bunch, active during the Scottish wars (one of them went down fighting against Jamie Douglas in 1307). During the thirteenth century, the king of Scotland was the de Thirlwalls' feudal superior, and he heard a case in 1279 where the baron was in dispute with the Prioress of Lambley: one of those litigious matters to be settled with trial by combat. Baron de Thirlwall's reputation was enough to overawe the lady's champion and she coughed up the damages.

Later Thirlwalls fought in the French wars of Edward III, and one, giving evidence in 1385 before Richard II, stated his father's age as 145![13] During the Three Hundred Years' War the Thirlwalls lived like robber barons. One such, in the mid fourteenth century – possibly the ancient greybeard referred to – earned a particularly bad reputation, using his commission as licence to thieve. It seems that he employed a steward who was even worse. Thirlwall had amassed quite a haul, but his innumerable victims had reached the end of their tethers and launched a major retaliatory strike. The Northumbrians were losing when the steward, refusing to surrender, threw a heavy sack of valuables down the well and jumped in after it, collapsing the shaft as he plummeted, so the loot was buried forever. Hope here for some future detectorist, possibly.

If you were looking for a fantasy *Scottish* tower house, Smailholm, just five miles (eight kilometres) west of Kelso, really does fit the bill. It's a slender stone tower sitting on a small crag above a wee dark lochan – the sort of place you'd expect Scott to invent. Well for once he didn't have to – you could say Smailholm helped invent Scott.

The sickly boy was sent to spend summers in the bright clear air of his grandfather's farm, just below the tower. No budding romantic could be unmoved and Smailholm appears in both *Eve of St John* and *Marmion*.[14] Scott's uncle partially restored, certainly consolidated,

what was then a ruin, and the great man of letters brought the great man of art, Turner, to see the place in 1831: his drawings of Smailholm are in the Tate Gallery in London. The site is superbly conserved and maintained by Historic Scotland.[15] This is about as reiver as it gets: the tower seems to have grown up from the natural rock that forms its base on a high stone plateau, surrounded by an eroded *barmkin* (defensive) wall. It speaks of pride, wildness to a degree we can't even begin to comprehend, endemic violence and what we might now call attitude – 'wha daur meddle wi' me'?

Much further east and on the coast, there's not much left of the great fortress at Dunbar, despoiled by the Scots themselves in the sixteenth century. Cromwell beat a covenanter army there in 1650.[16] In 1338 an English force laid siege to the place. 'Black' Agnes,[17] the defiant chatelaine, commanded only a handful of defenders but was determined to make a decent fight of it: 'Of Scotland's King I haud my house, I pay him meat and fee, and I will keep my gude auld house, while my house will keep me.' To borrow from G. M. Fraser once again – 'Sod off!'

The Earl of Salisbury, commanding the besiegers, let fly with a barrage of missiles delivered by a range of timber-built siege engines. This was probably more psychologically threatening than anything else, but Agnes refused to be cowed – she ostentatiously paraded on the battlements, using her handkerchief to dust the merlons after the bombardment. This kind of theatre matters in sieges. The English responded by building a great siege tower or 'beffroi', which could overtop the walls and launch men at arms onto the parapet. Agnes's men managed to lever a massive boulder down onto the tower, wrecking the thing.

Archers on both sides tried to pick off targets of opportunity. The Scots were decent shots and one of Salisbury's close companions was skewered next to him. 'Agnes' love shafts go straight to the heart,' the Earl joked, his knightly sangfroid undisturbed. Next, he resorted to bribery – usually a sound choice – and paid off a junior Scottish officer to leave the postern gate open and unguarded. The canny Scot took the cash but reported straight back to Agnes. When the English commander led his men through the gate, the portcullis slammed down. Salisbury himself jumped back just in time, though others were captured.

Having tried brute force, starvation and skulduggery, Salisbury fell back on terror. He had earlier captured Agnes's brother John Earl of Moray, and now threatened to string him up if his sister didn't strike her colours. Agnes casually retorted that while she'd like to spare her sibling, she wasn't about to hand over the keys and, further, if the unlucky John *did* swing, well then she would inherit the title (he was childless) and become the next Earl of Moray! In the event Moray was spared, and Agnes probably knew Salisbury was bluffing … or you'd hope so. As Dunbar is on the coast, completely encircling the castle and cutting off

all means of supply wasn't easy; Salisbury was determined to try and he did his best, but Ramsay of Dalhousie managed to cram a company of reinforcements into small boats and run the blockade. He sneaked his men inside by the sea gate, then promptly launched a raid on the English outposts, causing confusion and alarm. After five long months Salisbury conceded defeat and lifted the siege. It was 1-0 to Agnes: 'Came I early, came I late, I found Agnes at the gate...'

Go back west, and if you drive to pretty Castle Douglas in Dumfries then just a mile and a half (2.5km) from the town, on an island in the River Dee, stands Threave. It's impressive, even though just a ruined shell. You still need a boat to get onto the tiny island, rather bigger now than it was, and it's a superb setting. It's grim though; there aren't any frills here.

Threave is probably the first true tower house built in Scotland, some time in the 1370s. It is a big, solid keep-like structure, sixty feet by forty (18.4 x 12.1 metres), originally five storeys high with access to the first-floor reception hall from a wooden stair tower as you came over a movable timber bridge. The basement could only be reached by ladder from above; its barrel-vaulted rooms were for storage. Climbing a spiral stair set into the massively thick walls, you would ascend to the grand hall and then, if so privileged, to the Lord's accommodation above that, with a garret for servants (or additional defenders) at the very top. It exudes strength and purpose.[18]

What is the difference between a keep and a tower? Outwardly, they look very similar but in fact they're very different in specifics. The keep forms part of a wider defensive layout and people don't necessarily live there; it is both a last-chance bastion and symbol of power. The tower – every bit as mighty and with every bit of the status – is a residence, and often has no wider defences other than a courtyard or barmkin wall.

Even so, Threave looks business-like rather than homely; here was a man who knew he had enemies, and the Douglases always had plenty. As author Marc Morris points out, Chris Tabraham's[19] extensive excavations in the 1970s showed that just outside the castle there were once separate high-status buildings, probably an ancillary hall and chapel. These were undefended and the island was home to a thriving township, so in the late fourteenth century it didn't really look all that forbidding.

It was grim enough though, and soon got grimmer. Archibald Douglas's glittering career was really the zenith of the family's power. In the following century the 8th Earl, before being done in by James II[20] (mind you, the earl himself was no angel) had extended the defences quite dramatically. He had added an artillery 'house' or curtain, studded with gun loops and bolstered by three stubby towers, as well as a defensive wall on the riverbank. The artillery provision is the first of its kind in Britain and shows that the earl was expecting trouble. He hadn't wasted his money.

His successor, the 9th Earl, completed the artillery house and added earthworks north of the tower. His civil war against James II ended in defeat at Arkinholm in May 1455;[21] one by one his castles fell, until only Threave held out. The King himself came to lay siege to it that June and, it's said, he dragged the great bombard (cannon) Mons Meg[22] overland to blast the place, which proved difficult. The castle held out for two tense months until the king abandoned might in favour of money, and effectively bribed the garrison to surrender. Much later, in 1640, during the Bishops' Wars, a royalist force held out there for thirteen weeks and the vengeful covenanters wrecked the place to avoid a repeat. What we see today is what they left. It's still big and still grim, though.

James Douglas mentioned earlier, known, appropriately, as 'The Black', was one of Robert Bruce's most active supporters. The War of Independence wasn't gentlemanly; Longshanks had rather set the tone when he allowed his men to rape Berwick in 1296. Eleven years on, and Bruce was a guerrilla lurking on his home turf in the Carrick Hills. Douglas had to watch on as an English garrison sequestered his family seat at Douglas Castle and diverted his rents. The king gave him authority to mount a raid on his own patch and he set off with just a couple of mates to raise some hell. Douglas was very good at this.

He knew the ground, naturally, and contacted his father's old steward – Thomas Dickson – to muster a gang of tenantry keen to have a crack at the invaders. Douglas knew that the entire garrison would leave the battlements to attend mass at the local church on Palm Sunday, as would everyone around. His volunteers, locals after all, mingled with the unsuspecting English. Though the attack began a little earlier than intended, the English garrison were all killed or captured.

James and his merry band returned to his newly liberated castle and ate the Sunday dinner already laid out. After dining and clearing out everything portable, he poisoned the well, spoiled the remaining stores, beheaded his terrified prisoners and added their headless corpses to the pile. He then set fire to the place. This was the 'Douglas Larder' – a fine example of 'frightfulness' – another atrocity in an atrocious war and a lesson to the English squatters and freebooters – 'we know where you live.' Besides, as his accessories were all local tenants he couldn't leave any witnesses to identify them. The rule in this Anglo-Scottish war was that there were no rules at all.

Black Douglas hadn't finished. One of the Thirlwalls was appointed commander at Douglas Castle. This time Douglas used the old reiver's trick of sending in a squad to seize grazing cattle and draw the occupiers out into an ambush. It worked: Thirlwall took the bait, which cost him and half his men their lives; the rest scattered back behind the walls. Third time lucky for the English? Not a chance! Sir John of Webton was the new castellan, and Jamie devised yet another ruse. Sentries on the

parapet spotted what seemed to be a slow-moving column of loaded hay wains, led by women: just what they needed, as fodder was running short. Sir John duly led a sally, but the girls turned out to be boys – the sort that carry swords – and many more of them were skulking in the woods. The English were routed and this time Douglas battered in the gates and captured all the survivors. It seemed Sir John was a decent enough sort though, so he and the rest of his men were paroled. In accordance with Bruce's doctrine, Douglas then razed his own home.[23] This was total war...

By the middle of the sixteenth century, life in the south of England was becoming relatively safe and prosperous, while the borders still languished in strife. Families in the area began to replace their old steadings, made of timber and earth, with relatively strong buildings made of stone; indeed, the availability of local material was one reason for bastles being built. On the whole it was fairly well-off tenants who undertook this work rather than landlords – after all, it was their families and cattle that were under threat. These new, defensible farmhouses or bastles, may derive from the French *bâtir* to build, as in *bastille*, or fortified building. Unification of the Crowns in 1603 did not completely negate the need for bastles, which continued to be built for many years. Most were built between 1550 and 1650, although many bear a later date which is the date of *renovation* rather than that of original construction.

They weren't isolated structures. Many had outbuildings, the remains of which can often be seen (as at Black Middens in Tarset), and they were often built in sight of other bastles – indeed they are often found in small groups.[24] This would allow those under attack to summon help from their neighbours. Evistones township, near Otterburn, is a fine example of a community of bastles (more below). Some were extended, a second building being built onto the end of a first, at the 'byre door end'. In other cases, they were built in terraces, as at Wall village, where individual bastles kept their integrity although they were linked to their neighbours.[25]

Some bastles are known as *peles* or *peels* – Thropton Peel is an example. The words are often used synonymously, but the etymology of peel is from the French *pel*, meaning wooden stake. Bastles were defensible farmhouses; as such they are neither glamorous nor pretentious.[26] Rough-hewn, they stand as firm as if they had sprung organically from the harsh upland itself, utilitarian and austere, their allure (if they can claim such charm, and I think they can) arising from durability.

On the ground floor was the byre, into which cattle were driven when a raid was imminent or during particularly bad weather. Without drainage

or stalls, it seems unlikely that this space was meant to be utilised for lengthy periods. Above lay the family's spartan living quarters, devoid of comfort other than a fireplace set into one gable (usually at the opposite end to the doorway). Rarely bigger than twelve by eight metres, bastles are rectangular in shape and typically have walls between 0.7 and 1.4 metres thick.[27] Constructed of large, irregular stone blocks, gaps between the blocks were packed with smaller stones set in mortar. They have steeply pitched gables and many were probably roofed initially with heather thatching.

Past the fine pair at Gatehouse, just after Tarset, then Black Middens, there's a crop of others half buried among regimented Forestry Commission trees.[28] I've mentioned the distinctly 'New World' feel of these. One of these bastles, known variously as Barty's Pele or Corbie Castle, was the home of Barty Milburn. His grayne, along with Charltons, Robsons and Dodds, were the principal names in a decidedly lawless tract. Barty was a chip off the old block and renowned as a swordsman. Above the doorway of his bastle is a narrow channel cut through the thickness of the wall; this is thought to be a channel through which water would be poured to douse fires lit against the door!

Barty awoke one morning to discover the view from his narrow window had been transformed. Once it had contained his fat, contented flock; now it was deserted. This was more than a passing annoyance and, according to border custom, Barty was entitled to follow the posse trail or 'hot trod'. He enlisted the aid of his fellow Tynedale laird 'Corbit Jack' who occupied a nearby bastle. Together, strapping on swords, they set off in hot pursuit. Oddly, they proceeded on foot, both probably owned horses but shank's pony it was.

Their hunt led them northwards and over the border at Carter Bar, the 'Reidswire' of evil fame. No sign of either sheep or thieves. A couple of miles further on, by then growing tired no doubt, they came to Letham where the missing flock was sighted. When I say 'missing' these were not necessarily Barty's lost animals but, in fairness, they looked very similar and were soon on their way south. Such high-handed retribution wasn't likely to go either unnoticed or unchallenged. The Laird of Letham didn't fancy crossing swords with Barty Millburn so he swiftly hired in Sandy and Bonny Douglas, equally noted for their keen sword-play. By Chattel Hope Spout above what is now Catcleugh Reservoir, the hunters found themselves the hunted; two on two and stalemate.

In the annals of border thievery such a stand-off was not unusual. There were protocols. As murderous as they were, borderers preferred to avoid a fight if possible, since bloodletting fomented a blood-feud – generations of re-cycled hate and murder. Border history was well stocked with feuds and nobody really wanted another one. The dialogue probably went along the lines of Barty protesting that he was the aggrieved party and

swearing blind that they were his sheep. Clearly they were *not*, as the Douglases pointed out, and their employer was not Barty's thief. Barty would next offer to split the flock and call it quits. The Scots were not inclined to go with that proposal either – but they really should have done.

Swords clashed in the afternoon, most likely single-edged backswords. The first pass saw Corbit Jack go down, and he wouldn't be getting up. Meanwhile, Barty had trapped his opponent's blade – it was thrust through his thigh. Undeterred, he riposted with a killing stroke. The other Douglas lost heart and bolted, but Barty, big with vengeance, decapitated him with a slashing cut: 'His heid bounded along the heather like an onion.' Barty drew the blade from the flesh of his thigh, bound the wound, gathered up the swords of the fallen, heaved his deceased friend over his shoulder and departed, with the sheep, to whence he'd come.[29]

If you want that 'real' borderer experience and you don't have time to get to Hermitage, try Evistones. On the main road to Carter Bar, past Otterburn and around eight miles (13 kilometres) north of Bellingham, you pass a sign branching left marked 'Redesdale E.H. Farm'. This stands for Experimental Husbandry and was established by the then Ministry of Agriculture, Food and Fisheries (MAFF) some time after the end of the Second World War. Its mission statement was to improve efficiency amongst the hill farming community. One of their far-sighted innovations was to fit ageing ovine mouths with stainless steel dentures to overcome tooth decay.[30]

Drive onto the track and pull up onto the verge and then walk downhill toward the river and Stobbs Farm on the north bank. In his magisterial study, John Dodds[31] identified this as a likely bastle in its original incarnation, but there are more across the old Bailey bridge that spans the Rede. Keep on the lane that runs along the south bank heading north-west; past a set of barns it turns back on itself, climbing a reasonably steep incline. Halfway up look to your right and you'll see the place some eighty yards or so above the track. Then you'll be in Evistones – and there's nowhere like it. If it were warmer and less windswept, drier and brighter, this could be Fort Bravo or some forgotten firebase in the Mekong Delta. But it is a reiver township, a cluster of stone bastles, one of which has the vault still standing. John Dodds counts three bastles[32] but I'm prepared to hazard there's nearer a dozen, the whole compound surrounded by a curtain wall or palisade, the footings for which can be traced around. It's bare, basic and bleak, built for all-round defence, every building planned for war; not too many parterres or peacocks.

I can't imagine there was ever anything likeable or quaint about the place. The inhabitants seem to have been Hedleys and Fletchers, a bad lot according to such scant records as exist, and it seems to have been abandoned at some point in the seventeenth century. If we want

to understand the reivers, this place certainly helps. The quickest glance will tell you that the arts of peace never flourished in these surroundings, and that those who lived here had much to fear and lived their lives in anticipation of attack, probably by way of retribution.

What we lack is a Samuel or Mrs Pepys of the border. We hear *about* the reivers rather than *from* them. How the goodwife felt about her husband's nocturnal enterprise is generally unrecorded. Domestic life, of course, did go on: people married, often in defiance of the cross-border prohibition, raising children and focusing on the daily business of survival. In the midst of the mayhem are the women, sitting quietly at home... Well, not really. The women of Redesdale were as notorious as their men, riding out in their own right when necessary. Those remaining in the bastle could act in defence of home and property using gun, bow or knife to fend off intruders. Or they would send out the raiders themselves. A famous nineteenth-century painting shows a goodwife presenting her husband with a pair of spurs on an empty platter instead of his dinner: *Fetch the Supper In*.[33]

On the English side, the border was a very remote frontier, far away from centres of power, difficult and expensive to police. The Scottish side was far closer to Edinburgh but no easier to control. A fairly complex means of trying to keep order was established as early as 1249, when the Scottish and English monarchies agreed that the border should be divided into the marches that I described in the previous chapter. From 1297 these districts were controlled judicially and militarily by march wardens. On the English side, officers were latterly appointed from the south of the country, in order to avoid the obvious possibility of bias (for or against) the feuding names over which they were intended to hold sway. The examples of Percy and Neville in the fifteenth century were evidence of the risks attached to conferring such vice-regal powers on unruly local magnates.

It was the warden's duty was to see that peace was maintained, to administer justice and to deal with 'bills', or complaints. Backed up by a staff of deputies, captains and troopers, they tried – with varying degrees of success – to administer the law, but in doing so they would frequently create personal enemies (some were murdered)[34] and would foment further bitterness between already bellicose riding names. In short, they frequently caused more problems than they solved and most certainly did not implement peace and safety for the marchers. One such warden was the notorious Sir John Forster, not from the south we're proud to say, but a native Northumbrian:

A regular subject of Border correspondence, he was the target of frequent accusations ranging from collusion with the Scots and neglect of duty, to using his office as a cloak for thieving and skulduggery,

his accusers further adding that Sir John's catalogue of shortcomings 'would fill a large book'. Most of this was in fact true and his protestations of innocence are somewhat less than convincing.[35]

Sir John was a truly Falstaffian character whom I've played on a number of occasions, and I do sincerely hope the old rogue would be flattered by these portrayals. To be fair I've offered him as choleric, addicted to strong drink, enjoying a wager or two, untrammelled by any conflict twixt duty and reward.

After a raid, with the lifting of cattle and possibly taking of lives, the thieves would naturally set off without delay for the relative safety of tower or sheltering moss. Above all else, success would lie in the speed with which sortie and getaway were accomplished. Escaping reivers would be much hampered by their four-legged spoils – cattle are notoriously difficult to move at speed – and it was essential to be familiar with every step and inch of the landscape so that temporary lying-up places and strategic sites for ambush were known and used with facility.

The victim of such a raid had three choices: to make complaint to the warden, to bide his time until he could wreak revenge (with interest if possible), or to mount a hot trod.[36] If some time elapsed before the pursuers set out it was known as a *cold trod*. Either way, the legality of the trod depended on its being within six days of the raid, and as MacDonald Fraser points out, 'a careful line was drawn, under border law, between a trod and reprisal raid.' If the trod was cross-border, it was essential to make it clear that legal pursuit was underway: a lighted turf was to be clearly visible on the pursuer's lance point, 'an earnest of open and peaceful intentions'.

He had a legal right to assistance from marchers across the border and trying to hinder the trod was a punishable offence, one far more honoured in the breach than the observance. The trod could easily become a brawl; however strict the supposed rules, the chase might frequently end in a fierce skirmish during which fighters from either side stood to lose life or limb. 'The law was not likely to call a trod-follower to account if his rage got the better of him and he dispatched a reiver out of hand.'[37]

A typical reiver looked nothing like a traditional knight in plate harness. As a specialist he needed the right gear for such dangerous business. First, and most importantly perhaps, he required a horse. Remembering that the borderers could be called up to fight for king and country (never with any marked enthusiasm), their horses needed to be suitable mounts both for light cavalry work in time of war, and for raiding in time of ostensible peace. Known as hobblers, hobilars or garrons, they were sturdy and fast, and like Cumbria's hardy Herdwick sheep, they were cheap to keep. There is evidence that they weren't groomed and didn't have need of shoes. They were said to be capable of

...transporting a man from Tynedale to Teviotdale and back in 24 hours[38] ... Given the need (above all) for speed and ease of manoeuvre, the reiver rarely wore expensive armour even if he could afford it, which in most cases he could not: the preferred means of protecting the body was the 'jack' or 'jacke' which was widely used until the end of the sixteenth century.[39]

To protect their arms and upper legs, many dalesmen would sew on pewter or brass chains, wrapped around four or five times; their lower legs were protected by long, leather riding boots not unlike modern 'biker' boots.

Body armour might consist of plate 'breast and back' but more likely just a padded jack. Accoutred in this manner, they were able to combine mobility with an element of protection. On his head, the reiver would wear a form of helmet called a *burgonet*, in use from the middle of the sixteenth century. This *burgonet* or *steill bonnett* was 'a rather more stylish helmet (than the earlier *salade hat*) which, in its lightest form was open and peaked.'[40] These offered good protection, having cheek plates and a flared rim at the neck as well as a peak at the front. There's a very good example in Tyne and Wear Archives and Museums collection, which has some interesting battle damage: someone has taken a hefty swipe with a bladed weapon at the wearer and the blow bit deep into the raised comb. The owner would have been pleased he'd bought the kit, though he probably had quite a headache. In time (from about 1580) these were in turn largely superseded by the *morion* or *pikeman's pot*.[41]

Borderers carried a variety of weapons. As George MacDonald Fraser points out, the sixteenth century was the 'bridge between the medieval knights and men-at-arms, with their heavy armour and weapons, and the age of firepower'.[42] Most would sport a lance, used for thrusting and throwing. Equally as ferocious was the 'Jeddart staff', made (or said to have originated) in Jedburgh; this was a slim four-foot (1.25-metres) blade set into a wooden staff, the blade having a cutting edge and a fearsome spike. Another favourite weapon was the *bill*, which had a spike, a hook and a single heavy cutting edge. Both at war and on a raid, the reivers would also use a backsword,[43] a dagger and possibly a brace of handguns, although the guns of the time were inaccurate at a distance and useless at close quarters.

It was the unenviable task of the border wardens to seek to maintain law and order while also acting as local generals in time of war. A corpus of unique border laws, *Leges Marchiarum*, was drafted to cope with

the vibrant brand of lawlessness that prevailed. In many instances these officials, like Sir John, who clung to his office until well into his nineties, were more of a symptom than a cure: Sir John was a leading shareholder in most of the disreputable ventures within his march and was far from being an exception.

> The seventh of July the suith to say
> At the Reidswire the tryst was set
> Our wardens they affixed the day
> And, as they promised, so they met.
> Alas that day I'll ne'er forget!
> Was sure sae feard, and then sae faine,
> came theare justice for to gett,
> Will never green to come again[44]

Days of Truce had been a feature of the administration of border justice since the mid-thirteenth century when the wardenship system was formally established. In theory, every march warden was to meet with his opposite number once a month, though in practice this rarely occurred due to bad weather, hostilities between the two nations, or prevarication on the warden's part.

Protocols were exact: both parties, mounted and fully arrayed (i.e. harnessed for war) would approach the agreed meeting place. The Reidswire (*swire* was a narrow neck of land) was ideal ground. Before either warden met, the two parties would eye each other up, then an English rider would spur forward to ask 'assurance' of the Scottish warden. Once this was given the process was reversed then the two sides – warily – would advance.

Traditionally, meetings were actually held in Scotland. It was said that Scottish wardens were reluctant to enter England after one of their number – Sir Robert Ker of Cessford – was killed by notorious 'Bastard Heron' at a Truce Day in 1508. We shall encounter the colourful Heron in connection with the Flodden campaign (see Chapter Nine). Whether this was a formal duel or just plain murder, the Kers were avid for revenge. Heron's two seconds or accomplices, Lilburn and Starhead, fled for their lives but no distances could place them beyond borderers' vengeance; both were hunted to death.[45]

This assurance, or guarantee of peaceful intent, was to hold from sunrise on the agreed day to sunset of the next, to allow all present to reach home in one piece, the most notorious breach of this observance being the seizure of the totally reprehensible Kinmont Will Armstrong in defiance of convention in 1596 (more of that later).

Much business of the day revolved around the hearing of complaints from both sides. The indictments or 'bills of complaint' were lodged

beforehand by plaintiffs and heard on the day. Often a jury of a dozen, six from each side, was empanelled to decide the matter, or a decision could be achieved on the warden's oath, or on the oath or *avower* of some prominent man effectively acting as the defendant's guarantor. Trials were noisy, lively and contentious; most of those present did not come with entirely clean hands. If a bill was proven or *fyled* then the defendant had to agree compensation; if the accusation failed and the defendant was found *cleane* then no redress was due. Compensation monies could be calculated on the penal basis of *double and sawfey* – three times the value of the goods lifted. Levels of compensation were defined at various times. In 1563, the compensation value of livestock was agreed as follows: ox = 40s; cow = 30s; young ox or cow = 20s; sheep/swine = 6s.[46]

These days of truce were occasions for much drinking, betting and gaming. Horse races were held and everyone dressed in their finery. Hearings took place in the open and the crowd no doubt contributed vociferously. Virtually all present, from both sides of the line, knew each other; they'd drunk, fought, ridden and wagered together many times before. Everyone went armed, and drink was a major factor in disturbances. Frequently the wardens themselves, especially men of the cut and temperament of Sir John, were far from impartial. Scott of Buccleuch (The Bold Buccleuch), Ker of Cessford and Lords Hume and Maxwell were all active in border politics.

The 'Raid' of the Reidswire in 1575 turned out to be one of the more memorable meetings. On 7 July, Sir John Forster came face to face with his Scottish counterpart Sir John Carmichael, Keeper of Liddesdale. It's unclear if the two men had already disagreed, but from the outset matters seemed unlikely to remain cordial. The meeting took place at the Reidswire with several hundred attending from both sides of the line. Matters begin amicably enough, but then a bill was brought against an absentee defendant named Farnstein (probably Falstone). The case was proved – *fyled* – but Sir John prevaricated over the man's non-appearance. Angry words followed between the two lawmen who, like their followers, had been drinking steadily. Carmichael may have been overly aggressive and Sir John was haughty and dismissive, reminding the younger man of his inferior status.

> Carmichael then speak out plainlike
> And cloke no cause for ill or good
> The other answering him as vainlie
> Began to reckon kin and blood
> He raise and raxed him where he stood
> And bade him match him with his marrows.[47]

The rank and file happily joined in the abuse and then, it is said, the Tynedale men loosed several arrows into the ranks of the Scots and a mêlée ensued: 'Then Tindaill heard them reason rude, and they loot off a feight (volley) of arrows.' The two officials, rapidly sobering up, attempted to calm things down, but the Tynedale men got properly stuck in. The Scots were in difficulties until the Jedburgh men, arriving late, came up as reinforcements. The fight was long and hard, but the English were eventually worsted, with many dead and wounded on both sides. Forster was temporarily taken prisoner, as were his son-in-law Lord Francis Russell[49] and Cuthbert Collingwood. The English Deputy Warden, Sir George Heron, was amongst the dead.

It is 2005, in North Tynedale and the Tarset Reivers prepare to re-enact the fray. Helpfully, this has been funded by the Festival of the Tyne. There's plenty of imbibing and even folk music this time round, with belligerent housewives and loud-mouthed wardens. There's a telling resonance among these ancient hills: many of those present bear the same names as would be heard in 1575 – Charlton, Robson, Dodds, Milburn, Ridley ... The marchers knew all about survival.

4

Cocidius and Me

'Objects contain absent people.'
Metroland, Julian Barnes

On a bright Saturday in autumn 2019, one of those fleeting mild days clinging on to the past summer, I was with a group of historians and archaeologists who trekked up to the bluffs at Yardhope, north of Elsdon, on the MoD artillery ranges. It was a gloriously still day with a cloudless sky; the light would make an artist weep for joy – the ancient shrine of the *genius loci*, Cocidius, looked crisp and precise, shown to the best possible effect. The sweeping views of moorland landscapes have scarcely changed since he was in vogue.

He was a native North British deity worshipped by the local Celts (if I dare call them that). He was the equivalent of the Roman Mars, the god of war and hunting and also Silvanus, deity of woods and wilderness. Rome was quite good at suborning local deities and he was probably worshipped by auxiliaries stationed along the wall and beyond. The derivation may be from the Brythonic *cocco* for red and perhaps his image was originally daubed in scarlet. Cocidius might have originated in the west, by the Solway and (as mentioned) he has associations with Bewcastle; inscriptions have been found at both the fort there and at Birdoswald.

In 2006 another image was discovered at Chesters and was branded as the 'little man', probably because he's not very big. He appears to be male – aggressively so (if such gender-based assumptions are allowed). He's hefting an upraised shield in his left hand with drawn sword in his right; a scabbard hangs from his belt. He stands four-square and braced. Fifteen hundred years later he could have been bragging, *Wha' dare meddle wi' me?*

He's not Roman, not ethnically anyway, but he might show signs of cultural assimilation. Rome was here for a long time, from, say, Agricola's era till the mid-fifth century AD. The legions and their host of second echelon auxiliary units imported their own pantheons. It seems more than likely that, over time, and given that Rome didn't need to mess with local deities, these numerous cultures welded and meshed. So rather than being suppressed, Cocidius gained a whole new cohort of believers and worshippers, primarily drawn from other ranks rather than officers.

> The (Yardhope) shrine is visible as a roughly square, natural chamber formed in bedrock; the east side is assembled from large boulders, leaving an opening 0.45 metre wide at the north-east corner which opens onto a natural gully. The chamber is 2 metres square and between 1.5 to 2 metres high. On the north side of the chamber there is a rock cut ledge which originally supported one side of a roof. Immediately to the east of this feature there is a niche 0.4m by 0.15 metres interpreted as a place to hold a lamp or offerings. On the rock face at the north side of the entrance there is a carved figure 0.32 metre high and 0.20 metre wide...[1]

He's beautifully preserved ...seems to jump up at you, as neat as the day he was carved; he has a spear in his right hand rather than a sword, and again his shield in the left. He's arresting; something magical about him. He was first discovered in the 1980s – he had been lurking up there for at least a millennium and a half, maintaining his patient, ancient watch over his country ... and it *is* his. You can tell somehow. *Genius loci* isn't just a figure of speech; he's the real thing. Surprisingly, the style of the work suggests Roman rather than native influences (or perhaps a local craftsman heavily influenced by Roman style). He's there to watch, and he does.

Our border region has a rich pre-history. At Howick in Northumberland, Mesolithic[2] hunter-gatherers built a lodge around 7,500 years ago, one of the oldest structures in Britain. Neil Oliver memorably chronicles the transition of society from hunter-gatherers to farmers during the Neolithic age, and how profound a shift this was: a time when people began not only to cultivate crops and husband livestock but also when they put down roots and established territories. They interred their ancestors in elaborate tombs, using (as he argues very persuasively) their dead to fix the living to their ground, as much signposts as memorials.[3]

He also argues, looking at the fabulous remains on Orkney, that a new wave of 'cosmic consciousness' headed southwards, rather than the other way round. We northerners knew this instinctively of course: the age-old tombs were carefully, reverentially, sealed and a new wave

of belief spread. There is far more we don't know, but if we visit some monuments – for example Castlerigg near Penrith or Duddo Stones in North Northumberland – we can sense levels of connectivity which we kind of glimpse, even if we don't quite 'get it'. These resonances are real, a barely conscious link to our distant ancestors. We haven't completely lost that knowledge … we've just locked it away like the mad woman in the attic.

Rock art, those strangely enigmatic cup and ring carvings, proliferate throughout Northumberland. Stan Beckensall is the leading expert on this region and has spent a long lifetime studying and writing about them. Theories as to what they represent are legion, from blood gutters used in some form of ancient sacrifice to the more prosaic notion that they're a form of road sign. The latter may be boring but perhaps closer to the truth.

My own introduction to empirical archaeology came from the age of seven onwards as, initially, a member of a pro-am group led by the late Professor George Jobey (introduced in Chapter Two). A Tynemouth man, George served with distinction during the Italian Campaign with 16 DLI, was severely wounded there in '44, carried the cranial scars and was awarded two MiDs[4] and a DSO. George began his study of archaeology while an undergraduate at Bede College, Durham, and worked, briefly, as a history teacher at his old school after the war. Following this he moved to the Department of Extra-Mural Studies at King's College Durham (later Newcastle University). His obituary (he died in 1991) records:

> His interests extended into south-west Scotland and he produced a number of parallel papers for that area. He also enabled a greater appreciation of the relationship between the native population and the Roman forces, and began to show the 'barbarians' as rather more sophisticated peoples than was often believed or admitted: his work on Burnswark Hill, in particular, showed that the assumed relationship between the native settlement and the Roman camps was mistaken; his review of Traprain Law demonstrated the significance of its unparalleled assemblage of Roman material; while his papers on population problems linked developments on native sites to the Pax Romana. In short, he transformed our understanding of the interaction between Roman and native in the Tyne/Forth Province: it is a measure of his contribution that his works are still the fundamental reference for anyone working in the period in North Britain.[5]

My first actual dig was at Halton Chesters (*Hunnum*) Roman Fort on Hadrian's Wall, near to the present hamlet of Halton, led by the equally remarkable John Gillam. At that age I was expecting more from a Roman fort, a bit more Fall of the Roman Empire than a muddy trench. Even

when older I was still obsessing about what I'd read in Leonard Cotterell's books, but we never really found anything to rival the Mycenean Gate.

I realise now that it was the essence of George's genius that he carried his teacher's instincts into field archaeology and gathered round himself a stellar and eclectic cast of individuals he moulded into his own dedicated, if wildly eccentric, tribe. Hardly any were professional archaeologists. Alec Bankier was a metallurgist who had served with the RAOC at the end of the war, who gave me some of his meticulous sketches of Lewis Guns and other small arms, together with loads of militaria, including a de-activated Mills Grenade: schoolboy heaven. He had an instinct for ground that Wellington might have envied and travelled in a series of now iconic VW Martin Walther caravettes. He and Wilf Dodds knew every inch of the county and of most of the whole border region. Wilf hacked down bracken with a very nice kukri, which I always thought remarkably stylish, and his extensive geology collection had its own exhibition in Bowes Museum.

My education covered every summer season until I was an undergraduate, sadly reading law not archaeology. We dug extensively on a rescue basis in North Tynedale when Kielder Reservoir was being constructed; the work threatened to drown a whole galaxy of sites, mainly Iron Age. Money was magically available for this, at The Belling and Tower Knowe (near the present information centre). Tynedale is challenging in summer: usually wet, generally cold, and attended by its own demonic horde of midges. Even so it was enormous fun, although we never did find that long-lost treasure. Parallel to the main road, across the valley heading up from Falstone, the line of the old railway (devoid of tracks) ran straight as an arrow, our own four-wheel drive version of Indy500.

* * *

The pitiless Bronze:

Patroclos first cast a spear into the thick of the struggle near the stern of Prostesilaos' ship and hit Pyriachmes; this was the leader of the Paionians, who came with chariots from Amydon on the Axios. The spear went into his right shoulder and he fell onto his back groaning, while his Paionians fled in all directions; for they were panic stricken when Patroclos brought down their leader and champion... There were a number of scattered combats here and there. First Patroclos pierced the thigh of Areilycos at the moment he turned to fly; the spear broke the bone and he fell flat on his face. Next Menelaos wounded Thoas where his chest showed over the side of the shield and he collapsed. Phyleides watched his moment as Amphiclos ran at him, and lunged

at his first – hit the bulging thigh where the muscle is thickest and cut through the sinews and darkness came over his eyes.[6]

As I write I'm hefting my own bronze sword, created by the prodigiously talented Neil Burridge.[7] It's a facsimile of an original Bronze Age blade of the Ewart Park type from *c*.800-700 BC.[8] There were many styles being produced in Britain during the period and according to the Portable Antiquities Scheme:

> Most Bronze Age swords in museum collections in Britain come from the Ewart Park Phase. Generally these swords have a bulging shape in the blade at the midway point before narrowing towards the shoulders and the terminal which is fan shaped. Size and number of rivets vary greatly; these swords developed from the Wilburton swords with little influence from the continent and it appears they first occurred in Northern Britain.[9]

This is what excites my northern blood: these wonderfully stylish blades weren't foreign imports. This brand of talent was home-grown, and the swords were sometimes made for an export market. Neil Oliver describes the process of working with Neil Burridge to cast a bronze blade and captures brilliantly the excitement of the process and its almost mystic intensity: 'Again the mystery was all around, the disbelief that accompanies anything that confounds mind and eye, or at least asks for more than a scientific explanation. How can it be? What had been a glowing orange liquid, moments before, radiating heat like the sun, was now an elegant green sword.'[10]

We don't have a local Homer to thrill us with tales of a border Achilles or Hector. Did they exist? Probably in a warrior society they did. Bronze weapons, though very much 'high status' items, were intended for use. From Homer we can clearly see that the spear was the principal weapon, with swords used more for back-up. It's unlikely, or there's no evidence to suggest, that our local heroes carried those large figure-of-eight shields; it's more likely that they used round, leather-covered laminated targes or just thick, toughened-hide bucklers. How did they fight? The dynamic of bronze is very different from iron. In the film version of *Troy*, Brad Pitt (Achilles) and Eric Bana (Hector) hammer it out in best Errol Flynn style. It's good cinematic action but the real duel, as Homer tells us, was very different: swords were never drawn. It was an almost balletic contest of spears, with Achilles 'the very murderer of a silk button', as Mercutio might have said, had he been watching.

Iron isn't as pretty as bronze and it loves rust. Happily for archaeologists, bronze does not and our ancestors, as part of their belief system, hurled vast quantities of precious kit into rivers or still waters to

propitiate their gods. Water was seen as a portal 'twixt this world and the next, and I can understand why: when you look into a mirror of shining, peat-coloured stillness it does seem fathomless, yet somehow significant, as if you could touch the surface and disappear, Alice-like, through the mirror. Like bronze before it, iron was a game-changer: weapons and tools became far cheaper and easier to make. Warfare was no longer a province of the elite; the lower orders could get stuck in too, though the sword reserved its mystique. Climate changes during the later Bronze Age[11] reduced the amount of cultivable land and put pressure on agrarian communities. Hill forts in the borders received makeovers: deeper ditches, more formidable defences... Just being prepared.

What did the Celts ever do for us? The very term 'Celts', as Dr Fields points out,[12] is a constant source of controversy. Both Greek and Roman writers use the term sweepingly to refer to a broad swath of peoples living within a wide belt of territories north of the Mediterranean. They are generally perceived as barbarians, viewed with a mix of fear, grudging fascination and contempt. Nonetheless, it was these same unkempt savages who occupied Rome in 390BC and humiliated the Republic. This element of terror would colour relations.

Tacitus, writing about his father-in-law's experience as Roman governor in Britain during the first century AD, was not complimentary: 'On a general estimate, however, we may believe that it was Gauls who took possession of the neighbouring island. In both countries you will find the same ritual, the same religious beliefs. There is no great difference in language, and there is the same hardihood in challenging danger, the same subsequent cowardice in shirking it... Their strength is in their infantry.'[13]

What we would broadly term 'Celtic' Civilisation (nobody can agree on the correct term, and it isn't a description the people themselves would ever have recognised) began in the Upper Danube region during the late Bronze Age, say 1300 BC, roughly around the time of Troy. Six centuries or so later, iron had replaced bronze and the beginnings of the Celtic Iron Age are named after Hallstatt in Austria. Celts, Gauls, and Galatians – as Alice Roberts points out:

> These three names sometimes seem to coincide in meaning. At other times they are used to differentiate between different levels of ethnic groupings: Celts within the larger territory of Gaul: Celts as a group of tribes in the West and Galatians as a group of tribes in the East. Celts and Galatians are essentially the same and referring to anyone living across a huge territory, maximally defined as stretching from Iberia to Central Europe.[14]

How this grouping spread across Europe is still under investigation. Old theories, which showed them spreading through what would become

Gaul into the Iberian peninsula and across the Channel into southern England, have been challenged by the work of archaeologists such as Barry Cunliffe. A new focus on the Atlantic Fringe is bringing to light the challenging complexities of these remarkable people, a people with differing languages, customs and social organisation. They had as much to distinguish them from each other as they had in common. Groups occupied a hierarchical structure: differences in group size, status, wealth, degree of nobility, and – above all – power and political influence, marked them out.

At the top stood, if one existed, a royal household, followed by the important families of the nobility. Women enjoyed a complex status in Celtic society. On the one hand they had a place on the battlefield and enjoyed a high social status, particularly as marriage partners cementing relationships between the various groupings. Most marriages were endogamous, which is to say that individual members sought a marriage partner within their own tribe. An exception, however, were the members of the leading aristocratic families, who for political reasons kept up an intertribal marriage network. On the other hand, polygamy was also practised in aristocratic circles. Women played a key role in the formation of alliances between tribes. In a society in which kinship played such an important role, descent mattered. Important political ties were established by marriage among members of leading aristocratic families and, above all, by sacred genealogies, in which entire peoples, subgroups or individual families traced their descent from mythical ancestors, usually gods or demigods. This belief in the sacred origin of a social group was deeply rooted. Indeed, it still holds: it is nothing short of amazing how many Irish claim to be descended from Brian Boru.

Fostering – the placing of a child in the household of another member of the affinity group – was another method of creating a shared descent. The old tales are full of fosterlings whose conflict in later life had all the resonance of a conflict between blood relatives. To some degree those tales reflect another factor holding communities together: co-residence, the sharing of territory or home, which could also create affinity between clans with little blood relationship. The inclusion of servants, slaves and clients in a household was not uncommon and while they may have been of low status, they were viewed as members of the group rather than outsiders.

There is common agreement that Celtic societies were extremely war-like. 'It seems that it was important to Celtic warriors, and probably to their status and identity, to have something warlike to do and this need appears to have been satisfied by raiding or by fighting as mercenaries.'[15] Roman commentators noted their tendency to quarrel and fight at the drop of a hat, viewing it as a sign of weakness, although this quarrelsome propensity is something that was probably a matter of pride to the

participants. Ironically, a society of warriors may find it difficult to recruit a standing army: an emphasis on personal glory and prowess makes taking orders difficult.

To be a famous warrior, to have the bards, during those long, cold winter nights, extol your triumphs, your individual feats of arms, was what it was all about. Warfare was, for these paladins, never a collective undertaking for the weal of the state; it was all about the individual. This was wonderfully hubristic but it only worked against those who were like-minded. Against a superior state, geared for war as a matter of policy, trained, equipped and well led, the warrior elite were redundant: an archaic survival, out of kilter with the new reality.

'Iron Age' and 'hillforts' are terms inextricably linked in our understanding, and these great oppida are potent survivors. Most impressive in the borders is Traprain Law.[16] It's 725 feet (221 metres) high, rising from a flat coastal plan, four miles (6 kilometres) east of Haddington. It's huge, not as big as the great Gallic versions like Bibracte, which even got a grudging nod from Caesar, but nonetheless covering some forty acres (16 hectares). It was certainly in use during the Bronze Age and was already fortified by 1000 BC. It was given numerous makeovers during its long history, was lived-in at the time of the Claudian invasion and probably not abandoned until around the time when the Antonine Wall was being built. After that hiatus it was re-occupied until the Romans left, undergoing yet another and massive makeover, before finally being permanently abandoned.

Ptolemy called the place *Curia* and he and his fellow Romans recorded the name of the inhabitants as the Votadini.[17] Their Brythonic name is Gododdin,[18] as in the later epic verse, and they were the dominant tribe or confederation with Traprain Law as their likely capital. From there they moved shop to Din Eidyn, Edinburgh. But here there was treasure. In 1919 Alexander Curle found a vast cache of hacked up silver inside the oppidum. This weighed in at a hefty fifty-three pounds (24kg). Peter Hunter Blair and other writers have assumed, probably rightly, that this had belonged to some wealthy local trying to hide his riches during the fractious times when Rome's grip had slackened. Dates of coins found as part of the treasure would support that.[19]

It was quite a haul, too: much of it was table silver, indicating a high-status owner, along with early Christian religious artefacts and part of a senior Roman tribune's personal gear. It *is* possible that the whole lot had been pilfered by Votadini and then re-hidden. Now restored and on display in the National Museum of Scotland,[20] it's astonishing: a wonderful and mesmerising window onto the vacuum left in Rome's imperial wake.

While it is far bigger than most hillforts, Traprain Law is by no means alone. There are hundreds: Old Bewick in Northumberland as

mentioned, Yeavering Bell, Humbleton Hill and the Ingram Valley. Many of these date to the time of the Roman Conquest or before it, and we have no evidence of any last ditch stand like Maiden Castle, no defenders' skeletons transfixed by *ballistae* bolts, no grave-pits as at Danebury Hill. Not to say it didn't happen … it's just we have no evidence. Most are in fact quite small, probably high-status, manorial complexes with a settlement clustered about – sort of motte and bailey style.

I climbed up to most of them as a child, clambering over the ancient remains. Here were my Troy and Mycenae. I and my friends fought over the ditches and ramparts with a handy arsenal of wooden weapons and just one real one, a French bandsman's sword *c*.1860, with a leaf-shaped blade, brass grip and stubby quillons, a conscious imitation of *gladius hispaniensis*. Two of my favourite hill forts are in Upper Coquetdale and I returned there for the first time in forty years when thinking of this book.

Harehaugh, a small multivallate fort near Hepple, is strategically sited to control a decent-sized swath of ground. Its ditches are still deep and easily traced, impressive – more so (or at least for me) than those of its bigger brethren. It's up on high ground overlooking the small valleys of the Harehaugh and Grasslees Burns; elliptical in shape, it covers an area of 160 metres east-west by 100 metres north-south. It represents two distinct phases of construction, split by a scarp, with its main gate leading into the larger western enclosure. Here, the fort is guarded by four walls with three superbly intact ditches, thrown up using both earth and stone, four metres deep with the ramparts over a metre wide. A single line covers the north flank with two covering the south and east. Suggestions of a further ring beyond the main defensive lines can be traced.[21]

It's proper Homeric, it has that hilltop citadel feel to it. Whoever lived here and built the place over successive generations were people who mattered; they had status. They looked out over land that was identifiably theirs. They *belonged*. Just north is the nineteenth-century equivalent, Holystone Grange; it's less martial but far more comfortable than the earlier version. Just south and east of Harehaugh across the Graslees Burn is Witchy Neuk, which also overlooks the Coquet. These two would have looked out on each other, Montagu and Capulet perhaps, or Armstrong and Elliot.

Witchy Neuk is built on a mini rise between two streams, Swindon and Whitfield Burns. Whoever the builders were, they knew what they were doing. The crag itself provides a natural barrier on the north flank, and the enclosed area is smaller than its neighbour: about 90m east-west by 45m north-south. There's just a single rampart and ditch: massive, revetted in stone. Entrances were located at east and west gateways, protected by additional right-angled earthworks or *clavicula* – Iron Age barbicans. This place was intended to be defended. Neither of these small

forts was any kind of folly; they're not some wealthy magnate's artistic embellishment. Inside the enclosure, the footings of two substantial circular stone dwellings have been identified. Both these places and many others like them pulsate with the resonant rhythm of a long-vanished past. Abandoned probably for a millennium and a half, they still dominate their environment, tingling with history. I never visit any of them without feeling the charge.[22]

There is a school of thought that views these ditches and ramparts as essentially window-dressing – not necessarily military. I disagree. These fortifications are exactly that and were laid out by people who knew what they were about and who, we can assume, had experience of war. Go to Elsdon (not so far from either) and look at the Umfravilles' Norman motte. I see distinct similarities, and while we can push the analogy too far, I feel entitled to speculate about the likely nature of the defenders. The Norman lord controlled a lot of ground with a handful of mailed horsemen; his castle was as much about offence as defence. Might his Iron Age predecessor have done the same? Mounted forces, light cavalry, were certainly plentiful judging by Roman accounts, and that crucial extra mobility over such ground would have conferred significant advantages. Most medieval castles were never attacked but they could all be defended – it's a double statement underlying lordly power. And no, I can't prove any of it.

** * **

And then there was Rome.

Pax Romana: General Gaius Suetonius Paulinus, campaigning in Britain, was facing desperate odds against Boudicca in AD 61. His biographer, Tacitus, received his core narrative almost directly from the horse's mouth: his future father-in-law, Julius Agricola, was tribune (essentially aide-de-camp) to the general. Tacitus records some pithy battlefield oratory from Suetonius, who was very much a soldier's soldier: he didn't waste words or prettify the task ahead. But as descriptions of Celtic armies go, this one can't be far off the mark. After all, his men could see all too clearly what they were up against:

> Disregard the clamours and empty threats of the natives! In their ranks, there are more women than fighting men; unwarlike, unarmed, when they see the arms and courage of the conquerors who have routed them so often, they will break immediately. Even when a force contains many divisions, few among them win the battles – what special glory for your small numbers to win the renown of a whole army! Just keep in close order. Throw your javelins and then carry on: use shield bosses to fell them, swords to kill them.[23]

Part of what Suetonius was doing was reminding his men that *they* were the professionals; the Britons were a mob, a mere rabble of boasters. By the time of Boudicca, Rome had amassed generations of fighting experience across all terrain and against an impressive range of adversaries. And the Romans were professional. Even Flavius Josephus, that wily survivor of the First Jewish Revolt (AD 66-73), Rome's former enemy turned enthusiastic collaborator and latterly historian, was forced to respect his former adversaries' capacity:

> This vast empire of theirs has come to them as the prize of valour and not as a gift of fortune. For their nation does not wait for the outbreak of war to give men their first lesson in arms. They do not sit with folded hands in peacetime only to put them in motion in the hour of need. On the contrary, as though they had been born with weapons in hand, they never have a truce from training; never wait for emergencies to arise. Moreover, their peace manoeuvres are no less strenuous than veritable warfare.[24]

Michael Grant describes the army as a corporate force. Rome, he states, possessed a standing army.

> The sword of the state, which from a tradition rooted in the hoplites of Greek city states, would grow and develop into the anvil of empire. The original legionary was a citizen, a man of property and position who could afford to turn out with his own kit. He had a personal stake in the survival and expansion of the state but he only expected to serve for the duration of hostilities. Essentially, he was a small farmer who went to war when called upon. Nonetheless, he was tough, resourceful and competent. What he didn't like were long periods of service at a distance; he was never a regular in that sense; as the empire began to expand, his limitations (notably in relation to length of service) became more pronounced.[25]

Further expansion would demand a new type of army, led by a novel brand of general. The adventurer Julius Caesar was the greatest of these, a consummate gambler and opportunist. His restless genius, not to mention personal economic necessity, would lead to the conquest of Gaul (58-51 BC), the boldest and most ambitious of Rome's imperial gambits, one of the boldest of all time and one that would shape world history.

Caesar's campaigns would not have been possible without the giant shadow cast by his predecessor (and uncle by marriage) Gaius Marius (157-86 BC), a brilliant bruiser who transformed the Roman Army.

Vegetius,[26] writing many decades later, was in no doubt that such tough love paid dividends:

> In every battle it is not numbers and untaught bravery so much as skill and training that generally produce the victory. For we see no other explanation of the conquest of the world by the Roman People than their drill-at-arms, camp discipline and military expertise. How else could small Roman forces have availed against hordes of Gauls? How could small stature have ventured to confront German tallness?[27]

This was a new type of soldier then, as much the armed extension of the body-corporate as individual warrior. His loyalty was primarily to the state, but all too often this transferred to the person of his commanding general who would lead him, hopefully, to victory and to riches. Charismatic and successful leaders like Marius, then Pompey and Caesar after him, were viewed as 'celebrities' rather than state appointees. Their style of leadership was more personal, their armies loyal to *them*. Caesar had a great commander's gift of getting his men to love him, though this adulation might occasionally be expressed in unflattering terms.

Prior to contact, legionaries in their triple lines (*triplex acies*), relied on missiles to soften up the opposition before coming into contact. Normally, javelins wouldn't be thrown until the enemy was, say, thirty metres away. Then the front rank moved smartly forward with swords drawn to exploit confusion caused by the volleys. This wasn't sophisticated, elegant swordsmanship: heavy shield bosses were used to batter opponents, knock them off balance and open them up for a decisive thrust, a single purposeful lunge, pushing the victim, now dying, back into his own ranks, disordering them further. Time for the next one … repeating the process of butchery till the enemy broke, rear ranks spilling outwards to escape the inexorable killing. As they stamped and hacked forwards, the shields, helmets and armour worn by the legionaries protected them from the deluge of spears zipping across the fight. Generally, Celtic forces would have their best-equipped fighters in the front line. When they went down, those further back were less protected and so more vulnerable.

There was nothing vaguely romantic or chivalric in the legionary's work. Personal honour and reputation had no part in the enterprise of slaughter. As the Roman line punched forward, giving their deafening war-shout or *barritus*, the rear closed up, adding their *pila* to the barrage. Wounded legionaries could be carried clear and any gaps instantly filled so that those coming into the fight were fresh. If the contest was drawn out, the second rank could shift their javelins, normally intended for throwing, to stab between the lines of swordsmen. Momentum and cohesion were preserved. The enemy was offered no chance to recover. Discipline, training and comradeship all combined to create a battle-

winning formation. Wounded enemies still breathing would be swiftly dealt with and trampled.

> Just when you think you are at the world's end, you see smoke from east to west as far as the eye can turn and then, under it, also as far as the eye can stretch, houses and temples, shops and theatres, barracks and granaries, tricking along like dice behind – always behind – one long, low rising and falling and hiding and showing line of towers. And that is the Wall!
>
> <div align="right">Kipling: Puck of Pook's Hill[28]</div>

I do encounter folk, invariably from that vague region we call 'The South', who believe that the Wall is the actual border between England and Scotland. Once it was far more than that; it marked the north-west frontier of Rome, an empire so vast that its southern flank rested on the Euphrates, on the fringes of the Sahara and, to the east on the Rhine. Yet any soldier or merchant journeying here to the north would instantly recognise the distinctive and largely unvarying plan of all the forts, that distinctive playing-card shape. There was the HQ and commandant's accommodation centrally, with four gates feeding through internal roadways; barrack blocks, stables, granaries and sick bay all where they should be. Over *there*, past the Wall, was 'Indian Country': tribal lands never completely subjugated, frequently blitzed by retaliatory sweeps, which later reivers might have recognised as wardens' raids. This wild tract beyond the *limes* – frontier – had been occupied but then abandoned. The Wall was, as some of us might say, 'awesome' and in the proper sense it was. But the very act of its construction is an admission of previous failure.

Gaius Julius Agricola was a member of the Roman governing class. 'There is no subsequent period in the history of Roman Britain, or even in the early history of Anglo-Saxon England, for which we have a similarly detailed narrative from a written source.'[29] The general had served his apprenticeship under the redoubtable Suetonius Paulinus and was blooded in the fierce campaign against Boudicca and her Iceni. Later he was promoted legate of the Legio XX Valeria Victrix.

By the time he began to cast his eyes northward he was already the imperial governor of Britain, probably in his early forties, and at the height of his considerable powers. He was appointed in AD 77 by the Emperor Vespasian. Earlier in that same decade, Q. Petillius Cerealis had conquered much of northern England and subjugated the hitherto independent Brigantes. His successor, Julius Frontinus, hammered the wild Silurians and Ordovices of Wales. This policy of expansion was continued by Agricola, who, within the first two years of his tenure, completed the conquest of Wales and set a firm grip on Brigantia.

To provide logistical support for his ambitious policy he established a line of frontier forts between the Firth of Forth and the Firth of Tay, supported by a typically efficient road system.[30] An early expedition penetrated as far as Strathmore and created a forward outpost at Ardoch near Dunblane. Later, in his subsequent campaigns, he sought to block the main exits from the Highlands by constructing forts at Fendoch, Dalginross and Callander. At Inchtuthil, near the junction of the Isla and Tay, he built a major fort, intended to serve as a legionary base.

The first expedition, in AD 80, required a force of some 20,000-25,000 legionaries, 5,000 auxiliary cavalry and 10,000 infantry. Shock troops were drawn from the four British-based legions: Legio II Augusta, from Caerleon; Legio XIV Adiutrix, from Gloucester; men of the Legio IX Hispana, marching out of Lincoln; and his old legion, Legio XX Valeria Victrix, based at Wroxeter. He first advanced into Scotland and overran the country as far north as the banks of the Tay. He consolidated his gains behind the Forth/Clyde line but two years later, spurred on by Domitian's hunger for glory, he began an ambitious and aggressive exploration of the west coast. The following year he made the strategically important advance beyond the Tay and in the final storm fought his great battle which we know as Mons Graupius.[31] (For an exhaustive but still fascinating examination of the location of the battle, see Simon Forder's *The Romans in Scotland and the Battle of Mons Graupius*.)

He won, and he forced the tribes to submit. Conquest was complete but the suits back in Rome either became jealous or just couldn't balance the books. Expenditure had been prodigious and revenue meagre. Costs associated with maintaining a garrison infrastructure vastly outweighed projected returns, rampant inflation could only be exacerbated … so give it up, get out. Accountants, an admirable and precise profession, don't always see the fuller picture. As they understood it, Britain's resources were in the south, that was where the harvest was to be gathered, so why waste time and treasure policing a wasteland further north? The problem was that something would have to be done: you both conquer and hold the whole or you'll have to draw a line somewhere. Hadrian's response, begun forty years later, was logical but costly and never completely effective. The drain on resources to maintain a Wall garrison of, say, 30,000 personnel was colossal. As the empire faded, the burden was just too great.

Agricola had established a frontier of sorts along the line of the Stanegate,[32] his forward supply depots for the Scottish campaigns. This wasn't ideal or even planned; it was just there. We don't know a great deal of what was happening here during Trajan's time (AD 98-117). Consummate soldier that he was, his laurels were won in the Balkans and in the east. It was left to his successor, Hadrian, to ponder what should be done about the British problem. Hadrian was not a direct

heir; he was the son of the old emperor's cousin, and it was he who first recognised that the Empire had reached its natural limits. Rome couldn't manage a larger territory so he wasn't bothered about expansion, just about consolidation.

A very rough neighbourhood – seventeen centuries later it would be the British Empire facing a similar situation: the North-West Frontier of India. It's steeped in romance, particularly for those who've never been there, and it's consistently been a very rough neighbourhood indeed. Tough and fractious hill-men lived along the broad spine of a border that runs like a surgical cut down the length of high ground. These were no respecters of formal frontiers, and they were imbued with the savage realities of asymmetrical warfare centuries before the term was first coined.

What to do? The Colonial administration could simply seek to occupy the whole contentious belt of hills and keep a lid on the locals, but this was far easier said than done, vastly expensive and most unlikely to succeed. Moreover, this could only work on *our* side of the divide, never over the border in Afghanistan where whatever passed for central authority had no currency whatsoever among the Pathans. This was a Hadrian's Wall job, and it was estimated that the campaigning would have cost twenty thousand casualties and taken a decade to achieve – if it could ever be accomplished at all.[33]

The other alternative was to write the mountains off and fall back to the eminently defensible line of the Indus, but that meant leaving a wild marcher realm beyond; an equally large garrison would be needed. And (a very big *and*) there was always the Russian Bear to worry about. He was long suspected of wanting to get his claws on the Jewel in the Crown and Afghanistan was his preferred axis of advance. The ambitious Romanoffs had been steadily expanding their territories eastwards across the limitless horizons of steppe since the start of the century. With huge armies at their beck, the threat was tangible.[34]

A compromise, never ideal, was thought out: the British created an Administrative Border with tribal districts, varying in depth from ten miles (16 kilometres) to a hundred (161 kilometres); this was a pale or buffer zone, run by the tribes but with a series of strategic outposts guarding key choke points. These were linked by a road network with a de-militarized strip a hundred yards (91 metres) wide on either side. Tribal leaders were buttered up with hefty bribes, dependent on them toeing the line. Any pious hopes that the Pathans might be converted into model citizens along European lines soon disappeared: this would always be an armed frontier with the spectre of conflict bubbling away, regularly bursting into flames of varying intensity.[35]

Nearer home, Rosemary Sutcliff brilliantly imagines such landscapes in *The Eagle of the Ninth*.[36] Hadrian decided to create an administrative

border of his own. Many people looking at the Wall see it purely as linear defence; some academics think of it as largely symbolic, a statement of power. Both are wrong. The Wall was both defence in depth and a massive killing field. North of the Wall itself was a series of outposts – Birrens, Netherby, Bewcastle, Risingham, Rochester – to give warning of any mass attack or indeed of a strong localized threat. Behind it was a line of forts along the north/south highway of Dere Street with twin anchors: legionary fortresses Chester and York, east and west.

All of the forts have gates facing north and with cavalry stations; three of these projected beyond the line of the Wall so that mounted forces could deploy rapidly and concentrate. Success in war focuses primarily on *logistics* and *concentration*; Hadrian thought about both. Any enemy force could be gripped in a pincer movement from both flanks and dashed to destruction against a giant cliff-face. It was a thoroughly well-conceived idea, and the proposed line took full advantage of high ground in the centre – the exposed basalt backbone of the Whin Sill.

It's not certain, but the emperor's attention might have been drawn here due to 'bother' during his predecessor's reign. Quite what bother, and who was bothering, are unclear but it does seem there had been trouble and that extensive punitive action was needed. By AD 122 a new and active governor, Aulus Platorius Nepos, was in post and it was he that Hadrian instructed to get started on a wall. On his visit that year the indefatigable emperor rode along and surveyed the route of his proposed *limes*. He might have instructed work to begin beforehand, and we can probably assume the grand plan, in its initial form, was his alone. Only he had the authority, and his plan was ambitious, breathtakingly so. He was a man who liked grand building projects – part policy, part ego – and this one would keep his troops busy – which was always useful.

He devised a plan for a wall that would run eastwards from Bowness-on-Solway for thirty-one Roman miles,[37] built in timber sod and turf, then, for a further forty-nine miles, constructed in stone, with a series of regular outposts or milecastles, with towers or turrets in between. Quite why different materials were preferred for different sections isn't known and the plan was no sooner underway than it was radically changed. Previously, the back-up garrisons were to be supplied from the Stanegate forts, but Hadrian decided to add a whole series of wall forts – sixteen of them – on the line itself, which in places meant demolition and re-building. The whole massive undertaking was accomplished in around seven years, an astonishing feat – it normally takes that long to get planning consent for a garage extension in the twenty-first century.

There's additional debate about whether the Wall was finished with a fighting walkway, and if the front (or north) face was lime-washed. There would be a fighting platform; why build a rampart without one? The dazzling whiteness would have been impressive, designed for shock

and awe. There'd be plenty of both. We have to try and imagine the effect of such a structure on indigenous tribes, akin perhaps to a jet airliner landing in the depths of uncharted jungle. If you live in a small, rural community of narrow fields and wattle and daub cottages, think how this must have looked: a brilliant, apparently unending stone structure leaping along the central section from crag to crag. It would have seemed like the work of the gods: the power, pomp and might of Rome writ in stone.

I spent a lot of my childhood walking the Wall. Half a century on and the pull is every bit as strong, though quite often these days I walk as the Romans walked – in full auxiliary kit. That teaches you respect. And I was very lucky to be a frequent visitor to Newcastle University's Museum of Antiquities, run in partnership with Society of Antiquaries. Located in a now demolished building,[38] this was wonderfully intimate, and for the modeller it held a series of wonders – scale models (generally around 1/48th I think), crafted by Billy Bulmer.

He built stone and timber milecastles (Dad and I spent hours creating my own in 1:32 scale for a school project), gateways, bath houses, and smaller scale models of forts; most of the time I was the only visitor – it was mine to enjoy.[39] Dr Lindsay Allason-Jones described the museum's role: 'In the intervening years (it opened in 1960) the Museum has acted as the county museum for Northumberland, covering every period from the earliest prehistory to the Tudor and Stuart period. It is acknowledged as the main museum for the World Heritage Site of Hadrian's Wall and has become famous for its innovative computing and education work.'[40] At about the same time, in the early to mid-sixties, Airfix started producing a range of 1:72 scale Romans and Britons, together with an excellent milecastle model. Wargamers have moved on, but I still have a great affection for those figures: they took forever to paint but you could get a fair bit of detail in. I'm afraid the Romans always won.

At Wallsend – the Wall ends. Yet if you live on the east side you tend to think it begins there and ends at Bowness – no idea which way Hadrian saw it but he probably did move east to west. We don't know what the locals thought but we could guess they weren't enthused. Why would they be? The grand new frontier project crossed tribal lands and divided communities … and there's no evidence of any consultation.

Most think of the Wall as it appears in the centre, sweeping along the spine of the Whin Sill. Wallsend (Segedunum) is rather different. Most traces of it vanished long ago under industrial sprawl and housing; the great flowing artery of the Tyne, crowded by ships and shipbuilding, erased any spirit of place that might have once existed. Originally, the fort covered an area of some four acres (1.6 hectares), with a quartet of double gates and an exterior ditch. During the second century AD it was garrisoned by 2nd Cohort of Nervians, then later by 4th Lingonians, a

cohors equitata, 480 infantry with 120 attached cavalry. It was manned for three centuries; far longer than the shipyards. It might mark the end of the Wall now but it wasn't at the start. Excavations in 1929 revealed that the section of the Wall that joins it to Newcastle (Pons Aelius) was constructed on the narrower gauge – so second fix. Originally the wall stopped a bit further east.

Today, the Roman traces have been uncovered and a bath house recreated, based on the bathhouse at Chesters Fort. The remains of the original (revealed in 2014/15) are also on display. And there's a good museum in what were former shipyard offices with a clever and distinctive viewing tower. We've often done Roman Murder mysteries there: the museum space lends itself admirably. 'Murder at the Fort' went down very well and the commandant's wife died so convincingly from poison that members of the audience decided to nudge the 'corpse' fairly aggressively to determine if all was well – method acting has its perils.

Segedunum is a valiant effort and a damn good heritage offer, but it does suffer from its location. Arid tarmac, nondescript housing and the general air of decay doesn't help. Wallsend was shipbuilding ... you take that away and there are only supermarkets and charity shops left. My wife is from there so I must be careful, but on the 'murder' day I did chance to venture, in full centurion kit, into the nearest supermarket to buy sandwiches for our murder crew. As I was leaving I was bawled at by some uniformed bouncer who yelled that I had somehow gone out of the wrong door, and that I must come back in and exit properly. In passable Latin I invited him to go forth and multiply, which led to a standoff in the car park; happily I was the one who was armed. It was touch and go though, and attracted an audience, none of whom seemed to notice I was dressed that bit differently.

If you're determined to walk the Wall proper then you must march east along the modern road system to Newcastle. It's not overly edifying, and even *Pons Aelius* doesn't yield many clues. The fort sat on top of a natural hump overlooking the river crossing, but the site is now dominated by the medieval castle with just an outline shown in stone setts. The bridge, too, is long gone; it spanned the river more or less where Armstrong's iconic Swing Bridge stands. The Great North Hancock Museum has some really good material, very well displayed, and there are traces of the fort at Benwell (*Condercum*).

As you head west, finally breaking out into open country, it gets better, though there's nothing to see at Rudchester (*Vindovala*) or Halton (*Hunnum*). Corbridge (*Corstopitum*) is different. Just south of the Wall on Dere Street it started its long life as a fort, then became a supply-base and thriving commercial centre, an arsenal where armourers from both 2nd and 20th Legions manufactured, serviced and repaired kit. The civilian settlement reached urban proportions. Stone from the base was

later re-cycled in Corbridge's Saxon church tower and in Wilfrid's great foundation a few miles west at Hexham.

Chesters (*Cilurnum*) is glorious, both the fort with its attendant bath house, the stub of the old bridge abutment and the grand eighteenth-century house, once owned by Clayton. It's a microcosm of our whole fascination with Rome, an umbilicus between the original and the great eighteenth- and nineteenth-century revival. So much of our culture is influenced by classical precedent and Chesters sums it up. The splendid small on-site museum, as Victorian as the Albert Hall, cements these layers of association.[41]

I still walk the Wall, with or without *lorica hamata*,[42] carrying my father's edition of J. Collingwood Bruce's *Handbook to the Roman Wall*. Like Clayton, he was both singer and song. Born in 1805, he was a teacher and headmaster, obsessed with Roman antiquities, a pioneer archaeologist and epigraphist. His seminal guide first came out in 1863; my copy is the 11th edition, from 1957. The equally distinguished Ian Richmond[43] wrote in the preface to this edition: 'It has all the virtues of a small book written by a man who has the subject at his fingers' ends. Nothing is said but what is essential; the descriptions are vivid and terse; the style is rapid and eloquent and the reader is carried along with a stride like that of the Wall itself.'[44]

Heading west as the ground begins to climb through Walwick and on to Carrawburgh (*Brocolitia*), 'nothing to see here'. But just south, on the other side of the Military Road, is one of the most remarkable and evocative sites on the Wall. In marshy and quite uninviting ground, Clayton dug out an old well and uncovered a real treasure trove of 'coins, inscribed stones, altars, more coins, jars and incense burners',[45] A slew of votive offerings came out of the well, and the total cache of coins totalled very nearly fourteen thousand, mostly bronze but with gold and silver, too.[46] This was the shrine of Coventina, a local nymph goddess. It appeared that at some point in the late Empire, possibly influenced by Christianity, the site was officially desecrated and all associated items just thrown down the well.

You might think this would be sufficient wonder for the vicinity but in 1949, during exceptionally dry weather, shrinking peat showed up the outline of a rectangular building, and a trio of stone altars dedicated to the soldiers' god, Mithras,[47] were exposed. This temple had been dedicated at the opening of the third century and stayed open for business for the best part of a hundred years with a couple of makeovers. Finally, it was closed down and slighted, presumably part of that same pious cull that had banished Coventina. For most of my life there was a full-sized replica in the Museum of Antiquities. Contentiously, this became a casualty of the move to GNM; a kind of compromise was thrown in, but that space was soon re-cycled. It was a great loss.

My 1957 guide quotes the entrance fee to Housesteads (*Borcovicium*) as sixpence. It's rather dearer these days, but there's a good visitor centre off the road, managed by the National Trust, and an excellent museum on site provided by English Heritage. Housesteads is one of the most visited sites not just on the Wall but in Britain, attracting several hundred thousand visitors a year.

Rosie Serdiville (my co-author and frequent co-conspirator) and I spent three very wet and windy weeks in the summer of 2007 at Housesteads. We were offering themed history walks around the fort in the guises of Regina of the Selgovae (innkeeper and Celtic activist) and the reprehensible Magnus Maximus (late imperial governor and scoundrel, who stripped what was left of the wall garrison in AD 383 to support yet another failed bid for the purple). The real star of this particular show was Arnie, a sort of wolfhound, who was with us on loan. He played Regina's hunting hound, and he sauntered off at one point, bored by the same old patter, dragging the hapless innkeeper with him face down in the mud and muck, still bravely clinging on. Authentic smell for the rest of the day: wretched *Britunculi* indeed.

Chesterholm, better known by its Latin brand *Vindolanda* (it's not on the Wall, being part of the earlier Stanegate works) is perhaps the best-known fort of all. During the third century it was home to the 4th Cohort of Gauls. We don't know who was there earlier, but the place was originally constructed from timber, was rebuilt many times, and an extensive civilian township or *vicus* grew up outside the walls. It is now associated with the Birley family, three generations of whom have dug, studied, developed and loved the site. Since the early seventies a series of annual digs have unearthed a fabulous hoard of real treasures: the celebrated tablets, leather-ware and a whole cornucopia of artefacts. The museum on site is by far the best on the Wall and the lovely little valley garden with its rebuilt grottoes gives it a unique flavour. Robin Birley also constructed some sections of timber and stone wall (sneered at by some academics), which nonetheless greatly add to the visitor experience.

Minding the strategic passage of the Irthing Gap stands Birdoswald (*Camboglanna*), probably my personal favourite. It's three miles west of Carvoran, also managed by the Birleys, and housing their excellent Roman Army Museum. Birdoswald is a large fort, over five acres (2 hectares), and was held, third century, by the 1st Dacians and then the 1st Thracians – Rome was a vast cosmopolitan enterprise. Like Housesteads, Birdoswald shows signs of later occupation, cruder work by local *foederati* or militias; as Rome contracted, more and more forts shrank, too. Civilian settlements were abandoned and folk moved inside the walls, increasingly tribal rather than imperial. In the sixteenth century the east tower of the south gateway was re-fashioned as a bastle. That's a very long occupation!

Cocidius and Me

I'm going to leave the summary to Dr Lindsay Allason-Jones, an eminent scholar of the Romans in North Britain:

Initially the Roman invasion probably didn't have much impact on the tribes-people of Northern England; like the Channel Tunnel, it probably seemed to them that it would only affect the southerners. Eventually they would have learned otherwise. By the 70s AD they would have got used to seeing Roman soldiers littering the landscape, taking their food and asking for taxes. How much fighting there was would have depended on each tribe's attitude to the invaders and whether each Roman commander behaved according to the rules or let rip.

As the years went past people would have got used to it all, whether they liked it or not. However, I think none of it really 'took' and I sometimes wonder how much of an underground resistance movement there was. Within fifty years of the official end of Roman Britain most of what people consider to be typical of Roman Britain had disappeared. This is largely because what we think of as 'Roman' takes a great deal of bureaucracy, money and manpower to maintain: roads, bridges, bathhouses, sewers, aqueducts, central heating, etc.

By the end of the 5th century there had been no maintenance regime for a couple of generations and it doesn't take that long for buildings etc to fall apart. Some towns did survive but in a very dilapidated state and with very small, poor populations. Christianity had mostly gone – given that Britain had come under constant threat from outside forces after the third century; I can imagine that many people would have gone back to the old religions as Christianity didn't seem to have done very well for its worshippers.

Curiously, the Latin language seemed to have been abandoned also, along with literacy, which suggests that most people had continued to speak their native Celtic dialect when not interacting with the authorities. All these 'benefits' of Roman occupation had to be reintroduced several centuries later. What does seem to have survived from Roman introductions to the present day are better sheep and cows, leeks (as well as some other vegetables, such as radishes, turnips and parsnips), and the hairpin. Not much to show for 400 years of occupation!

As George Macdonald-Fraser pithily summarises: 'And the men who built the Wall in the rain, and defended it and died beneath it and begot their children to grow up beside it, and finally left it, probably looked back as it faded into the mist and thought what a waste of time it had all been; they were quite wrong.'[48] It's a great piece of writing even if it never happened that way; the Wall just fell away bit by bit, the whole massive

structure too big, too long, too expensive and (with crumbling resources) unmanageable. But he was right: it wasn't a waste of time. It connected us here far, far to the north, plugged us into the classical mainstream. And though the ideas faded, they never vanished, but lay like seeds below the turf, ready for the right time to re-flower.

Furious Norsemen

'Yea, how they set themselves in battle array
I shall remember to my dying day'

John Bunyan

I'd like to say that my fascination with the Norsemen began with detailed reading of the *Anglo-Saxon Chronicle*, but in fact it was down to Kirk Douglas and Tony Curtis in *The Vikings*[1] that got me going, as it did many of my generation including (if I remember rightly) Neil Oliver. Fort la Latte in Brittany doubled for Bamburgh. Also known as 'Castle of the Rock Goyon' just south-west of Cap Frehel and west of St Malo, it's very impressive in its own right, with a primeval location at the tip of its own small peninsula. Some years later and still in thrall, we visited family at Tonsberg, south of Oslo on the banks of the long, widening fjord. I took the local train up to the capital: slow, clanking – more *Heroes of Telemark*[2] – to get to the Viking Ship Museum. I'd dreamed of seeing the Osberg and Gokstad ships. Read as much as you like, dream and fantasise, but nothing quite prepares you for the reality, and they definitely didn't disappoint. As soon as I came face to face with Gosktad, it felt, in that moment, that the very essence of the Vikings was alive in front of me.[3]

'This last, dim, weird battle in the west' – Tennyson described the final battle between Arthur and Mordred in those terms. There were three of these 'futile' fights, when Celt fought Celt instead of uniting against common enemies. One I briefly mentioned earlier, as described by Skene, was the battle of Arfderydd, which occurred near Arthuret on the English West March. Here, according to the *Annales Cambriae*,[4] 'The Sons of Eliffer [fought] Gwenddolau son of Ceidio; in which battle Gwenddolau fell.'[5] The date is given as 573 and we know from the *Annales* that these two sons, Gwrgi and Peredur, were both dead by 580.[6]

It was for the site of this scrap that Skene (the Welsh antiquarian, see also Chapter Two) was searching in the nineteenth century, and he relied on local oral tradition for its location, linking Liddel Moat and the parish of Carwinley with the fallen hero. Nobody is quite sure who the combatants were but Skene felt – and this seems plausible – that these were successors to the Novantae of Galloway and Selgovae of Dumfriesshire. This puts the dead king's ground north of Rheged, perhaps part of what later become Strathclyde.

One of the players was the loser's bard/priest/druid Myrddin, who we know better as Merlin. Whether this was Arthurian Merlin or another we don't know; date-wise he appears far too late, but the idea is appealing. Battle casualties were around three hundred and the dead were just dumped into marshy ground. The horror was too much for the temperamental druid who lost his wits and fled into the woods. Even with Gwenddolau killed, his war band (or the survivors) fought on for another six weeks, which suggests a campaign consisting more of extended skirmishes, most likely fought over territory. But both factions would have done better banding together and focusing on Saxon intruders, all set to gobble up their petty realms.

Ida was a Saxon war leader who'd taken over the infant state of Bernicia in 547: 'This year Ida began his reign, from whom arose the royal race of Northumbria; and he reigned twelve years and built Bamburgh.'[7] He probably came not from the Continent but from an earlier settlement further down the east coast. From its inception, his new mini-kingdom embarked on an era of relentless expansion. This shouldn't imply that the Angles had it all their own way: their expansion wasn't uncontested. Largely relegated to the land of myth is the principality of Rheged, the capital of which may have been Carlisle and whose kings claimed descent from the late Roman governor and imperial pretender, Magnus Maximus.[8] Even the boundaries of this Celtic province remain a mystery. Nonetheless, its most celebrated ruler, Urien,[9] was a favourite hero whose praises were sung by bards Taliesin and Llywarch Hen. He defeated the Angles in a series of battles and succeeded, for a while at least, in penning them up in their coastal fortresses.

> Hussa reigned seven years, against whom four Kings made war, Urien, and Rideric, and Guallian and Morcant ... and he shut them up three nights in the island of Metcaud [Farne Island]: and during that expedition he was slain, at the instance of Morcant, through envy.[10]

Disunity – a tragic flaw of the Britons – jealousy and an assassin's stroke ended Urien's brilliant reign. He was murdered by the mouth of the

Low Burn near what is now Beal, presumably at the instigation of his supposed ally, Morcant. With Urien gone, his crown passed to his son Owain, known as 'Chief of the Glittering West'; he was a hero worthy to succeed his father. Owain, too, became a favourite of the bards, whose verses chronicle the death-throes of Celtic Britain. Owain is credited with a great victory over the Angles at *Argoed Llwyfain*[11] when the Saxon prince Fflamddwyn is said to have suffered defeat and death. Ultimately, he, too, failed to stem the tide and went down at the battle of Catraeth (Catterick?) around 593, an end made glorious in the poet Aneirin's epic, 'Y Gododdin'.[12]

Though Rheged vanished, other British kingdoms survived. Saint Patrick wrote to the Damnonii, secure in their rocky fastness at Dumbarton (the future capital of Strathclyde) and ruled by Coroticus or Ceredig; the saintly traveller lambasted them roundly for trafficking in slaves. North of the Britons lay the kingdoms of Picts and Scots. The former, who made up the majority, were descendants of those tribes who had rallied to Calgacus, leading his stand against Agricola.[13] Their origins were obscure; Irish legend chronicles the Picts' first arrival as invaders from distant Scythia, an interesting if unlikely conjecture. It does appear that there were two distinct Pictish kingdoms. As early as 310, Cassius Dio refers to the Caledonii as living north of the Maeatae, who had earlier disturbed the reign of Commodus. In 565 Columba visited the Pictish King Bridei in his fort or dun near the future site of Inverness,[14]

These Anglians were an aggressive race, sprung from Saxon stock, imported as mercenaries in the service of Rome and latterly of those Romano-British chiefs they were soon to supplant. Warlords with a good track record attracted hardened warriors – household men who were expected to follow their leaders to victory or to death. In fact, for one to return home when the chief had gone down was the greatest dishonour. Service was not determined by ethnicity: a trained and experienced warrior could always find employment. In return for absolute loyalty and good service he would expect – indeed demand – substantial rewards, typically silver arm rings and above all, land. A warrior could become a landowner, a *thegn*, but he was still bound to his lord. The greater success the lord enjoyed, the more men he stood to recruit. Of course, they would expect to be rewarded in turn, so peaceful cooperation with neighbours was not incentivised.

This professional warrior elite, a real band of brothers, was thoroughly trained to fight in late Roman shield wall tactics, a heaving scrum where discipline and cohesion would win the battle. Good swords were still relatively rare and most fighters would rely on the shorter seax[15] and heavy thrusting spears. Shields were rounded and slightly convex, of wood covered with hide and stiffened by a metal rim and bands. Lords and warriors would be protected from throat to thigh by a short-sleeved

mail shirt or *byrnie*, the 'ring woven corselet' or 'woven breast nets' of *Beowulf*. Iron-framed helmets, finished with plates of horn, were sometimes surmounted by the warrior's crest, a bronze boar say, such as the example found in a burial at Banby Grange in Derbyshire.[16] It wasn't unusual for helmets of this period to come with sculpted face-pieces, giving the wearer a degree of anonymity. The most celebrated example of this is that found at Sutton Hoo.[17]

Swords themselves were rare and precious things, the true emblem of fighting men, given as prestigious gifts or handed down through families. They would have a yard-long blade, straight, double-edged and shallow-fullered, with short, functional quillons and grips of wire-bound wood. The distinctive, angular or 'cocked hat' pommels might be mounted with gold and bejewelled. Particularly prized samples were often given names, such as the hero Egill's *Dragvandil*,[18]

When Ida of Bernicia died, several successors came and went in fairly quick succession. Eventually Aethelfrith, possibly a bastard grandson, took control. In his eventful lifetime he would transform this small, insignificant principality into a super-power, whose reach stretched as far north as the Forth and beyond, west into Northern Ireland, south to the Humber and across to the Welsh marches. Despite his being pagan and demonstrably violent with it, Bede approved of him: 'At this time Ethelfrid (Aethelfrith), a most worthy king and ambitious of glory, governed the kingdom of the Northumbrians and ravaged the Britons more than all the great men of the English.'[19]

Owain and the Gododdin (successors to the Votadini) were first to be dealt with: Aethelfrith carried the Northumbrian banner into the Lothians and established influence that would endure for over four centuries. By then he had arranged a shotgun wedding with a princess of Deira, the Anglian kingdom centred on Durham. He married the King's daughter, then disposed of her father and sent her brother, Edwin, into precarious exile. Edwin would become an obsession … a special project.

Aedan mac Gabran, ruler of Dalriada, was his next opponent. These Dalriadic Scots were recent immigrants who had filtered across the Irish Sea in relatively small numbers, probably not beginning to arrive until after the fall of Rome. By the year AD 500, their chieftain Fergus Mór and his two brothers had established toeholds in Kintyre, Lorn, Islay and Jura.[20] Their capital was Dunadd, a site which even today remains marked by the imprint of history.[21]

Alarmed by Northumbria's rapid and violent rise, the Scots and their affinity invaded, aiming for a pre-emptive strike. The clash occurred at 'Daegsastan' which might be Dalston in Cumbria, Dawston in Teviotdale or even Dissington in south Northumberland. It was a hard-fought action. In the first contact the Northumbrian vanguard, led by the King's brother, Theobald, was badly cut up and killed. Aethelfrith

counter-attacked with his centre, and for a time both sides held their ground as casualties mounted. Finally, the discipline and staying power of the better-drilled Anglian warriors began to tell and the Scots army disintegrated; Aedan fled but his losses were high. 'From that day until the present,' wrote Bede, 'no King of the Scots in Britain has dared make war on the English,'[22]

Aethelfrith hadn't finished: as his empire expanded, the Welsh princes became alarmed. In 616, he marched south-west to Chester where he won another dazzling victory: 'Ethelfrid ... made a very great slaughter of that perfidious nation.'[23] Bede was prepared to overlook that the king cut down a great number of Welsh monks who had come out to pray for their side. At last his hatred of Edwin, or perhaps just fatal overconfidence – maybe he'd started to believe in the myth of his own invincibility – got the better of him, and he faced his brother-in-law, with his sponsor Raedwald of East Anglia,[23] on the banks of the River Idle.

This was, finally, a battle too far and though he did considerable damage to his opponents, killing the other king's son, his smaller force and he along with it were annihilated. Earlier though, Raedwald had had doubts and he had thought of just handing Edwin over, but God (in the person of Raedwald's queen) interceded, removed his fears and put heart into Edwin: 'Thus Edwin, pursuant to the oracle he had received, not only escaped the danger from the King (Aethelfrith) his enemy but by his death, succeeded him in the throne.'[24]

Edwin it was who, to Bede's great joy, introduced Christianity into Northumbria, and his reign became a kind of mini Golden Age: 'This Edwin, as a reward of his receiving the faith, and as an earnest of his share in the heavenly kingdom, received an increase of that which he enjoyed on earth, for he reduced under his dominion all the borders of England ... a thing which no British King had ever done before.'[25] Of course, this was a not so subtle hint to his contemporaries and posterity that Godliness and prosperity went hand in hand.

Bede's World in Jarrow has on show a grand model of Edwin's palace complex of Ad Gefrin. Today, the archaeological site stands just north of the B6351 in North Northumberland, commemorated by a fine roadside memorial. This wonderfully evocative place, under the shadow of Yeavering Bell with its impressive hillfort, was where Paulinus preached and baptised many converts in the River Glen. Excavation carried out by Brian Hope-Taylor[26] in the nineteen-fifties and early sixties, revealed a mightily impressive citadel of vast timbered halls and ancillary buildings, instantly evoking King Hrothgar's Heorot:

[W]e took our places at the banquet table. There was singing and excitement: an old reciter, a carrier of stories, recalled the early days. At times some hero made the timbered harp tremble with sweetness,

or related true and tragic happenings; at times the king gave the proper turn to some fantastic tale, or a battle-scarred veteran, bowed with age, would begin to remember the martial deeds of his youth and prime and be overcome as the past welled up in his wintry heart.[27]

Most enigmatic of the finds were traces of a raised timber amphitheatre or grandstand, almost certainly some form of civic structure – an open-air debating chamber, theatre and performance space perhaps, or a cattle auction area, or maybe a combination of these and more.[28]

Bede was in no doubt, but just in case his readership hadn't got the message, he rammed it home: 'It is reported that there was then such perfect peace in Britain, wheresoever the dominion of King Edwin extended that, as is still proverbially said, a woman with her new-born babe might walk throughout the island, from seas to sea, without receiving any harm.'[29]

If you drive westwards along General Wade's military road towards Carlisle, you'll pass a large wooden cross on the right not long before the road swoops down to Chollerford. This is Heavenfield, in old English *Hefenfelth*, where King Oswald routed the Welsh and restored the kingdom of Northumbria to its rightful owner (himself) in AD 633/4.

He needed God's help, as things were in a pretty poor state. A potent alliance between Christian Cadwallon of Gwynedd and pagan Penda of Mercia had resulted in the defeat and death of sainted King Edwin at Hatfield Chase (near Doncaster) on 12 October 633.[30] Their victory exposed Northumbria to a hurricane of pillage. Then, the reeling kingdom was divided into two regions – old Bernicia and Deira. Eanfrith, Oswald's brother, was quickly disposed of by Cadwallon, and Osric of Deira rapidly went the same way.[31] With classic showmanship – and we shouldn't lose sight of the fact that Bede is a superb storyteller – cometh the hour, cometh the man: 'Oswald, a man beloved by God.'[32]

Oswald, along with a surviving brother Oswy (who would succeed him after 642), had been in profitable exile among his kin, the Dalriadic Scots, where he had built up a reputation as a formidable fighter – *Whiteblade*.[33] King Domnall Brecc, Oswald's Scottish overlord, was happy for him to return home and try to win back the crown of his father (that same gloriously *Game of Thrones* Aethelfrith). The Scots' king would not technically lend military support as he was allied to Cadwallon (though not to Penda) but he did provide the brothers with a strong war-band to ensure their safe passage back to Northumbria's ravaged borders.[34]

Once home, Oswald rallied the Northumbrian militia or *fyrd*[35] and his war-band was swelled by Scottish fighters who, even if they were disobeying their king's explicit instructions (as he may well have anticipated, or even intended), could legitimately claim they were fighting

for Christ and St Columba. Abbot Segine of Iona was ranged with Oswald's affinity and this validation by the Celtic Church carried a great deal of weight. Indeed, Oswald might have brought a squad of monks with him to provide spiritual gravitas – one hopes they were unaware of how many of their brethren his father, Aethelfrith, had killed at Bangor.

The exiles came down the valley of North Tyne, by which time Cadwallon, still at York, became aware of the threat and immediately marched north. He came up Dere Street, then branched left along the line of the Wall at Stagshaw. Oswald had occupied a strong defensive position above Chollerford, flanked by the Vallum. During the long watches of the night before battle, Oswald received a visitation from Saint Columba (Cuthbert provided similar inspiration later, for Alfred on Athelney). This was most heartening, as the saint promised God's strong arm would be with them: a huge boost to morale, given that Oswald was greatly outnumbered. And these portents mattered: his polyglot, ad hoc force would need all the motivation it could find. Oswald's war council was easily convinced and his army advanced to contact.

It seems the Welsh were not expecting this. Maybe Cadwallon was lulled by too many easy victories, but this time the clash of shield walls was decisive. After a short sharp shock, the invaders broke; their front, hemmed in by Vallum and Wall, was far too narrow for their greater numbers to tell. The broken army was chased back down the length of the Denise Burn in a running fight. They'd made no friends in Northumbria and probably plenty of locals were willing to lend a hand now their enemy was beaten. Cadwallon was among the dead and Northumbria was reunited under a new king, one who would soon be recognised as *Bretwalda* – king of kings. As Bede exulted: 'The place is shown to this day and held in much veneration where Oswald, being about to engage, erected the sign of the holy cross and on his knees prayed to God that he would assist his worshippers in their great distress.'[36]

Bede clearly loved St Oswald but he, too, failed against Penda, being defeated and killed by him in 642, 'in a great battle, by the same pagan nation and pagan king of the Mercians.'[37] Oswald's younger brother, Oswy, succeeded him and (remarkably for a Northumbrian king in this heroic age) died in his bed at the age of 58: a good innings. It was Oswy who finally settled his family's account with the ageing Penda in 655: '... the engagement beginning, the pagans were defeated, the thirty commanders and those who had come to their assistance, were put to flight and almost all of them slain.'[38]

Northumbria had now reached the dazzling zenith of its power, ruling or dominating the whole of what became the Anglo-Scottish borderlands. Oswald and Oswy were also influential in importing Celtic Christianity from Iona, which became established and flourishing on the coastal archipelago of Lindisfarne. Also known as Holy Island, Lindisfarne is

cut off twice a day from the mainland by a long rolling tide that has frequently caught out the unwary on the narrow finger of causeway (now equipped with a refuge tower where the over-confident can watch their cars drown, and ponder on how they'll phrase this to their insurers). It's two different places: when the tide's out it's a tourist Mecca, overrun during the summer by a convoy of tourist buses, cars and camper vans, some as long as one of the village streets. But when the tide is in it morphs into something very different: quiet, shut off and shut in.

Roman Polanski filmed both *Cul de Sac*[39] and his *Macbeth* (my personal favourite film version)[40] there. I do have a family connection on my mother's side: the graveyard is full of my Kyle relatives, and a number still live in the village. As a boy I attended a cousin's wedding on the Island, and the bride was impressively volleyed as she left the Priory Church, before performing the ritual of jumping the 'Petting-Stone', a long-established custom. Apparently, the latter brings fertility and good luck. I was more diverted by picking up the expended shotgun cartridges.

First Aidan and then Cuthbert led a community of Celtic monks there. They were devout, austere, 'of the people' in a way that the far more worldly Bishop Wilfrid of Hexham could barely recognise, and their rigid piety and poverty clearly annoyed him. These Northern saints are with us still; that later medieval monastic remnant is a place of pilgrimage: 'The Isle of Lindisfarne ... which place as the tide flows and ebbs twice a day, is enclosed by the waves of the sea like an island; and again twice in the day, when the shore is left dry, becomes contiguous to the land.'[41] Their Saxon structures were timber, all the better to burn down, the Vikings might have said. An aura of that sanctity clings not just to Lindisfarne but to Cuthbert's retreat, nearby Inner Farne – the sort of meditative sanctum where you can really understand what austerity means.

Oswy facilitated the great Synod of Whitby in 664, where the procedural breaches with Rome were papered over in Rome's favour and Bishop Wilfrid clearly got the upper hand. Celticism was marginalised but did not disappear; Cuthbert was a mightily important political figure, much favoured by Oswy's son and successor, Ecgfrith. This last of Northumbria's heroic line seems to have been bold and aggressive to the point of rashness. He sent 'Beort, his general, with an army into Ireland, miserably wasted that harmless nation ... in their hostile rage [they] spared not even the churches or monasteries.'[42]

The disaster that a confederation of Picts and Scots and Britons from Strathclyde inflicted on the hitherto almost invincible Northumbrian army at Dunnichen Moss (Nechtansmere) among the Sidlaw hills in the spring of 685 was a momentous victory for them and proof of Ecgfrith's gung-ho folly. It was a local Little Big Horn.[43] It put an end to the systematic inroads onto Scottish soil which had threatened to turn the Pictish kingdom into a Northumbrian client. In 1985, on the occasion

of the 1300th anniversary of the fight, it was hailed as the most decisive battle in Scottish history.[44] Bridei mac Bile, who beat Ecgfrith, brought all of the Picts beneath his own colours and moved against the Scots of the western seaboard, attacking Dunadd. His descendant, Oengus Mac Fergus (752-61), finally defeated the Scots and established Pictish hegemony.[45] For Northumbria, this was bad news.

Ecgfrith had had nothing but contempt for the Picts, a disregard born out of earlier, easy victories. Apparently, quite early in his reign, a Pictish confederation had rebelled against the Northumbrian yoke, only to be cut up when the Angles stormed their base. Ecgfrith's cavalry, possibly aided by disaffected Pictish allies, slaughtered their lightly armed opposition in a lightning attack, 'filling two rivers with the corpses', according to the Anglian Chronicler, Eddi.[46]

It was a classic case of familiarity breeding contempt: 'That same king, rashly leading an army to ravage the province of the Picts, much against the advice of his friends ... was drawn into the straits of inaccessible mountains and slain.'[47] Bede is making a further point here: if you don't listen to your bishop, in this case Cuthbert, you're headed for the rocks! Though Ecgfrith was succeeded by his half-brother Aldfrith, the long decline of Aethelfrith's grand empire had begun.

* * *

If Northumbria was no longer heroic, it was just embarking on its 'Renaissance' or 'Golden Age', lasting from the mid-seventh to mid-eighth centuries. Despite its political and military decline, the northern kingdom produced a magnificent treasure-trove of art, becoming renowned throughout Europe as a centre of excellence. This period coincides with the life of, arguably, Northumbria's most famous son, the Venerable Bede.[48] Happily, in a note to his *Historia Ecclesiastica*, he gives us some biographical details. Born in 672 (or perhaps the year after) at Monkton in Durham, he entered Benedict Biscop's monastery of Wearmouth aged seven. At twenty he followed Bishop Ceolfrith to Jarrow and St Paul's, remaining there all his life, adding to the already impressive library (it held somewhere between three and five hundred texts).

His classical credentials were impressive: he spoke Latin, Greek and probably Hebrew. He was a man of his times, devoted to an allegorical mode of interpretation yet possessed of vast wisdom, deep humanity and a ready wit. So profound was his influence that he has been dubbed the 'teacher of the Middle Ages'. His output was prolific, but his most influential work is his five volumes of *Historia Ecclesiastica Gentis Anglorum*, which covers 'English' history from Caesar's expeditions up to his own time, and while he does leans heavily on earlier sources such as Orosius, Gildas and Prosper of Aquitaine, he includes much original

material. This is a milestone not just in the history of Northumbria and the borders but of Britain, it is a welding together to produce something which is truly and uniquely English.

In death he travelled further than he had during his lifetime. Dying in 735, he was first interred at St Paul's then moved to Durham around 1022, where he was laid with St Cuthbert in the choir of the great cathedral. Three and a half centuries later his remains were reburied in a splendid monument within the Galilee Chapel. This, like so much else, was vandalised during the Reformation and Bede's bones relegated to a simpler grave. It wasn't until 1831 that his present and glorious tomb, constructed from carboniferous limestone, was built.

St Cuthbert, from his original resting place on Holy Island, did his own fair share of roving. For a while he rested at Chester-le-Street before his final interment in Durham. A number of locations have been called Cuthbert's or Cuddy's Caves. There's one near Doddington, just over the upland golf course (which demands a seriously vigorous breed of golfer) and another at Holburn, in the Kyloe Hills between Belford and Lowick.

I prefer the latter. While the term 'magical' might be (and generally is) overworked, it still applies here. You walk uphill then branch right into modern woodland, pointed by a cup and ring stone. The cave is a lateral hollow overhung with frowning sandstone, like a vast frozen fist. If this place had once been a Mesolithic shelter, it would not be surprising. Viewed from the western approach though an avenue of trees it has the sanctity of some ancient temple. Inscribed on boulders around are wonderfully resonant memorials to members of the Leather family from Middleton Hall, Belford, who owned the land.[49] Colonel G. F. T. Leather, who wrote his *New Light on Flodden* in 1937 (an intriguing soldier's take on the events of 9 September 1513) served with distinction during the Great War and managed to 'acquire' several miles worth of narrow-gauge railway in Flanders, bringing it back for use on his family estate. The reivers would have heartily approved.

Bede's home, St Paul's in Jarrow, is still a remarkable site. Founded in 681 by Bishop Biscop on land granted by King Ecgfrith, it's the other half of the Jarrow/Wearmouth monastic complex – 'one monastery in two places' as Bede describes it. The late seventh-century square-sided chancel is a Saxon survivor with much later re-building of the fabric. What remains of the monastic buildings is much later, secularised during the Reformation. The chancel is wonderful and preserves a distinct feel of ancient sanctity. What claims to be Bede's original chair is not, having been carbon-dated. It's also rumoured there's a vault below which might just contain the mortal remains of Ecgfrith himself, repatriated after his unfortunate Scottish excursion of 685.[50]

Just north of the church, on what used to be industrial ground, is Bede's World, a heritage site clustered around nineteenth-century Jarrow

Hall. It is housed in an imaginative millennial building, now in need of maintenance and a dynamic makeover. I was a manager there from 2013-2014 and have regularly re-enacted in the recreated Anglo-Saxon settlement. My friend and colleague Colm O'Brien, archaeologist, author and lecturer, was one of those involved in what was a very challenging project. Colm records: 'I've been involved with Bede's World one way or another from the early stages of the A-S farm ... sometimes from the edges and for a period as a member of the Trustees' Board.' He was initially consulted to advise on the development of the reconstructed buildings from an archaeological standpoint.

> There were great plans for experimental projects ... in farming: methods, crop types and yields etc, until it became clear that the soil that had been put down after the clearance was so intractable that no self-respecting A-S farmer would have gone anywhere near it.

Any attempt to recreate a living version of the past is tricky and inevitably tainted with compromise. The site itself was reclaimed ground and it stands in the middle of a near post-apocalyptic landscape of industrial profusion and waste. 'A good case of the naïve purism is the tree cover on the slopes. When it came to planting, a question arose over the plastic tubes to protect the seedlings. Those who knew about growing trees recommended them but we solemnly declared that plastic tubes were not in use in AD 700'. All very admirable, but without tubes the seedlings died: 'Next time around there were tubes.'

Similar quandaries emerged over the building techniques to be used in constructing 'Thirlings Hall':

> We took what we might call a minimalist view; nothing to be included unless it could be justified by archaeological evidence ... I came eventually to think that this approach meant that we undersold the building, so to speak. It's too rustic. We have a pretty good notion of where that building (the original, I mean) should fit within a social hierarchy, and it's not peasant ... it's not aristocracy but we might think of it as gentry ... I took to suggesting it was a C6 equivalent of the sort of place that many of Jane Austen's characters inhabited

Both Colm and I loved working with the ever-ebullient Pearl Saddington, a great example of what a heritage professional should be, able to balance a programme for visitors, schools and academics. The site now seems to be in penurious limbo. Nonetheless, I do remember a luminous evening when Colm hosted Northumbrian author Max Adams for the launch of his magisterial account of the life of Oswald, *King in the North*.[51] We staged this in the recreated Yeavering-inspired open auditorium in

glorious spring sun where the magic worked; it was really possible to imagine we were in the remote past.

'*A furore Nordmannorum, libera nos, Domine* – 'From the fury of the Northmen O Lord, deliver us' was a litany without need of vellum. It was graven on the hearts of men whenever and for as long as that fury fell.'[52]

In summer 2013, the Lindisfarne Gospels were on display in Durham; it was quite literally a once in a lifetime chance to see this astonishing work of art, one of the most important survivors of the early Middle Ages, written here in Northumbria. Eadfrith, latterly Bishop of Lindisfarne, may have spent as long as a decade copying and illuminating the Gospels. This was around the year 700, and the work was bound in unpretentious leather bindings, which was fortunate. The current, blinged-up version is a Victorian gothic fantasy.

The *Anglo-Saxon Chronicle* records that the portents for the year 793 were unfavourable: 'There were excessive whirlwinds and lightning and fiery dragons were seen flying in the air.'[53] For the inhabitants of Northumbria at least, this dire forecast was spot on. In that year the community of Lindisfarne was the first to taste the fury of the Northmen. They came out of a bright clear sky, sunlight chasing the movement of the oars, three long, sleek ships of a kind never before seen in these coastal waters. They were elegant and graceful, seeming to skim across a placid sea, but the great square sail snarled pagan and a dragon's head reared from the curved prow. They 'lamentably destroyed God's Church on Lindisfarne through rapine and slaughter.'[54]

Those men who swept ashore were tall and well proportioned, clad in gleaming ring mail, their weapons were spears, Danish axes and double-edged blades. The monks were killed without pity or comment. Anything of value was methodically looted and piled; any likely girl or boy was seized. In the brief fury of the sack, lay and clergy were pillaged, settlement and monastery given to the flames, the place stripped and emptied. The Vikings had arrived. That the Gospels escaped the Vikings' attentions verges on the miraculous – the great work was probably saved by its unostentatious binding: no bling and it wasn't worth taking.

Such scenes were to be repeated along the coasts of England, Scotland and Ireland as the sea-rovers made their presence felt. The image of their terrible swiftness – the emergence of these pagan warriors in their rapier craft, springing from the very vastness of the oceans – is a powerful one but probably misleading. The Norse raiders were, of course, good sailors but long voyages over open water were risky: island or coast-hopping was preferable. After 865, coastal raiding gave way to conquest, and the ancient, tottering kingdom of Northumbria was the first of the

Saxon homelands to fall. Happily, despite many adventures, the Gospels survived.

Island-hopping also provided opportunities for re-victualling at small harbours and staging posts, or by raiding the *strandhogg*. Making free with handy flocks or herds of cattle could be accompanied by the lifting of local teenagers for the slaving business. Where no useful harbour presented itself, ships could just be beached, ideally on an island or river-loop where a defensive stockade could be thrown up: loss of their ships was crippling to the sea-raiders and they would go to great pains to ensure secure anchorage.

For many years those two famous Viking vessels preserved near Oslo, the Osberg and Gokstad ships, were the principal source of archaeological evidence for the methods of construction used. In 1962 a further rich haul of five sunken boats was made off Skuldelev, in Roskilde Fjord, Zealand ('The Skuldelev Ships').[55] These were vessels built for war, developed in the course of the tenth century, sometimes referred to as *drekar* (dragon) ships, a reference to the carved prow. The Gokstad ship is described as a *skuta* or *karfi* – a more all-purpose craft that could be employed for civil or military use. In constructional terms the man o' war was longer and sleeker (a classic 'long-ship') than its fuller-bellied cousin.

When these Norsemen first blitzed Northumbria in 793 and for several seasons following, these were hit and run raids with slaves and booty the main prizes. It was a long while, not quite a full century, before the Vikings came back to stay, led by the sons of legendary Ragnar Lodbrok ('hairy breeches', as featured in *The Vikings*). He may or may not have existed but Ivar the Boneless[56] certainly did, and his ambitions extended far beyond mere banditry. He came to conquer.

Between those times Northumbrians and Scots still found plenty to fight over. Just on the northern fringe of the border marches, in the Lothians, is the village of Athelstaneford. It stands on a short east/west ridge and covers a route over the (Scottish) River Tyne; it's not too far from mighty Traprain Law. Since Aethelfrith's day, Northumbria had maintained influence over this region, stronger at some times than others, probably not with any direct form of vassalage but some if its rulers might have been Northumbrian clients.

King Oengus (Angus) II, ruler of Pictland, led a raid during 832, a savage spoiling which prompted instant reprisal. King Athelstan of Northumbria hurried north with a sizeable war-band and caught the Picts just north of Athelstaneford, surrounding their camp with superior numbers. Fervent prayer seemed an appealing tactic and Oengus vowed to honour God and everyone else, especially St Andrew, if they'd just spare a moment to extricate him from this particular mess.

During the night St Andrew came good and promised victory next day beneath his talisman. Spiritually sustained and enthused, the Picts sallied

out and launched a surprise attack of their own, presumably at dawn, and won the day. Athelstan and his thegns were cut down and their army bolted. This may be the origin of the Saltire, the cross of St Andrew, as a national flag, though there is little or nothing left on the probable ground today; marker stones said to have been on the field have long since vanished.[57]

In the summer of 2018 it was 1100 years since Vikings and Scots slogged it out at Corbridge. For a pleasant market village, Corbridge has respectable form in the mayhem stakes: a later, better-known fight took place there during the Civil Wars in 1644. Of the earlier battle we say 'Norsemen' and 'Gael', but it was never quite that clear-cut: Ragnald commanded a force of Norse and Irish from Dublin, with probably a good few opportunists from Northumbria as well. The Scots, under King Constantine III, weren't all Scottish either: other Northumbrians, supporting Eadred of Bamburgh, were part of his force.

The history was complex: Ivar the Boneless had taken over Northumbria in 866/867: 'This year the [Norse] army went from East Anglia over the mouth of the Humber to York in Northumbria. And there was much dissention between the people and they had cast out their king Osberht and had taken to themselves a king Aella, not of royal blood.'[58] Ivar cannily exploited this internecine squabbling to occupy York and then tricked the careless Northumbrians into attacking him on his own terms. He killed both would-be kings and made himself master. The old rump of Bernicia, ruled from Bamburgh, survived as a form of client of an emergent Norse kingdom centred on York. This Great Norse Army had terrorised Mercia and seemed set to sweep up Wessex until Alfred, done with burning cakes and after good advice from St Cuthbert, famously turned the tide and stopped 'em dead. He, his son, grandson and successors steadily eroded the invaders' territories.

The Norsemen were forced onto the defensive. By the early tenth century they were having no luck anywhere. In 901, according to *The Annals of Ulster*, they had been heaved out of their bases in Ireland by the locals and obliged to seek alternative lodgings. Some settled in the Wirral where more bother ensued. With the English ascendant, most Viking aggression seems to have been directed north against Scots, the independent kingdom of Strathclyde and the old rump of Bernicia. Attacks on Bamburgh involved both Danes and Norwegians, unlikely allies given previous internecine conflict, but needs must ...

Led by Ragnald these incomers (the Danes) did rather better than remnants of the settled Great Army and he managed to wrest Bernicia away from the Old Saxon elite. Meanwhile, the southern fringes of the Danelaw were crumbling beneath the juggernaut from Wessex. As the English surged north, Ragnald dashed south and took a fragile grip on

York. There was only going to be one winner, and Edward the Elder compelled Ragnald to recognise him as supreme ruler.

As is usually the case with confrontations such as Corbridge, details of any fighting are sketchy and we have no real idea on numbers. Probably these weren't great on either side, though we do know that Ragnald divided his forces into four divisions or 'battles', three of which faced the Scots with a fourth deployed cunningly in ambush.[59] Both sides would have adopted a shield wall formation, linden shields overlapping, with a barrage of missiles fired ahead of the main clash (no frantic running about, as films and TV would have us believe). Training, *esprit de corps* and effective command and control of sub-units were still what counted. The Norsemen were good at this, but their enemies had proved quick learners and King Constantine of Scotland's shield wall broke Ragnald's line. Fighting would split up into a series of untidy melées – sharp, savage and murderous.

It was only the timely intervention of his hidden reserve that stopped the rot. These men had been well hidden and were led by Ragnald himself, intended to deliver the *coup de grace*. It's axiomatic in war that no plan ever survives contact with reality. While the Scots were pushed back, they didn't rout; they escaped in good order. It was effectively a draw.[60] Ragnald held on before bending his knee to Edward in 920, the same year he died.

As the powers of the Anglian kingdoms of Northumbria and Mercia crumbled beneath the Viking onslaught, Scottish kings used their growing influence to interfere in the affairs of northern England. Opportunists like Ivar, allied to a (possible) half-brother/cousin (Olaf of Dublin, who had elevated Viking slaving from cottage industry to major conglomerate), were always able to play off various sides at once. Scotland's King Constantine had been trying and failing to bring Strathclyde under his control, but the great and stubborn Dumbarton Rock laughed off any siege. However, Ivar had a proposition: he and Olaf would reduce the fortress, hand it to the King and take their fee in slaves. Ivar wasn't called 'Boneless' (if this means cunning as a snake) for nothing, because he had worked out the Rock's Achilles' heel: the Norse besiegers simply found and cut off the defenders' water supply. They were forced to surrender. Job done and three thousand wretched Britons – only the best of the bunch – found themselves on the market.[61]

Northumbria's fall meant that the old northern province of Bernicia once again was distinguishable from the Viking principality based in York. Edward the Elder, son of Alfred the Great, brought all England south of the Humber under his sway. His son, Athelstan –brilliant and aggressive – clearly perceived York as ripe for plucking. The death of Sihtric of York in 927 gave Wessex the opportunity to intervene and Athelstan ruthlessly drove out the Norse pretender Olaf Guthfrithson,

who fled to his compatriots in Ireland – normally no friends of York Vikings.

With the north-east of England apparently secure, in 934 Athelstan conducted a *chevauchée* through Scotland, an enthusiastic show of strength that involved an English fleet sailing as far as Caithness.[62] Constantine, thoroughly alarmed, clearly decided that a buffer state in northern England was needed to insulate Scotland from the West Saxons. In 937 he formed an alliance with Olaf and the Strathclyde British: Scots, Norse and Celts driven by fear of Wessex. Olaf, with a fleet said to number six hundred keels, sailed boldly up the Humber to reclaim his lost kingdom. His ranks swelled by Norse and Britons from the west and by Scots from the north, he posed a substantial threat to Athelstan.

This Saxon King was not so easily deterred and raising his own substantial forces he confronted the allies, possibly somewhere on Humberside. A fearsome battle ensued, a combat begun at dawn that raged till dusk: Mercians against Norse, Saxons pitted against Scots. Constantine's son was among the many dead and this catastrophic defeat seems to have broken the King's spirit: 'This year King Athelstan and Edmund his brother led a force to Brumby and there fought against Anlaf and, Christ helping, had the victory and they there slew five kings and seven earls.'[63] Any hope of Scotland creating a 'buffer zone' or even of annexing Bernicia outright, perished on that field and in 943 King Constantine withdrew to monastic life.

Some time later, however, there was a resurgence of Danish power centred on York, and Malcolm I of Scotland (943-64) was able to conclude a treaty with Edmund of Wessex, whereby the Scots effectively 'leased' Cumbria, hopefully (in Edmund's view) closing the 'back door' from Ireland. Nonetheless, English influence steadily increased. In 973 King Edgar steered his ceremonial barge down the River Dee; at the oars were six client kings, including Kenneth II of Scotland (971-95). The unhappy reign of Ethelred the *Unraed* ('ill-advised' rather than just 'Unready', though he was both) provided an opportunity for the Scots to reassert themselves and warlike Malcolm II was quick to profit.

He annexed Strathclyde and in 1006 swept through Northumbria, terrorising the ineffectual Earl Waltheof. Dismayed by the older man's apparent faint-heartedness, his son Uhtred fought back. He raised the siege of Durham then pushed Malcolm's forces back across the Tweed. Newly created earl in his father's stead, Uhtred went over to the offensive, driving Malcolm north almost to the Tay and re-asserting Northumbria's ancient grip on Lothian. In 1016 the earl's career was cut short by assassins and his less aggressive brother, Edwulf, who succeeded to the title, withdrew. Malcolm gained both a respite and an opportunity.

Loss of substantial revenue from estates in Lothian outraged the Northumbrian clergy, who in 1018 swore to protect their income by

force of arms. A great levy of warriors was raised, amply blessed and commanded by prelates; they clashed with a Scots army, led by Malcolm, at Carham on the Tweed, probably at a location a quarter of a mile or so north-west of the Norman motte at Wark.

After a savage scrap the Scots emerged victorious and many English went down, including a score of Northumbrian nobility and no fewer than eighteen leading churchmen.[64] The fight proved – with time – decisive, for the line of the Tweed finally became the accepted border, and English claims to Lothian lapsed. King Malcolm's victory at Carham raised the question of the annexation of Bernicia once again, to create a buffer zone between the Scots and English – but a late resurgence, a last gasp you could say, of Northumbrian power under Siward the Dane forestalled any such attempt.

Siward, who features so aggressively in *Macbeth*, was a Norse warlord King Cnut hired to keep the north in order, which involved fighting against the Bard's Macbeth: in '1054; [Siward] led a great army into Scotland and made much slaughter of the Scots and put them to flight... And many fell on his side, as well Danish-men as English and also his own son.'[65] He did a good job ... rather better than King Harold II's brother Tostig, who was expelled by the fractious Northumbrians[66] but returned with a vengeance in the company of fearsome old Harald Hardrada of Norway. They defeated local forces under the brother earls Edwin and Morcar at Gate Fulford near York, then both were killed at Stamford Bridge by his brother Harold II,[67] who was killed in turn by Duke William at Hastings. Game over for Anglo-Saxon England and welcome to the Middle Ages and feudalism.

King William the Conqueror wasn't necessarily that bothered with Northumbria or the border region. Edwin and Morcar submitted but having then transgressed, he handed the earldom to Copsig, of Tostig's old affinity. A poor choice, he soon went down in another internecine brawl, and was replaced by Cospatric, who defected during another abortive rebellion led by the two brothers. This soon fizzled out, but William's attempt to install a garrison in Durham under Robert Comines ended in a flaming Norman Alamo, locals 'slew him and 900 others'.[68] This sparked yet another Northern uprising and William was obliged to lead an army north to restore his grip.

A fresh garrison under William Fitz Osbern was left in York but resurgent rebels, aided by opportunistic Norse reinforcements, wiped them out: 'And so they went to York, demolished the castle ... they also slew many hundred Frenchmen.'[69] This was all too much for William who decided upon a final solution to his northern problem: the ruthless 'Harrying of the North' – pacification by wholesale destruction. Northumberland north of the Wear escaped the worst of this, probably being too poor to be worth wasting. Now it was (another) Earl Waltheof's

turn to rule – Siward's surviving son, and outwardly a safe bet. Yet he, too, raised a rebel flag in 1075 and ended up in gaol. The king now appointed Bishop Walcher of Lorraine who was installed at Durham. Another local dispute sparked yet another fracas and the Bishop – together with his Norman household knights – was immolated at Gateshead. William then sent his capable and avaricious half-brother, Bishop Odo of Bayeux, to give the Northumbrians a taste of his kind of final solution and restore order.

Earlier, in 1072, the king had dealt with Scottish raids instigated by Malcolm III; he 'led an army and a fleet against Scotland ... King Malcolm came and treated with King William and delivered hostages and became his liege-man.'[70] But after the Conqueror's death, Shakespeare's Canmore came back with more fire and sword, firstly in 1079, when he 'laid waste Northumberland as far as the Tyne'.[71] He should have stayed away after that as he finally came to grief at Alnwick in 1093.[72]

He wouldn't be the last Scottish monarch to lose out in Northumberland: William the Lion was also defeated and captured at Alnwick in 1174, David II likewise at Neville's Cross in 1346 and most famously, James IV went down at Flodden in September 1513. The line of the border might be settled geographically but it would remain a frontier, and warring armies would march both ways for the next six centuries.

6

Great Causes

'For as long as a hundred of us are left alive, we will yield in no least way to English dominion; we fight not for glory, nor for wealth, nor honour; but only and alone we fight for freedom, which no good man surrenders but with his life.'

Declaration of Arbroath 1320[1]

The year 2020, was the seven hundredth anniversary of the Declaration of Arbroath, seismic in its day and a banner for Scottish nationalists ever since. In the sometimes clouded view of Scottish writers, this period has two great heroes – William Wallace and Robert Bruce – and a classic anti-hero, Edward I of England, 'a villain to hand, ready at the wings'.[2] Needless to say, both *Braveheart* and Bruce are viewed rather differently by some in Northumberland – as murderous, ruthless terrorists.

On 22 August 1138[3] Norman English knights and men-at-arms deployed a couple of miles north of Northallerton in North Yorkshire, stood looking uphill at a dazzling array of Scottish lords, banners blazing and backed by a wild-looking crew of Gallowegians from the south-west. King David I of Scotland (r. 1124-1153), who had spent many years at the court of Henry I, had come late into his inheritance, taking with him many Norman knights: infiltration rather than conquest. His army also included Germans, English, Northumbrians and Cumbrians. Having spent so long at the English court it was hoped 'he had rubbed off all the tarnish of Scottish barbarity.'[4] What he planned to do was to revive the idea of extending a Scottish 'pale' – or area of influence – as far south as the Tees, a buffer state whose resources could then be harvested at will.

His timing was good: England was on the brink of a dire civil war between Stephen and Matilda – the 'Anarchy' – that would devastate and paralyse the English polity for the best part of a generation. Northern Normans took a different, robust view of the Scottish attempt to extend

their border southward and mustered at the call of Archbishop Thurstan of York, who invoked divine blessings in triplicate, flying the banners of three great northern saints from a high mast: St Peter of York, St John of Beverley and St Wilfrid of Ripon. The saints came through for Thurstan. A wild downhill charge from the Scots was met with an archery barrage that decimated the unarmoured Gallowegians, their bodies so studded with arrows they seemed 'like hedgehogs with quills'.[5] This invasion, or large-scale incursion, followed those earlier precedents of 1061, 1070, 1079, 1091 and 1093. Though a period of relative calm followed this and the later defeat of William the Lion at Alnwick in 1174, there would be no lasting Golden Age. England and Scotland were not destined to be good neighbours.

* * *

Alexander III of Scotland was, according to some of his contemporaries, a prodigious womaniser: 'Neither storm nor floods nor rocky cliffs would prevent him from visiting matrons and nuns, virgins and widows, by day or by night as the fancy seized him.'[6] In March 1286 he had been married for five months, his new (second) bride being Yolande, daughter of the Count of Dreux. On 18 March the king, having presided over his council at Edinburgh, decided to return to his new wife at Kinghorn in Fife. His adult sons had predeceased him and he was in desperate need of a male heir; his dynastic duty was an imperative. Though the day was blustery and inclement and it was getting late, Alexander chose to brush aside the cautions of his courtiers to delay his trip: dynastic duty is dynastic duty and the weel of his kingdom depended on it. Yolande was also beautiful and more than twenty years younger than her husband.

It was snowing heavily; a cold wind whipped the leaden waters of the Forth as the king reached the crossing at Queensferry. Ignoring further warnings, this time from the boatman, a perilous crossing brought the royal party to Inverkeithing. Here, the road passed along the foreshore and in the bleak, smothering darkness the king became separated from his guides and some time on that fateful night he met his death, with a fall that plunged his country into a deeper abyss than any who discovered his mangled body on the foreshore next day could possibly have imagined.

At the time, England was ruled by Edward I ('Longshanks'): 'Like Alexander, he would speedily subdue the whole world, if fortune's moving wheel would stand still forever.'[7] Later spin would christen him *Malleus Scottorum*, 'Hammer of the Scots'.[8] Longshanks, 'a great and terrible king', had earlier crushed the English barons under Simon de Montfort on the bloody field of Evesham, thunder and lightning adding background music to what was butchery: *realpolitik*. Though he later became a staunch and trusted ally, the de Vesci Earl of Northumberland

was one of those Montfortian remnants who had needed a tap on the shoulder to remind them of their due obeisance.[9]

Edward had systematically conquered the hitherto independent Welsh principalities and now, possibly seeking new horizons, he cast his eyes northward. A peerless knight and accomplished commander, Edward was a force of almost elemental power, single-minded to the point of obsession, austere and utterly ruthless. When Alexander took his fatal tumble, his only direct heir was a child, his granddaughter, the Maid of Norway, and Edward was quick to propose a marriage alliance with his own young son, the first Prince of Wales. Unhappily, the little girl died in Orkney on her way to Scotland, leaving an empty throne. In fairness, Longshanks had enjoyed cordial relations with his brother-in-law Alexander III (his first wife had been Edward's sister, Margaret) and had shown no interest in adding Scotland to his portfolio ... not yet.

However, when opportunity came knocking he wasn't one to let it pass, though his early attempts to overawe the Scottish regency council ('Guardians') fell flat and he failed to intimidate as he expected – and indeed usually did.[10] The Guardians, naively perhaps (with hindsight), assumed that Edward would simply choose between John Baliol and Robert Bruce 'The Competitor' (grandfather of the future king). When the council baulked at Edward's efforts to coerce them into accepting the fact of England's feudal superiority, Edward took a sideways step, outflanked the Guardians, and demanded fealty from any and all candidates and – just to muddy the waters a bit more – opened the field to any who thought he had a claim.[11]

There was no shortage of enthusiastic candidates. Bruce and Baliol (the latter backed by the powerful de Comyns) were already at each other's throats in Galloway. Longshanks also wanted control, strictly temporary of course, of all key Scottish castles. Edward and the tribunal's final judgement favoured Baliol as king, whose claim in law was undoubtedly the stronger.[12] Longshanks went home well pleased, having by forcefulness and diplomacy effectively added Scotland to his titles without striking a blow. Eventually, however, King John reached the limit of his malleability and rebelled, dragged along by a wave of anti-English sentiment. From Edward's point of view, the war that followed was no chivalric contest, but rather a squalid revolt to be put down swiftly, effectively and without mercy. This more or less set the tone for the next three centuries – King Alexander's fatal tumble would release rivers of blood.

John Baliol was scarcely cast in a heroic mould, but the Scots did draw first blood by raiding south. Edward was swift to retaliate and stormed northward; on 30 March 1296 he overran Berwick-upon-Tweed in a day, overcoming timber palisade and ditch. Bower tells us[13] that Longshanks used captured Scottish banners (a ruse he had employed at

Evesham over thirty years earlier) to confuse the enemy and to allow him to draw close.[14] This heraldic Trojan horse worked and Berwick opened its gates. 'As soon as the deception was revealed and the truth learnt, they endeavoured to resist,'[15] but much good it did them: the sack was terrible. At this time Berwick was a major port, one of Scotland's largest towns, far outshining its Northumbrian rival, Newcastle. As an intimation of the carnage to come, Berwick was systematically pillaged and its merchants ruthlessly slaughtered. Thereafter the town would be rebuilt as a fortified outpost in a hostile land, like a *bastide* [16] in Gascony or the castles of Wales.

While Berwick burned, the Scots army was still north of Dunbar, and on 23 April Edward dispatched John de Warenne, Earl of Surrey, with a mounted contingent to secure the castle there. In theory this shouldn't have been difficult: Patrick, Earl of Dunbar, had remained loyal to the English Crown. However, his wife, a patriot, duped her husband's household knights and opened the gates of the fortress to King John's forces. De Warenne was not dismayed and leaving a skeletal force to man the siege lines and counter a sally, drew up in battle array to face the Scots as they came over the brow of Spottismuir. The English commander didn't intend to just stand on the defensive: he pushed his men downhill towards the crossing of the Spott Burn, which flowed across the front of both armies. The Scots, assuming that the English were about to flee, abandoned their vantage to launch a precipitate charge. Counter-attacking in good order, de Warenne drove the Scots back. Hundreds of infantry were cut down and many knights captured.[17]

This débâcle demonstrated, with chilling clarity, the weaknesses of the unprepared Scottish host, who were hopelessly outfought by the English. Edward's campaign became a triumphal march; the King simply overawed the Scottish nobles with the terrible lessons of Berwick and Dunbar still fresh. He confronted his abject puppet at Montrose where Baliol was ritually humiliated, his coat of arms torn from him and flung to the ground. On Baliol's surrender, Edward 'having entered Scotland with his strength, had conquered and seized it as a lord might in justice do with his fee upon the vassal's renouncing his homage and behaving as Baliol had done.'[18] The sacred Stone of Destiny was amongst the haul, pillaged from Scone, along with the most treasured relic in Scotland: the Black Rood of St Margaret. Tired of local surrogates, Edward chose to ignore the claims of Bruce, or any other, and appointed an English viceroy to govern. Scotland was a kingdom no more. As Edward re-crossed the border into England, he is said to have summed up his feelings towards Scotland thus: 'A man does good business when he rids himself of a turd.'[19]

Though her army had been shattered, her pride broken and her nobles enfeebled, the guttering flame of liberty was not extinguished ... one

man at least would never surrender Scotland's freedom while he lived. The origins and antecedents of William Wallace are uncertain. He belonged to the minor gentry, a younger son of a tenant of the Steward, Sir Malcolm Wallace of Elderslie. 'Wallace stature of greatness and of height/was judged thus by discretion of sight/that saw him both on Cheval and in Weed.'[20]

Bower was equally eulogistic: 'The famous William Wallace, the hammer of the English ... was a tall man with the body of a giant, cheerful in appearance with agreeable features, broad shouldered and big-boned ... pleasing in appearance but with a wild look.'[21] He appears to have been outlawed and was hiding out in the forest of Selkirk, a northerly Sherwood infested with broken men and desperadoes. Legend relates that his woman and her family perished, burnt out by an English patrol after a skirmish with the hero and his merry men. Wallace is said to have sought out the perpetrators and dispatched them all.[22]

William Wallace was not alone in fomenting resistance. In Moray, Andrew Murray, son of Sir Andrew Murray of Petty (who had been caught in the disaster at Dunbar) raised the flag of rebellion. As the scattered patriots garnered support their example rekindled defiance, prompting the former governor of Berwick, Sir William Douglas, and James Stewart, a leading landowner, to throw off the English yoke. Scots nobility, tied by their oaths to Edward and fearful for their estates, vacillated. The king even sent Robert Bruce to lay siege to Douglas's castle, so confident was he of loyalty – overly confident as it turned out, as his protégé experienced a change of heart and threw his lot in with the patriots.

Northumberland quickly felt Wallace's sting. Early in 1296 he raided Redesdale. By the summer of 1297 he was becoming more than an irritant. In August, his partisans fought a running battle with the English garrison of Glasgow led by Anthony Bek, the fighting Bishop of Durham, who was driven from the streets and obliged to seek refuge in Bothwell Castle. De Warenne, victor of Dunbar, commanded English forces in Scotland, though this responsibility appears to have been shared with Hugh Cressingham, Edward's chief tax collector and one for whom the patriots reserved a particular hatred.

In the first week of September Surrey's forces had reached Stirling to find Wallace, now joined by Murray and the men of the northern shires, posted in strength on the far side of the River Forth. What followed was a masterpiece of expanded guerrilla tactics, exploiting English complacency and tactical folly to win a key battle. With his and Murray's victory[23] Wallace's prestige soared. At a stroke the shame of Dunbar had been wiped away and the myth of English invincibility punctured. In the autumn Wallace raided Northumberland, basing himself, for the second

time, in the Forest of Rothbury. His guerrillas 'took up' Tynedale, even robbing Hexham Abbey for which their commander had to apologise to the monks: '... they killed many and collected great spoils ... priests and monks of all orders flying for their lives.'[24]

In the forest of Selkirk, during the spring of 1298, the barons entrusted Wallace with sole Guardianship of the Realm.[25] In the meantime, Edward had become entangled in his difficult relations with France and in more wrangling with his own barons. But matters in the north couldn't be avoided, and by the following spring he had planted his royal standard at York and was preparing to deal with Wallace once and for all.

Longshank's army was formidable: with 2,500 cavalry and as many as 12,000 foot soldiers, it was a heterogeneous force with archers from Wales and crossbowmen from Gascony. By July this leviathan was plodding northward up the east coast, an English fleet in close support. Energetic Bishop Bek took Dirleton and a brace of other garrisons, but the logistical difficulties in feeding such a large army were massive and supplies soon dwindled. Wallace and his army seemed to have disappeared and Edward was seriously thinking of withdrawing when Gilbert d'Umfraville and Patrick, Earl of Dunbar, brought vital intelligence – the Scots were a bare fifteen miles (24 kilometres) away, bivouacked in Callander Wood. Edward proceeded to win an impressive all-arms victory using heavy cavalry, infantry and bowmen to utterly defeat Wallace, whose army was destroyed. The hour of the great Welsh/English warbow was at hand.

The Road to Bannockburn: Wallace's star plummeted after Falkirk, there was no coming back from so great a defeat. He spent the miserable years until his capture and execution in 1305 as a hunted outlaw, rejected by the Scottish polity but never giving up. In 1995 Mel Gibson revived him in the movies. *Braveheart,* despite having only a passing resemblance to history, became an instant favourite and its fantasy became reality for a generation of Scottish nationalists.

With Wallace gone, the mantle of leadership passed to Robert Bruce. In the early years, the future king lived – as had his predecessor – the life of an outlaw, but Bruce had the inestimable advantage of noble birth and a legitimate claim to the throne. On 10 February 1306 he met with his arch-rival, John Comyn, in the sacrosanct cloisters of Greyfriars' Church in Dumfries. Harsh words passed between the two men, neither of whom was noted for his patience, and Bruce or his affinity settled the argument with daggers.[26] Within five weeks, he was enthroned at Scone.

Experience had tempered the hot-blooded passion of the Scottish King's youth. He was dogged, single-minded, courageous, a superb warrior and natural leader who had the rare gift of being able to combine generalship with statesmanship; he'd need both. Bruce could be both violent and ruthless while capable of compassion; his conviction and charisma won over old enemies and promoted fierce loyalty.[27] He

chose his subordinates well: the names of Edward Bruce, Douglas and Randolph became synonymous with dash and daring.

Longshanks, though ageing, had not forgotten Scotland and he chose as his lieutenant his half-cousin Aymer de Valence, who also happened to be brother-in-law to the murdered Comyn. De Valence was given a free hand in his treatment of the Scottish rebels and set to work with a will. By June he had secured Perth and left a trail of victims swinging in the breeze. Bruce rashly decided to take the offensive and on 19 June he came on but was roundly defeated at Methven Wood. Bruce's fortunes were now at their lowest: he was a fugitive, hunted, his family dead or in chains; his sister and the Countess of Buchan were held, like captive birds, in iron cages hung suspended over the battlements of Berwick and Roxburgh. Longshanks wasn't the temperate sort and rebels deserved no better.

Such savagery simply fed the patriot cause, and in the following year the old warrior Longshanks died, almost literally in the saddle, at Burgh on Sands as he prepared for yet another campaign. Though dead, his spirit seemed destined to live on – he left instructions for his son, now crowned Edward II, to continue the offensive and for the old king's coffin, like some malevolent talisman, to be carried before the army.[28] But Edward II was not the man his father had been; he was indolent, pleasure-seeking, surrounded by favoured catamites. War did not hold the same allure, so Scotland had a respite. Bruce did not – he had to begin with a civil war, stamping his will on Baliol's old partisans and his enemies, the Comyns and MacDougals. Fratricidal it certainly was, but Bruce was learning and honing his art of war, training the nucleus of what would prove a battle-winning army. Castle after castle, town after town, fell; the pro-English faction was harried to death or despair, their increasingly desperate begging for aid from England went ignored.

Edward made no effort to stem the rot until 1310, when he came north in force. Declining battle, King Robert pursued a scorched earth policy until the English withdrew, leaving Northumberland to bear the fury of Scottish vengeance. By 1313 Stirling Castle was the only major fortress that remained in English hands, her only significant claim to dominion. Soon Stirling itself was besieged and, according to custom, the castellan undertook to strike his colours if not relieved by 25 June of the following year. Reluctantly stung into action by this threat to his last remaining bastion, King Edward summoned a vast army including the flower of chivalry. This force, which mustered at Wark on 10 June, might have numbered as many as 17,000, including a substantial Scots contingent: the Comyns, still un-reconciled, MacDougals and MacNabs. A train of two hundred wagons was needed to equip and feed such a behemoth. Though Edward himself commanded in name, he relied heavily on the advice of a council of war made up of such seasoned campaigners as the Earls of Hereford and Gloucester.[29]

Though King Robert was anxious to prevent the relief of Stirling, he could not hope to match the English numbers, relying, at best, on perhaps 5,000 seasoned infantry and barely 500 light cavalry. Edward commanded bowmen drawn from the breadth of his dominions: from Wales, Ireland and the northern shires. On 17 June the English army marched from Wark, a dazzling array, the hot spring sun glancing off burnished plate and mail, a forest of pennons proclaiming the pride of English knighthood. It was the greatest army ever to cross the border. Edinburgh was reached without opposition and a halt was called to await resupply by sea.

On 22 June the army marched on to Falkirk, and on the following morning the old Roman road echoed to the tramp of marching feet and the ring of hoof-beats as the English set out for Stirling. They had two days remaining before the deadline expired. A contemporary chronicler has left us an image of the English army on the march during the Scottish Campaign of 1300:

> There were many rich caparisons embroidered on silks and satins; many a beautiful pennon fixed to a lance, many a banner displayed. The neighing of horses was heard from afar; the mountains and valleys were covered with pack-horses, tents and pavilions.[30]

Such a colourful vision, which could come directly from the pen of Scott or Tennyson, is highly idealised; the reality would be rather more mundane. Knights would ride light horses, palfreys, on the line of march, saving their precious destriers for combat. The armies would proceed in a cacophony of noise, mounted arm to the front and as rearguard, mainly with harness stowed, horses throwing up vast clouds of dust. The footsoldiers would be tramping in long, straggling columns, ill-fed, ill-accoutred and swallowing the dust of their betters. There would be livestock on the hoof, for the army took its provisions along, and wagons laden with small beer, tents, cordage, baggage and provisions.

Battle was joined south of Stirling Castle on 23 June 1314 and continued the next day. Edward's lumbering army was broken and scattered, Stirling fell and Scotland was free. I have been to Bannockburn many times; the old visitor centre had a wonderful clunky charm to it, even though the main battle site has long been obscured by housing. The new centre was open just in time for the 'Homecoming' in 2014, the 700th anniversary of the battle. This was an SNP event orchestrated by Alex Salmond (some say to boost the independence vote at the upcoming referendum, through the timing doesn't back this up) to bring back Scots from around the globe.

From then on, the memory of Bannockburn would haunt any king of England who dared to venture north of the border; never again

would England reduce her northern neighbour to mere dominion. But this phase of the very long wars left a bitter legacy. Scotland was now a nation in arms and her success meant the full fury would fall on Northumberland and the other northern shires. In 1318 Bruce recovered Berwick, the following year the Scots won a victory at Mytton and three years later Bruce chased Edward from the field at Byland. King Edward had recovered his nerve sufficiently by 1322 to venture north again, sacking Holyrood and Melrose and leaving Dryburgh in flames, but this aggression was brief. 'Robert Bruce, as King Robert I of Scotland, was to inflict upon Northumberland the darkest and most miserable conditions it has ever had to endure.'[31]

John Barbour in his epic *The Bruce* recounts the many deeds of his hero king and of Douglas, perhaps King Robert's chief and most enthusiastic enforcer, gleefully celebrating Black Jamie's many triumphs including successful combats with leading English knights including Lord Neville: 'When Nevell thus was brought to ground ... the dred of the Lord Douglas and his renown awa scalit ['armoured' – consolidated] was throughout the marches of England, that all that was thar-in duelland dred him as the devil of Hell.'[32]

Edward II's feeble efforts, rare as they were, swiftly came unstuck, as Walter Bower gloats: 'On 1 October (1322) King Robert entered England with hostile intent and laid it utterly waste as far as York, after despoiling monasteries and putting very many towns and villages to the torch.' Edward's ad hoc forces were scattered at Byland, 'not without great slaughter'.[33] Durham set up a regular mechanism for paying off the Scots; it was almost a direct debit. In 1327 the monastery of Blanchland claimed it had lost forty acres of wheat and rye, a hundred acres each of oats and hay, five hundred sheep with an additional twenty marks worth of food sent from Newcastle. The canons didn't just blame the Scots – they accused government purveyors of requisitioning goods on account without payment.[34]

Many other claims were coming in from ecclesiastical institutions hit by the Scots. Durham Cathedral had a large South Tweedside estate including Norham and Holy Island and was entitled to a steady income from over thirty settlements and various other rents. Bursars' accounts show that a normal income of, say, £400- 420 declined in 1314/1315 to £280, then fell steadily, and was down to just £9 by 1318/1319. Temporary truces brokered in December 1319 and June 1323 had little reviving effect.[35] Evidence from elsewhere in the county was equally depressing: rents collapsing, lands wasted.[36]

This was economic warfare; 'frightfulness' as it was called. These days we might call it terrorism and it was effective. Northumbrian gentry weren't just losing revenue, they ran the risk of death or capture, loss of armour, weapons and horses and the Crown was distinctly laggardly in

paying any monies due. Some, out of sheer desperation 'defected' to the Scots or just took to banditry. I live in the village of Belsay, which has been held since just after the Conquest by the Middletons. Sir Gilbert de Middleton was one of those who went 'bad'.

He and Sir Walter Selby of Seghill ambushed the Bishop of Durham elect, Lewis de Beaumont, and his brother Henry at Rushyford about ten miles north of Darlington, on their way to Durham for the Bishop's enthronement. The haul of victims included two cardinals, Gaucelin D'Eauze and Luca Fieschi, travelling to Scotland as international mediators. The cardinals were released but not before they'd been robbed of everything they had. Middleton and Selby dragged the Beaumont brothers to Sir Gilbert's lair at Mitford Castle to be held until ransomed. In December, Middleton and his brother John were both captured there by Sir William de Felton; they were sent in chains down to London and were executed on 26 January 1318.[37] Selby got away with it for the moment, holed up at Horton near Blyth. He held out for two years before giving himself up in the hope of a pardon. He didn't swing but had a long wait: he was incarcerated until 1327.[38]

Frustrations with Edward's apparent mix of indifference and incompetence drove Sir Andrew de Harcla from the English West March (who'd saved the King's bacon by defeating the Earl of Lancaster's rebels at Boroughbridge in 1322) to mediate a separate peace with Bruce. Lancaster had, as early as 1313, been in treasonous communication with the Scottish king and Harcla's efforts, while genuinely attempting to broker peace, still cost him his head. Virtue did not bring rewards: John de Fawdon had participated in the apprehension of the Middletons and was promised an annuity of twenty marks – he never got it but was captured twice by the Scots for ransom and was burnt out on no fewer than three occasions.[39] Men such as Harcla and de Fawdon found just how evanescent the gratitude of princes can be, especially one like Edward II.

About the dire consequences of these raids, Ridpath writes:

These desolations of war increased the scarcity and dearth which had arisen from a succession of destructive seasons so that a quarter of wheat was sold in the North of England for forty shillings and the Northumbrians were driven to the necessity of eating the flesh of dogs and horses and other unclean things.[40]

This was echoed by later accounts including that of Cadwallader Bates in the late nineteenth century: 'The condition of Northumberland was terrible in the extreme. For fifteen years after 1316 the whole county remained waste, no one daring to live in it except under the shadow of a castle or walled town.' If having the Scots on your back wasn't bad

enough, English royal officials were just as happy to profiteer from the troubles: 'The poor people of Bamburgh Ward were not allowed by the Constable of the castle to purchase a truce from the Scots unless they gave him a similar amount of blackmail.'[41]

For these lightning campaigns King Robert had created a new class of soldier, a breed of light cavalry that defied every chivalric convention. These were the *hobilers*, the genesis of what (or who) would evolve into the Steel Bonnets. They were lightly armoured riders on sturdy ponies – the 'hobbys' that gave them their name. They rode fast and they struck hard, the tactical equivalent of 'float like a butterfly, sting like a bee'. They could outride what they couldn't outfight and outfight what they couldn't outride. They were not slowed down by baggage trains or legions of camp-followers. They were what, much later, the Boers of the Transvaal would call 'commandos'. Subsequent generations of British commanders would find out how successful such will-o'-the-wisp riders could be; essential Boer tactics were speed in concentration and attack, with a readiness to withdraw. They led vastly superior forces on a merry dance over the veldt.

These hobilers, then, were very effective; perfectly suited to the ground over which they ranged. Conventional forces couldn't catch them, locals couldn't match them. Archbishop Melton of York tried to challenge a Scottish commando at Mytton, seven miles east of Boroughbridge. The Scots dismounted and formed up as a schlitron, fighting as infantry, firing haystacks to give smoke cover (a not unusual Scottish gambit: the smoke would obscure the infantry advancing to contact, shielding them from arrows). They routed the Yorkshiremen leaving many dead, using their lances as spears. The idea worked and carried on working[42] Ridpath picks up the description: '... the rest of their provision consisted of oatmeal which they were wont to carry in bags behind them and of which they made a thin paste that they baked into cakes by the help of iron plates trussed in their saddle; their drink was from the nearest fountain, stream or lake.'[43] That was the hobiler commissariat. England had no immediate answer to these long-riders but soon understood the concept.

Andrew de Harcla used hobilers in the English West March, as did his contemporary and rival, Anthony de Lucy. As early as 1316, just two years after Bannockburn, he was stationing forty such riders with only fifteen men at arms in his outpost at Staward Pele in South Tynedale.[44] The adoption of such indigenous light cavalry marked a sea change in the history of the marches; border warfare now took on a distinct character of its own. It proved very easy to adopt and adapt ...shrugging off the habit would be far trickier.

In 1323 the English King agreed to a formal truce, to last thirteen years, and three years later, by the treaty of Corbeil, Bruce and Charles IV of France renewed the 'auld alliance'. In 1328, Bruce's excommunication (which Edward had secured) was withdrawn, while Edward himself was deposed in a coup d'état engineered by his estranged wife, Queen Isabella, and her paramour, Roger Mortimer. Imprisoned, the king may have suffered a hideous death (or perhaps not) while his son, a temporary puppet of Mortimer and the Queen, was crowned Edward III. In March 1328, a draft treaty was agreed by Queen Isabella at Edinburgh and ratified by Edward, most unwillingly, at Northampton.

Within two years Edward had taken Mortimer's head, packed his mother off and assumed full authority. But before that Edward, still a prince and far more his grandfather than father, had campaigned on the border in the dank summer of 1327. The Weardale campaign was a bit of a fiasco; hugely expensive, it left the young king weeping tears of rage and frustration. You could see why: those nimble Scottish hobilers ran rings around his knights. But after this unfortunate start, this royal, unlike his supine father, proved to be a quick learner. His new expedition comprised a conventional force of barded[45] knights and men at arms, expensively hired and provisioned. In 1328 Edward had married Philippa of the Duchy of Hainault, and now he commanded a detachment from his wife's duchy; chronicler John le Bel accompanied the column. First blood was self-inflicted: the Hainaulters fell out with Lincolnshire bowmen at York over dice and it descended into violence. A bad beginning …

Leaving York on 1 July, Edward reached Durham on 19 July. Both Douglas and Randolph were ahead of the game; two flying columns were beating up the West March and North Tynedale. There was no viable opposition and the western pincer barrelled down as far as Appleby and Kirby Stephen. De Lucy was fearful for Carlisle, but it's more likely the two arms would link up in Weardale, as intended. It is possible, even probable, that this was a calculated pre-emptive strike.[46]

Edward's lumbering knights, heavy men on heavy horses with no local knowledge, were fully equipped and straining for a great cavalry charge that would brush this irritating enemy aside: a finale that never came. Chasing shadows was enervating, supplies were gobbled up at an alarming rate and no enemy had yet even been sighted, just the distant smudges of smoke, darker grey on grey skies, from burning byres and shocked, 'be-reaved' peasantry. It was cold and it was wet, destriers stumbled in the endless morasses and were lost in dense thickets of bog oak and myrtle. It would have been like taking today's Blues & Royals in full ceremonial kit and dumping them among Afghanistan's mountains. It was all very ungentlemanly.

Jean le Bel had a degree of admiration for these invaders:

In just such a fashion they'd now invaded the country and were burning and laying waste the land and finding more livestock than they knew what do to with. They numbered three thousand heavy cavalry, knights and squires ... and fully twenty thousand other men, fierce and bold, armed in the fashion of their country and riding the smaller hackneys ... And I tell you, they had two very fine captains ... a most noble and worthy prince the Earl of Moray ... and James, Lord Douglas who was considered the boldest and most daring knight in either kingdom.[47]

At last, on 31 July, a scout spotted the Scots. Edward marched out after them the following day, in a nine-mile dash towards the Wear. But Douglas and Randolph would not oblige: they just dug in on high ground forming an ad hoc redoubt, too well entrenched to attack. It appeared to be stalemate, but it was just a tactic. No sooner had the English sat down than the Scots slipped out from their redoubt and mounted a brilliant night attack on Edward's camp. Nobody on the English side had seen this coming and the king, at one point, was in imminent risk of capture.

The Scots were seen off but only after casualties had been sustained. Fully on alert now, the young king waited for more but none came. The enemy had gone.[48] Ridpath describes the scene that greeted Edward's men as they recce'd the deserted enemy base:

The English who passed over to view the deserted camp, saw in it proofs of that simplicity and hardiness of living which gave their enemies, when under proper direction, a superiority to forces far more numerous and regular but at the same time more luxurious than themselves. The skins of the beasts they had slain for food being in the form of a bag suspended loosely on stakes were hanging over the remains of their fires; these hides serving as kettles for boiling the flesh; a great number of spits had meat roasting on them with many carcasses of black cattle.[49]

No sooner had Edward withdrawn – out of cash and out of luck – than King Robert, just to underscore the point, conducted a major raid through North Northumberland, which the king of England was powerless to prevent. It was game, set and match. The Weardale campaign was a costly joke, but Edward learnt the lessons and they wouldn't be forgotten. Nonetheless, the Treaty of Northampton was the crowning moment of Bruce's highly eventful career; he was recognised by his inveterate enemies as a free prince and, as his health failed, he bequeathed an orderly realm to his successor.

After his death, his heart was taken by the faithful Douglas, now also ageing, on a journey to the Holy Land, an adventure the doughty Scot did not live to complete; he died a quixotic death in an insignificant Spanish

skirmish. Randolph, the last of the paladins, died at Musselburgh in 1332, thus bringing a magnificent era to an end. With the death of Bruce, Scotland was left with two harbingers of dissent: a boy king and a caste of exiles. The latter were the Scottish nobles who had thrown in their lot with England and, as a direct consequence, had suffered the forfeiture of their estates – the 'Disinherited'.[50]

Despite having put his name to the Treaty of Northampton, Edward III was determined to avenge the humiliation of Bannockburn and to recover Berwick, upon which so much English treasure had been lavished and which remained, as always, the key to the eastern marches. Bower (the Scottish chronicler) warned the Scots: 'An Englishman is an angel who no one can believe; when he greets you, beware of him as an enemy.'[51] He may, of course have been prone to bias. This class of redundant Scottish nobles, led by Edward Baliol, son of the unlamented King John, provided a ready-made insurgency and the English king was happy to provide a fleet of eighty-odd ships, in which the adventurers set sail from the Humber in the summer of 1332. The Disinherited made an unopposed landing at Kinghorn and boldly marched inland to Dunfermline, aiming for Perth. This manoeuvre was interrupted when they found their advance blocked by a superior force under the regent, Donald, Earl of Mar. What followed was a stunning warbow victory as lumbering Scottish spears in dense schiltrons were shot to pieces.

The Earl of Mar, the Earls of Menteith and Moray, Robert Bruce, Lord of Liddesdale, Alexander Fraser, the High Chamberlain, eighteen lesser nobles, three-score knights and perhaps two thousand rank and file went down.[52] The Disinherited reported losses of only thirty-odd knights and men-at-arms. It was a victory cheaply bought. Not one archer is said to have died. Baliol had won himself a kingdom and Dupplin Moor, as the battle is known, became a model for later English victories at Halidon Hill and Neville's Cross (Baliol fought again at both). The lesson of Dupplin Moor was plain: lumbering spearmen would always be vulnerable to archery and should not seek to engage unsupported – a lesson that went unheeded. Baliol's flimsy grip on the throne proved as insecure as his father's and though crowned at Scone, he failed to command any serious following. In December of that same year the new Regent for David II, Andrew Moray of Bothwell, passed the baton of command to Randolph's son, the Earl of Moray, who surprised and scattered the Disinherited at Annan, driving Baliol 'half-naked' from the realm.

Short-lived as it had been, Baliol's incumbency had given him a taste for power, and he remained game for another try. He sought, successfully, to solicit English support by promising (based solely on his capacity as *de facto* king, recognised by the English) to cede Berwick. The following summer, Edward marched north and laid siege to the town. The King conducted his campaign with a professionalism and ruthlessness of

which his grandfather would have been proud. Two young sons of the castellan, handed over as hostages, were hanged without compunction. Archibald Douglas, the new Scottish regent, began the forthcoming campaign by raiding into the English West March; he 'took up' Gilsland below Spadeadam Waste, striking at Dacre's Lordship. Anthony Lucy from Cockermouth retaliated, causing destruction in the Scottish west and winning a skirmish at Lochmaben, despite sustaining severe wounds.[53] By 15 July, the garrison at Berwick was in desperate straits and the grieving governor conceded that he would strike his colours if not relieved by 20 July. A relief army, hastily assembled, was on its way led by Douglas, although unfortunately he was a poor successor to his legendary predecessor. Having feinted unsuccessfully against Bamburgh, and seeking but failing to divert Edward, the Scots prepared to march directly to the aid of the beleaguered town and provoke contact.

Leaving only sufficient men to deter a sally by hungry defenders, the English withdrew from the siege lines to deploy on the south-facing slope of Halidon Hill, which rises some six hundred feet (183 metres) above sea-level (now neatly bisected by the A6105); it was an ideal defensive site, the summit crowned by trees, a bog at its base. Edward formed his knights and men-at-arms into three divisions, or battles, drawn up in line with each battle flanked by a contingent of archers; the right was commanded by Thomas, Earl of Norfolk, King Edward led the centre and Baliol took the left.[54] Douglas, blundering onto the field, had the more numerous army: twelve hundred knights and men-at-arms with perhaps 13,500 spearmen, formed into four dense schiltrons.

His first brigade was commanded by John, Earl of Moray; the second was nominally under David, the boy king, but in reality was commanded by Sir James Stewart; the third was led by Douglas with the Earl of Carrick and the last by Hugh, Earl of Ross. Attacking, apparently without pause for any tactical considerations, the Scots advanced down a gentle slope but lost all momentum, stumbling and thrashing through the mire, barely having time to dress ranks and begin lumbering up the slope towards the English when their archers began to shoot.

English bowmen, those men 'of the grey goose feather' had practised since childhood to build their fearful skill and stamina. They were unique, world class, and when properly deployed they were nigh on unbeatable. King Edward knew his trade. Calmly, methodically, volley after volley was loosed into the packed files; men were dropping by the score, tussocks soon slippery with blood. We have no idea how terrible the arrowstorm was. It didn't kill like a machine gun kills; there was no numbing shock of the bullet. Men were transfixed, writhing, stuck with repeated shafts, shuddering and screaming. After the dreadful toil of that fatal climb the Scots never really got to grips. As the schiltrons wavered,

Edward gave the order to mount and the English knights swooped like falcons. The rout continued for five corpse-strewn miles.

Douglas paid for his blundering with his life, as did the Earls of Ross, Sutherland and Carrick, hundreds of men-at-arms and thousands of spearmen. King Edward had proved a master tactician, combining lance and bow to near perfection and keeping his cavalry in reserve, to follow and capitalise upon success. No more wild charges – this was very much an all-arms war machine. Berwick surrendered and English balladeers finally had reason to be cheerful:

> Scottes out of Berwick and out of Aberdeen,
> At the Burn of Bannock ye were far too keen;
> King Edward has avenged it now, and fully too, I ween.[55]

Now Baliol enjoyed a second brief period in charge, although he was no more popular than he had been the first time. The Scots, though beaten, were not cowed and young King David was sent to safety in France. The puppet king danced to the same tune as his father, doing homage and ceding his acres on demand. Resistance continued and Edward was forced to administer some more of the same medicine three years after Halidon Hill, laying waste as far as Lochindorb in Moray. In time the English king began to lose interest, his attention focusing more on his ambitions in France, where he would lead his armies to further legendary victories. The patriot cause received a significant boost with the defeat of the Baliol faction and the death of David of Strathbogie, Leader of the Disinherited, at the Battle of Culbean on 30 November 1335.

In 1341 King David returned from France, a young man of seventeen but now apparently deemed fit to rule in his own right. His reign was destined to be long but far from happy. Any promise of his youth was dissipated by middle age and by the eleven years (1346-1357) he would be held captive in England. Scotland seemed to have been spared by King Edward's obsession with France, but David, unwisely, responded to a plea from the hard-pressed King Philip of France to intervene on his behalf:

> A thousand and three hundred year and six and forty thereto clear the King of France set him to raise the siege lying about Calais and wrote in Scotland to our king and made him right special praying that he would make war on England ... Then King David that was young stout and well made and yearned for to see fighting agreed to fulfil his yearning and gathered his host speedily.[56]

In the autumn of 1346, at the head of his army, David descended on Northumberland. Hexham and Lanercost were burnt and by 16 October the Scots had advanced as far south as Bearpark near Durham. King Philip naturally hoped that this harrying by the Scots would divert the king of England from his ambitions in France, but Edward was fortunate in his northern barons, Neville and Percy, who were not intimidated. This would be the first major test for Edward's scheme of homeland defence and the northerners weren't about to let him down. Jean le Bel recounts how Queen Philippa responded:

> As soon as the Queen of England heard the news she went to Newcastle upon Tyne to give heart to her people there, and summoned the bishops, archbishops, and all the able-bodied men left in England to muster between the city of Durham and Northumberland, each of them with all the troops, archers and footsoldiers he could muster and as well armed and provisioned as he could manage.[57]

Obeying the Queen and under the aegis of the Archbishop of York, the northern magnates were soon mustering at Bishop Auckland; by the morning of 17 October, they were on the march and intercepted a foraging party under Sir William Douglas some three miles north-west of the town. The Scots, wholly unprepared, departed with indecent haste. King David, whose scouting was clearly lax, only realised the English were marching towards him when Douglas's survivors staggered back into camp.

By this time the English, perhaps 15,000 strong, were deploying within sight of the Scots camp at Bearpark, along a low ridge running north to south, near to one of a series of ancient crosses that ringed the city of Durham (this was soon to be renamed Neville's Cross in honour of their commander, Ralph Neville). The ground fell quite gently towards the Scots' position about two hundred feet (61 metres) below. Drawn up in their customary three battles with a body of archers in front, Henry Percy took the right, Neville the centre, and Sir Thomas Rokeby, aided by the spiritual guidance of the Archbishop, commanded the left. Cannily, Neville deployed a mounted reserve under the irrepressible Baliol, concealed by a fold in the ground behind his line. King David had the larger army – as many as 20,000 – who advanced to contact, brigaded in three strong columns: Sir William Douglas (now recovered from his unpleasant surprise) commanded the right, David led the centre and Robert, the High Steward, took the left.[58]

The ground here wasn't suited to such cumbersome formations: Crossgate Moor, which the Scots were obliged to traverse, was split by a natural defile and bisected by a deeper cut that deflected Douglas from his line of march towards the English left, echeloning his men into the

king's division, the whole concentrated mass presenting a superb target for English longbows. Jean le Bel continues: 'The Battle was fought on a Tuesday around the hour of terce (around 9am) and was as fierce and as mighty as any ever seen, with as many fine feats of prowess and bold ventures and valiant rescues as ever were made by Roland and Oliver...'[59]

English arrows spread death and confusion. Already the Scots were in trouble and made little headway on the right. Their left, under the Steward, fared better, driving hard against the English right, pushing back the screen of archers and crashing into the infantry. The fight hung in the balance. On the embattled right of the English line, sheer pressure of numbers began to tell. Edward Baliol, a seasoned fighter, chose his moment and with superb tactical skill launched his horsemen in a flank attack on the Steward's division, neatly tipping the scales and driving the Scots back in near rout.

With his left flank gone and his right a shambles, the Scottish king's brigade was horribly isolated and the English, like wolves closing upon a wounded bear, hacked at his exposed spearmen. David, whose courage outweighed his judgement, fought superbly, rallying his faltering ranks, by now almost encircled. But bravery alone wasn't sufficient; the battle was soon lost and with 'lamentable slaughter'.[60] Tired, wounded and dispirited, the king, now alone, was captured as he hid beneath the span of Aldin Grange Bridge: 'There John of Coupland took the king by force, not yielding in the taking the king two teeth out of his head with a blow of his knife him robbed.'[61]

The loss of the King was a disaster for his country and he remained a prisoner in the Tower for eleven years while both sides haggled over his ransom. Edward Baliol enjoyed a final tenure as a vassal of England before King Edward finally pensioned him off.[62] The Scots were neither cowed nor passive and won a skirmish at Nesbit Moor in 1355, briefly recovering the town of Berwick, though the castle remained in English hands. King Edward retaliated with vigour, laying waste Haddington and Edinburgh. By the Treaty of Berwick, signed on 3 October 1357, the captive king of the Scots was returned to his throne, at a cost of a hundred thousand marks, payable over ten years.

In October 1996 I attended a conference on the battle of Neville's Cross, held in Durham Johnstone School (since rebuilt), which, fittingly, sat squarely on the battlefield. The academic lectures were accompanied by a lively re-enactment on the playing field. This was a full day's shift and by eight in the evening everyone was getting battle fatigue, but the last show was from the late and great Robert Hardy, very well known actor and renowned expert on the English warbow. This was different ... this was real *performance* not an earnest, hesitant recitation. Hardy bestrode his stage like a colossus; he *was* Henry V, 'a little touch of Harry

in the night'. He devoted full attention to his audience, bringing his subject instantly to life. That taught me a lot about teaching.[63]

King David resumed his interrupted rule and reigned until his death fourteen years later. His realm was in a relatively prosperous state, despite being wasted by near-continuous war and (after 1348) by the horrors of the Black Death. The King's popularity waned; he never enjoyed an easy relationship with his magnates. In 1363, while visiting London and with the payments of his ransom hopelessly in arrears, he promised that should he die childless, his crown would pass to England. The Scottish Estates refused to ratify so unpalatable an undertaking, preferring to seek yet a further rescheduling. David died in February 1371 to be succeeded by the Steward as Robert II. The Stewart dynasty was born.

Meantime, it was inevitable that so warlike a family as the Douglases should clash with the leading family of Northumberland, the Percies. In Alnwick, not far from the castle, there is a great bronze statue of Sir Henry Percy, better known as 'Hotspur' (1364–1403). He is depicted, slightly larger than life size, in full late-fourteenth-century armour, sword at the ready – just as you would imagine him. There's another inside the castle. Of Norman stock, the Percy family (all, unhelpfully, named Henry) had estates mainly in Yorkshire until they bought the Barony of Alnwick from Bishop Bek, a slippery prelate (the sale was very possibly fraudulent).

This was early in the fourteenth century, when the Scottish wars were beginning to bite and after Bruce's triumph at Bannockburn. Many Northumbrian gentry were ruined by the escalating costs of homeland defence. This was good for the Percies, who distinguished themselves against the Scots. They gained the coveted post of Border Warden – a licence to raise private armies and gobble up bankrupt estates at fire-sale prices. By the time Hotspur's father was created First Earl of Northumberland, they owned a vast acreage. The younger Henry was knighted by Richard II and went on to be governor both of Berwick and then of Calais. Hotspur was renowned for his élan, though nowadays we might rather call it thuggery. Then again, he lived in thuggish times.

The Percies enjoyed a fractious and malleable relationship with both English and Scottish crowns. The first Earl of Northumberland's grandfather, Henry Lord Percy (d.1352), was one of only three English magnates whose rights to Scottish lands were recognised by Robert the Bruce in 1328, a concession that Percy surrendered to Edward III six years later in return for Jedburgh Castle and forest, five hundred marks from customs annuities at Berwick, and the keeping of Berwick Castle; a pretty fair trade.

Harry Hotspur was appointed Warden of the East March some time between July 1384 and May 1385, accompanying Richard II on an expedition to the Borders where he was awarded his sobriquet 'Hotspur' by the Scots. Following a spell in France (during which time he was knighted), Hotspur was reappointed warden and commanded the English forces against the Scottish Earl of March and James, 2nd Earl Douglas, at the Battle of Otterburn on August 19 (accounts vary) 1388.[64]

It was Douglas who with the clever Earl of March, architect of a Scottish military recovery since 1369, led the eastern echelon of a double incursion during high summer. With only a strong commando of 3,000 lances, he stormed through Northumberland to attack Durham, convincing the Earl of Northumberland that his forces were far stronger than they actually were. These highly experienced hobilers fell back via Newcastle where, sparring in front of the outer timber barbican or barrier, Douglas, Froissart tells us, got the better of Hotspur and made off with his pennon, the ultimate chivalric challenge. Torching and looting as they withdrew, the raiders levelled Ponteland and briefly laid siege to the Umfraville tower at Otterburn. While the Scots hammered away at the defences, Percy mustered a fighting contingent at Newcastle and marched off in hot pursuit. He came up to the Scots camp at twilight on 19 August (the date is contentious, Scottish sources prefer 5 August) St Oswin's Eve, and with typical impetuosity, determined to attack immediately.

He had perhaps 6,000-7,000 men, easily twice as many as March and Douglas. The traditional site of the battle is marked by a battle stone and, as shown on the Ordnance Survey map, lies a mile or so north of the present township, with the waters of Rede on the left and rising ground to the right. Hotspur, coming from the south, light fading, deployed for an immediate attack, detaching, it is said, a portion of his army under Umfraville to sweep northward around the Scots' flank – an unlikely tactic given the gathering dusk.

More likely he directed an assault on the Scottish camp while he held his main brigade in readiness for a counter-attack from a second Scottish camp higher up, which held most of the knights and men at arms. This tactic proved successful: the servants and baggage masters holding the enclosed lower camp, even when partially reinforced, could not hold and were swept clear away, with the English on that flank pursuing; so far so good. Meanwhile Douglas, shielded by dead ground, prepared to strike at Hotspur's flank, a manoeuvre the Scots had trained for, having just such a scenario in mind. The mêlée was long and hard, hand-to-hand in the gloaming.

Though it was summer, encroaching dusk deprived the English of any chance of using their warbows effectively; as the fight wore on, the long day's march began to take its toll. When Douglas's attack smashed home the Northumbrians faltered, though the Scottish Earl – leading the charge

with berserker fury – was brought down with multiple wounds and died (initially unnoticed) in the half-light. As his army disintegrated the wounded Hotspur was taken prisoner, together with his brother Ralph. One Scottish knight, Sir John Swinton (destined to die in Northumberland fourteen years later at Homildon) performed prodigiously, almost single-handedly breaking Hotspur's line.[65] Despite the loss of one of their leading captains, the Scots won the field. Perhaps five hundred died on either side, and while the English survivors withdrew it wasn't a total rout by any means. Though another force under the bishop of Durham came up the following day, battle was not resumed and the Scots, bearing the corpse of their Earl, retired unmolested.

Though not a major fight, the very intensity of the battle and the balladry this inspired guaranteed its lasting fame. And though he lost, Hotspur's legend began to flourish. Froissart, who chronicled numerous conflicts, was sufficiently inspired to write: 'Of all the battles and encounterings that I have made mention of heretofore in all this history, great or small, this battle that I treat of now was one of the sorest and best foughten without cowardice or faint hearts.'[66]

He might have lost but the English paladin's ransom (7,000 marks) was soon raised and paid over. Hotspur suffered no fallout from the defeat and his subsequent military and diplomatic service brought him more royal favours in the form of grants and appointments. Yet, despite this, the Percies elected to support the future Henry IV by facilitating his coup and deposing Richard II in 1399. For this they were lavishly rewarded with extensive titles and extra responsibility in the East March and North Wales. But somehow a lot was never quite enough.

For Hotspur, his finest hour soon arrived: 'On Holy-rood day the gallant Hotspur ... Young Harry Percy, and brave Archibald ... That ever valiant and approved Scot ... At Holmedon [Homildon] met.'[67]

In June 1402 another Douglas, the Third Earl, led a *chevauchée* into Northumberland carrying fire and sword virtually to the walls of Newcastle. As his army – perhaps ten thousand strong – attempted to withdraw, Hotspur, marching out from Alnwick, blocked his escape near Homildon (now Humbleton) near Wooler in Glendale.

The Scots drew up on the lower slopes of Homildon Hill, which rises sharply from the natural plain, their backs covered by the ascending slope. Hotspur, now guided and advised by the same Earl of March (who had since defected as he was seriously at odds with Douglas) commanded a strong contingent of Welsh bowmen – recruits brought back from his campaigning against Owen Glendower. Advised against precipitate attack by the older and wiser counsel of the wilier March, he allowed his Welshmen to advance, unsupported, and loose their clothyard storm. Douglas seemed gripped by paralysis as his lightly armoured spearmen began to drop. The fearsome arrows were unrelenting: every time the

Scots charged, the bowmen steadily fell back and shot again, the speed and fury of their volleys never slackening. Men fell in droves. Douglas displayed not the slightest hint of leadership. His force wavered, foundered and broke, the river claiming as many lives as the Welsh bowmen: stampeding survivors drowned by the score. It's said the water killed five hundred while as many again lay dead on the field, including Sir John Livingstone, Sir Alexander Ramsey, Sir Walter Scott and Sir Walter Sinclair.

Douglas, who had lost both an eye and a testicle, besides suffering a further five wounds, was captured along with most surviving gentry. The ransom haul included a further two earls, two barons and eighty knights. Hotspur marred his victory by the cold-blooded execution of one of the captives, Sir William Stewart of the Forest, who he swore had wronged him. This bloody-minded act bore bitter fruit, for it was a dispute over the distribution of ransom monies that led to that final schism with Henry IV, setting Hotspur on the irrevocable path to death and dishonour at Shrewsbury.

Already the Percies had become increasingly impatient with the king over his refusal to pay them their expenses incurred defending his northern border. This was significantly exacerbated by this issue of ransoms and of King Henry's perceived failure to quell the Welsh rising – during which Hotspur's brother-in-law, Sir Edmund Mortimer, had been captured. His ransom would prove another bone of contention; the list was growing longer …

In fact, the king wasn't looking for a major rift with his previously steadfast supporters – his power base was far too narrow – but mutual anger was rising. On 2 March 1403, Henry granted the imprisoned Douglas's earldom to the Earl of Northumberland, hoping to ease strained relations with the Percies and to encourage Hotspur to re-establish an English pale on the Scottish marches: this would fulfil the Percies' own ambition, keep a lid on the Scots – and keep him out of Henry's hair. Hotspur was happy to oblige, thinking he might win further laurels and at the same time put additional pressure on Henry, leaving him vulnerable to attack. The first step in rallying support for the Percy banner was to besiege Innerwick Castle, near Dunbar, with the help of their new ally, Archibald Douglas, who had also experienced a change of heart and defected. Although the castle was badly burned, the siege was short and sweet; the allied forces soon withdrew and repairs were made. The dispute with King Henry hardened into open conflict: on 21 July 1403, Hotspur led a rebel army out at Shrewsbury to face the king's forces. This time, the Scottish Earl of March was fighting for Henry IV, and the battle began with the first longbow duel in English history.

It was both bloody and decisive. Hotspur was shot down by an arrow and killed. In January 1404, he was posthumously declared a traitor

and his lands forfeited to the Crown. His ever-duplicitous father lasted another five years before he, too, died a traitor's death at Bramham Moor. Douglas, after giving his oath on Holy Scripture to King Henry to be his man above all others excepting King James, and on the production of suitable hostages for his parole, was allowed to return to his estates. He was killed at the Battle of Verneuil in France on 17 August 1424, while leading the armies of the Auld Alliance against the English. He is buried in Tours Cathedral in the Loire Valley.

A later Earl of Northumberland, fated to die at the hands of his fellow countrymen during the opening clash of the Wars of the Roses, led a wardens' raid into Scotland in 1435. His 4,000 riders were intercepted by the Douglas Earl of Angus, warden of the Middle March, some two miles south of Wark at Piper Dene. In a swirling border mêlée the Northumbrians were put to flight and a great number captured. In 1448 the same lord mounted another raid across the Sark, crossing near Gretna only to be met by a Douglas leading a band of border levies, who, once again, trounced the English, taking many prisoners and leaving as many as five hundred dead or drowned in the waters of Sark.

It could be said, and I would agree, that it was in this red-hot furnace that the border character was forged. A generation of endemic warfare and the creation of a specialised breed of fighter, the hobiler, helped to create a class of uplanders on both sides of the line who were distinct and unique. In part, this was due to circumstances and the seemingly endless round of devastation meted out by both polities, but it was equally the result of a deliberate policy of plantation devised by Edward III. After Halidon Hill and the creation of an English pale in the Scottish borderland, Edward had no real interest in conquering Scotland as his grandfather had attempted. Like Agricola's 'bureaucrats' back in Rome, he probably realised that it simply couldn't be done and that even if it could, the game – in accounting terms – just wasn't worth the candle.

Besides, he had another throne in mind and this one was very much to play for. From his mother, the formidable 'She-Wolf', Isabella of France, he had inherited a claim to the throne of France. This would be disallowed by the French but he was ready to take what was his by force of arms. This began the so-called Hundred Years War, broadening out Anglo-Scottish enmity into a wider conflict. Edward knew that if he was to siphon off the cream of England's fighting men, he couldn't leave the back door open; the border with Scotland must be secured and he wasn't about to adopt his father's blithe indifference to the fate of his northern subjects. They would be ready and willing but must also be ready to see to their own homeland defence. He wouldn't be disappointed. Times were

bad anyway, even without the Scots: there had been famine in 1315 and for the following two years; perhaps 15% of the local population died.[68] The climate was changing: the medieval warm period (*c.*800-*c.*1250) was drawing to a close and it was colder and wetter. Just drive through Upper Coquetdale and you will see high medieval terracing sculpting the hills: it was farmed land before the shift, but you couldn't hope to plant there today.

There was worse: in 1348-1349 bubonic plague, the Black Death, reached Britain and spread from south to north. Nationally, mortality rates were between 40-50% in more populous regions, although it seems likely that the borderlands suffered proportionately fewer deaths; how much less cannot be ascertained.[69] Such had been the nihilistic fury of Bruce's raiding campaign after Bannockburn that the upland dales had become virtually uninhabitable and there had clearly been a diaspora of a sort.

Some kind of re-stocking was needed, with a breed of Pound-Land samurai who would keep that back door closed. These would be hobilers, and Edward was keen both to sustain those who had clung on through the storm and to fill the many gaps with newcomers. In Tynedale these may have been the Charltons, Millburns and Dodds, although these families will always tell you they go back long before then and wouldn't have been seen off by any gang of rampaging Scotsmen![70] The Halls and Redes filtered back into Redesdale and these survivors might well have been augmented by new recruits: Hunter, Stamper, Wilkinson and Yarrow appear in Tynedale; Potts, Forster and Fletcher in Redesdale.[71] At the same time, existing feudal tenures were being converted into military holdings and offered at discounts; it was a form of plantation.

Agriculture wasn't the lure. The earlier depopulation was being countered by an increasing tempo of militarisation. Edward was, from the earlier chaos, forming a new kind of frontier society.[72] This was where the reivers sprang from: from policy, not by accident. War did bring some dividends: a heap of beasts and booty were sent north during Bruce's hegemony, along with blackmail and ransoms. Scottish borderers would definitely have had their share. Armies, for all the harm they did, could bring dividends in terms of a market, income generated by garrisons and building work on new or better fortifications.[73] However, the overall effects on both sides were negative; death, destruction and degradation were the real spoils of these wars.[74]

Some writers have likened the border to a kind of frontier society, a British Wild West where the particular circumstances of the rugged marchlands produced a strong degree of alienation from national government – 'we do things differently here.' There was widespread resentment at any level of government meddling, along with rampant criminality.[75] I think this is a false analogy. The frontiersman comes

into a wilderness, generally not previously settled (except by indigenous peoples who tend not to count in the newcomer's thinking). That was never the case here. The border had been settled since prehistory with, by the thirteenth century, a long tradition of settled Christian worship and monastic culture. It wasn't a frontier, but it had become a war zone and it was that violent dislocation and subsequent re-structuring that produced this wild borderland. Degradation of the key feudal component of good lordship, when neither monarch nor magnate could shield their tenants, led to a partial reconstruction based wholly on militarisation.

What was the key message in all this? It was very simple: you're on your own, get on with it. And they did. A new society emerged, self-dependent, geared for raiding and war, where what others might term criminality became the new norm: it was the default survival mode. New affinities emerged based on family and blood, with wider alliances networking names and powerful marcher lords – Percies, Nevilles, Umfravilles, Douglases – whose notions of lordship were counted in broadswords. It was a new world: not a pleasant one, but it was all they had to subsist. The landscape of these wars was ugly. We merely have to seek accounts of their modern counterparts in the Balkans or elsewhere:

It would have been the ideal place to hide. Close the lid and the pit would be nearly invisible …What gave them away? I wondered. A cough? A sob?' … One girl had been shot repeatedly in the chest. It was difficult to tell if the other had had her throat cut or been shot … The expression on their faces had survived the damage. It was so clear. A time valve that opened directly onto those last moments, so you saw what they saw; I hope beyond hope that I never see it again.[76]

Such terrible tableaux would be enacted time and time again on both sides of the border. Hate- and drink-fuelled Balkan militias are mere amateurs compared to our ancestors here.

Such a society doesn't necessarily create any great cache of artefacts. On a cold, blustery day in March 2019 I was talking at Elsdon to volunteers from Revitalizing Redesdale,[77] a dynamic new environmental and heritage project, supported by the UK Battlefield Trust.[78] This involved my dressing up (irresistible) and listening to me banging on about medieval weaponry (doubly irresistible). Part of the heritage aspect is fresh evaluations of the Otterburn battlefield and continuing the debate over its possible location at Elsdon. One remarkable, possible survivor from the battle in 1388 is the Otterburn (formerly the Silloans) Sword. In September 1986, a team from 49 Explosive Ordnance Disposal, while doing a routine survey, came across traces of what appeared to be an ancient sword buried some depth beneath the surface. This was at Silloans

on the artillery ranges, no great distance from the line of Dere Street. We investigated the area thoroughly but nothing further was found – the relic had lain undisturbed for probably the previous six centuries.

The weapon is very fragile. The blade, of tempered steel, is badly corroded and only a single section of the iron cross-guard survives. No armourer's marks remain visible, though tantalizing fragments of the leather scabbard still cling. The best guide to dating was the pommel, which is of the chamfered disc pattern, a descendant of Viking prototype, which dates the weapon to around AD 1200-1350. These pommels were quite heavy so drew the point of balance towards the hilt, onto the ricasso just below the guard. This was an expensive weapon, gilded with copper, and a depression in the centre of the pommel would have been to allow the fitting of a coin, gem or holy relic. Although the pommel disc was decorated, the cross was left plain. The upper edge curves in a single regular arc, the lower edge is a drop-centred arch. Happily, the tang has survived despite being both bent and heavily rusted. The grip was most likely made from wood, covered in leather, possibly decorated or 'garnished' with the owner's coat of arms or, just as probable, overlaid with a spirally wound cord or thong designed to improve the grip.

This was a knight's sword, not some common soldier or archer's hacking falchion. It would have been made-to-measure and would easily have set a fourteenth-century owner back the equivalent cost of a modern car. Of particular interest is the 'chappe', or flat piece of leather located at the base of the grip. It would have overlain the central section of the guard. This wasn't pure embellishment: it had the distinct practical purpose of preventing water from running down into the scabbard, which would lead to corrosion. Surviving 'chappes' of this type are most rare. With the blade in such poor condition, it's difficult to be definitive. Earlier swords were designed more for the cut than the lunge, the weight tending to be further back as the blades tapered, thus adding heft and force to the blow.

Normal construction was by pattern-welding. Two core components, iron and steel, were twisted together and hammered under heat to form a blade both strong and flexible, with hard steel along the edges that could be sharpened to a fine lethality. Since the blades of later, thrusting swords tended to be wider at the guard, tapering to a needle point, it would be reasonable to assume that this blade was intended for the lunge – its diamond section clearly supports this. It's impossible to say for sure, but very tempting to suggest, that the sword may, in fact, be the only surviving artifact from the Battle of Otterburn. The border was the forge, and the fire and fury that spilled out from it was perhaps what forged the character of the borderer. It's a legacy that never quite goes away.

Lords of Redesdale

Who made me into a ruin like an old city?
Was it the soldiers who rode out on horseback?
Was it my old enemy the Scots?
Or was it those Border Reivers?
Perhaps it was just the centuries passing.

'The Sad Castle'[1]

There are a lot of castles in this book, so I've decided to focus in detail on just one. Largely overlooked, and nowhere near as popular as Alnwick, Hermitage or lordly Bamburgh, it has been spared the dread hand of the Georgian or Victorian improver. Half a century ago when I was a boy, Harbottle Castle was one of my childhood haunts. This was in the era when Walter Scott and maybe Errol Flynn were my primary inspirations; MacDonald Fraser's stark realism came little later but proved no less compelling. The stones are never completely silent and – while I wouldn't wish to sound like a new-age dreamer – they possess eloquence. As a juvenile romantic I always found the place enthralling. After a sprint up to the majesty of the Drake Stone[2] with the glittering tarn and evocative field of abandoned millstones nearby, I would return to the impressive bulk of the castle below, dwarfing the settlement.

Harbottle, like most castles, isn't the product of a single burst of building. Most castles – which dominated our landscape for several centuries – were organic. They grew and changed as trends shifted, becoming increasingly sophisticated throughout the high Middle Ages until (by the early sixteenth century) guns and gunpowder rendered them largely anachronistic. Norham, that great 'Queen of Border Fortresses' resisted a Scottish siege for two years in 1318-1320.[3] In 1513, however, the mighty artillery of James IV reduced the place in under a week.[4] This was a very noisy way of condemning a building.

Now Walter Scott's *Marmion* is set at Norham, not Harbottle, but it could have taken place at either. Marmion was a Lincolnshire knight whose girlfriend gave him a really stunning helmet. So far so good, and it was just what every knight really, really wanted, but there was a catch: he had to actually *earn* the right to wear it. This meant he had to distinguish himself somewhere seriously dangerous ... and where more so than Norham, which the Scots had been encircling for the last two years in a vice-like grip? So off he went. At Norham he was made very welcome and was soon put to work in the defences, although siege-craft is rather slow and unglamorous.

If he wanted glory though, it was there for the asking. The governor had a bright idea: Marmion could ride out alone and take on the whole Scottish army. While he was distracting them, the garrison would mount up and charge out behind him: 'Don't worry ... we'll be right behind you.' What could a knight do? He put on his armour and his precious helmet, mounted up and sallied out. Instantly the Scots were upon him and he was fighting for his life. Amazingly, his comrades *did* charge out to the rescue and they saw the enemy off ... siege broken and our boy was a real hero. I hope he dumped her, though.

For centuries, warfare was dominated by the perpetual and symbiotic duel between those who sought to erect defences and those who sought to knock them down. This contest continued until the age of gunpowder profoundly altered the balance. Prior to that, the advantage typically lay with the defender. It was the Normans, with their timber motte & bailey fortifications, who truly introduced the castle into England, (though some now debate this). During the twelfth century, timber was gradually replaced by masonry; great stone keeps such as Rochester, Orford, Conisburgh, Richmond and Newcastle, soared up – and mighty impressive they were. This wasn't 'Sod off!' in stone – more 'Sod you, I'm in charge!'

Now the castle wasn't just a fort; it was the lord's residence, the seat and symbol of his power, centre of his administration, a secure base from which his mailed household could hold down a swathe of territory. Castles were both potent and symbolic. The dire civil wars of Stephen and Matilda[5] spawned a pestilence of unlicensed building, fuelling the omnipresent lordly threat to Crown authority. Castles grew thickest on the disputed marches of England, facing fractious Welshmen and Scots. In the north-west of England the mighty red sandstone fortress of Carlisle rose up, a clear warning to any Scots who coveted Cumberland. It was never taken, at least not until 1745, when Charles Edward's Jacobite army succeeded. Much good it did them.[6] In the words of Patton, 'Fixed fortifications are monuments to man's stupidity.'

Concentric castles, influenced by Arab and Byzantine precedent, appeared in Britain when Edward I began his great chain of towering

Welsh fortresses. As the country had enjoyed a long spell of peace many lords had invested in what might now be termed 'makeovers' – aiming to improve standards of living rather than add to defences. Larger, more ornate chapels and great halls replaced their workaday predecessors; gardens and orchards were laid out to provide tranquil spaces within the walls.[7]

This tended not to happen on the border; castles here would never win any plaudits from *House Beautiful magazine*. They were workmanlike buildings, designed to hold the line, more fire-base than palace. When we unveiled a scale model of Harbottle Castle,[8] as it might have looked in, say, 1500, quite a few people were disappointed: 'It's a bit small … It's not very grand, is it?' A generation of movie-goers expects something more ornate; the reality is more Camp Bastion than Camelot.

Most castles of the earlier medieval period, of which Harbottle is one, relied on the strength of the great keep. Tall, massive, built in fine ashlar, the keep would have a lower vaulted undercroft reserved for storage and an entrance at first floor level, frequently enclosed in a defensive fore-building. On this level the great hall and chapel are typically located; the lord's private apartment or solar would be above, on the second floor. Spirals were set in the thickness of the wall leading to a rooftop parapet walk, often with corner towers. A strong stone wall enclosed the courtyard or bailey, which would also house the usual domestic offices. The keep was essentially a refuge, a passive defence.

From the reign of Henry II onwards, strong flanking towers were frequently added to provide defence against mining; the polygonal keep at Orford in Suffolk (1165-1173) is a fine example. At Pembroke, William the Marshal[9] built an entirely circular keep. The curtain wall was also raised and strengthened, furnished with D-shaped towers, the section beyond the curtain rounded at the corners to frustrate mining. These towers made the attacker's job much more difficult. If he breached or surmounted a section of the rampart, he would be corralled between the towers, which would have to be assaulted in turn. This was leading toward the concentric design where the strength of the whole was distributed through the towers and the great keep, as a defensive feature, became far less important.

Siege warfare was costly, time consuming and tedious; the attacker might be stuck in front of the walls for weeks or longer, consuming his supplies at a fearsome rate, at risk from the defenders' sallies, from dysentery in the crowded lines, or from a relieving force. He would try to negotiate, to persuade the castellan to come to terms; if he acceded before the lines were fixed then convention would allow the defenders to march out under arms and depart unmolested. Captives were useful tools. As we saw, in 1333 Edward III, when besieging Berwick, threatened to hang the governor's two young sons if the place did not open its gates.[10]

Despite the horrors of siege warfare, many castles never saw hostile action in their entire span. Nonetheless, at all times they combined several key functions within the feudal pyramid: a residence for the lord, his family and retainers, they were also a centre for his wider and all-important affinity. They were certainly forts but were as much for offence as defence. A mounted garrison, well-trained and well-armed, could hold down vast tracts of land. Control of territory was what it was all about and Harbottle was a perfect example. The castle also acted as an administrative and judicial centre, the hub of surrounding communities, a place where justice was dispensed. All of this reinforced the lord's status, and 'good lordship' was a central pillar of feudalism. It was his duty not just to rule his people but to offer them stability and security.

Why build at Harbottle? The River Coquet rises high in the Cheviots and flows along the valley that bears its name for forty-odd miles, passing through the settlements of Alwinton, Harbottle, Holystone, Hepple, Thropton, Rothbury, past Brinkburn Priory, Weldon Bridge, Felton and down to the coast at Warkworth. Harbottle Castle dominates the bottleneck of Upper Coquetdale – that stretch from the head of the river down to Brinkburn – say, twenty-five miles or so. This is the strategic significance, and the reason to go to the tremendous trouble and expense of building a castle.

Above Alwinton the valley closes in, hemmed in by the lowering hills, a narrow winding passage, fit for *Lorna Doone* or, of course, the border reivers. As Dippie Dixon points out,[11] the whole of this wild upland brims with history, from the Neolithic age to the Cold War. Harbottle Castle is part of this, rooted both in landscape and history. An ancient sentinel, it once ranked amongst the principal fortresses of England, key to a violent and fractious border constantly prone to sparking into near-anarchy and bloody violence. It still has many secrets and the patient work of unlocking these will take generations.

Hike up to the Drake Stone; it's an uncompromising, great square boulder thirty feet (9 metres) high and weighing in at over 1,800 tons, left behind by the titanic grind of a prehistoric glacier. Now look down on the linear settlement below. Behind you runs Harbottle Crag with the long spine of Gallows Edge – the ideal spot for hangings. One winter's day a friend and I went up the hill and scrambled up onto the stone, then walked over to the small tarn that fringes the start of the MoD ranges. The water was frozen after an earlier frost and thaw. Mortar rounds had clearly smacked into the ice, which had re-frozen over the mini ice craters. To overactive teenage imaginations this was wonderfully surreal.

Below, the River Coquet winds lazily around the northern flank of the castle plateau toward a sharp bend known as the Devil's Elbow. Across the river, Camp Hills are said to be where invading armies pitched their bothies and banners. Nearby Park House denotes the site of the lord's deer park. It all looks wonderfully calm, yet you can frequently hear the roar of the guns behind you from the artillery ranges. Thank God that our reiver ancestors never acquired that kind of firepower!

Our leading architectural historian, Sir Nicklaus Pevsner, rather lightly dismisses the village as 'exceptionally pretty though without any buildings of note'.[12] The school is mock Tudor from 1834 and the Clennel Memorial Fountain, erected in 1880 and designed by Macmillan of Alnwick, is 'inappropriate but good fun'[13] The almost universal sandstone is pale and deeply attractive, almost reminiscent of the Cotswolds, though the climate differs. From our elevated position by the Stone we can still see how the clearly defined motte with its wide, kidney-shaped bailey continues to dominate the settlement. Surviving stonework is quite sparse: from the castle, most was recycled to build the village. So the settlement, though not fortified, is the natural continuum to the castle: not different, not detached, just re-imagined.

The fortress itself sits on a steep-sided, boat-shaped ridge running east to west with the Coquet flowing round almost three sides. On the fourth or south flank, the village sits in a shallow groove that marks a former line of the waters. Strategically, this place is the cork in the bottle. To the north, the ground dips quite sharply towards the river and terraces have been formed from historic land spill. There's a natural spring that rises from just below the barmkin with evidence of attempts at water management. The bailey ditch which encroaches from the west has been partially filled by a more modern track. Whether the slippage is pre- or post-construction is impossible to say. Four stone clearance heaps stand on the largest of these terrace features, but there are no obvious traces of cultivation.

Judging by the name of the place, which is early old English, the value of this eminently defensible location predates the Norman Conquest. The position is ideal, with good all-round vision, that 'long view' so valued on the border. Scouts on the higher Lord's Seat to the west could give warning of any impending attack and the site dominates the line of Clennel Street, winding over Bloody Bush Edge and Windy Gyle (well named) to the border, one of the principal thoroughfares across the marches. Just south at Holystone, the old Roman route, the 'Swire' from Low Learchild to High Rochester, crosses the valley. The spur on which the castle sits divides the lower and upper reaches of Coquetdale. The higher ground west, hemmed in by steep-sided hills was open pasture, shielings only.

George Common and his family, who farm also at Belsay, are rooted in the soil of this valley and are descended from Bruce's mortal enemies, the Comyns. Murdering Red Comyn had Bruce excommunicated in 1306, but the vendetta cost the Comyns just about everything. George will tell you that the family has been in Coquetdale for eight hundred years and the family historian, Eric Common, has amassed an extensive and fascinating archive.

As well as the commons, Harbottle Castle and its history are inextricably linked to the powerful Umfravilles, Lords of Redesdale, marcher barons and frontiersmen. We tend to assume that the borderland was, from the outset, an embattled and much fortified landscape. This isn't necessarily so. It is more likely that the tempo of conflict stepped up after the onset of the Border War or 'Three Hundred Years' War' as it's now called – the steady upgrading of defences at manorial castles such as Aydon would certainly suggest this.[14]

William by the Grace of God King of England and Duke of Normandy, to all his men whether French and English or Norman, greeting: know you that I have given to my kinsman Robert de Umfravill, knight, lord of Tours in Vian, otherwise called Robert with the Beard ['cum barba'], the lordship, valley and forest with all castles, manors, with lands, woods, pastures, pools with all appurtenances and royal franchises, formerly Mildred son of Akmans, late lord of Redesdale and which came into our hands by conquest To have and hold to the said Robert and his heirs, of my and my heirs, kings of England, by the service of defending the same against enemies and wolves forever with that sword which I had by my side when I entered Northumbria ...[15]

This is rousing stuff and probably pure fiction. The deed was unearthed in 1641 by the antiquary Dodsworth, written in Latin of course, and is dated 10 July 1076. Most subsequent scholars cast doubt on its authenticity and there's no agreement as to the actual origins of the Umfravilles. It seems unlikely that Robert-with-the-Beard would have been old enough to have charged at Senlac Hill, though Hodgson overcomes the timeline question by offering the notion there was an *earlier* Robert who, as the County History argues, *could* have crossed the Channel in 1066.[16]

Even if the charter's a fake, it's probably a very old fake, possibly created to justify the holding of the lordship by subsequent generations. We can be sure the Umfraville connection is an ancient one. In terms of the historical record we can date a Robert de Umfraville from an entry in the Pipe Roll[17] for 1130-31. This Robert seems to have been in the affinity of the anglophile David I of Scotland, who spent a very long apprenticeship at the English court and was created Earl of both Huntingdon and Northampton.[18]

Robert's son, Odinel I, succeeded his father, and his career is well attested; he appears as a witness to a range of Scottish charters between 1144 and 1153. Before 1158, he also witnessed Henry II of England's grant of the churches of Newcastle and Newburn to the canons of St Mary of Carlisle.[19] From then on we can trace the line through the whole turbulent era to its final extinction; the story of Harbottle Castle is, in many ways, a saga of the Umfravilles, quintessential marcher lords. Odinel I was succeeded by his son Odinel II. The Umfravilles' first strongholds were at Prudhoe and the impressive motte at Elsdon, before building the castle at Harbottle began around 1157. This site is far better suited to the defence of Redesdale – the location described by Richard de Umfraville in the following century as 'usefully planted on the marches of Scotland towards the Great Waste'.[20]

Following his conquest, the Conqueror needed strong warlords planted on his borders. The line of the Tweed had been fixed after the Battle of Carham in 1018[21] but in the generations after Hastings, kings of Scotland had their eye on an extended frontier or pale which would stretch as far south as the Tees. David I, for all his anglophile sentiments, tried to take this ground with the sword. As we saw earlier, the northern barons smashed his army at Northallerton in 1138, fighting beneath the omnipotent banner of St Cuthbert their talisman: the Battle of the Standard.

Northern fiefs were not regarded as plums. Richer, more settled pastures in the south went to those greater lords who had stood beneath Duke William's flag at Hastings. Nonetheless, the those fiefs afforded sufficient privilege and quasi-autonomy to attract those wilder spirits into the wilder frontier, the 'threap' between two nations whose ongoing history was not destined to be one of amity. Their job was to consolidate and hold, and not just against the Scots: they were also expected to curb the worst excesses of their robust marcher subjects.[22]

Whether Robert-with-the-Beard did gain his lordship directly from the Conqueror, or if the award came later, the grant was for the valley and forest of Redesdale in 'comitatu' – a shire to be held in private hands. Despite a brief alarum in the reign of John, the Umfravilles would hang on until 1436, nearly four centuries. In feudal terms, Redesdale was a barony or chief manor of Harbottle, which by 1290 included the manors of: Otterburn, Monkridge, Elsdon, Garretshields, Woodburn, The Leams, Troughend, Chesterhope, Lynshiels, Broomhope and Corsenside.[23] A lord needs a castle. On the border this would always be doubly necessary.

In plan, the original castle is similar to Mitford, Alnwick and Norham: a strong motte standing in the middle of the south flank with the kidney-shaped bailey circling on three sides. It's the absolute classic motte and bailey derived from the flatpack IKEA-style forts Duke William ferried over the Channel. In a later phase of rebuilding the bailey was bisected

north/south by a stone outer wall, creating an inner and outer.[24] This second phase of rebuilding in stone is likely to date from the early thirteenth century. The castle William the Lion smashed was probably still timber, but the stronger re-construction withstood a siege in 1296, though it fell again to Bruce in 1318.[25] Pevsner describes the site as 'one of the finest medieval earthworks in the county'.[26]

After 1154, Henry II was attempting to deal with the Scottish claims to parts of northern England. He made a deal with Malcolm IV whereby the two monarchs agreed that the Scottish king would abandon any pretensions to control the Carlisle area and Northumberland in return for being created Earl of Huntingdon. As the Scots had failed militarily to enforce their territorial aspirations, this clearly had an appeal. At the same time, Henry strengthened the frontier just in case anyone changed his mind. The Tweed had been the official line since Carham over two centuries before, and now became the (largely) fixed frontier. Berwick, as mentioned, would change hands fourteen times in the course of the Border Wars,[27] Redesdale was the front of the front and would remain so until 1603.

Strong keeps at Newcastle, Bamburgh and Wark on Tweed were rebuilt or strengthened. Bishop le Puisset, whose See of Durham controlled Norham,[28] was persuaded to give the place a substantive makeover. In 1157 Henry gave Odinel de Umfraville instructions that he should shift his key strength from Elsdon to Harbottle and that he should rebuild in stone (though it's more likely, in the first instance, that he stuck to timber). Stone was clearly more desirable. A timber stockade, aside from being vulnerable to fire, had a working life of about thirty years, whereas stone endured. But there was one difficulty, as the Umfravilles discovered at Prudhoe: a man-made motte and bailey, while compact enough to take the weight of timber, might not stand that of stone.

It was also in 1157 that William the Lion received the Liberty of Tynedale as a further quid pro quo for giving up his wider designs on Northumberland. That did not deter the Scottish king from poking around in English affairs in 1172 and, two years later, he came down again in full force. William laid siege to Prudhoe Castle, the Umfraville bastion, but was seen off and fell back to invest Alnwick, though not before he had taken and slighted Harbottle. One wing of his army 'took up' Warkworth and immolated the terrified inhabitants inside their own church.

The king might have remembered what happened to Shakespeare's Malcolm at Alnwick,[29] a salutary precedent, but he stayed far too confident and a relief force of English knights, including Odinel de Umfraville, attacked his quarters in a dawn raid and caught him in the rout. So the Lion's abortive campaign ended in a costly debacle, with him captive and his forces reeling.[30] Next, the king of Scots was obliged

to bend the knee and do homage for his lands to Henry II, though the Liberty of Tynedale was restored to him the following year and would be held by his successors for a century and a half. Richard the 3rd Lord of Redesdale also did good service in the Crusades and became Richard the Lionheart's Captain of Acre.[31] The bards lauded Odinel in verse: 'Then Odinel rode so much on his good brown bay/ Day and night always spurring/That he gathered good valiant people/ Four hundred knights with their shining helmets/ They will be in battle fighting with him/ They will succor Prudhoe with their trenchant swords ...'[32]

Although the Scots were beaten, they had left a trail of destruction behind. Odinel II was awarded a grant of twenty pounds from the rental of the mines at Carlisle to pay his garrison at Prudhoe. After William the Lion's capture, Odinel also received a share of the recovered plunder, a lifetime grant of the manor of Elton in Yorkshire and he netted the forfeited estates of Thomas de Muscamp, Baron of Wooler.[33] Odinel made numerous grants to religious houses, though he was at odds with the prior of Tynemouth. He died leaving substantial debts and was succeeded by his son, Robert. It was only after Robert's own death in 1195 that his successor, a younger brother Richard, paid off the last of the cash owing to Jewish financiers from York.[34] At about this time, the citizens of York dealt with a local debt crisis by murdering the entire Jewish community.

Richard de Umfraville (the first) fell foul of King John and was obliged to surrender all of his four sons as hostages plus Prudhoe Castle as surety for his good behaviour. This didn't stop him 'coming out' with rebellious barons in 1215 and his estates were duly confiscated. This fall from grace endured for five years until he was fully reinstated. On his death in 1226, his eldest son, Gilbert, succeeded as Lord of Redesdale and Baron of Prudhoe.

Gilbert was a leading magnate in the north, serving Henry III on several important missions. His second wife, Matilda, was the daughter and heiress of Malcolm Earl of Angus and the widow of John Comyn. As well as fresh lands, the Umfravilles gained a claim to the Scottish earldom of Angus. (This was where the Commons came in and, tidily, the family now owns the castle.)[35] Gilbert's son, another of the same name, had a distinguished career in Longshanks' service, campaigning in Wales, Gascony and Scotland.[36] Gilbert was a rough diamond. These marcher lords were no plaster saints. Hardened by near continuous military service and presumably enjoying themselves, they weren't over-burdened by respect for authority – not even of so terrifying a figure as Longshanks.

Though we may doubt the authenticity of the supposed original grant from William I, Gilbert, as 5th Lord, relied on its terms to see off an attempt by the Crown to usurp or take back his judicial rights attaching to the Liberty. Despite his loyal service to the crown, he

was ordered by Edward I to hand over certain alleged 'malefactors' but demurred on the grounds that his own justices were empowered to hear such cases in Harbottle. Gilbert, refusing to be bullied by Longshanks (who knew a thing or two about bullying), reminded his sovereign that *he* was the one who could make judicial appointments within his fiefdom. He remained solely entitled to any profits from litigation; he could seize the goods of criminals and generally beat up their holdings.

The legal argument was that the Liberty was granted in grand 'sergeanty'[37] – 'by the exercise of defending that part of the county forever from enemies and wolves, with that sword which King William had by his side when he entered Northumberland' – an echo of the ancient claim.[38] 'Wolves' meant not only four-legged predators but human outlaws: 'wolf's heads'. As it happens, the last of the canine variety to be hunted down in England is said to have been killed at Harbottle. Gilbert's unrepentant defiance brought him into conflict with Longshanks' authoritarian temperament and the king, much as he valued his subject's sword-arm, would never pass up an opportunity to clip his wings.[39]

Not entirely surprisingly, Gilbert was a law unto himself in his own domain – perhaps the very epitome of a robber baron. In July 1267 he sent a full company of shady characters to forcibly eject William Douglas from the manor of Fawdon near Girsonfield. These thugs applied themselves to their task with considerable energy, pilfering and abusing at will. Hapless Douglas and one of his sons were thrown into the cells at Harbottle before Umfraville accused William of treason, though he himself was later accused of murdering his captive's son.

Gilbert was an enthusiastic practitioner of the borderer's art of extracting 'black rent' or blackmail. Even his relative William, who held Elsdon, wasn't immune. When this unfortunate kinsman dared hold a market, thinking he had acquired such commercial rights by view of his tenancy, Gilbert sent his heavies in to trash the stalls.[40] He married Elizabeth, daughter of Alexander de Comyn, Earl of Buchan, further cementing the family's links to the Scottish aristocracy.

Dying in 1307, he was buried inside his own chapel in Hexham Priory church in a suitably splendid tomb (part of which survives). Gilbert was succeeded by his second surviving son, Robert, who also became Earl of Angus. Robert, like his father, had a distinguished career, though interrupted by incarceration after his capture at Bannockburn in 1314. He was soon ransomed and active again until his own death in 1325, being buried before the high altar in Newminster Abbey. Through his first wife, Lucy, he had inherited substantial estates in both Yorkshire and Lincolnshire. His second wife Alienore was from the powerful family of the Earls of Clare.[41]

Harbottle Castle passed through numerous transitions during its long career of nearly half a millennium. Heritage purists want to lock castles into a particular day, say a fine Tuesday in 1253, but it doesn't work like that. These places weren't built as tourist destinations; they were functional buildings intended for a serious purpose. Initially at Harbottle, a causeway crossed the bailey ditch, coming in from the east and at the base of the motte, which wasn't directly accessible. It could only be approached from the west, from within the bailey. The stone castle, shell keep, cross wall and middle gate (*c.*1200), comprise phase one. The masonry curtain wall which bisects the original, larger outer bailey was finished with the addition of a strong tower in the north-east corner.[42]

The shell keep, complete with projecting towers, was constructed on the top of the motte. A century later, phases two and three saw the gateway being rebuilt on a grander scale. This was in time for Bruce to attack the place after 1318, and there are traces of damage inflicted at the time. The outer bailey was probably abandoned around then and the defensive enclosure marked by the cross wall, which then became the outer perimeter with the rebuilt middle gate serving as a main entrance.

Castles changed immeasurably in the course of the medieval era. This wasn't just the transition from timber to stone, or from great tower to concentric style. In the earlier period it was all about communal living; the lord lived alongside his family and retainers. This gradually changed, as gentlemen sought more private family accommodation, distancing themselves from sweaty commoners. Standards of luxury and refinement rose; a running water supply for the lord was not uncommon. He retained the great defensive donjon as a refuge, but he took his ease in more comfortable domestic buildings ranged around the inner bailey.

Within the shell keep at Harbottle, the Umfraville Lord would have had his hall, probably kitchen and private chapel. His followers would have been accommodated in the bailey below. Most of what we see on the motte is Tudor rebuilding, so the original layout is harder to fathom. What we do need to understand is that the structure was not purely defensive. All-round defence would be a priority but the of course the place represents Umfraville authority. It would have soared loftily above the humble cabins of the ordinary folk clustered around and below, a symbol of feudal power, not just the lord's writ but, through him, that of the Crown of England. It was intended to impress, even to dazzle, and certainly to intimidate.

Redesdale was on the front line for several centuries. By the fifteenth century, gentlemen were thinking far more of comfort than war; their strongholds were transformed into country houses. Later castles such as Bodiam or Herstmonceaux are in fact facsimiles, not fortresses. Even the cataclysm of the Wars of the Roses (see the next chapter) did not see

many sieges: really only those of Harlech in Wales and of Bamburgh, here in Northumberland. On the marches it would always be different. Harbottle remained a redoubt well into the Tudor age. Even after the development of artillery had rendered medieval constructions redundant, the terrain and terrible (or even non-existent) roads made transporting great guns a near impossibility.

Despite this harshness of the northern frontier, great lords such as the Umfravilles would have retained a full household; the sheriff or Keeper was a person of note who would deputise for the lord in his absence. The Umfravilles would have employed stewards of the various household offices, cooks, clerks, personal servants, almoners, vintners, bakers, brewers, smiths and farriers, armourers, bowyers, fletchers, a personal chaplain, barber-surgeons, tutors, carpenters, joiners, masons, roofers, personal servants and ladies' maids.

This wasn't the world of *Downton Abbey*: there were no green baize doors. The lord would be on first name terms with his people and yet be served on bended knee. His authority was so absolute that it didn't require underlining. He wasn't some *nouveau riche*; social mobility was almost unheard of. His superior, Olympian status was part of the unchallenged natural order. There was no concept of equality: the feudal pyramid was generally fixed, and he was from the top tier, or near enough.

Harbottle was a living, bustling entity, an entire, self-contained community. Looking at the empty fragments, it's hard to envisage just what it was like in the thirteenth century, newly finished in stone. It would have been crammed. Men, women and children would have been crowded into the bailey, barrack room, kitchens, smithies, brew-house, privies, store rooms and stables. Odours would have been pungent and mixed. Nobody would have been idle. Everything had to be toted by hand. Keeping the walls in readiness required constant maintenance, with some part or parts constantly under construction. Sheep, cattle, goats and horses, from the lord's mighty (and mighty expensive) destrier to the more humble garrons of his affinity, would be competing for space. The ring of armourers' and smiths' hammers would be constantly sounding.

In time of calm or relative calm, the place was like a walled and fortified mini-township. In times of war (which were often), it would have bristled. Timber hoardings would have appeared above the battlements, creating fighting platforms for archers. Ditches would have been deepened and possibly planted with obstacles, and an additional gateway defence – a barrier or wooden extension to the barbican – might have been thrown up. The red banner of the Umfravilles would fly defiantly above the keep. There would have been readiness: that need never went away. At any one time the fighting garrison would have numbered no more than, say, a couple of knights, a dozen men at arms and perhaps a score or so archers.

This would be regularly swollen by local marchers, an ad hoc militia, boisterous and unruly, a proper *bobinantes boreales*.[43]

Once the castle had contracted behind the east wall, the area beyond may have been abandoned. There is evidence of ridge and furrow ploughing over what had been the outer bailey. The overall condition had deteriorated again by the middle of the fourteenth century, having been constantly buffeted by Scottish raids.[44] Then, during period four, the place gets another makeover with work on a drawbridge and barbican. By 1438, when Harbottle was held by the Talbot (Tailbois) family, the keep was in fit condition to house a keeper or constable and his household.[45]

Maintaining local forces needed a sound revenue stream; the Crown was at best parsimonious. Otterburn was probably the most valuable single holding within the lordship, rated at 2½ knights' fees and, like Harbottle Castle itself, it was retained by the Umfraville lord rather than tenanted. Gilbert de Umfraville attempted to deprive Longshanks of the 40 marks[46] due from his estate to the Crown as death duties and wardship fees by granting a late tenancy to one of his affinity. Tax avoidance is not a modern phenomenon.[47] By the middle of the thirteenth century a third of the tenancies were held on military tenure while others were parcelled out as 'petty serjeanty' – rent being met by a gift in kind made annually to the lord. Carucates[48] at Elsdon and Otterburn, together with a twelve-acre parcel in Ravenshope, each went for a pound of pepper. An additional tenement in Greenshomehillslea gave a pound of cumin.[49]

The Umfravilles held Prudhoe, Ovingham, Elsdon and Bothal, but Harbottle seems to have been their principal seat. Despite the ravaging of 1174, the Liberty was probably relatively settled in the thirteenth century. If there had been frequent alarums it is unlikely Richard de Umfraville would have found himself in court over his failure to acquire a licence to crenellate,[50] which led to an order to dismantle unlicensed fortifications.[51] This was in fact the consequence of an action begun by Philip of Ulcotes, a former sheriff of Northumberland whose own hold was at Nafferton. He had tried to build without a licence but had been prevented by the king – this kind of building always raised royal hackles, harking back to the anarchy of Stephen and Matilda's wars when feuding magnates threw up fresh castles at will. Whether Ulcotes was prompted by spite or rivalry we can't say, but he told the authorities about the de Umfraville failure to acquire a licence. Richard was censured in the first instance but on appeal was successful, arguing that the strengthening of his works had been 'with the consent and by the order of King Henry II'.[52]

At the time of writing, Chris Jones is the National Park's presiding archaeologist and the authority has recently built an ambitious and innovative visitor centre at the Sill on Hadrian's Wall; it's the first really

major infrastructural project begun in my lifetime. He is fascinated by Harbottle Castle, which he regards as an undiscovered gem. We took a group of the Park's enthusiastic young archaeologists there to learn about the castle and about border warfare, teaching the youngsters all about historic knife, sword, spear, lance and gun crime.

Even after the eruption of the Scots Wars in 1296, the Liberty and manor of Otterburn at the start of the fourteenth century was valued at 500 and 40 marks respectively.[53] When hostilities began again in 1296, before Longshanks trashed Berwick, and de Warenne the Scots army (such as it was) at Dunbar, Harbottle was, as ever, in the front line. The Scottish siege of 1296 was conducted by Robert de Ros with the earls of Athol and Menteith, who are said to have led an army forty thousand strong. This is most unlikely and as with most chroniclers' estimates of numbers in medieval armies, it's probably best to shift the decimal point. Even though they failed to break in, the Scots made free with the king's deer and were subsequently obliged to make a compensatory gift of twenty bucks and eighty does.[54]

It's very likely that the Northumbrian dales benefited from the surge in wool production: in the High Middle Ages, England's wealth came from the backs of her flocks. Even if the coarser fleeces of the hill breeds were less valued, there was still burgeoning demand.[55] Increasing production, a more industrialised approach to farming, caused a shift away from demesne management under the lord's own hand towards the appointment of professional farm managers or bailiffs and a move from labour-based to money rentals.

These Umfravilles weren't just Lords of Redesdale and leading local magnates; they were active as senior officers of Crown forces during the Scottish wars, which entailed long absences and so lack of time to micro-manage their estates. This drove the need to appoint an estate manager or keeper – a paid agent. By 1294, John de Harle of Hatherwick in Monkridge and of West Harle was in post.[56] This made very good sense. If the lord was campaigning in Scotland – and his absence could last for months – then somebody had to keep the ship at home on an even keel, with the castle acting as a forward supply base for forces in the field. Even when not directly involved, such important border bastions as Harbottle functioned as depots, conduits for supplies, men and materiel. War is primarily about logistics; the winning general will be the one who can concentrate his forces, ready, fed and equipped in the right place at the right time. If he can accomplish that, tactics are almost secondary.

From the mid-thirteenth century, as mentioned, the Umfravilles were also Scottish Earls of Angus. Such cross-border holdings were by no means uncommon. Despite this apparent twin (and competing) allegiance, the Lords of Redesdale remained loyal to the English crown – most of them, anyway. The exception was Sir Ingilram, who 'defected'

in 1308.[57] Ingilram, from the cadet branch, was in fact found heir to a Baliol estate in Scotland and served the Scottish kings in a variety of important diplomatic roles. He maintained this allegiance and suffered forfeiture but was reinstated by Edward I in 1305; he must clearly have begun to fight for England at some point after 1308 as he was another of those taken prisoner at Bannockburn.[58]

The Gilbert who had married the widowed Countess of Angus was subsequently labelled and lauded as a 'guardian and chief flower ... a matchless ornament of the north of England'.[59] This loyalty came at a price. Fighting in Scotland was hard, dangerous and unrewarding; Scottish knights were deemed traitors, so had little or no ransom value. However, the Umfraville Lord was among the haul of English captives after the disaster at Bannockburn, and English knights *did* have a cash value. The defeat allowed Robert Bruce to carry the war down into northern England, a task he undertook with gleeful malice and ruthless efficiency. Harbottle Castle was one of the casualties of that 'Shameful Peace' – the Treaty of Northampton.[60]

Bruce had already attacked Tynedale via Harbottle in 1311. The onslaught seven years later was serious. This was a feature of Bruce's policy: if he captured an outpost over the line, a timber redoubt or peel, he'd pull it down. Castles meant control, and destroying them would weaken the English grip. At Harbottle, repairs were carried out straight away but by 1322 its future was again in doubt. The truce entered into at that time provided that the castle, already occupied by the Scots, should be handed back but on condition that if a lasting accord couldn't be reached, it would be returned to Scottish hands or levelled completely. With Bruce still firmly in the driving seat, he demanded the castle be slighted. This must have been a bitter moment, insult added to injury as Scottish hobilars were continually raiding at will.

Edward II remained militarily useless, and the keeper of the day, John de Penrith, was instructed to carry out demolitions. A writ to this effect was served on John de Fenwick, County Sheriff, who was ordered, along with Roger de Horsley, Gilbert de Burghden (Burradon) and Richard de Emeldon, to bear witness to the work.[61] Clearly the place suffered, but it was not left beyond repair. A subsequent keeper, William Harle, was compensated with forty tuns[62] of wine and the younger Gilbert, in 1328, had his expensive wardship curtailed to avoid further losses. Inevitably, the value of individual holdings within the lordship declined rapidly.[63]

Bruce's triumph – as ensured by the treaty – did not deal with the thorny question of cross-border estate. This was a tricky matter: he'd already parcelled out those lands previously held by English lords among his own affinity. It was a dark time: the savagery of Scottish incursions had ruined many estates and the upland dales were unmanageable as local violence flared in the wake of the anarchy. Worse, the climate was

deteriorating. Even more dire news: the scourge of the Black Death was just around the corner.

As we saw in the previous chapter, Edward III detested the peace made by his mother and her lover. He applauded Edward Baliol's unexpected victory at Dupplin Moor.[64] This Baliol, though made of much sterner stuff than his useless father, did no better and was soon sent packing. Edward still took back Berwick in 1333 and heavily defeated the Scots at Halidon Hill.[65] While he had little long-term interest in Scotland, he had to bar England's back door. His frontier policy, as described, was thoroughly tested at Neville's Cross[66] and found fully fit for purpose, as David II discovered to his cost, losing both his army and his freedom. The marcher lords proved that they could look after themselves and successfully take on a Scottish national army.

By this time military service was being widely substituted for both cash and in-kind renders.[67] This didn't necessarily bode well for law and order. The keeper of Harbottle, in the wake of the Scots raids, was Sir Roger Mauduyt of Eshot who more than consolidated his position by marrying Robert de Umfraville's widow Alienore, dowager Countess of Angus. He thereby alienated a portion of the Umfraville inheritance and he kept tight hold of the reins even after the young Lord Gilbert, his stepson, came of age. Sir Roger did attempt to maintain the Lord's authority and was raising men for defence as early as 1317. Altogether, he had a pretty good innings; he didn't renounce the share of the inheritance his marriage had alienated until 1368, by which time he must have clocked up a fair number of years.

It wasn't just the Scots the keeper had to contend with. He managed to round up a bunch of malcontents who had been doing their bit for the prevailing anarchy. His own marchers sprang them from gaol, not out of fellow feeling, but so they could sell the collaborators directly to the Crown and pocket the cash![68] Robert's successor was his stepson Gilbert, who having ostensibly been born in 1302 would have been of age, yet he did not come into his inheritance until 1328 and, even then, his stepfather remained in control of both the dower lands and Redesdale. (It is possible that this Gilbert was in fact a *younger* son, born in 1302 and who died a minor, and that the second Gilbert might, in fact, have been born in 1309 or 1310, a son rather than a stepson.[69])

Once he'd finally come of age, Gilbert was soon in the saddle, fighting with the Disinherited in 1331. The Scots weren't slow to reciprocate. In 1336, Gilbert was permitted to house prisoners in his other castle at Prudhoe as Harbottle had been beaten up again – 'destroyed by war with Scotland'.[70] Bates gives the date of this petition as 1351, though he may, of course, have made the same request twice. Yet, by the end of Richard II reign, at the time of Bolingbroke's usurpation, Sir Robert Umfraville was governor with a force of twenty men-at-arms and forty archers. By the

standards of the day this was a fairly strong garrison and clearly argues the place was, once again, in sound repair. His fees and expenses for services rendered during the campaigning season in 1336 were valued at the not inconsiderable sum of £274 1s 8d. Short periods of uneasy truce were followed by more alarms. On 20 March 1340 he was commissioned to raise and lead a force of four knights with thirty men-at-arms and as many archers against the Scots. He held the March Warden's job in 1359, 1367, 1369, 1371 and 1372.[71]

Despite this, the Crown had not lost its appetite for interference in the affairs of the Liberty. Gilbert, the 7th Lord, reacted vigorously in 1344 against an attempt to poach on his sacred turf.[72] Edward III, eighteen years later, was ordering his then March Warden to take steps against the keeper, who was refusing to hand over offenders. Within the frontier zone of the Liberty it remained the custom that the beneficiaries of condemned traitors would not automatically suffer loss of their inheritance.[73] That vital pool of ready fighting men had to be maintained.

Though many lords had found their estates unprofitable in the wake of such widespread damage, their difficulties provided opportunities for those who were rich enough and bold enough to take advantage; the Percies were both. By the end of the century, they owned a very great deal of Northumberland and wielded near regal powers – 'no prince but a Percy'. Gilbert's children predeceased him and in 1375 he settled the barony of Prudhoe on himself and his wife Matilda with the remainder to the first Percy Earl. The Percy had been Gilbert's eldest son's brother-in-law. Gilbert died first in 1381 and Matilda inherited, promptly marrying the Percy Earl, who succeeded to the barony under the entail of 1375.[74]

Redesdale had already been the subject of a settlement which included two brothers, Robert and Thomas, who were bastards. One of Gilbert's half-brothers, Sir Robert, became connected by marriage to the Widdringtons. He served as Sheriff of Northumberland and as Keeper of Newcastle Castle, dying without heirs in 1379. His surviving half-brother, Sir Thomas, therefore succeeded as Lord of Redesdale in 1381.[75] He didn't enjoy his inheritance for very long, expiring six years later. His bastard son, another Sir Thomas, next inherited and served as MP for Northumberland. This Thomas fought at the battle of Otterburn in 1388 and probably died about three years after.

His son, Sir Gilbert, came into his estate as a minor but very soon proved himself as a knight, raiding into Scotland and campaigning in France on the orders of Henry IV. His courage became the stuff of legend and he served the fifth King Henry during the epic campaign of 1415, which culminated in that most remarkable of English victories, Agincourt. He rose to be Henry's Marshal in France, benefiting from numerous grants including the seigniory of Offranville which might, by a quirk of fate, have been his ancestral lands.[76] His career came to

an abrupt end at the disastrous Battle of Beauge in April 1421, when the king's rash younger brother, believing English arms to be invincible, threw his slender forces into an ill-judged attack and succeeded in getting himself, Gilbert Umfraville and most of the rest of his men killed.

On Gilbert's death, Redesdale went to his uncle, Sir Robert. Another tough customer, Robert already had a reputation as a scourge of the borders and had thrashed a Scottish incursion at Fulhope Law, earning his elevation to the Garter. He did rather well out of the 1st Earl Percy's final fall and traitor's death at Bramham Moor, adding Warkworth castle to his holdings. He fought on land and sea, beat up the banks of the Forth and, by land, razed Jedburgh. He garnered so much loot he was nicknamed 'Robin-Mend-Market' – from the quantity of lifted beasts and sheep he sold through the county's markets. He fought at both the siege of Harfleur and at Agincourt. When he died in 1436, the direct male line came to an end.[77] His knightly fame was commemorated in contemporary ballad:

> Of sapience [wisdom] and verray gentilnesse [courtesy]
> Of liberal heart and knightly governaunce
> Of hardiment [toughness], of trouthe, and grete gladnesse
> Of honest mirth withouten greviaunce
> Of gentile bourdes [jests] and knightly dalliance
> He hath no make [equal], I dare right well avouwe
> Now he is gone, I may nought gloss him nowe.[78]

With Sir Robert gone, Redesdale passed via a daughter of Gilbert de Burradon and his wife Elizabeth, who had married sir Henry Tailbois (Taylbois) of Hepple and it was their grandson, Sir Walter Tailbois, who inherited. This was fortuitous for the Percies as the Tailbois were already their vassals; they held three manors from the 2nd Earl – this was Hotspur's son, who'd patiently rebuilt the family fortunes after the costly disaster of his father's and grandfather's abortive rebellion. The Lordship would remain in Tailbois hands till the death of Robert, 3rd Lord Tailbois in 1541. His sister, who inherited his holdings and was married to Thomas Wymbyshe, swapped the lordship for Crown estates in Warwickshire and Worcestershire.[79] Various border surveys were carried out when English kings were contemplating leading armies over the Channel. That of 1415, undertaken prior to the Agincourt campaign, lists Sir Robert as owner though in fact Sir Gilbert, his nephew, then serving in France, was Lord.[80]

Later reports from the sixteenth century provide much useful detail:

> On the south side stood the keep, on a conical hill, rising steeply out of the hill on which the other parts of the castle were placed ... Of small

extent is the area on the top, so that the erections there, though high were never of great extent ... The hall of which the foundations remain, was 48 feet long and 30 feet broad. The two baileys are overlooked by the keep, the inner one lying towards the north-west, and the outer one to the north-east, and they are still divided from each other by a wall, partially ruined, running from the keep to the outer curtain wall ... Here too were the draw well, the kitchen, the brew-house, the bake-house, and the horse-mill... Fragments there are of a tower on the north side where, probably, the postern was situated, which required an iron gate, 6 feet 9 inches high, and 3 feet 9 inches broad. On the east side stood the barbican, or entrance gateway, whose iron gates were 10 feet 3 inches high and 9 feet 9 inches broad. A projecting tower was incorporated in the wall north of the gate. The outer wall was 6 feet thick and 27 feet high, within the outer bailey were the stables, with lofts above them which were used as granaries and lodgings for the garrison.[81]

One thing the marchers could generally be assured of? There was worse to come. George Common, the current owner, and I have frequently stood on top of the steep conical mound of Harbottle Castle. Keen, restless winds shift down the narrow funnel of the Upper Coquet Valley, usually cold enough to slice like a blade. If you don't understand the castle structure it's tricky to put a visual image together from what's left; there was too much recycling into the modern village. Yet the place still has a feel to it, a residue of the solidity it once possessed.

George, very aware of his Comyn ancestry, has a strong sense of proprietorship. In one sense the landscape is unchanged: the hills still rise as they did, hunched and stripped, and the river flows in a lovely, lazy curve. We shouldn't get too carried away though. The village itself is primarily nineteenth century and most of those who live there are incomers; retired teachers, lawyers and accountants far outnumber farm workers. It once boasted three pubs but now only one. In 2019 this enjoyed a much-needed makeover and would soon boast such contemporary features as inside toilets.

It was during the nineteen-sixties and seventies that dark and distant valleys such as Upper Coquetdale began to change. Increasing mechanisation of farming meant that farmers had far less need of labourers; forestry, too, was slimming down. At the same time an urban *bourgeoisie* – doing very nicely out of the post-war boom on Tyneside – wanted to go rustic with a country cottage. An accountant once grandly informed me he was spending the weekend in his 'country house' – I knew this to be a terraced cottage in Corbridge. Harbottle still reverberated to the sound of gunfire, but these shotgun-wielding invaders came from the south, not from Scotland. Now the traditional names of Rutherford,

Bartram, Hall, Hindmarch, Murray, Dagg, and of course Common, are becoming ever scarcer.

John Common, George's father, is 93 at the time of writing and has spent virtually all of his life in the valley. From 1944 to 1947 he served in the Coldstream Guards and has never lost that impressive bearing – he's still every inch a guardsman. His uncle was George Armorer Common who had joined the Royal Flying Corps in the previous war. This George was a distinctly colourful character in his day; between the world wars he was a highly successful Cumbrian wrestler; his account books, preserved by the family, show he earned £34 a year in winnings, at a time when a house in the village might cost you £350. He was a notorious poacher who worked in cahoots with Adam Foster, another equally reprehensible local. It was decided that the best way to stop him was to make him fisheries and water bailiff: truly a poacher turned gamekeeper. This proved quite effective, but George couldn't always help himself when it came to fleecing incomers. One, a city gent, fancied the poaching experience and was duly taken out one shining night. The mark was led through brambles and generally half drowned for a tally of three trout. Panic set in when the trio were accosted by the local bobby. Terrified he'd end up in the dock, the greenhorn was told to go down to the Unicorn (now Star) Inn and buy a bottle of whiskey to persuade the constable to look the other way. Needless to say, this was a set-up; George and Adam were joined by the 'polis' to dine on trout washed down by scotch.

During the Second World War the castle was occupied by the Home Guard who actually levelled some of the surviving walls to improve fields of fire. George the poacher/gamekeeper was put in charge of ammunition and fuel dumps. Initially, the total ammo available amounted to four .303 rounds and three 12-bore cartridges. Happily, this time around the ancient defences were never tested.

One mystery that has endured is the business of tunnels. It's often supposed that Harbottle, as other medieval strongholds, could be re-supplied by a network of tunnels dug out beneath the bailey. There's no hard proof that these existed, though local legend asserts they did. John Common recalls that when he was a boy, four score years ago, he knew two elderly spinster sisters who had played in the tunnel when they were children. A possible entrance, ten feet in height, three feet wide and built from fine cut stone, was partly uncovered during utilities works in the 1990s.

Now, for half a century or more, the villagers have taken a single spruce from the Harbottle forest for a Christmas tree. Locals are adamant that this is their right, formally granted by Forestry England in the 1970s and since hallowed by uninterrupted use. Not this year. When the tree had been felled, those who had done the felling received a visit, not from an early Santa but from Forestry enforcers backed by police. Their crime

was taking the tree without consent. The culprits behind this heinous offence were obliged to pay £200 in compensation. Harbottle's local councillor, Steven Bridgett, took up the cudgel: 'It is incredibly mean-spirited and Scrooge-like of Forestry England to report the villagers to the police and ban them from taking a tree from their local forest during what is supposed to be the season of goodwill ... Since the 1970s they have allowed the villagers of Harbottle to have a tree at Christmas; we see it as a bit of recompense for having to put up with the environmental and social impact of timber extraction.'[82]

Bill Gibson, from the Harbottle Christmas Light Committee, added that the tree was a symbol of community spirit; 'The tree means a lot to the village. It brings the community together. It is the centrepiece of the village at this time of year ... the children decorate it and sing Christmas carols around it.' The response from Forestry England, suitably stilted and Orwellian, was that they had 'evidence' of persons entering forestry land and removing a tree without consent with, inevitably, a risk to health and safety. An icy blast of bureaucratic spite upon 'uncontrolled tree-felling activity' suggests tree-rustling on an industrial scale rather than the taking of a single tree in an act hallowed by custom and honoured by the Forestry for half a century. That's fifty years of goodwill thrown away in an afternoon. On an altogether more festive note, and in a true Christmas spirit, the MoD has offered to donate a tree annually to the village, and they'll even deliver it.

This is reiver country, where wrongs are taken seriously and memories endure for a very long time indeed.

Kings and Car Parks

The war of the roses, a bloody fight.
A battle of evil against darkness and light;
Red rose and white rose, seeking control;
A crown of thorns the ultimate prize.

Maria Shaw

In September 2012, skeletal remains were unearthed beneath a civic car park in Leicester at a location opposite the cathedral. This was the site of the former Franciscan Grey Friars Priory and the body was believed to be that of King Richard III, killed at Bosworth on 22 August 1485. Following an intensive examination, on 4 February 2013 the team at the University of Leicester confirmed that these were the king's mortal remains.

No monarch in these islands has ever exercised quite the same hold as Richard with an army – a very voluble army – of supporters behind him, ranging from the mildly to the rabidly partisan. To most he's the wicked, Machiavellian uncle portrayed in Shakespeare's play, but to some of his fans he's the wronged, romantic hero, whose true chivalric memory was blackened by those nasty Tudors. Blacken him they did, but he did kill an awful lot of people and, at the risk of heresy, it has to be odds-on that this includes his nephews.

For three years the wars were fought out in Northumberland and the marches. The borderers from both sides of the line certainly did their bit, which failed to recommend them to their more tame southern contemporaries. And, just possibly, none of it ever need have happened anyway if it wasn't for those two great houses in the north of England: the Percies and the Nevilles.

When, in the north, Percy adherents tried to ambush a Neville wedding party, on the surface the affair may have appeared as little

more than a local, bloodless brawl. Nonetheless, it could be said to represent the first significant armed clash between these two pre-eminent northern affinities, which were active in the wider movement to reform and ultimately remove the Lancastrian administration.[1] A policy, begun by John of Gaunt, of buttressing the power of the Nevilles as a counterweight to the Percies, was continued by Henry VI and the rise of the former was (not infrequently) at the expense of the latter.[2] Neville prestige was particularly high in County Durham, where the influence of their rivals was noticeably weaker.

Richard, Earl of Salisbury, inherited the bulk of the Neville holdings in Yorkshire, centred on the valuable estates of Middleham and Sheriff Hutton. The worth of this legacy, Salisbury being the son of the Earl of Westmorland's second wife, sparked a deep division with the senior branch, which retained the title and lands in the north-west. Undisturbed by this family rift, Salisbury went on steadily to build up his holdings. His own eldest son, another Richard, added the dazzling Beauchamp inheritance and the earldom of Warwick to his titles; he would mature into a key figure in the political landscape, bringing the power of his name to its ultimate zenith before crashing to ruin: 'Warwick the Kingmaker'.

The three ridings of Yorkshire were parcelled out, in terms of land ownership, between four of the greatest magnates of the realm, the Crown (as Duchy of Lancaster) the Percies, the Nevilles and the Duke of York (Salisbury's brother-in-law). The Percy holdings east of the Pennines were interspersed with those of Salisbury and York, though the latter showed little interest in his northern estates.[3] During the years from 1416 to 1440, while the Earl of Northumberland was recovering the bulk of his father's lost inheritance, Salisbury (who had been elevated to his earldom in 1429) had had ample time to consolidate his hold on manors in Cleveland, Westmorland, Cumberland and the important lordship of Raby.[4]

The most aggressive of the Percy brood was the Earl's second son, Lord Egremont, who had threatened the life of the Sheriff of Cumberland, Thomas de la Mare – an adherent of Salisbury.[5] Egremont, who had gained his lordship in 1449 at the age of twenty-five, typified all the adverse traits of his name: '... quarrelsome, violent and contemptuous of all authority, he possessed all the worst characteristics of a Percy for which his grandfather (Hotspur) is still a byword.'[6] Salisbury's sister, Eleanor, was married to Northumberland, but the ties of blood counted for little in a game with such high stakes. Both families possessed mature and ambitious patriarchs, each with a brood of young, restless and potentially lawless sons, and no shortage of available manpower.[7]

When Thomas Neville married Maud Stanhope, this proved a provocation too far for the volatile Egremont. The bride had been married before, to Robert, Lord Willoughby of Eresby, who had died

the previous summer. She was also – and significantly – the niece and co-heiress of Ralph, Lord Cromwell, a choleric character himself but one who had acquired the leases on two choice manors, at Wressle and Burwell in Lincolnshire, that were previously in the hands of the Percies.

In February 1440 Cromwell had purchased the reversionary interest. Northumberland, whose line had spent lavishly on Wressle, had litigated in vain. Thus, when Cromwell married his niece to a Neville he was adding insult to injury.[8] Tension had been mounting throughout the early summer of 1452. In June the king had summoned both Egremont and John Neville to appear before him for a royal bashing together of heads; by the end of that month, Neville was laying plans for an ambush of his own. On 2 July, Henry dissolved Parliament and journeyed north to confront his quarrelsome vassals. He proposed that Percy and his affinity should be ready to serve in Gascony, which would have sent them nicely out of the way. However, the proposal came to nothing.

The king established a commission of Oyer and Terminer (a Royal Commission of Enquiry), the membership of which included both of the rival earls, Viscount Beaumont and some fourteen others,[9] A fortnight later, the commission was re-issued but to little effect. Salisbury, who unlike Northumberland sat in the Council, undoubtedly used his influence to pack the membership with allies, including such Neville stalwarts as Sir James Pickering, Sir Henry Fitzhugh and Sir Henry le Scrope of Bolton.[10]

Despite the commission's excellent credentials, it proved ineffective amidst a rising tide of disorder. By the end of July, a new (and perhaps less overtly partisan) body was set up under the guidance of Sir William Lucy, a knight of Northamptonshire and Council member, his leadership supported by leading counsel. Sir William set to work immediately, summoning Ralph Neville, Sir John Conyers, Sir James Pickering, Sir Ralph Randolf, Sir Thomas Mountford, Richard Aske, Thomas Sewer and John Alcombe. On 10 August, nine Percy adherents were summoned, together with both Sir Ralph and Sir Richard Percy.[11]

Undeterred by a failed ambush at Heworth in 1453, Richard Percy and a band of thuggish adherents now embarked on a spree of vandalism, culminating in the kidnapping of Lawrence Catterall, the bailiff of Staincliff Wapentake, who was roughly dragged from his devotions in Gargrave Church on 9 September. He was subsequently incarcerated, at first in Isel Castle and then at Cockermouth; obviously the luckless man had, in some unrecorded way, offended the Percies.[12] The unrest continued: on 25 September a brace of Percy retainers, John Catterall and Sir John Salvin, pillaged the house of William Hebdon, vicar of Aughton. This may have been in reprisal for John Neville's plundering of the Earl of Northumberland's property at Catton.[13]

On 8 October King Henry wrote plaintively to both earls, asking them to exercise some degree of control over their headstrong siblings. At this time the king's mental health was already causing concern; he had a history of instability and his queen and court faction were not inclined to advertise the fact. The exact nature of the king's malady has never been definitively diagnosed, though catatonic schizophrenia has been suggested.

Whatever the cause, the plain fact was that Henry's deteriorating mental condition contributed to his administration's weakening grip on law and order. By 17 October Egremont had assembled perhaps fifty 'tooled-up' retainers, who mustered at Topcliffe. About half of these were from the Percy heartland of Northumberland or the City of Newcastle.[14] Heedless of feeble royal admonitions, both sides were squaring up and a confrontation of sorts occurred at Sandhutton, probably on 20 October.

Here, Salisbury and Warwick, joined by Sir John and Sir Thomas Neville, were bolstered by such trusty friends as Sir Henry Fitzhugh and Sir Henry le Scrope. Not to be outdone, the Percy affinity were led by the earl and Lord Poynings, Lord Egremont and Sir Richard Percy. The standoff seems to have amounted to little more than bravado on both sides, but the magnates themselves had now clearly shown their hands in the fracas. Battle lines had been drawn, even if very few blows had yet been struck.[15]

As the tempo of strife rose, the king's grasp on reality declined. By now it had become impossible to hide his condition. Matters had been further stirred by the birth, on 13 October, of a son – Edward of Lancaster. With this, York's hopes of securing the succession from a childless monarch vanished. Increasingly vociferous, the duke, as the senior magnate, was clamouring to be appointed as regent during the term of the king's illness, a demand the queen and Somerset were equally determined to resist. On 25 October the Council convened at York with both Salisbury and Warwick in attendance. Northumberland and Lord Poynings were pointedly absent.[16] The Duke of York had married Salisbury's sister, Cicely, the celebrated 'Rose of Raby'. As a man he was '… a somewhat austere, remote and unsympathetic figure, with little capacity or inclination to seek out and win support from his fellow noblemen or from the wider public.'[17]

York had no love for Somerset. He perceived him, almost certainly correctly, as the main block to his inclusion in the king's inner circle. No sooner was York in office than his former rival was consigned to a sojourn in the Tower.[18] Meanwhile, Lord Cromwell, notoriously litigious, had been at odds in the courts with Henry Holland, Duke of Exeter. The matter had become so heated between these two choleric peers that in July 1453 both had been temporarily incarcerated. With the Neville marriage, Cromwell found an ally in Salisbury; Exeter, inevitably,

sought common cause with the Percies.[19] On 27 March 1454, the Duke of York was formally installed as Protector and, less than a week later, his brother-in-law was appointed as Chancellor.

Secure in his high office, Salisbury summoned Egremont and Richard Percy to attend upon his convenience on pain of forfeiture and outlawry.[20] Whereas the Percies might disdain the king's feeble complaints, Salisbury, in the mantle of Chancellor, could not be ignored. York's appointment marked a period of more decisive governance, though the Nevilles were clearly, as ever, motivated by self-interest. Sensing the mood, Sir Thomas Neville of Brancepeth (not Salisbury's son, but a younger brother of the Earl of Westmorland, and no friend to his cousins) took the opportunity to 'take up' the property of Sir John Salvin at Egton in Eskdale. This was accomplished with a body of two dozen armed retainers who lifted some £80 worth of movables.[21]

In May 1454, York, as Protector, sent a strongly worded summons to the Earl of Northumberland, ordering him to appear before the Council on 12 June. Lord Poynings and Ralph Percy were summoned to appear ten days beforehand. Already, on 3 April, Exeter had been removed from his lucrative and prestigious post of Lord Admiral.[22] Not unsurprisingly, the Percies were not minded to follow the path of humility.

On 6 May, they showed what respect they had for the new Chancellor by vandalising his house in York and roughing up one of his tenants, John Skipworth. Many of these now involved in this fresh rash of disturbances had been 'out' on Heworth Moor the previous summer. By the middle of May, Egremont was mustering his affinity at Spofforth and there, on 14 May, he was joined by Exeter, who was bridling at his humiliation. Riotous behaviour broke out in the streets of York, alarming the burgesses, especially after the mob brutally assaulted the Mayor and the Recorder. A wave of anarchy now swept through the North Riding, while Exeter, not to be outdone, busily stirred up trouble in Lancashire and Cheshire.[23]

Needless to say, the invigorated Council, supported by York as Protector, were not minded to remain inert while these troubles flared. Sir Thomas Stanley, the Duchy of Lancaster's Receiver for the counties of Lancashire and Cheshire, ably assisted by Sir Thomas Harrington, saw Exeter off in short order. The Protector himself entered the City of York on 19 May and the rioters fled the streets.[24]

Exeter, whose pitiless traits matched those of Egremont, was, nonetheless, one of King Henry's closest blood relations, tracing his line through John of Gaunt. It is conceivable that he perceived in this localised brawl the chance to light a fuse that might unseat York and see himself appointed in his stead.[25] On 21 May, with Egremont and his affinity, he reappeared in York and set about further intimidation of the much-abused Mayor and burgesses. Disorder flared once again through

the shire. Egremont was sufficiently inflamed to solicit aid from James II of Scotland. The Scots had recently violated the previous year's truce and the herald dispatched to Edinburgh to register the Council's protest was kidnapped at Spofforth. This smacked of rebellion and the rebels (as they could now be termed) planned to lure the Protector into an ambush beneath the walls of York.[26]

York summoned both of the ringleaders to appear on 25 June and used the intervening time to consolidate his position and build up local forces. By 15 June he had been reinforced by Warwick and Lord Greystoke, and a week later Lord Clifford, the Earl of Shrewsbury and Sir Henry Fitzhugh added their retinues. A number of summonses had been issued and several individuals suffered forfeiture or even outlawry. Exeter, Egremont and Sir Richard Percy all failed to appear.[27]

For all their violent posturing, the rebels had completely failed to achieve any serious objective. Exeter crept back to London. By 8 July he was in captivity, and by 24 July he had been safely incarcerated in Pontefract Castle. The snake might appear to be scotched but it was still writhing. With the Percies still at large, York did not feel sufficiently secure in the north to return to the capital.[28] Matters continued in this tense vein until the autumn, when a further confrontation took place – this time at Stamford Bridge, heavy with ancient blood, some miles east of York and held by the Nevilles. Whether any actual fighting occurred is doubtful, but the Percy faction were confounded by treachery when one of their own bailiffs (Peter Lound) deserted with some two hundred followers. The Nevilles, led by Thomas and John, pounced on their discomfited enemies and captured both Egremont and Sir Richard Percy.

If the Nevilles felt they had cause for satisfaction, their triumph was short-lived: in December 1454, Henry VI recovered his wits and was deemed able to resume the reins of government. The office of Protector was thus redundant. On 7 February Somerset was freed from the Tower and reinstated to all his many offices. A month later Salisbury bowed to the inevitable and resigned as Chancellor. A mere seven days after his departure, Exeter was set at liberty. Somerset and the queen were in the mood for retribution rather than compromise; a further and greater trial of strength now appeared inevitable.

What had changed since that earlier showdown at Blackheath was that York was now not entirely isolated. True, the Courtenays, disgruntled at the duke's handling of their feud with Lord Bonville, had switched their allegiance to the court faction, but now York had the powerful support of the Neville earls, Salisbury and Warwick, with their large affinities. Somerset had blundered in allowing the alienation of the Nevilles, who, with York, now believed the duke (with Wiltshire, Exeter, Beaumont and Northumberland) was at the head of a faction intent upon their destruction. The situation was considerably more volatile than it had

been in 1450; the scene was thus set for armed confrontation. On 22 May 1455, the first armies clashed in the streets of St Albans. When the battle ended Northumberland was among the dead, as were Somerset and Lord Clifford. First blood had been drawn.

* * *

First but not last … the fires ignited here would spark and burn for over thirty years and involve both realms. For her grand raid south after destroying York and Salisbury at Wakefield on the freezing 30 December 1460, Margaret of Anjou recruited a vast horde that included many borderers. On their march south they outraged their southern contemporaries who had never experienced anything like a visit from their northern neighbours, and the chroniclers waxed lyrical at the sheer viciousness of their pillaging. It ended on the sleet-driven field of Towton on Palm Sunday 1461, the biggest bloodbath of all and a massive defeat for Lancaster. An Act of Attainder, passed by the victorious Parliament of the Earl of March, now crowned as Edward IV, stripped all of the northern lords who had fallen in the battle of Towton: the 3rd Earl of Northumberland, Lords Clifford, Neville and Dacre.[29]

A really big fixture like Towton should have been it, but the denouement, for this phase at least, would not come for another three years. In his correspondence with the Milanese Ambassador Coppini, George Neville – Richard's brother and a leading cleric – was at pains to stress the magnitude of the victory: 'The armies having been formed and marshalled separately, they set forth against the enemy and at length, on Palmsunday (sic), near a town called Ferrybridge, about sixteen miles from our city (York), our enemies were routed and broken in pieces.'[30]

Though the Lancastrians had been hammered, the Milanese ambassador to the court of Charles VII, Prospero di Camulio, writing a mere four days after George Neville, sounded a shrewdly cautious note: 'Firstly, if the King and Queen of England with the other fugitives mentioned above are not taken, it seems certain that in time fresh disturbances will arise.'[31] This observation was to prove grimly prophetic as the focus of the war moved northward into Northumberland and the border, where it would fester for the next three years.

The county of Northumberland was a different region from North Yorkshire, where the troubles of the preceding decade (and the battles of that phase of the Wars which occurred between 1459 and 1461) had been centred. There is, perhaps, a tendency amongst historians to point generally to 'the north' as though the land north of the Trent were a single region. This is, of course, not the case, nor was it so in the fifteenth century. The cultural, topographical and social fabric of the north embraced 'a kaleidoscope of overlapping regions and localities'.[32] Northumberland is

of course the most northerly of English counties and shares a long border with Scotland, and as we've seen, Northumbrians and Scots had been embroiled in endemic warfare since the late thirteenth century.[33]

Carlisle, with its great red sandstone Norman keep, had been the gateway to the English west for centuries, defying every assault by the Scots. The city was a flourishing port in its own right, plying the busy routes to Ireland and Man. Naworth and Askerton castles stood along the west march – the Scots' frequent choice of incursion route. A number of these fortifications were to prove significant in the struggles of 1461-1464 but none more than the three great, east-coast fortresses of Alnwick, Bamburgh and Dunstanburgh. Of these, the first was a jewel of the Percies and much improved by them over several generations.[34] Bamburgh, as we've seen, occupies a spur of the whin sill, rising a hundred and fifty feet (46 metres) from the flat coastal plains.[35] Begun by Thomas, Earl of Lancaster, Dunstanburgh also occupies a dolerite outcrop, much rebuilt in the later fourteenth century by John of Gaunt, who held the wardenship in the 1380s.[36]

After receiving the unfortunate news of her army's defeat at Towton, Queen Margaret fled north into Scotland. With King Henry in tow, her young son Edward of Lancaster and a scattering of survivors including Somerset, Lord Roos, Exeter and Sir John Fortescue, she sought sanctuary in the northern kingdom. Margaret might have shared the view that Northumberland was solidly Lancastrian in sentiment, following the lead of the Percies, who, as it has been argued, 'have the hearts of the north and always have had'.[37]

James II, King of Scotland, had led a six-day chevauchée through the English borderland in 1456 and had attempted to re-take Berwick in the following year. His interest in the dynastic struggle unfolding in England was largely opportunistic and he had petitioned Charles VII of France to launch an assault on the Calais pale. When James heard of the Yorkist victory at Northampton and the capture of Henry VI, he sat down before (laid siege to) Roxburgh, the last bastion of the former Pale. On 3 August, with his batteries sited, he was to be joined by his Queen, Marie de Gueldres.

The king ordered a cannonade to herald his consort but one of the great guns burst – a not infrequent peril – and James was fatally wounded when a fragment smashed his thigh.[38] His heir, now King James III, was only eight and Scotland was again subject to the uncertainties of a regency council. This body quickly split into factions – the 'Old' lords led by Bishop Kennedy of St Andrews and the 'Young' who championed the widowed Queen. Margaret of Anjou was so desperate for allies that she offered to trade both Carlisle and Berwick for Scottish support. On 25 April, the keys of Berwick were duly handed over, but the citizens of Carlisle would have no truck with the Scots and grimly barred their gates, refusing the queen's summons.

As a result, a joint Scots and Lancastrian expedition was dispatched to besiege the city, a threat that the Yorkists perceived to be so serious that the coronation of Edward IV was brought forward to 28 June so that he would be free to lead a march northwards. In the event this proved unnecessary as the resourceful Lord Montagu, Warwick's highly able younger brother, was able to raise local forces that saw the besiegers off. Margaret had demonstrated not only the measure of her desperation but also her epic disregard for the sentiments of the very northerners she sought to woo, to whom the Scots were a despised and frequent foe. Berwick-upon-Tweed was destined to remain in their hands until 1482.[39]

There were further rumblings. The French were rumoured to be about to descend on the Channel Islands, led by Queen Margaret's fervent admirer Pierre de Brézé. However, with the death of King Charles VII on 22 July, the likelihood of French meddling diminished; the new sovereign had little time for the gallant de Brézé who was effectively put out to grass.[40] Warwick won the loyalty of a Burgundian captain, the Seigneur de la Barde, who, having succumbed to the Earl's charisma and the attractions of his pay chest, led a company of hand-gunners previously in the service of Duke Philip, joining the Yorkist ranks after the disaster at Wakefield.[41]

In Northumberland the Lancastrian lords – Dacre, Roos and Rougemont Grey – launched a raid into Durham, advancing their banners as far as Brancepeth, with King Henry present in their train. True to his fresh allegiance, Lawrence Booth, the Prince Bishop (previously a staunch Lancastrian supporter, but now converted by the great victory at Towton into an equally enthusiastic Yorkist) mustered the county levies and saw them off: 'The problem here (the north) was a complicated one, Henry VI and his supporters were sheltered and aided by the Scots, and, to a lesser extent, by the French. The region itself was remote, difficult of access and dominated by the great fortresses.'[42]

In July, Warwick was appointed Warden for both east and west marches, ably assisted by his brother Montagu. The Nevilles continued mopping up until September, by which time Alnwick surrendered and a garrison of one hundred men at arms was installed. In early October Dunstanburgh capitulated, the terms of surrender being negotiated by the Lancastrian castellan, Sir Ralph Percy. It might be assumed that the Yorkist triumph was complete, but for as long as the defeated court had a base in Scotland, the border would be troubled. King Edward was disposed to permit Sir Ralph to remain in charge at Dunstanburgh, but this was a mistake because the Percy soon reverted. Another Lancastrian, Sir William Tailbois (encountered in the previous chapter), emerging from Scotland, swiftly re-captured Alnwick, while in the west Lord Dacre seized Naworth.[43]

Right: 1. Cocidius: image of the long-lost Romano-Celtic God near Yardhope in Northumberland, hidden for roughly 1,500 years until rediscovered in the 1980s – he's still keeping watch. (Beverley A. Palin)

Below: 2. Vindolanda: Roman Chesterholm on the Stanegate, which went through a number of makeovers in its three centuries of active history, superbly and excitingly excavated by the Birley family and a dedicated group of volunteers. (Vindolanda Trust)

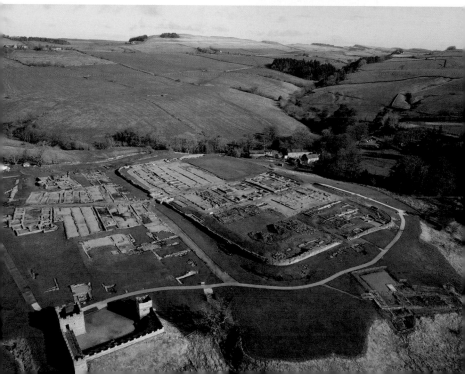

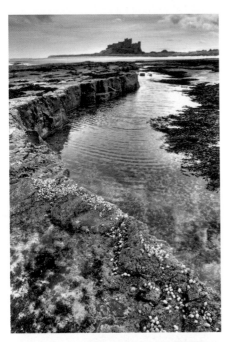

3. Bamburgh Castle: Lancelot's 'Joyous Garde' perhaps but certainly capital of the ancient kingdom of Northumbria and a major border fortress, remodelled by Lord Armstrong from the 1890s. (Adam Barr)

4. Malcolm's Cross: just east of Alnwick, said to mark the spot where Malcolm III – Shakespeare's Canmore – met his end. He raided once too often! (Alan Grint)

5. Hotspur Statue: Sir Henry Percy, warlike son of the 1st Earl of Northumberland, is immortalised in bronze by sculptor Keith Maddison, unveiled in 2010: *and by his light did all the chivalry of England move to do brave acts ...* (G. Tomlinson & R. Serdiville)

6. Recreated thirteenth-century mounted knight: Lord Neville (Paul Martin) proudly astride his destrier ('Blue') in Durham Market Place in 2020; such a look would have been typical of those lords who followed Longshanks in 1296. (Author)

7. Flodden-era reiver's kit: typical of the gear a borderer might have carried at the time of the Flodden campaign in the early sixteenth century. Workmanlike and unostentatious, this was the business-wear of its day. (Hawick Reivers Festival)

8. Dunstanburgh Castle: 'The Fortress of Earl Thomas' on Northumberland's wild and rugged coast. Imposing and commanding, this great Lancastrian fortress featured in the War in the North from 1461 to 1464. Much of the original gatehouse with its large drum towers survives. (Adam Barr)

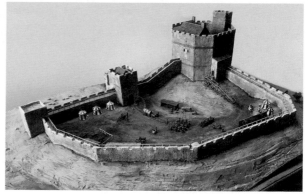

Above left: 9. The Silloans Sword replica: crafted by master sword-maker Ulfric, this copy of the original 'sword in the bog' will be on show, fittingly, in Elsdon Church. Dedicated August 2020, and artfully modelled by Beverley A. Palin. (Beverley A. Palin)

Above right: 10. Harbottle Castle Model: superbly crafted by Dave Grey, this shows the castle as it might have looked in 1500. Archaeology might yet cause us to remodel certain sections. Many secrets remain to be discovered – the area of the shell-keep would be of particular interest. (Kimmerston Design)

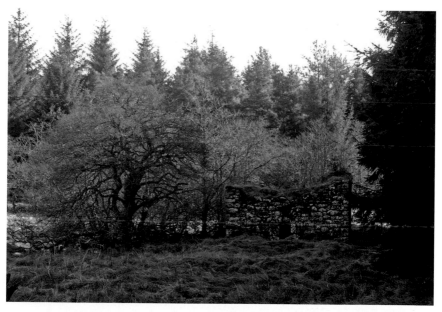

11. Barty's Pele: it was from here that Barty Milburn and Corbit Jack set out on their deadly adventure to track Barty's stolen sheep. Jack didn't survive the experience, though the sheep, or some very like them, were recovered. (Alan Grint)

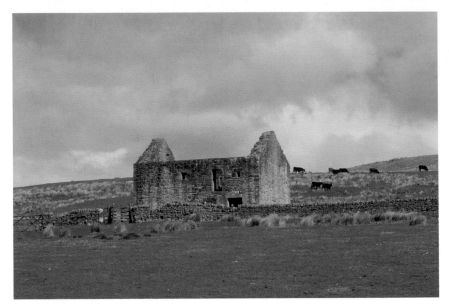

12. Black Middens Bastle: around 7 miles north-west of Bellingham in North Tynedale, a typical four-square bastle, preserved as a controlled ruin and converted after the Union of the Crowns and later into a handy byre. (Alan Grint)

13. Woodhouses Bastle: near to Harbottle in Coquetdale, this fine example has been conserved by Northumberland National Park Authority. It's a classic bastle design, four-square, no nonsense and no frills, more blockhouse than *Homes & Gardens*. (Alan Grint)

14. Dilston Castle: impossibly romantic ruin set above the Devil's Water and home of the Radcliffes. The tower was wrapped into the later, far more extensive mansion but is now, with the adjacent chapel, all that survives. Regrettably the current occupiers of the adjacent college do not encourage visitors. (Author)

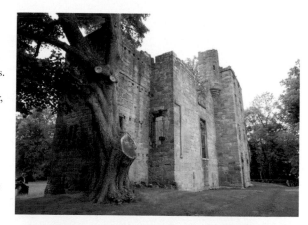

15. Hepburn Bastle: very close to Chillingham Castle in North Northumberland and more of a substantial hall tower, the site is not generally accessible and, certainly during the author's lifetime, no major conservation work has been undertaken. (Alan Grint)

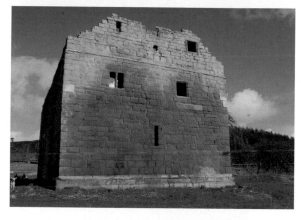

16. Hole Bastle: located near Bellingham, this important bastle is pretty much intact and shows how such fortified buildings were incorporated into later farm complexes as barns – the bastle is on private land and permission to view needs to be obtained from the farmer. (Alan Grint)

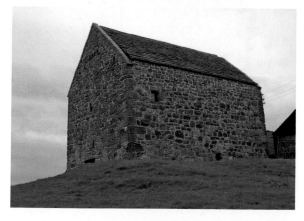

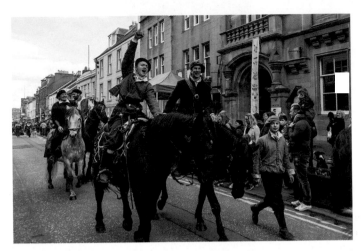

17. The Hawick Callants ride: annual recreation of the famous Riding and Reivers Festival, an important commemoration of reiver and border heritage. Normally enacted in early spring each year, the tradition has a very long history. (Hawick Reivers Festival)

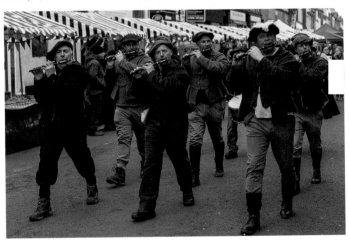

18. The Hawick Fifer March: the foot parade through the ancient streets is a feature of the festival which attracts re-enactors from both sides of the borders with enthusiastic local support – an awareness, often neglected, of reiver history. (Hawick Reivers Festival)

19. Facsimile sixteenth-century backswords: a 'backsword' is sharpened only along the leading edge, allows the use of a cheaper blade, primarily intended for the cut; a horseman's weapon – equally effective on foot, however! (Adam Barr)

20. Facsimile Jeddart Staff: a polearm – notorious from the Battle of Dryfe Sands in 1593 for 'Lockerbie Licks', which were hideous slashing wounds inflicted by foot 'loons' striking at mounted adversaries. (Adam Barr)

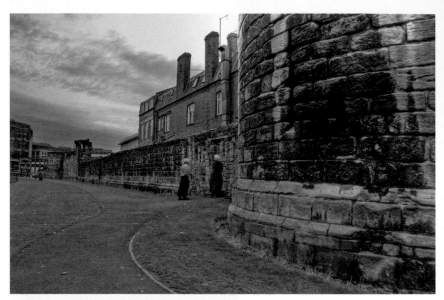

Above: 21. Newcastle upon Tyne City Walls: the medieval circuit still largely intact during the Civil Wars and held for the King by Mayor John Marley throughout the epic siege of 1644 until stormed by Covenanting forces under the Earl of Leven that October. A few substantial sections are preserved. (Adam Barr)

Left: 22. Newcastle Keep: the Norman donjon, mostly intact though threatened by railway development in the nineteenth century; it was (unlike Berwick) spared ruthless demolition and restored by local architect John Dobson and now, much refurbished, is open to visitors. (Adam Barr)

23. Rothley Castle: wonderfully atmospheric and splendidly situated on its crag just north of Scots Gap in mid-Northumberland, this seemingly imposing structure is in fact an eighteenth-century folly built to commemorate the romance of chivalry rather than the reality. (Adam Barr)

24. Winter's Gibbet: this marks the spot where the murderer Winter swung for all to see after a keen-eyed shepherd boy identified him by the unique pattern of nails on his boots, an almost Sherlockian moment that proved enough to hang him. (Johndal under Creative Commons)

25. Blyth Battery: originally built to defend the north-east coast during the Great War after the salutary experience of Hartlepool's dreadful bombardment, it was refurbished for the next war but spared action; it's now admirably restored by the Durward family and volunteers. (Blyth Battery)

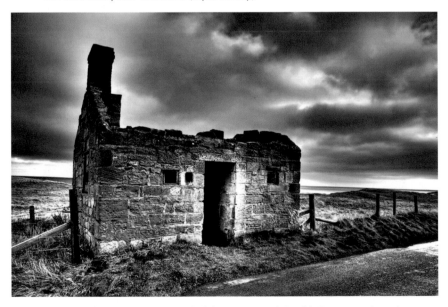

26. Druridge Bay: more coastal defences, Second World War era, when the north-east coast was thought to be a potential invasion target after Dunkirk; this pill-box is cunningly disguised as a minute fisherman's cottage, and was manned initially by the Home Guard. (Adam Barr)

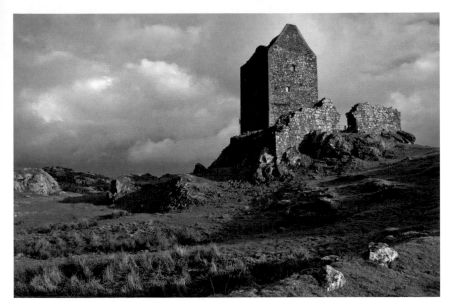

27. Smailhom Tower: perhaps nowhere better sums up the ideal of the Scottish border tower house. Originally a Pringle hold, now in public ownership, it was also the inspiration for a youthful Walter Scott, sent to convalesce at the farm just below the tower. (Tom Parnell under Creative Commons)

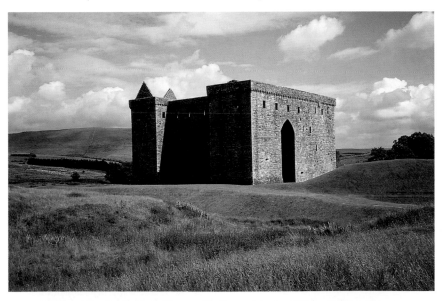

28. Hermitage Castle: 'Sod off in stone' in George Macdonald Fraser's pithy summary, and he's not wrong; the key to Liddesdale, bold, grim, unique and uncompromising – there's nowhere else quite like it. 'Atmospheric' doesn't quite cover it. (Trevor Sheehan)

29. Jedburgh Abbey: one of King David I's four great border foundations, beginning here as a priory in 1138 before gaining abbatial status sixteen years later, and occupied by brethren probably imported from St Quentin Abbey near Beauvais. (Trevor Sheehan)

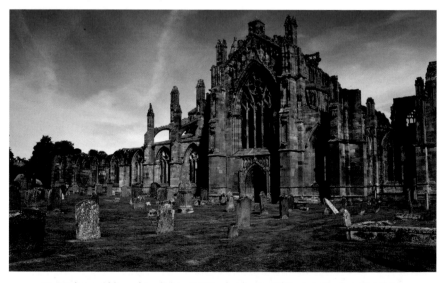

30. Melrose Abbey: founded in 1136, also by David I, and the first Cistercian house in Scotland. The original site was 3 miles away, laid down in the seventh century AD; like Jedburgh, this abbey suffered badly during the border wars and worse during the Scottish Reformation. (Gitta Zahn under Creative Commons)

Above: 31. Woodhouses Bastle. (April Jackson)

Below: 32. The Long View. (April Jackson)

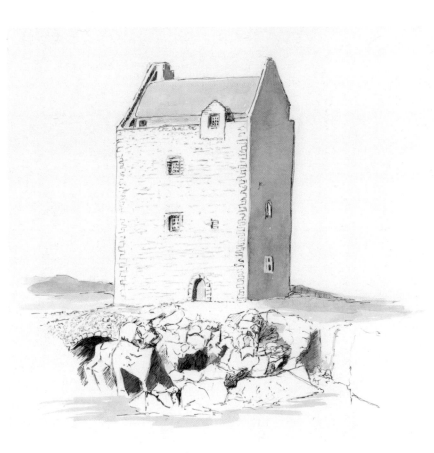

33. Smailholm Tower. (April Jackson)

Both Edward and his lieutenant perceived that a diplomatic offensive against the Scots, aimed at depriving the Lancastrians of their foothold in the northern kingdom, was the only sure means of establishing firm control over the English border marches. Warwick thus held preliminary talks with Marie de Gueldres in April 1462, followed by a further meeting in July – but the Scottish council, already divided, seemed determined to sit on the fence and wait upon events. In March, the Lords Somerset and Hungerford had returned empty-handed from a begging mission to the French court. Undeterred, Margaret of Anjou borrowed £290 from the Regent and sailed for France from Kirkcudbright in April, prepared, as a measure of her desperation, to trade Calais as she had done Berwick.[44]

While Warwick sought an accommodation with Marie de Gueldres, his forces in Northumberland resumed the offensive; by July Montagu had compelled Dacre's surrender and regained Naworth, a vital bastion in the west. In the east, Tailbois surrendered the keys of Alnwick to the Yorkist triumvirate of Lord Hastings, Sir John Howard and Sir Ralph Grey, while Bamburgh was taken by Sir William Tunstall:[45] 'The support and sympathy of the local population worked against what was regarded as a hostile government and enabled even small forces of active rebels to defy it for months on end.'[46] Detail on the surrender of Alnwick is somewhat confusing. Worcester is the only chronicler who mentions the event and the Paston correspondence places Lord Hastings at Carlisle with Warwick in July, though this would not necessarily have prevented him from accepting the surrender. Equally, there is no reason to doubt the appointment of Tailbois as Castellan; he remained a staunch Lancastrian until he was diverted by greed and misappropriated the funds placed in his care.[47]

On 25 October Queen Margaret made landfall, possibly, as Worcester asserts, at Bamburgh. This expedition was led by her faithful admirer Pierre de Brézé, leading two thousand French mercenaries. The invaders marched inland to Alnwick which, being but poorly provisioned, promptly surrendered. Hungerford and de Brézé's son were left in command. Somerset based himself at Bamburgh where, by a quirk of fortune, Sir William Tunstall was taken by his brother Richard; Dunstanburgh also changed hands. Though these achievements passed control of the border fortresses back into Queen Margaret's hands, there was no popular upsurge in favour of her house. Whether she intended simply to foment local anti-Yorkist sentiment or whether she was seeking, in the bigger game, to open a bridgehead for Scottish intervention, remains unclear.[48]

What is certain is that having secured these three key positions she immediately took ship, along with the bulk of her expeditionary force, presumably heading for Scotland, there to press for significant intervention. Though she and de Brézé managed to complete the sea passage, many of the ships were wrecked in the North Sea; men were

scattered, stores and cash were lost. About four hundred French were stranded on the Northumbrian coast, where, foiled in an attempt to enter Bamburgh, they fell back towards Holy Island, firing what remained of their boats. Though they overawed the few defenders, they soon found themselves under determined assault from Yorkists led by the bastard of Ogle and 'one Maners, a squire'. Falling back and barricading the Priory, the French were soon obliged to surrender.[49]

Though clearly wrong-footed by the queen, Warwick soon recovered and marched his forces into Northumberland by 30 October, with the king following behind, leaving the south on 3 November. Though he reached Durham by 16 November, Edward was debilitated by a bout of measles which enfeebled him for the rest of the year.[50] Meanwhile, the Earl vigorously prosecuted siege operations against the northern castles. Establishing his forward command post at Warkworth, he entrusted the Duke of Norfolk with responsibility for supply and logistics through the port of Newcastle. The Earl of Kent was charged to reduce Alnwick, with Lord Scales, the Earl of Worcester and Sir Ralph Grey tackling Dunstanburgh; Montagu and Ogle leaguered Bamburgh. This was Warwick at his best: it was a war of attrition, free from the uncertainties and snap decisions necessary in open field. The earl inspected his outposts daily; supplies from Newcastle moved smoothly despite the onset of winter conditions and the desperate state of the roads.

Tactical initiative had swung the other way. From Bamburgh, Somerset and the turncoat Percy looked out over the besiegers' lines. Sir Richard Tunstall and Thomas Fyndern held Dunstanburgh. John Paston recorded that William Hasildene, Matilda Walsh and John Carter acted as purveyors (of food and logistics) to the Yorkists before Bamburgh, and the king's pavilions were erected by William Hill, a servant of the Master of the Tents. Paston goes on to suggest that Warwick had mustered ten thousand men while Somerset had fewer than three hundred defenders.[51]

Thorough as these siege preparations had been, it would appear that the mere show of strength was sufficient to overawe the garrison. There was no bombardment; the great guns never progressed further than the dockside at Newcastle. Even the lighter field pieces were not deployed; these would have been turned against Scottish forces had any intervention occurred. There was a natural reluctance to reduce the border holds by gunfire since, in normal circumstances, they were vital for the defence of the northern shire and borderland. The prospect of campaigning throughout a miserable Northumbrian winter had scant appeal: 'Tough, hardy and used to discomfort as they were, medieval soldiers had a deep distaste for winter campaigning … Henry V had forced his armies to maintain winter sieges in Northern France, but no one had yet attempted them in the even bleaker conditions of Northumbria in December.'[52]

On Christmas Eve, the Lancastrian Lords negotiated the surrender of both Bamburgh and Dunstanburgh. In return for abandoning their allegiance to Henry VI, Somerset and Sir Ralph Percy were to be restored to their titles and property. Both swore fealty to Edward IV. This capitulation may have reflected a loss of morale: although neither fortress had been seriously threatened there appeared little hope of relief, and Somerset may possibly have been resentful of the Frenchman, de Brézé, being given overall authority over his head. Edward, for his part, had shown a fair degree of pragmatism for the sake of national unity. The blood of his father, brother, uncle and cousin stained Somerset's hands; the feud with the Beauforts ran deep.[53]

In the meantime, the remaining garrison at Alnwick stayed defiant. They had some cause for comfort as the indefatigable de Brézé was leading a Scots relief force. Warwick was caught off-balance and appears to have been seized with the kind of indecision that gripped him in moments of sudden crisis, where his careful planning and rigid control of events was suddenly undone. He withdrew his forces before Alnwick with such indecent haste that the Scots were led to believe they were being lured into an ambush. This produced a near-farcical about-turn as the Scots withdrew, leaving only a skeleton force and the besiegers re-occupied the lines they had so recently abandoned.[26] The depleted garrison wasted no time in coming to terms and Warwick appointed Sir John Ashley to command with Ralph Grey as deputy – a demotion the latter bitterly resented, believing that the senior post should have been his. As was so often the case, this personal grudge would bear bitter fruit.[54]

By the end of 1462 the position appeared to have returned to that which had obtained in the summer, before Queen Margaret's return. However, the Yorkist grip was flimsier than the tactical position would suggest. Percy was, at heart, a Lancastrian and Grey was nursing his resentment. In the spring of 1463 Percy reverted, opening the gates of Bamburgh while Grey seized Alnwick by a coup de main: 'And within three or four months after that false knight and traitor, Sir Ralph Percy, by false treason, took the said Sir John Astley prisoner, and delivered him to Queen Margaret, and then delivered the castle to the Lord Hungerford and unto the Frenchmen accompanied with him.'[55]

Having neatly reversed the position in Northumberland, the Lancastrians now concentrated their efforts against Norham, held by the Prince Bishop, a prize which had for decades eluded the Scots. Frustrated by the loss of Alnwick, Bamburgh and now Dunstanburgh, which Sir Ralph Percy had also gifted, Warwick was obliged to move swiftly and raise the siege of Norham, with Lord Montagu scattering Queen Margaret and her men after a lightning march; both she and King Henry were nearly taken. The Lancastrian garrisons made no attempt to interfere.

In spite of this success the Earl did not propose to sit down, once again, before the great walls of the coastal castles. He now preferred to bring further diplomatic pressure to bear on the Scots and thus cut off the Lancastrians' aid at source. Warwick could undoubtedly sense that enthusiasm for the House of Lancaster was waning; the Scots efforts at Carlisle and now Norham had been easily repulsed. Henry, sensing the mood swing of his hosts, transferred his truncated court either to Alnwick or Bamburgh.[56]

Edward had, by now, obtained a further grant of taxation revenues from the English Parliament to be expended against the Scots (though the Commons approved the funds it was some time before the King came into possession of the cash). Warwick had, however, precipitated offensive action, with the support of the Archbishop of York, by launching a destructive raid into the Lothians.[57] Margaret and de Brézé were both presently engaged in the siege of Norham; their forces were surprised and scattered by Montagu. After the failure at Norham, Queen Margaret, fearful for her son's safety, took ship for Flanders (accompanied by de Brézé) where she proposed to solicit aid from Duke Philip. These wily Burgundians, the duke and his son, the Count of Charolais (later famous as the mercurial Philip the Bold), were prepared to make encouraging noises and Charles wrote reassuringly to Henry who was immured inside Bamburgh's thick walls ... nice words but nothing else.

Gregory[58] asserts that the Lancastrians sailed immediately for Sluys, having escaped from the trap at Norham, pursued, as the chronicler avers, almost to the walls of Bamburgh. Margaret and her shrunken contingent, which included Exeter, Fortescue and the remaining Frenchmen, filled four 'balynggarys' (*ballingers* were large, sleek, double-ended galleys). Gregory also recounts that a French drummer boy refused to embark and waited calmly on the shore. The lad vociferously demanded a place in Warwick's retinue – and the earl agreed![59]

Unmolested by either Warwick or his brother, King Henry maintained a façade of dominion over his Lilliputian realm. His proposed strategy imagined a tripartite alliance of himself (as titular King of England) the Count of Charolais and the Duke of Brittany. He pleaded with the great lords of France to work against any understanding that might be brokered between Edward and Louis. He pleaded for help from the Burgundians. He begged aid, particularly ordnance, from René of Anjou, his father-in-law. He entreated the Bretons to exploit unrest in Wales and join with the Earl of Pembroke.[60] None of this was ever likely to happen. Henry's main difficulty was lack of cash, so all of his entreaties included a request for funds. Deprived of parliamentary grants, destitute of lands and treasure, he had no fiscal base to pay for aggressive action. His faction had no real leadership and the prospects for 1464 seemed bleak.

The single rogue card was John Beaufort, Duke of Somerset. His decision (taken that spring) to resume his core loyalty to Lancaster, would spark the final, dramatic finale of the campaigns in the north. Somerset, with Sir Ralph Percy and others, had been treated with extreme leniency. Percy was confirmed as Castellan of both Dunstanburgh and Bamburgh, and on 17 March in the following year he received a commission to accept the submission of other rebels.

This clemency reflects an element of realpolitik – Percy was still a name that carried great weight in Northumberland; if Edward secured Percy allegiance, he would effectively have kicked away the greatest Lancastrian prop in the north. Somerset fared even better. He appears to have served with some distinction against his former associates, having all the charisma and fortitude of the Beauforts. King Edward made much of him, hunting with his former mortal foe, who even enjoyed the signal honour of acting as a knight of the bedchamber. The duke received cash subsidies and a hefty annuity of a thousand marks. Tournaments were mounted in his honour and the king personally intervened to save Somerset from certain death at the hands of an unruly mob in Northampton.[61]

Why, then, did the duke defect and resume his former allegiance? He could, presumably, have accepted a safe conduct and withdrawn north of the border as other members of the Dunstanburgh garrison chose, though whether Warwick would allow the former commander-in-chief this option is uncertain. There is a suggestion he had already approached the earl some months beforehand to explore terms. On 10 March 1463, his attainder was reversed and yet, by December he and Percy had both reverted. Hicks has asserted, probably correctly, that this was not due to hubris or an unwillingness to accept reality; Somerset was neither fool nor dreamer. He must have known that the odds were long and that no second chances would be forthcoming.

What occurred was, therefore, a crisis of conscience … the pull of his affinity. His oath to Henry VI was too compelling, and it triumphed over expediency. The cause might be hopeless but honour outweighed the odds.[62] Possibly both Percy and Somerset regarded their earlier compromise as nothing more than a necessary ruse to gain time until matters turned more favourable. Having said that, there were scant grounds in December 1463 for imagining that the prospects for Henry VI were improving. The duke and Sir Ralph were not alone: both Sir Henry Bellingham and Sir Humphrey Neville subsequently defected. Some commentators, particularly Ross, regard Edward's policy of 'hearts and minds' as naïve and culpable, a political blunder.[63] It's not that clear cut. Edward had judged that suborning his former enemies not only brought new friends but demoralised the remaining diehards. By the close of 1463 he could have been justified in thinking that the flames of resistance had guttered out.[64]

Edward's contemporaries certainly took the harsher view. Gregory, no friend to Somerset, observed that; 'the savynge of hys lyffe at that tyme cuasyd mony mannys dethys son aftyr, as ye shalle heyre.'[65] Hicks views Percy's defection as the more serious because of the power of his name in Northumberland, notwithstanding the fact that the king still held both Somerset's brother and Percy's nephew as hostages.[66] Edward's policy of conciliation was at best a gamble and one which, in these leading instances, clearly failed.[67] At the time it seemed a risk worth taking if the prize was a lasting peace, but this was not achieved and the Lancastrian cause in the north was to enjoy a final, brief revival in the spring of 1464.[68]

Early in the year, sporadic unrest erupted throughout the realm. In fifteen counties, from Kent to Cornwall and as far north as Leicestershire, the disruption was sufficiently serious for the king to delay the state opening of Parliament. There is evidence from the contemporary record the Somerset might have, mistakenly, perceived that King Henry had received some fresh impetus and supply; 'herynge y King Henry was comynge into the lande with a newe strength.'[69] It is uncertain where these fresh troops were coming from and how they were to be paid; perhaps there was a hope the French might intervene, or even the Scots.

Somerset began his reversion by attempting to seize Newcastle – a considerable prize, being the Yorkists forward supply base. A number of his affinity formed an element of the garrison, but the attempt did not succeed; Lord Scrope with some of the king's household knights frustrated the scheme. The rebel duke was very nearly taken at Durham where he was obliged to flee from his lodgings in his nightshirt. Gregory reports that a number of his retainers were captured, together with their master's 'caskette and hys harneys ([helmet and armour)'.[70] Others attempted to slip through the net and escape Newcastle; any who were caught suffered summary execution.

There is also some further doubt as to fugitive King Henry's whereabouts. The 'Year Book' claims he was at Alnwick, though this may be incorrect since the same source claims that Margaret and de Brézé were with him, and we are certain that both were in Flanders at the time.[71] *NCH* still places his diminished court at lordly Bamburgh and this seems more credible: Alnwick was nearer the Yorkists at Newcastle while Bamburgh had access to the sea.[72]

Somerset may have proceeded directly to Henry or, equally possible, he may have made for Tynedale, where a crop of castles – Prudhoe, Hexham, Bywell and Langley – remained staunch. As some point, either in February or March, he was joined by his former comrades, Ralph Percy and Sir Humphrey Neville of Brancepeth, with their retainers. With the duke's defection a new sense of urgency infused the faltering cause of the house of Lancaster, which was just as well because the Scots

were showing willingness to treat with Warwick, who had detailed his brother Montagu to march north and provide safe passage through the uncertain reaches of the frontier for a team of Scottish negotiators. These talks were initially scheduled to take place at Newcastle on 6 March, but the increasing level of unrest caused the start to be delayed until 20 April with the venue shifted southward to calmer pastures.

On 27 March, Edward IV announced his intention to travel north and organise a suitable escort for the delegation waiting at Norham.[73] The success of any such mission would be fatal to Lancastrian hopes, so Somerset was placed in a position where he was bound to take to the field – with such forces as he could muster – staking everything. Consequently, he dispatched a body of foot, 'four score spears and bows too',[74] under the command of Neville, to lay an ambush 'a little from Newcastle in a wood'.[75] Forewarned by scouts or spies, Montagu easily avoided the trap and chose a safer route into the city where he was reinforced by 'a great fellowship'.[76] He then set out to march northwards to the border.

Somerset's best chance now lay in forcing contact: inflicting a defeat in the field would leave the Scots immured and would serve to show that the Lancastrians still had teeth. By mustering every spear he could find and stripping his handful of garrisons, the duke might, as Gregory suggests, have been able to muster five thousand.[77] This seems a very generous estimate, even if he could count upon his own affinity with those of Percy, Neville, Bellingham, the turncoat Grey, and Lords Hungerford and Roos. We have no note of the force Montagu was leading north, but it would certainly have been the equal of anything his enemies could deploy. As the Yorkists marched north from Morpeth, the Lancastrians sallied from Alnwick, both sides probing with a screen of light horse or 'prickers'. Nine miles west of Alnwick, Somerset dew up in battle order blocking the way northwards to Norham.

Though the chronicles provide only scanty details of the battle that ensued, a good look at the ground (which, apart from the spread of cultivation, remains largely undisturbed) indicates that the fight took place on the shelf of rising ground just north of where Percy's Cross now stands. This is the area between, to the south, the stand of timber known as Percy's Strip Wood and the monument ('Percy's Leap'). Here, the ground is roughly level, slightly undulating, rising toward the northern flank. In the spring of 1464 the land was not under the plough but was an expanse of open moor, largely devoid of trees. With the Lancastrians facing south, in front of Percy's Leap, the Yorkists most probably carried out their initial deployment on the line of the present woodland. As they approached from the south the main body of the Yorkists would have had no opportunity to view the strength of their enemy until they ascended the slight rise, which swells from the lower ground. The Lancastrians

would not have wished to deploy to the south of the position suggested, as this would be to lose the advantages the field conferred. Haigh[78] shows the Yorkists drawn up somewhat to the south of this position and indicates that the Lancastrians advanced to contact over open ground. I think this unlikely.

Of the two armies, morale was probably higher in the Yorkist camp: Montagu may have enjoyed greater strength and he was, by nature, a confident and aggressive commander. However, this is conjectural: the chronicles remain frustratingly silent as to the initial dispositions, and the numbers certainly cannot be assessed with any degree of confidence.[79] Somerset may, like Warwick, have been prone to indecision at key moments (his failure to reinforce Clifford at Dintingdale stands as a clear example).[80]

We can assume that the fight began with the customary duel of arrows (though there is no evidence) and Yorkist supremacy was swiftly asserted. Before ever striking a blow, the whole of the Lancastrian left or rearward division, commanded by Hungerford and Roos, routed leaving the centre under Somerset, Bellingham and Grey, together with the right under Percy, totally exposed. Montagu ordered an advance.[81] Most probably the mêlée, such as it was, occurred in the vicinity of Percy's Leap: a short, savage and largely one-sided encounter.

The Lancastrian centre soon bolted. Somerset and his officers were swept along, unable to stop the rot. By then, Percy was virtually surrounded. Fighting bravely, he sustained mortal wounds. An enigmatic legend lingers over his last moments: 'I have saved the bird in my bosom,' he is said to have uttered as his mount stumbled the dozen yards between two low outcrops. What he meant by this remains uncertain, but perhaps he was referring to his true loyalty to Lancaster – although that would be ironic given the number of times he had changed sides.[82]

Montagu's victory was complete and, though the chronicles give no hint of losses, probably cheaply bought. Aside from Percy and those retainers around him who had held their ground, most of the defeated escaped unscathed. Morale was clearly a major factor in the Lancastrian defeat. Despite this humiliation on the field, Somerse, was able to rally many of the Lancastrians and retreat in reasonably good order to Tynedale, while Montagu was fully occupied with the diplomatic game; King Henry's kingdom had shrunk further but was not yet extinguished.[83] With the Anglo Scots delegations at York, and the French in talks at St Omer (which had begun the previous autumn) the Lancastrians' diplomatic isolation was pretty much complete. As Northumberland was no longer viable as a bridgehead, there was little incentive for Somerset to disperse his forces in isolated garrisons; simply holding ground was pointless. With the Scots set to change horses, bargaining chips like Berwick and Norham had no further currency.[84]

Henry's prospects appeared brighter in the west, for in March there were some fresh disturbances in Lancashire and Cheshire. Resistance flared briefly in Skipton in Craven, seat of the Cliffords, who, with their local affinity, had bled so liberally for Lancaster. None of these morphed into any serious threat.[85] However, King Edward continued to feel insecure in the north and west; commissions of array were sent out to the Midlands and Yorkshire; no writs were issued in Northumberland, Cumberland, Westmorland, Lancashire or Cheshire.[86]

Both sides were short of cash. Edward had been granted subsidies to prosecute the war in the north, but apart from the relief of Norham and Montagu's notable success in the field, little had been achieved. Parliament's subsidies and a further grant from convocation had been gobbled up by existing commitments, particularly the garrison at Calais.[87] The Yorkist administration was surviving on loans and was substantially in the red; raising taxes built resentment in all quarters, which was exacerbated when there was no tangible gain.

So vociferous was this dissatisfaction that the King felt constrained, in November 1463, to remit some £6,000 of the subsidy granted in the summer.[88] Somerset was under even greater pressure: he had no taxation revenue, no grants nor other subsidies, and was obliged to beg, borrow and steal. Even when monies could be scraped together, these could disappear through misappropriation. When captured, hiding in a coal-pit after the final defeat at Hexham, Lord Tailbois was loaded with pilfered funds:

> He hadde moch money with hym, both golde and sylvyr, that shulde hav gon unto King Harry; and yf it had come to Harry, lat kynge of Ingelonde, hyt wolde have causyd moche sore sorowe, for he had ordynyd harneys and ordenance i-nowe, but the men wolde not go one fote with hym tylle they had mony.[89]

Henry now appears to have moved his lodgings to Bywell Castle, where he was in residence by the latter part of April. After the rout the victors found evidence of a hurried departure, the king's helmet or 'bycoket' (a coroneted cap), 'richly garnysshed wt ij crownys, and his followers trapped wt blew velvet'.[90] There was a suggestion that the Lancastrians might have been bolstered by 'a great power out of Scotlade'.[91] More likely these were riders from Liddesdale and Teviotdale, drawn by the scent of booty. Bywell was not a significant castle and possessed no strategic value.[92] Both Tynedale and Redesdale were administered as Liberties – franchises where the Crown sub-contracted the business of local government to franchisees, which led to a fair measure of autonomy. The Lancastrians still had a foothold in Tynedale,[93] holding Hexham, Prudhoe and possibly other centres.[94]

How much local support the Lancastrian cause enjoyed in questionable. The northern lords – Percy, Dacre and Clifford – had all bled freely; their affinities were thinned and leaderless. Much had changed since the halcyon days of 1459-1460; even then Queen Margaret had offered free quarter and plunder as incentives, now her cause was depleted by the disaster at Towton and three more years of attrition.[95] There is no indication of how long King Henry remained at Bywell; in all probability he shifted westwards to Hexham, was likely gone before the battle to come, therefore the story of a precipitate flight from Bywell may be fanciful. Somerset would have been a fool to leave the king so exposed – however diminished Henry seems to have been, the king was his only trump. Montagu left Bywell undisturbed as he approached; he would not have done so had he entertained any notion of Henry's presence there. Hexham was a larger castle and further west; in the fifteenth century the enceinte comprised the Moot Hall and gaol, linked by a strong curtain wall.[96]

By the end of the first week in May, Montagu had returned from York to Newcastle. Being made aware (by scouts and agents) of Lancastrian activity in Tynedale, he resolved to take the offensive. On this occasion he would not be hamstrung by diplomatic duties and could concentrate his considerable abilities toward achieving a decisive outcome. Thus: 'on xiii of May, my lorde Mountague toke his jornaye toward Hexham from Newcastelle.'[97] Advancing with his forces strung along the north bank of the Tyne, Hexham was his immediate tactical objective, his strategy being to expunge the Lancastrian presence once and for all. Somerset would have been aware of this and though some Tudor chroniclers assert that King Henry was present on the field, this is clearly fanciful. Gregory avers he fled north back into Scotland, but as this was no longer safe it is more probable he slipped further to the west, to Lancashire.

Montagu crossed the Tyne either at Bywell or Corbridge; only the line of the Devil's Water now stood between him and the Lancastrian base of Hexham.[98] Devil's Water follows a meandering course from the high ground of the Shire toward the Tyne. From Hexham the ground shelves markedly toward the crossing at Linnels Bridge, some two miles distant, then on the south side rises steeply in the direction of Slaley. The traditional site for the battle of Hexham (challenged by Dorothy Charlesworth) lies south of the present B6306, on low ground by the banks of the stream and as featured on the OS 1:25000 map.

As the best contemporary source, the Year Book describes the actual field as 'un lieu appelle Livels sur le ewe Devyls.'[99] Worcester says a hill one mile from Hexham.[100] Ramsay, who had visited the location or talked to someone who had, observes tellingly that the site 'is a nice, sheltered camping ground ... but a very bad battlefield'.[101] The Year Book, which also states the fight occurred on 15 May, merely points to

Linnels as the general area. Worcester refers to a hill, suggesting rising ground, and Dorothy Charlesworth observes that the low ground is indeed most unsuitable.[102] It appears clear from a perambulation that the traditional location for the battle is badly flawed. To the rear it is hemmed in by the water and to the front by steeply rising ground, which impedes visibility and inhibits manoeuvre, making a gift of the heights above to the attacker.

Later writers accepted the traditional view[103] without re-examining the topography and considering the implications. Dr Charlesworth argues, compellingly, that while Somerset may have camped on the Levels he did not deploy for battle there. Rather, on the morning of 15 May, he drew up his forces on the higher ground along the crest of Swallowship Hill. Had he not done so, Montagu could have outflanked him and gained Hexham from the ford over the Devil's Water directly below the hill. The chroniclers do not really give us any assistance here;[104] we are in the area of 'inherent military probability' as advanced by Colonel Burne. If, as Dorothy Charlesworth supposes, the defenders occupied the rise of Swallowship Hill, no such outflanking move would have been possible, with the stream circling the base, the crest of the hill commands all of the viable crossings.

As the ground, on both elevations, drops quite sharply toward the Devil's Water, it would be possible for Somerset to refuse both flanks and channel the attacking Yorkists against his centre. It may therefore be that his line was curved to conform to the contours, Grey and Neville commanded on the left, Hungerford and Roos the right. The Lancastrian left thus dominated the ford that lay below them and that to the north by Earl's Bridge; from the right it was possible to cover the fords at Linnels and Newbiggin. This is conjecture, but the nature of the ground clearly favours Dr Charlesworth's view. This was the deployment which confronted Lord Montagu, who then made his own dispositions accordingly. While he probably fielded more troops, with higher morale, both of his flank commanders, Lords Greystoke and Willoughby, were former Lancastrians. The former, on the left, had fought at 2nd St Albans, where the latter, now on the right, had served with him, losing his father Lord Welles in the wrack of Towton. Willoughby had made his peace with Edward at Gloucester in September 1461, and had done good service since.[105]

Whether this fight began with a duel of arrows is not recorded. The Yorkists may have advanced swiftly to contact and the mêlée was both swift and certain of outcome. Hungerford and Roos, on the Lancastrian right, were the first to give ground, and the line dissolved in precipitate rout. Somerset may have tried to cling to the crest and rally, but he was swept away in the confusion of panic; the fords were soon choked with fleeing men. With the brief fight over, only the business of pursuit

remained.[106] Casualties in the combat were most likely very light: the chroniclers don't mention any knights killed on the field. Indeed, more gentle blood by far was spilt by the executioners in the killing spree that followed. Worcester argues that Montagu fielded ten thousand against Somerset's five hundred,[107] but no commander would accept battle against such odds; perhaps the duke could count on no more than half a thousand retainers of his own immediate affinity.

Conversely, Warkworth argues that the Lancastrians had 'gathered a great people in the north country' and that the Yorkists were outnumbered, having no more than 4,000.[108] Looking at the ground, the position on Swallowship Hill covers a front of around 1,000 yards. Allowing one man per yard and a gap between divisions, a force of at least 4,000 would be needed to give substance to the deployment. For his part, Montagu would surely have been less enthusiastic to engage had not his army been equal to or greater than that of his opponent.

Unlike the immediate aftermath of his previous victory, Montagu was not encumbered by distractions and was fully able to harry the fleeing Lancastrians; Somerset, Hungerford and Roos were all taken, captured 'in a wood fast by'.[109] Henry Beaufort, 2nd Duke of Somerset, could not anticipate any further clemency since Montagu, like his brother, was not interested in reconciliation. It was now time for retribution, and the duke was executed the following day in Hexham marketplace. Hungerford and Roos also faced the axe, 'behedid at Newcastle'.[110]

Others, including Sir Philip Wentworth, Sir Edmund Fitzhugh, John Bryce, Thomas Hunt and a reiver called 'Black Iaquys' ('Black John' or 'Black Jack'), were given appointments with the headsman at either Hexham, or perhaps Middleham, 'after some writers'.[111] At least one captive, Sir Thomas Hussey, was executed at York. Lancaster in the north was ruined, Somerset and the rebel lords were hunted out, their retainers scattered. Humphrey Neville managed to escape the hounds; like Beaufort his attainder dated from Towton but he, too, had subsequently been pardoned. Previously he had escaped from the Tower and possessed a genius for survival. With Sir Ralph Grey and the odd remnant he now regained Bamburgh, where the reduced garrison maintained a show of defiance.

The embezzling Lord Tailbois we encountered as Lord of Harbottle was also netted and his hoard provided a handy bonus for Montagu's soldiery: '... the sum of 3,000 marks. And the lord's meinie of Montagu were sore hurt and sick, and many of him men were slain before in the great journeys, but this money was departed among them, and was a very wholesome salve for them.'[112] Tailbois was executed at Newcastle on 20 July, the last of the prisoners to face the axe. Barely two weeks after Hexham, John Neville, Lord Montagu, was elevated to the earldom of Northumberland before king and court at York, and in the presence of

both of his brothers. This was the high-water mark of the Nevilles. While at his northern capital King Edward ratified the treaty with the Scots, concluded on 11 June, which secured a truce of fifteen years duration. Warwick, as the King's lieutenant, was charged once again with the recovery of the three border fortresses.

To assist in these operations Edward had assembled a formidable siege train, 'The Great Ordnance of England'; bombards ''Edward', 'Dijon', 'London', 'Newcastle' and 'Richard Bombartel'.[113] The sight of these great guns was sufficient to overawe the shaken defenders at Alnwick, which capitulated on 23 June, followed the next day by Dunstanburgh. Bates, however, maintains that the latter was, in fact, stormed and that the governor (John Gosse, of Somerset's affinity) was taken and sent southwards to York to face execution.[114]

Bates goes on to assert that Warwick maintained the feast of St John the Baptist at Dunstanburgh while Henry VI was still within the walls of Bamburgh. He further claims that Henry made good his escape with the aid of Sir Henry Bellingham. *NCH* concurs and suggests Sir Thomas Philip, William Learmouth, Thomas Elwyk of Bamburgh, John Retford of Lincolnshire, all described as gentlemen, together with John Purcas of London, a yeoman, Philip Castelle of Pembroke, Archibald and Gilbert Ridley, from Langley, Gawen Lampleugh of Warkworth, also a gentleman, John Whynfell of Naworth, yeoman, and Alexander Bellingham from Burneside in Westmorland, were all in the king's reduced household during this episode.[115]

This is most certainly inaccurate: none of those mentioned appears to have fought at Hexham and even if they did, they definitely avoided capture. It is more likely that these individuals were in Henry VI's service before the disintegration on Devil's Water and fled westwards with the king at the same time. Bates, with the *NCH*, suggests Sir Ralph Grey also escaped back to Bamburgh before the rout, rather than after.[116] Once again, this seems unconvincing: Grey and his retainers would be needed on the field: Bamburgh was very much a last resort for a defeated captain who was all too aware that his duplicity excluded him from amnesty.

Though perhaps the greatest of the Northumbrian fortresses, Bamburgh was not built to withstand cannon, and the deployment of the royal train before the massive walls gave ample notice of deadly intent. The Earl of Warwick dispatched his own and the king's herald, Chester, to formally demand the garrison's surrender. Quarter was offered to the commons but both Grey and Neville were excluded from any terms, 'as out of the King's grace without any redemption'.[117] Grey, with nothing to lose, breathed defiance; he had 'clearly determined within himself to live or die in the castle'.

The heralds responded with a stern rejoinder and one can perhaps hear the words of the Earl of Warwick resonating through the chronicler's account:

> The King, our most dread sovereign lord, specially desires to have this jewel whole and unbroken by artillery, particularly because it stands so close to his ancient enemies the Scots, and if you are the cause that great guns have to be fired against its walls, then it will cost you your head, and for every shot that has to be fired another head, down to the humblest person within the place.[118]

Thus began the only siege bombardment of the Wars. The bombards 'Newcastle' and 'London' were emplaced, sighted, loaded and began firing, the crash of the report like the crack of doom, with a great sulphurous cloud of filthy smoke drifting over the embattled ramparts. Whole sections of masonry were blasted by roundshot and crashed into the sea.[119] A lighter gun, 'Dijon', fired into the chamber wherein Sir Ralph Grey had established his HQ in the eastern gatehouse; he was injured and rendered insensible when one of these rounds brought down part of the roof[120] Humphrey Neville, ever the survivor, seized the moment of his ally's fall to seek terms, securing clemency for the garrison and, cleverly, for himself. The dazed Sir Ralph was tied to his horse and hustled as far as Doncaster to be tried by Sir John Tiptoft, Earl of Worcester and Constable of England. One of the indictments lodged against him was that 'he had withstood and made fences against the king's majesty, and his lieutenant, the worthy lord of Warwick, as appeareth by the strokes of the great guns in the king's walls of his castle of Bamburgh.'[121] Grey was executed on 10 July – war in the north was, at last, over. Well, for the moment at least.

* * *

Poor King Henry was captured the next year and imprisoned in the Tower where he languished, largely forgotten, until Warwick's amazing volte-face in 1470. Having by then fallen out with King Edward, Warwick stirred the pot in his great northern fiefdom, setting up Sir John Conyers as his agitator under the brand of 'Robin of Redesdale'. Montagu, who had kept out of his brother's intrigues, was finally and fatally drawn into the net and both brothers died on the field of Barnet on 14 April 1471. The Lancastrian heir-apparent, Edward of Lancaster, was killed at Tewkesbury on 4 May; his father, King Henry, was quietly disposed of in the Tower soon afterwards. Thus Edward IV had finally arrived and could embark on a gilded Yorkist age after that long winter of discontent. He had only his brothers to worry about: fractious George and ever-loyal

Richard, who scooped up Warwick's great northern fiefdom. Clarence remained a problem until Edward finally dealt with him in 1478, leaving Richard of Gloucester as his only surviving sibling and one upon whom, he must have thought, he could rely totally. And indeed he could – as long as Edward was alive.

Dominic Mancini, Milanese ambassador and a cannily astute judge of character, wrote of Richard:

> He very rarely came to court. He kept himself within his own lands and set out to acquire the loyalty of his people through favours and justice. The good reputation of his private life and public activities powerfully attracted the esteem of strangers. Such was his renown in warfare, that whenever a difficult and dangerous policy had to be undertaken it would be entrusted to his direction and his generalship; by these arts Richard acquired the favour of the people and avoided the jealousy of the queen, from whom he lived far separated.[122]

King Edward wasn't alone in having ambitious and mercurial younger brothers; James III of Scotland was in exactly the same boat, but he lacked the English king's successes and ruthlessness. James didn't have what the Scottish nobility wanted in a king, any more than Henry VI had satisfied the English. A great patron of the arts and a clear anglophile, James built much, ornamented more and might, if he had won victories, have been a model of a Renaissance Prince. He didn't share his magnates' love of military pomp, their obsession with skill at arms. Further, and dangerously, his sexuality was open to question. He surrounded himself with a set of artistic and low-born male favourites who came to exercise far too much influence and to incur the enmity of his fractious lords. This rage reached its horrible finale in the murderous cull at Lauder in 1482, as James stumbled towards an attempted relief of Berwick.

James's two brothers both fitted the more conventional bill, particularly the Earl of Albany who cultivated a *beau sabreur* image, tailored to match expectations. Like Clarence, he was also fickle and treacherous. It was said: 'he lowit (loved) nothing so well as abill men and a good horse and maid gret cost and expenssis thairon; for he was wondrous liberall in all thingis pertaining to his honour.'[123] James made him Lieutenant of the Borders, Gloucester's equivalent, but though he was outwardly more ambitious, he didn't have the steady acuity and self-discipline that ruled Richard. By 1479 he was very possibly in treasonous communication with Gloucester, and both he and his other brother (the Earl of Mar) were arrested. Albany, now a duke, was accused of fomenting troubler at a truce day and encouraging his marchers' scrapping ... although this was not, it has to be said, a difficult accomplishment.[124]

Mar died in captivity, not necessarily as a result of foul play, but Albany preferred not to take any chances and broke out of gaol, heading for safe harbour in France. Edward toyed with the idea of using Albany as a pawn to control Scotland and recover Berwick, a project close to his heart since Margaret of Anjou had traded the town in 1461. James dithered and tried to broker a marriage alliance between his son and Edward's daughter, but when that failed, he finally stirred himself to action, sending Angus's riders to tear up Northumberland, torching Bamburgh in time-honoured style. Gloucester, controlling his vast northern satrapy, didn't take kindly to such intrusions. When he received formal confirmation of his role as Lieutenant of the Marches, he immediately launched his own riders across the Tweed: tit for tat.

Gloucester laid careful plans for a major campaign by land and sea in 1481, but in the event it was only his fleet that saw any action. He wasn't helped by the fact that King Edward already appeared to be failing, despite the fact that he wasn't yet forty; the long years of excess were finally taking their toll on his Herculean frame. Like his grandson, Henry VIII, he was sliding into obesity and lethargy. Richard was by contrast bursting with energy and ambition. He appeared to be cooperating well with the 4th Earl of Northumberland – though as he would find out, no Percy ever put loyalty above self-interest. For the next season, 1482, Gloucester had a clear objective: re-taking Berwick.

He struck that spring, attacking Dumfries and bringing the exiled Albany under his banner as counterfeit king. He launched his main assault in July: this was a meticulously planned approach on Berwick, with an army said to number 20,000.[125] James's feeble riposte ended with the mass extinction of his catamites at Lauder. Berwick was still under siege while Albany, as mascot, marched – effectively unopposed – into Edinburgh. Within a month Berwick fell, changing hands for the fourteenth and (to date) final time. It was a very satisfactory conclusion and Albany, the viper, was lodged in the bosom of Scottish polity. Gloucester had done well, yet there were still jealous murmurings from the Woodvilles – the innumerable and avaricious relatives of the queen. If they'd had the wit to realise what was in the heart and mind of the king's younger brother, they'd have had much more to murmur about ...

Still, on paper Richard did well enough, with his writ extended to re-creating a wide English pale across the border, an impressive enough commission, though he had no resources allocated. Moreover, Albany, should he manage finally to supplant his own brother, would have been obliged to part with a substantial pay-off to the English Crown. Within the year the political landscape in both realms shifted again. Edward IV died, and Albany was back in exile. James III had survived the Lauder crisis and had regained control of the helm of state. And, for once, events

moved in his favour: the rebel Earl of Douglas was captured in 1484 and Albany died in a bizarre jousting accident in Paris the year after.

James had survived but he hadn't learnt much. Albany had successfully turned the Queen (Margaret of Denmark) and her eldest son the Duke of Rothesay (later James IV) against the king. Margaret died in 1486 but the younger James's suspicion of his father was deep and fixed. When James III advanced a favoured younger son at the start of 1488, his older boy, Rothesay, slipped the net and allied himself with a growing rebel faction, becoming the talisman of a swelling tide of opposition. His father had always been grasping and high-handed. On the border he clashed with both Humes and Hepburns who challenged his meddling in the affairs of Coldingham Priory. He declared them traitors – so they instantly defected to Rothesay.

Both factions begged aid from England and Denmark, but having defeated and killed Richard at Bosworth, Henry VII was far more interested in protecting his grip on the crown than fighting the Scots. The Scottish king turned to his half-uncle, James Stewart, Earl of Buchan – arguably the least popular man in the kingdom – a move that simply sufficed to antagonise waverers and direct them firmly toward the rebel camp. Matters deteriorated apace after that and soon standards were unfurled, drums beaten. A civil war was bubbling.

James III was as bad a general as he was a king. Father and son clashed near the hallowed site of Stirling Bridge, in a far less noble fracas. James decided he was the new Bruce and hurried towards a new Bannockburn. What he actually got was Sauchieburn on 11 June 1488. It's said he even carried Bruce's sword, but if it's true, a fat lot of good it did him. A much larger rebel army scattered his own, and the magic sword was left on the field. Casualties were few but included James himself, killed somehow in the rout, largely unnoticed and certainly unmourned. Any list of usual suspects would have been a very long one, but nobody was asking. James IV began his reign in violence and despite a quarter century of exemplary rule would end it in just the same way, but at a far greater cost to Scotland.[126]

Game of Princes

We'll hear nae mair lilting at our yowe-milking,
Women and bairns are heartless and wae,
Sighing and moaning on ilka green loaning
The Flowers of the Forest are a' wede away.

Flowers of the Forest

This is classic border balladry, a sad lament for all those who died in
James IV's ill-judged *Götterdämmerung* at Flodden. Its aim is to show
just how badly the English have behaved towards the Scots – even
though theirs was the invading army. I remember a solemn rendition in
the splendidly restored hall of Stirling Castle; it had American visitors
going through entire boxes of tissues.

There's a good display board by the monument on Piper's Hill, which
explains the real action quite clearly; the vantage point provides an
Englishman's view of the Scottish line along the crest in front. You can't
help but imagine the ground heaving with the great weight of Scottish
pikes, points glinting ... the crash and roar of the great guns. It's a
daunting prospect.

Step down into the line of the dip, look back towards the English line
and you can appreciate how so mundane a feature as a stream could lead
to total disaster. Think about that innocuous burn, spread with marshes,
swelled by the rains and churned by tramping feet, muddy waters turned
red with blood. Here fell a Scottish king who, if he failed as a general, did
not fail as a knight. Nor did he desert those who followed him and they,
true to their oath, fell around him. To be fair they didn't have many other
options as the English weren't taking prisoners.

Apart from increased levels of cultivation and effects of improved
land drainage in the eighteenth and nineteenth centuries, the field
remains remarkably unchanged. All of the principal features can be

easily identified.[1] The present line of the B6352 runs westward from its junction with the A697 and skirts the base of Flodden Edge. The great strength of this first Scottish position is at once apparent. This rise completely dominates Millfield Plain below, and those great Scottish guns were securely dug in and thus largely protected against counter battery fire.

At West Flodden, a right-hand turn leads past the flank of this position and continues over the saddle beyond leading towards Branxton Edge. This, the lowest point, is traversed by a very minor road running east to west through Branxton-moor and Blinkbonny, a pretty farmhouse. The road then breasts the lip of Branxton Edge and the field opens out before you. The formidable (or so it appeared) Scottish second position lay astride this ridge. Here, you're standing where those massed pikes of Errol, Crawford and Montrose's Division were deployed on 9 September 1513. For many, this was to be their first and last battle. As a brisk wind plays over the brow of the hill, it's not at all difficult to visualise that great phalanx of serried staves, men shuffling, nervous and uncertain. Skeins and eddies of smoke from burning rubbish, a rush of stinging, cold rain driven by an east wind, then a tentative sun, men turning to empty bladders, throats dry.

As you go down this undemanding hill, the line of that fatal burn is clearly visible. Now much tamed by ploughman and drain-layer, the nature of this obstacle is still apparent: a marked dip with an uphill struggle to reach the English line beyond. Westwards and the drop evens out, merges into smoother contours that fronted Home and Huntly. Here there is a far more level descent and you can see how, on this wing, the ground so favoured the Scots. At the base of the ridge, the terrain swells left towards the monument, beyond that is Windy Law and a drop into the shallow valley of the Pallinsburn, again much drier now than then. Further north and east, toward Twizel Bridge, stretches the line of the English approach march.

To follow this, take the B6525 which branches eastwards from the main A697 at Wooler. Stay on this road through Doddington, keeping the golf course and Iron Age settlements on high ground to your right. Barmoor Castle (much later and now a shell) is on the left, as is Watchlaw, as you pass over the crossroads just west of Lowick. Bear left at Bowsden toward Duddo. The remains of the sixteenth-century tower, a lone gable, make a good landmark. From Duddo head due west to the Till, that delightful bridge at Twizel and Heaton Fords. This is truly wonderful, a single-span bridge of stone built only a few years before the battle. Northwards the river curves in a lazy bend, lined by bluffs on the east bank. Above that is the softly hidden shell of a much later folly, wrapped around a far earlier tower that was very possibly there at the time. It's worth the scramble up through the woods … it's the sort

of place you'd expect to meet the Woman in White or, on a bad day, the Woman in Black.

At Etal Castle, where the shells of both gatehouse and keep survive, English Heritage has mounted a series of tableaux depicting the events of the battle. Ford Castle also still stands, though it is much modified and not generally open to the public (more on that below). Great Norham Castle remains,[2] also in the care of English Heritage. The great square stone keep is formidable, if denuded, as is the circuit of the walls.

One of the legends of Flodden is that James IV had a dangerous dalliance with Lady Heron of Ford and her equally beautiful daughter. Lady Heron's husband was a wretched hostage in grim Fast Castle, answering by proxy for the many crimes of his dangerous half-brother – the notorious and rather glorious 'Bastard Heron'. The liaison never actually happened; but Ford Castle is a fine place. Most of what you're looking at is nineteenth-century restoration, remodelled by the talented improver, Lady Waterford, around 1860. She gave the whole village (now owned by Lord Joicey) a full makeover while she was at it, and the result is both charming and unique.

If Lady Heron was not the key player she's built up to be, there's a woman who was. It takes local knowledge and a bit of luck to happen across Isabella Hoppringle, Prioress of Coldstream, although, of course, once she's identified you find that a host of intriguing references start to crop up. Thomas Grey, 2nd Marquess of Dorset, records Margaret Tudor's description of her and his own assessment: 'Her grace reported that the Prioress had been very goode and kind to her ... another cause which moved us to assure the sayd house was by cause the prioresse there is one of the best and assured spyes that we have in Scotland.'[3] Margaret might have been less positive had she known of Isabella's opinion of her: that she was 'very fickle: therefore counsel the man ye know not to take on hand over-much of her credence.' Thus reported Sir William Bulmer to Earl Surrey on 7 October 1523, a report Surrey forwarded to Wolsey.[4] Surrey mentioned another prioress (that of Eccles) who was also providing information; perhaps pointing to a tantalisingly under-reported female occupation of the sixteenth century!

Isabella was a member of a well-known reiver family, firmly Scots by this time but with affiliations and affinities on both sides of the border. Their grand, impossibly romantic tower at Smailholm – encountered earlier – is now administered by Historic Scotland; the family name was shortened from Hoppringle to Pringle some time in the course of the seventeenth century. Isabella was one of a series of Hoppringle Prioresses at Coldstream, its proximity to the border crossing making it a location of interest to both countries. Letters of protection were issued by Henry VII, advising the English Wardens that servants of the Priory were to be allowed into England to buy lead (not untypical of cross

border commerce). Isabella had been prioress for four years when James IV issued a licence to 'intercommon with Englishmen in the buying of vitallis, sheep, horses ... and other lawful goods.'[5]

Fiscal records suggest Coldstream had rights at Plesset Mill and Shipley in Northumberland, as well as extensive holdings in the immediate area. A 1589 plan reveals church, chapterhouse and cloister nestled next to what was, presumably, accommodation for the prioress. It also reveals a range of ancillary buildings including a guesthouse and service facilities (most likely, kitchen, brew house, bakery and malt kiln), in addition to burial grounds, orchard and farm buildings; all of this was substantial enough to merit attention from raiders as well as armies on the march.

We know that the Scots sacked the priory in 1310, maybe following the inspiring example of Edward I in 1296 (although the damage he left behind is perhaps better expressed as the consequence of too lively a set of house guests). English armies certainly dispersed the nuns in 1543 and 1545. Isabella was concerned enough about potential raids in 1515 (when the Priory was sheltering Margaret Tudor, who had been ousted as Regent, not least because she had married the deeply unpopular Douglas) to seek assurance from Lord Dacre that he would do her house no harm. Margaret wrote on their behalf and was guaranteed safety as long as the house were not supporting any who would harm the king, 'nor keeping nor receiving into hir hous any Scottishemen of war'.[6]

Local difficulties are underlined by a comment in a note to Bulmer in 1523, in which Isabella asserts she dare not come out of doors for fear of her neighbours at Wark. She seems to have been even-handed in her distribution of information, leaving the impression that what really mattered to her was the protection of her house. Nor is it hard to understand the necessity. We hear her voice quite vividly in 1523 talking about life on the borders:

> Lately heard from her that the Queen is gone to Stirling, and has taken with her all the Frenchmen that were about her son. Monday after Palm Sunday the lord Lieutenant was with Dacre at Morpeth. The latter has undertaken that the Riddisdale [Redesdale] men shall make redress for all the robberies committed by them since Lord Rosse's departure, by the 1st of May. Ralph Fenwick has done the same for the Tynedale men and brought in half a score of them as sureties. My Lord Lieutenant and himself have made proclamations for injured persons to bring in their bills to them, since his coming hither, strange to say, there have been no offences on either side, seldom has there been peace so long.[7]

It's said that on the morning after Flodden, wagons were sent from the Priory to gather up the noble dead and provide a burial for them. Sadly, no record remains to confirm or deny this story. However, we do have a

tantalising glimpse from Robert Chambers' *Picture of Scotland* of 1827 which refers to 'many bones' unearthed on the priory site. Even more interesting is a report by a Captain McLaren in the 1834 issue of the *Gentleman's Magazine*:

> On a spot said to have been the burying ground of the Priory of Cistercian nuns, immediately below the surface discovered a great number of human skeletons, which seemed to have been buried in the greatest confusion.[8]

It is impossible to tell, of course, without access to the burial, to what period these bones belonged.

There was, within James IV of Scotland's character, a fatal fascination with the art of war. Though he had partly subdued his rebellious Highlanders, quelled troublesome borderers and dreamed of the great crusade, he was no general. He was interested in the navy in the science of gunnery and by 1508 he was casting his own guns in Edinburgh Castle. He attempted (never successfully) to establish a standing army along Continental lines, though he was able to send a force of two thousand men to Denmark in 1502. A portion of his wider cultural inheritance was the 'Auld Alliance', which he had renewed in 1491-2.[9]

In England, after Bosworth Field in 1485, the victorious Henry Tudor could not sit easily upon his throne and during the early years of his reign he was beset by a series of pretenders. Henry couldn't really afford to fall out with his powerful Scottish neighbour and as early as 1493 the English king hinted at a marriage alliance. In September 1497, at Ayton, James and Henry came to terms and a seven-year truce was agreed. By a further treaty, signed in 1502, the English king pledged his eldest daughter in marriage to James and the nuptial agreement was supported by a further treaty for 'Perpetual Peace', the first such mutual undertaking since 1328. On 8 August 1503, the fourteen-year-old Princess Margaret married King James in the Abbey Church of Holyrood, and for the rest of Henry VII's reign the two countries existed in amity.[10]

His son and successor, Henry VIII, was a man of a very different stamp, superficially jovial and good-humoured, he was ruthless, bombastic and aggressive – as several of his wives were to discover. At a very early stage he headed for a collision with France by allying himself to the wily Ferdinand of Spain. France was obviously anxious to avoid English interference in the seemingly endless Italian wars and James was effectively employed as a diplomat to find an understanding between

the warring parties. In November 1511, Henry joined the Pope, King Ferdinand and the Venetians in a Holy League against France.

James was now in a difficult position. He was bound to France by the 'Auld Alliance' and yet was equally tied to England by the accord of 1502, though these agreements now appeared mutually exclusive. A more unscrupulous and more cynical man than James could have exploited this situation to his advantage. He certainly used his best endeavours to remain above the struggle in Europe, but the French were naturally anxious that their old ally should support them against England. Henry was determined to enjoy his hour of glory and accordingly prepared to invade France, which he did in the summer of 1513. Before this he had taken good care to ensure that the northern shires were in a state of defence and had appointed the ageing but competent Earl of Surrey as Commander-in-Chief.

James IV now felt bound by his relations with the French to intercede on their behalf and on 24 July he began to summon the shire levies. On 12 August he made a last-ditch attempt to negotiate with Henry, sending his chief herald, Lyon, King-of-Arms, to France to deliver an ultimatum. This was curtly dismissed and on 22 August the Scottish host crossed the border.[11] Lord Home, with five thousand East March riders, led the first foray into Northumberland. Having wasted the valley of the Till, he was ambushed while returning by a thousand English archers under Sir William Bulmer of Brancepeth.[12] In the ensuing mêlée the Scots came off worst with several hundred dead – not an auspicious start. Undeterred, James pressed on. His huge army is said to have numbered thirty thousand. His artillery train included a number of heavy siege guns, two culverins, four sakers and six demi-culverins.[13]

The first English castle to feel the punch of the Scottish cannon was Norham, then Etal and then Ford, which, once taken, the Scottish king made his headquarters. Such was the firepower of James's train that the castle was hammered into submission in five days. Even at the outset, the very size of the Scottish force began to pose problems as small groups, laden with loot, began to drift off homeward. This trickle of desertions was exacerbated by an outbreak of disease that further thinned the ranks. By the early part of September James had probably lost the best part of a third of his force.[14]

Despite the weight of his seventy years, Surrey displayed considerable energy. By 1 September he had reached Newcastle, and the shire levies of Lancashire, Cheshire, Yorkshire, Wensleydale and Swaledale began to filter in. The quality of these (often unwilling) recruits was at best indifferent and the only regular force upon which Surrey could count were the twelve hundred marines from the fleet under the command of his eldest surviving son, Thomas Howard, the Lord Admiral. Surrey, who understood the vainglorious nature of his opponent's character and

began a careful campaign of taunts and insults delivered through heralds, though James was too clever to rise to the bait.

This daily barrage of gentlemanly abuse was carried by the English herald, Rouge-Croix, who found the Scottish king and his army drawn up in a strong position on the north-eastern slopes of Flodden Hill. James, alone amongst his nobles having no apparent objection to giving battle, at least had the good sense to blindfold Rouge-Croix so as to avoid making Surrey aware of his dispositions.[15] Surrey now marched his army to Wooler, where he arranged an exchange of hostages to recover his herald. The intelligence brought back by Rouge-Croix can't have been encouraging: the Scots were in a position of considerable strength; their guns had been dug into the hillside effectively covering the passage between the east end of Flodden Hill and the line of the Till. A low-lying, waterlogged track was the only approach to the Scots' position and any attempt to advance would be subject to galling fire from above.[16]

It's uncertain who in Surrey's council of war suggested the idea of a flanking march to the north, but it may have been the notorious Bastard Heron himself, whose useful bandits had swelled the English ranks. The next day the English army broke camp, splashed across the Till and headed north, marching past Doddington up towards the heather-clad moors and then out of sight of the watching Scots. This was an impressive and risky gambit; no easy stroll either – hard going for hungry men.

That evening the English camped on Watch Law, invisible to the enemy, who appeared baffled by the manoeuvre. From the top of the hill, Surrey and his officers were able to get a far better view of the Scottish lines. The enemy position now lay to the south and a line of advance from the north, though equally precipitous, would be free from artillery fire. Local historian John Ferguson has now located the probable site of the English camp, shown on a hitherto unconsidered survey map from 1786.[17] Early on 9 September, the army was again on the march, abandoning all heavy baggage and gear and moving in battle order. The advance necessitated a further crossing of the Till. This proved difficult; the narrow bridge at Twizel could not accommodate the great array of men, horses and guns. While the vanguard and the Lord Admiral's division crossed by this route, Surrey led the main body across the shallows at Mill-Ford.[18]

By about 13.00 hours, the English deployment became all too visible and the alarm was raised. The Scottish lords were all for caution, urging James to withdraw, but throwing a violent tantrum, he made clear his determination to fight. The Scots began the cumbersome task of moving their positions almost a mile to the north of their first position but still to the south of the English line of march. They redeployed along the ridge of Branxton Hill, heaving only the lighter cannon with them. Although their new position was less strong, it still gave them a substantial advantage in height, or certainly appeared to.[19]

On the left stood Hume and Huntly's division, then that of Errol, Crawford and Montrose; in the centre was the king and on the left the Highland Brigade under Lennox and Argyll. Bothwell's division remained in reserve. In the Lowland divisions there were a number of French officers, and the whole army had been largely re-equipped with pikes at French expense. As the Scots decamped, the followers began burning the abandoned gear and refuse so that a great cloud of greasy smoke hung over the ridge, effectively obscuring each side from the other.[20]

Though clear of the Till the English were not clear of difficulties; the soft and marshy ground by the Pallinsburn was churned into a quagmire by marching feet. The van, under the Lord Admiral, was the first to clear the morass and in fact advanced too far, outstripping the main body. Had the Scots swooped down from the heights, the van would have been isolated and the army defeated in detail,[21] Realising his error but not losing his nerve, the Lord Admiral marched boldly on, along the southern bank of the Pallinsburn. Despite his appearance of confidence, he was sending repeated messages back to his father urging the main body forward. When finally deployed, the English right was under the command of Edmund Howard, Surrey's third son. The Lord Admiral stood left of him with Surrey himself taking the centre. On the English left the line was held by the experienced Edward Stanley – or would have been, except that Stanley was trailing, apparently lost. In front of Surrey's position, in the centre, there was a moderate decline falling into the wet gap.

This was important for the Scots. In order to attack they would have to cross the mire and advance up this seemingly insignificant slope, losing vital downhill momentum. James had schooled his levies in the latest Swiss pike tactics with the aid of his French advisers. The successful deployment of the pike phalanxes depended upon long and hard training, strict discipline and determined ferocity. All three of these were lacking in the Scots, and the choice of ground was disastrous. The Swiss also fought only for pay, whereas James' conscripts were unwaged; king and country was never such a strong incentive as hard cash.

Surrey was concerned about the position on his right. Apart from Howard, a handful of retainers and a knot of Cheshire knights such as Bryan Tunstall, this division was made up of raw levies from Lancashire and Cheshire.[22] This scratch-built brigade was facing Hume's tough Borderers, bred to endemic warfare. Moreover, as these were Stanley retainers they expected to fight under their own Eagles' Claw standard. Such things mattered.

English guns were sited between the bodies of foot and very soon began to make their presence felt. Coolly directed by Sir Nicholas Appleyard and William Blackenhall, the English gunners methodically raked the Scottish line and a furious artillery duel developed. It was now

that the relative inexperience of the Scottish gunners began to tell: one by one they were silenced. With his guns disabled and his gunners dead, James's line was exposed to the full fury of the English cannonade. This was probably very short in duration, but the fight was effectively decided before either side advanced to contact.[23]

The Scottish king, whatever the shortcomings of his leadership, had detected the weakness of the English right and he launched Hume and Huntly's division upon them. These tough Scottish Borderers cannoned into the English ranks and bulldozed them from the field. The men of Lancashire and Cheshire dissolved in rout, leaving Howard and a few diehards to sell their lives as dearly as possible. The heroic Tunstall flung himself upon the Scots, cutting down Sir Malcolm McKeen and several others before he himself was killed.

Despite this opportune beginning, James now proceeded to commit what appears to have been an exemplar of reckless folly. Seeing his advantage on the right and thinking the battle won, he placed himself at the head of his own division and led them down towards the English centre. In so doing he effectively deprived the Scottish army of any vestige of leadership. For the king to abandon his position as Commander-in-Chief and to elect to fight as a common knight was an act of gross negligence that was to cost both king and country dear. In James's defence, his tactics were entirely consistent with the Swiss precedent, which asserted that commanders should lead by example. Besides, once the pike columns were committed there was little a commander-in-chief could do to determine the outcome. The Swiss, whose doctrine was by then universal, also advocated attacking in echelon, launching divisions one after the other to deliver a series of hammer blows. So far, this appeared to be working.

The men of the king's division were exposed to the aim of the English longbowmen as they raced downhill, although the Scots had finally devised a tactic to resist the cloth-yard storm: their front ranks were now equipped with heavy wooden shields or pavises which could be raised as a protective screen and then discarded.[24] What *did* disconcert the Scottish soldiers was the swamp into which they descended at the base of the hill. Their momentum was checked and lost, so that they now had to lumber uphill towards the English ranks. The two sides met with a terrific shock – Scottish pikes levelled against English bills. Momentum, mass and cohesion, critical to the success of Swiss tactics, were irretrievably lost.

This English bill – a basic but effective weapon – was a hybrid of the battlefield, born of a useful union between the agricultural implement (the billhook) and the military spear. Originally the peasants of the feudal levy had simply mounted their billhooks upon longer shafts until, around 1300, the weapon was developed with a hefty blade, a long spear-like

head and a shorter, narrower cutting edge at the back. The bill now proved lighter and more versatile than the cumbersome pike and Surrey's men were able to lop off the heads of the enemy's weapons and then hack down the pikemen.

Both sides fought with undiluted fury. Casualties began to mount; the muddy ground became puddled with blood. Errol, Crawford and Montrose all fell at the head of their divisions and their levies could make no headway against Howard's élite marines. Increasingly, the king's division became isolated as Howard's lapped around the flanks. From one of difficulty, the king's position deteriorated to one of desperation, and though the fight was to rage murderously for a further two hours, there was little doubt as to the outcome. The Scottish right wing and reserve had been scattered by a bold (if belated) charge from Stanley's division, which finally appeared on the English right. The Englishmen had cannily infiltrated the north-eastern slope of the hill, whence they were invisible to the Scots until they ambushed them. English longbows made short work of lightly equipped Highlanders who, ill-suited to this form of defensive warfare, took to their heels. Both Argyll and Lennox, in the company of several clan chiefs, died in an attempt to rally their men.[25]

King James, though defeated, remained undaunted. Legend relates that, with his few surviving retainers, he launched one last Homeric charge against the banners of Surrey himself. Cut and slashed by bills, James fell dying, almost unnoticed by his men.[26] Dawn revealed the scale of the English victory. Surrey claimed he had accounted for ten thousand Scots and the toll amongst the nobility had been frightful: one archbishop, one bishop, ten earls, nineteen barons and as many as three hundred knights had joined their king in death. Whole counties and towns were stripped of the cream of their manhood. All of the Scottish artillery, arms and baggage fell to the English. The English themselves might have lost around seventeen hundred.[27]

The morning after the battle, a half-naked corpse was dragged from the pile of Scottish dead. Transported to Berwick, it was formally recognised as the mortal remains of James IV of Scotland; the body was disembowelled, embalmed and sent first to Newcastle and then, in a lead casket, to London. Catherine of Aragon, as Regent, debated sending the grisly trophy to her husband in France but finally sent the dead king's bloody surcoat instead. (To remind anyone as prone to sulking as Henry VIII of how much greater her victory had been than his, might, in the long run, have been an unwise move.) The body remained in the Monastery of Sheen and was thrown into a lumber room after the Dissolution. Years later, workmen in the house found the remains, cut off the head and used it as a macabre plaything.

Thereafter it apparently came into the possession of one Lancelot Young, Elizabeth I's master glazier, who kept it as a curio at his home,

until finally it was buried in an anonymous grave. Posterity sneers at losers. A contemporary chronicle offered this epitaph for the dead king:

> How could the matter be, hitherto we want, quhen we want him, a stout, just and devote King, who won great honour both in peace and war when other princes of his day contracted ignominie.[23]

Bull Dacre might have thought himself shot of Scottish royalty but he would have been mistaken. Some time later he had Queen Margaret as a guest at Harbottle Castle and found her a most demanding and difficult VIP.[28]

For the Scots, Flodden seems to have been a final flowering of an aspiring realm about to take its place on the European stage; the last chance in generations for an independent nation to act on its own behalf, free from the shadow of domination. Flodden was a lost opportunity and a lost generation ... or so it is portrayed. It is the death toll that made the greatest impact, and which seems to resonate through the centuries It's not until 1914-1918 that we see again carnage that strikes at the Scottish psyche in this way.

Such high losses must have an inevitably greater impact on a small population (estimates put the total at around 500,000 in 1513). Everyone would be likely to know somebody who was there. Wood claims that there was trouble and considerable rivalry over the filling of benefices left vacant by the death of their holders at Flodden.[29] Some of the fiction written about the event (of which there is a significant amount) seems driven by that consciousness. Take Elizabeth McNeill, for example, who, in the afterword to her novel, *Flodden Field*, questions whether the 1707 Act of Union could have taken place if so many men of power had not died on the battlefield: 'In 1513 the country was powerful, rich and on the crest of a wave but everything crashed to disaster in only two hours.' She contends that the disaster was worse than Culloden, because by that time Scotland was already subdued and had been sold out.[30] It's an interesting approach, even if not wholly persuasive; comparisons with Culloden are misleading – that was a very different war.

Literary interest in the events of September 1513 started early. The first printed poem appeared in 1664. The author, Joseph Benson, a declared philomath, was an adherent of the Stanley family and in his poem he is very clearly writing from an English perspective. A nineteenth-century editor asserts that Benson had access to an earlier source held by that family, but omits any details. Benson's poem seems odd nowadays, since it misses out two elements which rapidly became part of the Flodden story: the chivalrous nature of Scotland's king and the duplicitous nature of Lady Elizabeth Heron of Ford. Instead, he launches into a paean in praise of Henry VIII: 'Thou God of War! Do me admit/ For to discourse

with founding praise/ This bloody field, this founding fight/ Fought in our old forefathers days.'[31]

It is remarkable how the tale of Lady Heron and her daughter has developed over the years, despite there being no contemporary corroboration of the allegations. Such corroboration could reasonably have been expected – Dacre, Dorset et al were in regular correspondence with the court, and quite routinely passed on the most intimate details of the people round them. Dacre had no love for the Heron family (except perhaps for the Bastard who was really rather useful) and would surely have made the most of this gift. The story has, nonetheless, been gleefully seized upon and developed until we now hear routinely that lady Heron was bedding not only the king but also her brother-in-law. Clearly, the Flodden story needs a bad woman as well as a tragic heroine. The latter is usually the role assigned to Margaret Tudor, often depicted as the lovelorn wife who knows (as the result of a prescient dream) that her darling will not return.

Pitscottie, writing in the 1570s, appears to be the original source:

> Some say the Lady of Ford was a beautiful woman, and that the King meddled with her; and also his son Alexander Stuart, Bishop of St Andrews, with her daughter; which was against God's commandments, and against the Order of all good Captains of War, to being at Whoredom and Harlotry before any good Success of Battle or Victory had fallen unto them; and Fornication had a great Part of the Wyte [reason] of their evil Success. Notwithstanding, the King continued still there the Space of Twenty days without Battle till at the last all the Victuals and Vivers of the commons were spent: and many of the far North-land and Iles men were spent and wasted in the Famine; in this same manner; that it was force to them to pass home ...
>
> But this wicked Lady of Ford seeing the Kings host so dispersed for Lack of Victuals, and knowing all the secrets that were among the Kings men and army, both of the King himself and of his secret council ... subdued and enticed by the Allurement and false Deceit of this wicked woman, gave her over hastily Credence in this Behalf and believed surely all that had been true that she promised ... but this lady, thinking nothing that she had promised to the King, that, on no Ways, that she would keep it, for the Love she bore her native country; but hastily passed, with a deceitful mind, to the Earl of Surrey.[32]

Losers like scapegoats, and this presumably explains why the chivalrous James, having given his word to safeguard her property, burnt Ford as he left. The sixteenth-century Scottish chronicler, Pitscottie, is a useful resource but he's notoriously unreliable. For example, in the matter of what became of James' body he records that a convict offered to show

Albany the king's grave ten years after the battle, but the duke refused. From an early date, caveats have been expressed noting that he's liable to recount as fact stories that don't appear anywhere else in the historical record. Bethan[33] in 1804 makes this point, as does Chatton[34] in 1835. Chambers, also writing in 1835, is even firmer:

> The earnest and honest simplicity of the good old chronicler, however, is exceedingly amusing. He aims at nothing beyond a mere record of what he conceived to be facts, and these he goes on detailing, with a great deal of incoherence, and all the un-intellectual precision, of an artificial process, neither feeling, passion, nor mind ever appearing to mingle in the slightest degree with his labours. These characteristics of the chronicles of Lindsay [Robert Lindsay of Pitscottie] have greatly impaired their credibility and have almost destroyed all confidence in them as authorities.[35]

Sir Walter Scott set the alleged liaison firmly in the public mind by his reference to it in *Marmion* (1808). This epic poem, which culminates in the hero's return to prosperity and the girl because of his valour at Flodden (or Norham, as I said earlier) was panned by the critics when it was first published. Nonetheless, it was an enormous hit with the public, many of whom happily paid one and a half guineas for the first edition at a time when a skilled engineer or surveyor could hope for a salary of £290 per year. It remained popular for over a century. The publication of *Marmion* marks the time that Flodden can be said to take its place as one of the symbols of Scottish identity. Scott was not a promoter of independence – in his view the union was a positive step, one which accommodated a romantic ideal of Scotland as one of the British nations.

Flodden finds its place as part of Scots cultural legacy from the mid-eighteenth century onwards. *Flowers of the Forest* seems to have been written around 1758 by Jean Elliot, (although the tune is a much older one): 'Dool and wae for the order sent oor lads tae the Border!/ The English for once, by guile wan the day/ The Flooers o' the Forest, that fought aye the foremost/ The pride o' oor land lie cauld in the clay.'[36] It's a lament for the dead which has found a very particular niche in the years since it was written. The words are now words of official commemoration and loss, a ritual akin to the reciting of Laurence Binyon's 'For the Fallen' – They shall grow not old as we grow old – on Remembrance Sunday. Preserved almost exclusively for use on such occasions, *The Flowers of the Forest* is known to many as *The Lament*. A recent search on YouTube produced a range of comments and reactions which confirmed this. This one struck me particularly: 'As a piper I love playing this tune – I know it sounds odd, but you feel as if you're playing that final musical salute to whomsoever you are paying tribute to. I find

the tune itself either makes people well up in emotion of the death, or smile at the life, with no middle ground. Respects to those we can only remember.'[37]

Modern novels on the subject are often found on the romance shelves, picking up on the twin themes: James IV as the chivalric (if flawed) hero, and the devastating casualty rate. Elizabeth Byrd's 1969 book[38] focuses upon Margaret Tudor while Elizabeth McNeil's more recent volume follows the fortunes of a number of people, including, unusually, Isabella Hoppringle.[39] McNeil again gives us a generalised view of the Stewart kings. In her epilogue she refers to an illegitimate son of Alexander Stewart (the Archbishop of St Andrews) who was born of his liaison with Judith Heron (daughter of Elizabeth). She tells us that – like all his Stewart ancestors – he did not die in his bed. Rather more unusual is the novel *Tom Fleck*,[40] written from the view of an English archer present on the field. Modesty prevents me from touting my own fictional version, *Blood Divide* (2014), but it did get some half-decent reviews!

Go to Edinburgh Castle and there's a Mel Gibson lookalike on photo-opportunity duty at the top of Royal Mile. He looks the part and is a huge hit with tourists. I once asked why he wasn't *in* the castle where he'd be an even bigger draw. 'Och I'll ne'er gae in there while *that* flag (the Union Jack) is flying.' Flodden demonstrates that a forceful monarch in the Renaissance era could mould the identity and function of a nation state. Many have argued that Edward I was crucial to this process in English terms, fixing limitations on powerful magnates and enforcing royal authority at their expense. The creation of an administrative formula which was consolidated over succeeding reigns was a key component in the development of the English polity. It may be fair to say that most people living in this country now identify themselves as British first with their regional and personal affiliations taking a secondary (though still important) place. The evidence suggests things are rather different from a Scots perspective.

James IV had been engaged in a process of establishing control over his own magnates. This may seem to have been rather late in the day in comparison to his neighbours, but we need to bear in mind that it was only in the reign of his father that the last geographical part of Scotland to remain outside Crown control was finally assimilated: the Orkney and Shetland Islands finally came to the Scots' Crown as security for the dowry of Margaret of Denmark in 1468.[41] The king had demonstrated his capacity to deal with potential troublemakers – even when these were members of his own family. Despite the high regard shown by the French Crown for his cousin, the exiled Duke of Albany, James had made it clear that the latter was not welcome in Scotland. Nor was he willing to tolerate the longstanding quasi autonomy of the Lords of the Isles. In 1493 the title was forfeited, but his efforts to exercise hegemony through

nominees were not successful and the dismantling of the Lordship caused far more problems than it solved.

James's death at Flodden began a long period of internal instability which, some writers assert, frustrated any hope of united opposition to the Act of Union, even if Scotland's aristocracy of the day had wanted it. Tyler describes it vividly:

> The dignified clergy, undoubtedly the ablest and best educated class in Scotland, from whose ranks the state had been accustomed to look for its wisest councillors, were divided into feuds amongst themselves, occasioned by the vacant benefices. The Archbishop of St Andrews, the Prelates of Caithness and the Isles, with other ecclesiastical dignitaries, had fallen in the field of Flodden, and the intrigues of the various claimants distracted the church and the Council.[42]

What though, of the physical legacy of Flodden? Those monuments and museum displays that you would expect to mark an event of such matter for two nations? There has long been a curious gap here, too often filled with myth and speculation rather than hard fact or evidence. Take note of an online debate conducted in 2005 between a Scottish-American and the College of Arms. A petition was raised on the site and sent to the College, stating:

> The College of Arms located in London England is in possession of the personal effects of James IV, King of Scots, which were removed from his body after his death at the Battle of Flodden Field in 1513, whereas the English in years following the battle abused, disrespected and eventually lost the corpse of the Scottish King, it is only fitting that the personal effects taken from the body be returned to Scotland where they belong. We the undersigned hereby request that the College of Arms ... do their part to undo a great wrong of history and return the above mentioned items to the Scottish people at once.

The Herald's reply highlights a degree of speculation about Flodden artefacts that is entirely reasonable:

> As an initial point I must state that it is by no means certain that the items that we hold really were the possessions of James IV, the King of Scots, slain at Flodden; historians of weaponry are very doubtful that they really date back that far, and they may have very little historical value; the Scottish people would have probably little reason to be grateful if we were to offload this cache of dubious material on them.[43]

I've had this discussion with the Honourable Christopher Vane, Chester Herald, and have handled the copies of the king's sword and dagger held at Ford. They're about as genuine as Bonnie Prince Charlie's favourite brandy flask (though to be fair he'd have had a few). They are reminiscent of the kind of swords many people had on their walls above coffee tables, bought in Spain in the sixties, all previously owned by Don Quixote. They are more likely the work of Charles Dawson, a serial trickster who created 'Piltdown Man'. He seems to have fooled the Scots and English as well!

More credibly we turn to the spade ... Battlefield archaeology is a relative newcomer insofar as the first full conflict excavation seems to have been that undertaken by Dr Douglas Hunter in North Dakota on the site of the Custer battlefield. This was a fairly small-scale battle conducted by a blundering martinet, but one which has fascinated ever since. Battlefield archaeology is distinguished from 'recceology' – a study of surface finds, the objectives of which may be said to represent an endeavour to set the field in its wider human context. Archaeology, as in the case of Culloden Battlefield(1746), may often show us that the overall area covered by the conflict is much wider than the historical accounts may imply.[44]

From a historian's perspective, the beauty of archaeology lies in its cold, clear objectivity. Finds can tell us a great deal and they provide that compelling physical connection between us today and them: those who were actually on the ground at the time. And archaeology is coldly factual in its very muteness. We know, with Flodden, that the contemporary, primary sources are meagre and that much secondary material needs careful sifting. Writers are frequently partisan. I know I am. They run off at tangents of their own; they misunderstand the evidence; they fail to study the ground. The spade suffers no such limitations; it literally lifts the lid on the past.

Of course, the science is only as good as the evidence. Battlefield traces are notoriously elusive and we can all fall prey to misinterpretation. Whilethe archaeologist, as a scientist, must remain strictly objective and wisely cautious, the historian is allowed a measure of licence. We are free, for example, to use Colonel Burne's theory of military probability. Some will shudder, but we maintain that the soldier's view can lend valuable insight, as long as we refrain from letting our imaginations run wild.

There is general agreement as to the location of the field. Defoe in *A Tour of the Whole Island of Great Britain* observed:

> That there was such a battle, and that this was the plane [field], is out
> of all doubt; and the field seems to be well chosen for it, for it is a large
> plain, flanked on the north side, which must be the Scots' right, and
> the English left by Flodden Hills, and on the other side by some distant
> woods, the river Tull [Till] being on the Scots' rear, and the tweed itself
> not far off.[45]

Much of the solid archaeological work to date has focused on the area of the Scots camp on Flodden hill. Early maps by Armstrong clearly show a feature which very much resembles a small fort or sconce, having pointed bastions at each corner and covering roughly a hectare of ground. Nineteenth-century authors defined this as a possible Roman structure and the site is now much obscured by subsequent planting.

Excavations begun in the 2009 season[46] revealed a substantial structure, raised with dressed stone inner and outer facings and having a complex fore-work at the entrance. This did not appear to be an earlier, Iron Age survivor but possibly something dating from the Flodden era. Frustratingly, a lack of dateable finds defeated any attempt to fix the building in the early sixteenth century. Nonetheless, an abundance of discarded sharpening stones suggests the presence of significant forces equipped with edged weapons. A year before the battle, English secret agents had commented on a diamond-shaped bastion; the classic *trace Italienne*,[47] being added at Edinburgh Castle. Small forts or redoubts of the type identified at Flodden were not thought to have been a feature of field defences in Britain for another generation or so, but we must always bear in mind the number of Continental advisors on James's staff.

The structure would appear to conform to the basic tenets of Italian design as laid down by Leon Battista Alberti in the mid- to late fifteenth century.[48] According to Alberti, the fort should comprise low walls, wide in plan, with artillery towers projected at angles from the walls, complete with firing platform, the whole protected by a series of trenches and outworks. The parapet above the fighting platform could be built up of gabions; enfilade fire could be laid down from the bastions. While it cannot be proven, the find does suggest that the Flodden redoubt (part of James' fortified camp on Flodden Edge, his first position) is an early example of the *trace Italienne*, possibly the earliest in Britain. It was previously thought that, in the case of Scotland, fifteenth-century developments in the gunner's art had not significantly affected defensive architecture save for the addition of gun-loops in existing fortifications. Threave castle, the mighty insular Douglas hol,d which, for a while, defied James II, a consistent enthusiast in the science of gunnery,[49] boasted a gun-looped outwork and circular artillery bastions.[50]

As early as the year of Flodden, a 'blockhouse' was being raised to shield the vital harbour at Aberdeen, and the indomitable Dacre was reporting some ten years after the battle on a similar construction now seen at Dunbar, commissioned by the Regent, Albany. Here, the masonry rampart was up to 6.5m thick[51] and the overall style, with its distinctive wide-mouthed gun loops, showed a clear French influence. Dacre was clearly impressed by the strength of the new redoubt 'and if the said bulwark could be won I think there is no doubt but the castle be won.'[52]

A feature known as The King's Chair stands some 1,000 metres west of the redoubt, and aerial photography has revealed the presence of further contemporary defensive enclosures which encircle the high ground, perhaps linked by a system of trenches. Alberti would no doubt have approved and the whole of the enclosed area could plausibly contain an army of, say, 25,000-30,000 plus a large number of rear echelon personnel, wives and camp followers. Thus far, archaeology has not been able to provide any clues in relation to that vexed question of an alleged Scottish smoke screen, masking their deployment on the morning of 9 September. No evidence of burning has surfaced – yet.

In addition to sharpening stones, the encampment area has yielded cement-stone fragments, almost certainly gunner's or engineer's chalks. Widening the initial search area has produced an array of small finds: horse-nails, harness, buttons and coins. These artefacts were distributed rather too widely to focus our thinking on the overall location and course of the fight. A nineteenth-century antiquarian commented on the amount of cannon shot lying over the field at that time. Cultivation and collecting have, of course, scooped these up long since, though some fascinating finds have surfaced more recently. The OS map of 1866 does point to the location of two ordnance finds, just north-west of Branxton village.

A Mr Rankin from Sunnilaws Farm built up an impressive pyramid of shot in the late nineteenth and early twentieth centuries: somewhere between forty and fifty items. This collection was subsequently broken up and scattered. One survivor has a six-inch (152 mm) diameter with a most distinct casting seam and prominent sprue left by the moulding. A pair of stone shot, two to three inches (50-70 mm), were discovered near Barmoor. These and another iron ball, which was unearthed during construction work in Crookham, could very possibly be from the lighter English field guns. The Crookham shot shows evidence of flattening on impact and, most interestingly, had been drilled to hold what must have been a lead core: such practice was not uncommon, as the technique added weight to shot while not increasing the bore, thus a heavier round could be thrown by a light gun. Furthermore, the round might shatter on impact, creating shrapnel.

Some smaller stone and lead shot from the Scots side might be evidence that their gunners were preparing an early form of grape or lantern shot. Balls packed with flints and perhaps sawdust were crammed into a timber sphere and then fired when the enemy was coming to contact – point blank, virtually. The effect was that of a large shotgun cartridge: devastating against massed ranks at close quarters. This might simply be the normal usage of war, or it might imply that the gunners were aware of the limitations of their heavier pieces when deployed in the field, an attempt to add killing power at short range.

One question, an answer to which the ground stubbornly refuses to yield, is whether either side employed handguns. None are mentioned by the contemporary accounts, though this does not necessarily imply that none were deployed. The use of handguns had been evident a century before. While both England and Scotland had perhaps been rather slower than European states to pick up on these new weapons, we are aware they were used in England during the Wars of the Roses a generation and more earlier. The Earl of Salisbury, one of the more talented English commanders during the later phases of the Hundred Years War, was killed by a shot at the Siege of Orleans in 1428: 'A ball struck the Earl a fatal blow.'[53] We know the Earl of Warwick employed a company of hand-gunners as mercenaries in the 1460s.

These early weapons were smooth-bored, single-shot muzzle-loaders, generally with a short iron barrel lashed to a wooden stock. Early shooters fired from the hip or with their stock balanced on the shoulder. Ignition had been a major difficulty: the weapons were discharged by means of a length of heated wire or match-cord being applied to a touch hole. By the time of Flodden, however, a major step forward had been achieved with the introduction of the 'serpentine'. This is a 'Z' or 'S' shaped lever, attached to the side of the wooden stock and able to pivot a pair of jaws at the business end that clamped a lighted match.

When the long lever was depressed, like a primitive trigger, those jaws were lowered onto the touch-hole and the weapon would (it was hoped) fire.[54] Though a distinct improvement on its predecessors, these early matchlocks were still unreliable and were wildly inaccurate. The psychological effects of early black powder weapons partially compensated for their manifest inefficiencies. Though the stout yeomen who marched beneath St Cuthbert's banner might have stood by their trusty warbows, the days of the men of the grey goose-feather were numbered.

Of pressing interest, to historians and archaeologists alike, is the question of burials. If, say, ten thousand men died at Flodden, where were they buried? Logic and precedent would suggest that interment usually occurred where the fighting had been thickest. The dead generally have no currency and getting them off the ground and into it was a necessary if unwelcome chore. In 1910, possible burial pits were unearthed just south-east of the monument on Piper's Hill, and nineteenth-century records suggest further evidence of mass burials was uncovered during work in the churchyard. Grave-pits are one of the holy grails of battlefield detectives. It is hoped that, in due course, further archaeology will produce more evidence of these.

I had a meeting with Chris Burgess in the café of the epic Barter Books at Alnwick, a nineteenth-century station and one of the UK's largest antiquarian and second-hand book stores – the Harrod's of old books.

He was bouncing with joy as a cache of half a dozen swords had been found. And they were indeed from a battle ... just not Flodden. They actually dated from the Battle of Omdurman in 1898: the Sudanese *Kaskara* can easily double for a medieval broadsword.

Hydrology has also come to the aid of historians. Dr Paul Younger of Newcastle University, in his fascinating and groundbreaking research into the impact of hydrology on the outcome of the battle, has looked at the geology of the vicinity and concluded that there are three 'convergence' zones; these are areas where the water table first clears the ground then the water re-appears. The most notable is that at the foot of Branxton Hill, which so materially affected the course of the fighting. Furthermore, the Scots atop Branxton Hill were likely to have been standing on saturated ground while their enemies on Piper's Hill opposite remained dry. The effects of these factors on both morale and mobility should not be underestimated. Another convergence zone is located at the northern foot of Flodden Hill and would have constituted an obstacle that the Scottish forces would have had to negotiate before their deployment.

Now this was far less of a surprise than the more northerly feature, which did them so much damage and could have been crossed in a more considered or leisurely manner. Nonetheless, they almost certainly marched with wet and muddied footwear.

One ancient survivor, a prehistoric monolith standing some 2.5 metres in height and located just north-west of Crookham Westfield, is referred to and marked as 'The King's Stone'. This is said to mark the spot where James fell. This is a highly unlikely tale, unless of course we are prepared to accept that James survived the immediate wrack of his army and was done to death as he fled by disaffected elements on his own side. Lord Hume was blamed for this and much else besides, but he, had to hang on to his own marches and deal with the backlash of defeat.

In Bamburgh Castle there's a fine Maximilian-style breastplate, said to have been booty from Flodden. It's from the right era, but if the armourer told his Scottish client it was proof against bodkin-pointed English arrows, he was lying. The armour has a very neat bodkin-sized hole drilled in the centre, dead on for the heart. Had the purchaser survived, he could probably have sued, but it's fairly certain he didn't come through.

A Very Rough Wooing

Avenge not yourselves, but rather give place unto wrath; for it is
written, Vengeance is mine, I will repay, saith the Lord.

Rom. 12:19

It's most unlikely that the Bible was preferred reading for our reiver
ancestors, most of whom couldn't read anyway, but it seems equally
unlikely, even if they could, that they would agree with the sentiment. For
them, vengeance really was for the here and now: the ethic of reciprocity
(or their version of it) ruled constantly on the marches.

Ask Percy Reed. Percival was a kind of Deputy-Sheriff or Keeper of
Redesdale and the owner of a decent spread at Troughend.[1] From his
property he kept an eye out for malefactors (of which there was never
a shortage) and he was lively about his duties. As ever, the Liddesdale
names were high on the list and he managed, on one occasion, to nab
young Whinton Crosier:

> The Liddesdale Crosiers hae ridden a race
> And they had far better stayed at hame,
> For they have lost a gallant gay,
> Young Whinton Crosier it was his name.[2]

This was brave – veering towards foolhardy – since the Liddesdale riders
would not take kindly to this.

Crosier's heidman possessed the usual cross-border affinity and was
'in' with the Halls of Girsonfield: Redesdalers, yes, but no friends of
Percy's. What the Halls did next was pretty rough form, even by highly
malleable local standards. They asked Percy Reed to join them for a day's
sport ranging over Rooken Edge and Bateinghope, ending up with a well-
earned rest at the end of a long summer's day with flasks passed around.

Silly Percy dozed off and his hosts set to work. They took the tack off his horse, poured water down the barrel of his long gun (soaking the charge) and glued his sword into the scabbard. Job done, they woke Percy just in time to see five Crosiers looming up.

Reed still didn't get it. He entreated his three companions to stand with him and take the Scotsmen on. They advised him that they had pressing matters elsewhere, that he was on his own, their excuse being that they didn't want a feud on their hands. 'The three fause [false] Halls' as they were branded thereafter, left him to it. Percy now found the odds rising in a most unfortunate manner: he couldn't ride effectively; his gun was useless; his hanger was jammed. The Crosiers closed in, felling him with thirty-three blows: his hands and feet were hacked off and his mangled carcass left littering one of those miniature valleys that flow down into Rede:

> They fell upon him all at once,
> They mangled him most cruelly;
> The slightest wound might caused his deid
> And they gave him thirty-three
> They hackit off his hands and feet
> And left him lying on the lee.[3]

His remains were so carved up that what was left came back in several pillowcases. Even though it was a seriously rough neighbourhood those vicious and cowardly Halls weren't forgiven; they were hounded out. This was a nasty mix of murder under trust, compounded by siding with the enemy. Such things don't get forgotten.

In his superb DVD *Debateable Lands – In Search of the Border Reivers* with Eric Robson (1997), George MacDonald Fraser, breathing in the cold air of Hermitage, suggests that the borderers were *free* in ways we can't now comprehend. Andrea, the hopelessly naïve twentieth-century heroine of *The Sterkarm Handshake* mentioned earlier, breathes in the unsullied air of sixteenth-century Liddesdale and marvels at its unspoilt clarity, the brightness of its colours. I'm not so sure: freedom is a very relative concept. True, our ancestors weren't burdened by the endless restrictions of an all-powerful and deeply puritanical state, and internet bandwidth wasn't a problem – but they were constantly laden with more pressing concerns: food, health, safety, warmth. These were far more real and omnipresent and they had no safety-net, no welfare state; their lives were truly nasty, brutish and frequently short.

What they did have was their name – identity, rooted in the land: names they could recite back to Fairbeorn Armstrong, back even to Conn of the Hundred Battles. In Andrew Greig's astonishing novel *When They lay Bare* (1999), one of the protagonists, an Eliott laird, gets into a fight with yobs in Edinburgh who have insulted his young mistress. 'The blood rising in him and all his ancestors at his back' give him strength: it's a gang of thugs all much younger and feral, but he's an Eliott and *whaur dare meddle wi' me?* That's what sustains you ... who you are, the name you bear, the pride and courage of your lineage.

And that pride in your family name persists. Julia Grint, whom I've known for many years, is a gifted teacher and she and her husband founded and ran an independent (and happily still thriving) independent bookshop in Hexham that used to publish titles under its own imprint, Ergo Press. She explains her relationship with the riding names and her and her husband's own fascination with their fortified houses:

> Both of my parents were descended from Reiver names; it didn't show very often, but with one an Armstrong and the other a Ferguson it was in their blood, and therefore mine. I was brought up with their history, and when MacDonald Fraser's *The Steel Bonnets* was published, it became required reading. No surprise, then, that when time allowed, I began to dig a little deeper into the story of my forbears, and was hooked. Living in Northumberland it's an easy matter to take a long walk across the moors, breathing the clear air and – if you close your eyes – hearing the muted cries of reivers on their unshod ponies.
>
> My particular passion is for bastle houses: they're small, fortified farm houses, built from about 1551 to 1650 as a defence against marauding reivers. They're unique to the Borders and vary in size and shape while sharing certain features – massively thick walls; byre below for livestock in times of attack, living space above with access via a trapdoor or ladder; barrel vaulting in some cases, for extra strength; heavy wooden doors fastened with multiple drawbars. There are many around to explore, some restored, domestic and formidable, utterly beguiling. The *names* still live all over Northumberland; we remain pugnacious, proud, loyal to each other – far removed in spirit and place from central government. And if we no longer need to live in bastles, we're still not sure about the Scots!

Despite the enormous loss that the Scots sustained at Flodden, it was pretty soon business as usual on the borders. There were major English raids that autumn and the riding names kept riding. The problem that both sides shared was that while both could mount large-scale incursions, warden raids and the bloody trail of private enterprise, neither could hope to win any long-term strategic advantage. The old English pale of

Edward III no longer existed or appeared viable; Scotland was incapable of pursuing territorial ambitions south of the Tweed. To add to the northern kingdom's woes, James V was a minor and that engendered the usual dismal internecine squabbling of competing regencies.

Dowager Queen Margaret set the ball rolling by marrying Archibald Douglas, 6th Earl of Angus. Douglas was nobody's favourite, and despite being a tough fighter he would change sides with almost bewildering frequency. He was often head of a significant pro-English faction. James IV had a cousin, John Stuart, Duke of Albany, who, despite having spent most of his life in France and speaking little Scots or English, was persuaded to accept the Regency when Margaret was hounded out, and Francis I was perfectly content to have such an ardent Francophile running the show. Albany's task was a most unenviable one and he defected across the sea to France in 1517 but returned four years later when Anglo-French tension escalated yet again. Henry VIII was always dazzled by the memory of the Hundred Years' War, and longed to emulate the glory and success of Henry V. This obsession largely blinded him to Scotland, in which he had no interest beyond keeping the back door bolted.

Henry allowed that wily old fox Lord Dacre significant licence in how he controlled the marches. The warden was good at what he did, the only trouble being that it involved him in a lot of shady arrangements with dubious characters. He funded some riding names against others, using the royal purse to keep the pot simmering. This bribe/divide and conquer strategy worked well enough in its own way, but it didn't impress many on the English side. Dacre's Machiavellian doings would catch up with him eventually.[4]

Once hostilities between England and France started again in 1522, Albany was determined to help by bringing a large Franco-Scots army into play on the border. He was enthusiastic, as were his French officers, but the Scottish lords were not. Memories of Flodden and the price of dancing to France's tune were far too raw, and besides this, the Scots found the overweening arrogance of their guests intolerable. They refused to cross the border. They simply wouldn't budge across the Tweed. Dacre gave Albany a face-saving way out by proposing an extension of the existing truce and the duke had little choice but to accept. Henry was none too happy, but Dacre's pragmatic solution suited everybody.[5]

In the following year, 1523, things were back to normal. Dacre, with Surrey, pounded the Scottish marches. In his spring *chevauchée* the earl dragged light guns with his column to shoot up Scottish towers that were normally proof against raids. He came up against squat Cessford, a real blockhouse, upgraded by earth banks (or *rampires*) to soak up the effect of cannonballs. The siege stalled. In September he tried again, leading six thousand soldiers and pouncing on Jedburgh. Undaunted,

the townspeople fought back; it was a mini Stalingrad – street by street, house by house, they defended their town until the place was finally flattened. Surrey was a hard man to impress; the grit shown by the people won his admiration but not his mercy, as Ridpath records: 'The English, incensed by this resistance, burnt the town and demolished its ancient and beautiful monastery.'[6]

Andrew Ker's stronghold of Ferniehurst was next on Surrey's 'to burn' list and the situation wasn't helped by the fact that Albany had welcomed Richard de la Pole to Scotland. Pole was a successful *condotierre* in his own right, but importantly, he was Henry VIII's worst nightmare: the surviving Yorkist claimant to the English throne, a new and rather more convincing upgrade on Perkin Warbeck. Yet the duke was being constantly undermined by the queen and other disaffected lords who leaned more towards England; these planned: 'a project of putting the reins of government into the hands of the King, although not yet thirteen years of age'.[7]

In a raid into the Merse that July, a substantial force of English riders led by Sir John Fenwick, Leonard Musgrave and the Bastard Heron of legend, ran into an ambush and were badly cut up. A couple of hundred were taken prisoner and the fight proved to be Heron's last.[8] Dacre was faring rather better, according to Edward Hall: 'appointed to keep the borders against Scotland, (he) did so valiantly ... burned the good town of Kelso and lxxx (80) villages and overthrew xviii (18) towers of stone with all their barmkins and bulwarks.'[9]

That autumn Albany tried once more to bring a large Franco-Scottish force down to the Tweed, but again the Scots weren't having any of it. Determined to make some kind of effort, he led the Gallic contingent in an attack on Wark Castle, defended by Sir William Lisle[10] with only a single company of infantry. Their assault began well, breaking into the outer ward, but Lisle led a near-fanatical counter-attack, despite the odds, and cleared the French out, killing three hundred of them. Albany might have done better with adequate artillery support from the Scottish guns, but they'd already packed up and gone.[11] The duke, disillusioned and bitter, left for France again and didn't return. Two years later a formal truce was agreed, but Dacre, whose past sins were catching him up and whose enemies had grown strident, also became a casualty of sorts: he was stripped of his offices by Star Chamber.[12]

Surrey was withdrawn and for a brief interval the border stayed calm, or what passed for calm. With Albany gone, Henry worked to promote Angus, who was far more amenable, although both Arran (the Regent) and the young king distrusted the Douglas. They were right in this: never one for subtlety, he seized power in a bloodless coup, clinging to the reins until James V came of age in 1528. Like James II before him, James V had a hearty detestation of his stepfather and of his uncle. Angus was soon on

the run and sought refuge at the English court, which Henry was happy to offer.

The wheel of history was shifting inexorably as the king, obsessed with his need for an heir, put aside Katherine of Aragon and took up with Anne Boleyn, lurching towards the Reformation and the stripping of the altars. In Europe the great Catholic powers, France and the Empire, were temporarily reconciled. Scotland was still wedded – despite Henry's best efforts – to France. James sought a wife there, the king's daughter, though the Scottish climate quickly finished her off. He went back for a more robust model and married Mary de Guise, a handsome six-footer and no wallflower.

James was also under the influence of a rising star – David Beaton, Archbishop of St Andrews (latterly a Cardinal) – who fuelled the young man's inherent hostility to Protestantism, shoots of which were just emerging in Scotland. France and the Empire soon fell out and Henry was back in with Charles V. As ever, his ambitions were dogged by the threat of the Auld Alliance. Meanwhile on the borders, it was business as usual and what passed for peace couldn't endure. Henry had tried to persuade James to meet him at York but his nephew stood him up – a monumental and self-defeating gesture; Henry wasn't one to suffer humiliation well. If the young man couldn't see reason, then it was away with the carrot and pick up the stick.

Tension and trouble mounted. In August 1542, the Captain of Norham, Sir Robert Bowes, abetted by the renegade Angus and his brother George, blitzed Teviotdale. The Englishman commanded three thousand lances and following standard drill[13] stationed his main body at Hadden and despatched two flying columns, one with rough riders out of Redesdale and Tynedale, and the other with the more sedate, regular complement, stripped from the defences of Berwick and Norham. The Scots were ready: Sir Walter Lindsay of Torphichen [14] led a vanguard around two thousand strong, with their principal strike force under George Gordon, Earl of Huntly. Lindsay's fast-moving detachment interposed itself between the two flying columns and their main component. Random skirmishing sparked as the riders clashed.

This wasn't the kind of battle for which you could ever draw up a neat plan; it was the snapping, snarling savagery of bickering lances. Lindsay neatly nipped the salient created by the flung-out English columns to get between them and the rest. Huntly received a handy reinforcement of four hundred additional riders led by Hume. What followed was a retreat so hasty it became a rout. Angus, a tough customer and not given to panic, blamed English dalesmen for thinking more of their loot than their honour (in fairness they usually did). Bowes and his brother Richard, with William Mowbray, ended up as captives, along with many others, perhaps as many as six hundred.[15] Angus succeeded in hacking

his way out but was chased clear across the border. Some seventy-odd of the English riders were killed and Hadden Rig, though small beer in overall strategic terms, ranks as a resounding tactical victory for the Scottish borderers.

Further raids were already being planned even before the shambles at Hadden Rig; a hefty *chevauchée* led by Surrey, now Duke of Norfolk, saw Roxburgh, Kelso and a score of lesser townships reduced to ashes. Norfolk's tally of destruction looked impressive on paper, but in any strategic sense he'd achieved next to nothing. The list was carefully primed to placate Henry who was expecting rather more bangs for his bucks ... and these shows cost big bucks. Norfolk had encountered the classic hazards facing any English commander wanting to campaign north of the border, all exacerbated by the time of year, he hadn't set off until 23 October: lack of supplies, lack of carts and baggage animals, bad weather, poor roads made worse by autumn mud – and worse still, a serious shortage of ale.[16]

James was determined to get even, although, despite his earlier exhortations, the victors of Hadden Rig had declined to push their luck across the border. He summoned a levy to muster on Fala Muir about fifteen miles (24 kilometres) from the capital, but nobody wanted to cross that fatal line and the levy plan foundered. Undeterred, James, who was already chronically sick from an undiagnosed illness, raised an army from his magnates' affinities to be led by Robert, Lord Maxwell, West March Warden, a force possibly 18,000 strong [17], though I tend to favour lower estimates of 10,000-12,000.[18]

The expedition got off to a bad start. King James proposed to lead in person but, with his health failing, he could go no further than Lochmaben. Lord Maxwell held command, and was best suited to exercise it, but James could not bring himself to trust his warden (the Maxwells were notoriously slippery) and gave secret orders to his favourite, Oliver Sinclair, that he was to assume command once the army had crossed into England. This was a very foolish plan: swapping horses in mid-stream was bound to spread confusion and damage fragile morale. It was already near the end of November when the invaders broke camp – very late in the season. Nonetheless, the king's overall strategy had been successful, in that he had convinced Norfolk that his blow would fall in the east, which left the back door through the western marches seemingly undefended.

In the wee small hours of 24 November 1542 the Scots were on the march, moving down from Langholm and Marston Kirk, torching Graham steadings throughout the strip of Debatable Lands as they advanced; the resulting grey pall of smoke offered a familiar beacon. In the chill of that late autumn dawn they splashed over the waters of the Esk, beyond which lay the barren waste of Solway Moss. Lord Wharton,

Warden of the English West March, was a veteran of countless border actions and not prone to panic. A less aggressive captain might have been happy to hide behind Carlisle's massive walls, which had always successfully defied the Scots, but Wharton was determined to fight, having around three thousand troops available.[19]

Shadowing the invaders, Wharton commanded some of his patrols to harass the Scottish march behind them, by-passing the invading army to do some torching of their own.[20] As Wharton's riders pricked at the great mass of Scottish pikes they were initially seen off by covering fire from their light guns: Maxwell was dragging a decent-sized artillery train. Once across and on the English side, the attackers advanced past Oakeshaw Hill towards Arthuret Howes, following the line of the Esk. Their path was narrow and constricted, hemmed in by river and marsh – the great wet swamp of Solway Moss. Wharton had gathered his infantry, and moving from Hopesike Hill he set up a blocking position.

At this point, Sinclair declared his authority to lead. James had just stage-managed his own disaster, 'by the King's immoderate affection for Oliver Sinclair'. He had appointed this minion as Lieutenant-General of his army; Sinclair's commission was flourished at the critical moment of the appearance of enemy forces, and Sinclair himself was elevated on two pikes to show him to James's army as their leader. A general murmur was followed by a breach of all order.[21] A worse move could hardly be imagined. If Wharton had been hoping for a miracle, his prayers had just been answered. Lord Maxwell's observations can be imagined.

Perhaps almost at the very same moment, the English warden directed his deputy, Musgrave, to canter from the right of the thin English line and strike a blow against the Scottish left. Wharton, master tactician, could see how the extended enemy deployment could be hustled into that nasty wet ground by a timely attack. He wasn't wrong. With perhaps seven hundred riders Musgrove swooped, struck like lightning, and wheeled to re-form. Wharton knew how to best use his men, to keep pricking and avoid close contact. Meanwhile, Maxwell was arguing with Sinclair – who patently had no idea what orders to give so none were given, no dispositions made; the army remained inert while the Cumbrians hacked and harried their flanks.

Wharton, to his amazement, witnessed a rapid disintegration of the Scottish host. As always the rot began at the rear as men witnessed the damage being done further forward, and this trickle soon turned into a river and finally a tsunami. As the warden dryly noted, 'Our prickers ... gatt them all in a shake all the waye.'[22] James had dreamed of avenging the catastrophe at Flodden, but this farce – though the loss of life was minuscule by comparison – was an even greater humiliation. His army simply fell apart. Over a thousand Scots surrendered. Some hundreds died. for the loss, according to Wharton, of only seven of his own

marchers. It was said that fishermen were dragging corpses out of the water for days afterwards.[23] The shocked and dazed survivors, stumbling back through smouldering shacks on the Scottish side, suddenly found the Grahams, emerging like hungry foxes to avenge their losses. *Le renard* kills for sport, and so did the Grahams, but this time they also had scores to settle.

James's brittle personality, enfeebled by sickness, simply couldn't stomach such an outcome and, blaming his officers for his own folly, he died at Falkland Palace on 14 December; he was only thirty. Both of his infant sons had pre-deceased him, and his only heir was a baby daughter. Worse, the child's nearest male relative was her great-uncle, Henry VIII; the grim spectre that had harried Scotland after 1286 had returned once more. But with a difference, a doctrinal twist; one significant event of James's reign had been those first stirrings of religious discontent. New ideas and new thinking did not sit easily with the pomp and religiosity of the established church, where worldliness, nepotism, carnality and corruption were rife. Cardinal Beaton perfectly embodied all that old style Borgia stuff – and his unpopularity was swelling.

After the disaster of Solway Moss and James's death, Henry VIII appeared to be in an unassailable position. Wharton's victory had brought prestige and had netted valuable prisoners; the new Scots queen was a minor, and a strong anglophile party existed in the country. Arran, the current Regent, was undistinguished. Furthermore, at last the English king had a son, by his third wife, Jane Seymour. A marriage proposal was soon on the table. This was anathema to the spirited royal widow, Marie de Guise, French by birth and staunchly Catholic. Aided by Beaton, she attempted a coup but failed miserably and the Cardinal, hat and all, was temporarily imprisoned.

One who was both witness and player in these events was my own (possibly) distant ancestor, Sir Ralph Sadler (1507-1587). The legacy of Thomas Cromwell didn't die with his execution in 1540; the protagonist of the *Wolf Hall* trilogy was succeeded in influence by his protégé, Ralph. He, unlike his mentor, survived to become 'the richest commoner in England'. Sadler (sometimes spelled Sadleir) was a remarkable polymath and agile gymnast in the tricky survival game of the Tudor court, as well as in the dangerous maelstrom of Anglo-Scottish politics. For nearly half a century he was a key player. Sadler was unique amongst Tudor statesman and diplomats, not just for his humble origins but for the fact that he served four successive monarchs (though his time under Mary was fraught). He also lived to a ripe old age and died both wealthy and in his bed. Given the attrition rate amongst men of ambition, these were achievements in themselves.

Ralph was now the fellow entrusted with that most delicate of missions: broaching the matter of a marriage alliance after James V's

death, which Mary had previously declined. He now managed to achieve a degree of rapport with the formidable Mary of Guise and brokered the marriage alliance between the infants Edward of England and Mary of Scotland. Sir Ralph, as ambassador, had the tortuous task of cultivating the pro-Henry faction, championed by the slippery Angus. As he wrote to his master on 20 March 1543: 'The next morning I met with my Lord of Angus in the Blackfriars here, by appointment ... I discoursed with the great earl at length, thereafter with the Earl of Glencairn and then with both together. I found them both assured to your majesty in my poor opinion but they excused the not proponing [proposing] the matter for the government for your majesty "there was a governor chosen before" which they say "did change the case."'[24] Slippery customers indeed.

The Treaty of Greenwich, signed in August 1543, formalised the marriage deal; the throne of Scotland appeared within England's grasp. In this, his moment of near triumph, Henry proved to be his own worst enemy. His arrogance and condescension alienated many Scots and the pendulum of opinion swung once more towards France. By December, Beaton was free and Mary of Guise back in control. Henry wasn't a good loser and decided that if the Scots wouldn't listen to his kindly, avuncular overtures, more direct means of persuasion were needed. His brief to Edward Seymour, Earl of Hertford [25] for the 1544 campaign was as unequivocal as it was terrifying. He was

> ... to put all to fire and sword, to burn Edinburgh town, and do raze and deface it, when you have sacked it, and gotten what you can out of it, as that it may remain forever a perpetual memory of the vengeance of God lighted upon it, for their falsehood and disloyalty. Do what you can out of hand, and without long tarrying, to beat down and overthrow the castle, sack Holyrood-House and as many towns and villages about Edinburgh as ye conveniently can; sack Leith and burn and subvert it, and all the rest, putting man, woman and child to fire and sword, without exception, where any resistance shall be made against you; and this done, pass over to the Fife land and extend the extremities and destructions in all towns and villages whereunto you may reach conveniently and not forgetting amongst all the rest to so spoil and turn upside down the cardinal's town of St Andrews, as the upper stone may be the nether, and not one stick stand by another, sparing no creature alive within the same, especially such as in friendship and blood be allied to the Cardinal.[26]

It's not quite an incitement to genocide but it comes as close as you'd want. In May 1544, pursuant to instructions, a substantial force under Hertford, harnessing to the full England's amphibious capability, landed at Newhaven on the Firth of Forth and wasted both Leith and the capital.

Edinburgh Castle on its jutting crag, defied English guns but other, ad hoc defences were swept away in a deluge of blood and terror. Citizens battled with all they had, a courageous but hopeless defence. Hertford carried out his instructions to the letter, though Fife at least escaped the holocaust. This was the 'Rough Wooing' and it would be very rough indeed over the next six years.

One feature of the era was the English policy of *assurance*, effectively buying in Scottish names as temporary allies. Gold was always persuasive, and it shielded the *assured* Scots from harm. Many were happy to wear the cross of St George for as long as it suited. But it would suit only as long as the English maintained a whip hand; once that grip was prised free, it could swiftly be broken, and while money talked it did not entirely command.

Distinguished by his greed, even in such ruthless company, was the English Middle March warden, Sir Ralph Eure. Together with Wharton and Dacre, who were active in the west, he mounted a campaign of terror, targeting the Merse, Teviotdale and Lauderdale. This was so effective that a royal warrant was reputedly issued, ceding him all the territory he could conquer. This was unfortunate as these territories were largely in the ownership of Angus, who was tempted to turn coat again: 'He swore that if Ralph Eure dared act upon the grant he would write his sasine [nowadays a 'title information document'] on his skin with sharp pens and bloody ink.'[27] So Angus reverted to his Scottish allegiance, where his wily and aggressive temperament was never more needed. He was appointed Lieutenant of the Border – his past omissions overlooked – and declared his intentions by putting pressure on Eure's *assured* Scots, particularly the Nixons and Croziers. It was their appeals for aid that led Eure with his deputy Brian Laiton to assemble a motley force of about three thousand, many of them foreign mercenaries: Germans, Italians, French, Spanish, Irish and Greeks; the dregs of Continental armies. Crossing the border, he picked up a few hundred Scottish riders who soon seem to have fallen out with the rest of the hired help.

The English ploughed through the marches like a firestorm, leaving Melrose in ashes; the abbey, with its Douglas tombs, was wantonly desecrated. Such depredations could only stiffen Angus's resolve, but he didn't have enough men to risk a battle and had to be content with nibbling at the enemy flanks. He was joined by Arran but, even reinforced, he had only three hundred: enough for Leonidas perhaps, but Angus intended to win. Some time later he was bolstered by another contingent led by the Master of Rothes, so the odds were shortening. By this time the English were camped – stuffed with loot – on Ancrum Moor, hard by the banks of the Teviot and a bare five miles (eight kilometres) from Jedburgh.

Bolstered by Leslies and Lindsays, Angus's mini army now numbered over a thousand and more were on their way, led by the tough Walter Scott of Buccleuch. Though he had initially drawn up his forces on a slight rise overlooking the moorland rim, Angus was persuaded (probably by Buccleuch) to withdraw and deploy, both out of sight and dismounted, using lances as impromptu pikes: 'Having dismounted from their horses and sent them to some eminences in their rear they drew up on a piece of low ground where they were in a great measure hidden from the English who, from the motion of their horses, imagining they had already begun to fly, marched precipitately towards them.'[28] Eure's scouts and leading elements may also have been lured by on by a fleeing gaggle of horsemen – the oldest trick in the book.

Before the battle, and while 'taking up' the marchland, the invaders were said to have fired a tower at Broomhouse, incinerating the elderly owner and her dependents. The cry of 'Remember Broomhouse' would ring the death knell for many who had watched the flames. Laiton, hurrying on with the vanguard, topped the rise and ran headlong onto those levelled lances. Blinded by the rays of a setting sun, the attackers floundered. Behind, Eure advanced with the main detachment, mounted men at arms in the centre flanked on one side by archers and on the other by harquebusiers.[29] The Scots fought hard, emptying saddles and sending the vanguard crashing back against the middle. Seizing the moment, Angus ordered a general advance and the dogged files surged forward, chewing through the invaders' rapidly disintegrating ranks.

Eure and Laiton struggled to rally their polyglot army, knowing they couldn't expect quarter. Of the English, eight hundred or so were killed outright and a thousand more captured, eighty of whom were gentry[30] – a hefty cash dividend. Those *assured* Scots, mainly Liddesdale names, riding beneath English banners, selected the most judicious moment to revert to their national allegiance, swapping their crosses of St George for the Saltire (prudently they tended to wear one on top of the other, just in case). These were Mutual Assurance companies. Neither Eure nor Laiton got out alive. Those dazed survivors who escaped the fight had little hope of ever seeing the border: 'The peasantry of the neighbourhood, hitherto only spectators, drew near to intercept and cut down the English.'[31] 'Remember Broomhouse!'

One of the imagined heroines of the fight was 'Fair Lilliard' whose legend asserts 'upon the English loons [infantry] she laid many thumps/ And when they cutted off her legs she fought upon her stumps,'[32] anticipating Monty Python by four centuries. Ancrum Moor was a significant tactical success and a big morale booster for the Scots, though strategically nothing had changed. Henry plotted to remove Beaton from the scene by having the annoying Scottish prelate murdered, using the radical preacher George Wishart as his tool. Having studied at Cambridge

and in Germany, Wishart was a prophet of the new religion, fervent and ruthless, but he proved less successful as an assassin and ended up at the stake. In May 1546, however, a gang of ruffians finally completed his mission and Beaton was murdered.[33]

After the burning of his mentor, the banner of Reformation passed to John Knox. Born near Haddington in 1514, he trained as a priest before being assailed by doubts and converting to the Protestant cause. The murder of Beaton did the anglophile party little good, and Mary of Guise chased the rebels back behind the walls of St Andrew's Castle, where they continued to hold out for a time. The death of Henry VIII and the accession of a sickly boy, Edward VI, put paid to any hope from England and encouraged France in more overt support for the royalists. St Andrews was reduced by naval gunnery and the 'Castilians' obliged to strike their colours. Knox was sent to the galleys where he languished until released through English influence. He remained in England until his return to Scotland in 1559.

On the night of 28 January 1547 Henry VIII died, to the sorrow of few and relief of many. One who was very relieved was Thomas Howard, Duke of Norfolk, victor of Flodden and uncle of two queens of England,[34] both of whose death warrants he had signed. Norfolk had been due for his own appointment with the headsman that morning, but Henry's death saved him: an automatic amnesty. Ever the recusant, he would go on to serve Bloody Mary and die in his bed at a ripe old age. Edward Seymour, now elevated to Duke of Somerset, was, as Jane Seymour's brother, the young king's uncle and was appointed Lord Protector. Unlike Henry, he didn't see subjugating Scotland as a viable strategic objective. That didn't mean Scotland was no longer under attack: it just shifted the emphasis. What Somerset wanted was to win hearts and minds, taking assurances and buying friends while building up an English pale on the border.

This was nothing new of course; Edward III had attempted to do the same. What had changed was the landscape of faith. As momentum grew behind the Scottish Reformation, the Auld Alliance with Catholic France, which had always been rather one-sided, became progressively less attractive. Nonetheless, Somerset's grand plan would never work, despite a promising start. Costs would be prohibitive, construction, manning and supply would always be a logistical nightmare and, finally, there would be major French intervention to cope with.

Before any carrots could be delivered it was time to put some serious stick about. Somerset gathered his forces around Newcastle throughout August and by 1 September 1547 was on the road north, heading for a muster at Berwick. At the same time, Wharton would lead a second pincer, more of a large-scale raid, from the west, pointed at Annandale. Somerset's main strike force totalled just over eighteen thousand.[35] John Dudley, Earl of Warwick, acting as Lieutenant-General, effectively chief

of staff[36] led the vanguard of three thousand; Somerset commanded the four-thousand-strong centre or main battle and Dacre a staunch rearguard of another three thousand.[37] This was primarily a northern levy, though the men might be conscripts in name. They had been in the field on and off for five years and campaigning against the Scots was in their blood.

Lord Grey of Wilton commanded the cavalry, a mix of 'light' and 'heavy' two thousand 'demi-lances'[38] under Sir Francis Bryan, half a thousand stripped from Boulogne's garrison with four thousand 'heavies' under Sir Ralph Vane, including Sir Thomas Darcy's Gentlemen Pensioners of the Royal Bodyguard[39] and Edward Shelley's 'Bulleners'.[40] This was very much an all-arms force. Somerset had hired in mounted harquebusiers led by the mercenary Pedro de Gamboa, with Italian specialists under Malatesta. Scouting was undertaken by Sir Francis Bryan commanding four hundred riders.[41] Fifteen big guns made up the artillery train and the army needed a tail of nine hundred supply carts and a multitude of assorted wagons.[42] Just moving this huge contingent through enemy territory on appalling roads was a major logistical feat: fourteen hundred pioneers were needed and the vast column would have extended for twenty miles or more. Scottish riders, like jackals, would be hanging on the flanks waiting for any chance to strike,[43] and Somerset's own light cavalry would have been constantly busy.

The Lord Protector, a fine soldier if an indifferent politician, was an active commander and he spied out Eyemouth harbour as a potential forward operating base beyond Berwick. The Governor, Thomas Gower, was left to start digging foundations for a new fort.[44] This wasn't castle building. Old medieval walls could no longer withstand modern artillery so the new science of defence depended on timber and earth redoubts, designed to soak up roundshot and based on the *trace Italienne* model: wide flanking bastions that could be crammed with guns while also providing enfilade fire. Many such forts, such as the later construction at Haddington, were dug from scratch, others incorporated earlier towers, retained as blockhouses or modified as gun platforms. In the years 1547-1550, English strategy relied on such outposts and several later survived multiple sieges.

Four days later the army was approaching Cockburnspath, sixteen miles north of the line and the narrow defile known as the Pease. Somerset feared the Scots would be lying in wait there, where the Lammermuir Hills slip down towards the coast. High cliffs along the ragged coastline would have sheltered defenders from naval gunfire, as an English fleet under Lord Clinton shadowed the army: thirty-four warships, thirty transports, one galley and a shoal of lesser vessels.[45] Arran chose not to fight for the gap, so that abandoned trenches were all the English found. That evening the invaders approached Tantallon Castle and its formidable defences

seem to have deterred the Lord Protector, despite his big guns. Smaller fortlets, like Dunglas (which surrendered) or Thornton and Innerwick (which had to be assaulted) fell after short but stiff exchanges.[46]

At dawn the English marched westward again through East Linton, making camp at Longniddry. On 8 September the march was resumed over ground since covered by Prestongrange Golf Course, behind which the land shears away from the coastal plain and rises to form Fa'side and Carberry Hills.[47] Always a prudent man, Somerset pulled his troops back to camp on the coast, more or less where the present caravan park is located, undisturbed by the hostile garrison in Fa'side Castle. He had reason to be careful: deployed against him were those thirty thousand Scots the Governor had managed to muster.[48]

Arran had shown a shrewd eye for ground, his line fronted by the sweep of the Esk bellying out towards the sea, with steep banks on the defenders' side. He controlled the only bridge where the road to Edinburgh crossed the Esk. Huntly, on the left of the line, had thrown up an earth parapet to shield his men from Clinton's naval guns, his division beefed up with Argyll's four thousand clansmen.[49] Arran took the centre, strongly positioned on Edmonstone Edge, and Angus the right, his flank covered by Hume's fifteen hundred border lances and shielded by wet ground on both banks of the river but with a wider marsh on the south side. Somerset convened a council of war; Clinton's seaborne vantage gave him a perfect view of the whole Scottish position. Meanwhile Huntly issued the standard chivalric challenge – daring Somerset to settle the issue with a combat of twenty a side, ten a side or just the two of them having it out.[50] Somerset wisely declined.

On 9 September, Hume's borderers splashed across the Esk, trusting in their swift and sure-footed border garrons, aiming to rattle their enemies. Lord Grey was all for the charge but Somerset preferred caution; for a long time the English line stood while the Scots postured. Grey insisted, Somerset relented, trumpets blared and his cavalry advanced. Caught by surprise, the borderers soon fled and were hunted down; some were killed and perhaps eight hundred, including Hume himself, went into the bag: 'After a skirmish of three hours the Scots were defeated and driven back to their camp with great slaughter.'[51] This outwardly minor setback robbed Arran of what effective cavalry he had.

A little after 8am on Saturday 10 September, the Lord Protector ordered the advance. His immediate goal was the hillock, although he was only thinking of it as that day's campsite and as a handy spot for his guns.[52] Sweating and cursing, gunners and matrosses manoeuvred their great cannon. He hadn't, at that point, realised that the Scots were already marching – Arran had given the order to advance. Why did Arran choose to abandon such a strong defensive position? He may well have

feared the broadsides from Clinton's ships, but he could also see a chance of catching the English unawares, possibly while still in camp.

Somerset was wrong-footed as his army sighted the Scots moving towards them, and fast: '...coming towards us, passed the river, gathered in array and well nigh at this church [Inveresk] 'ere we were halfway to it'.[53] Though the armies were on a collision course, neither had been fully aware of the other, but as Huntly's rearguard moved out of the cover of their earthworks the fleet began firing, and the Master of Graham (son of the chief) and twenty-five other ranks were pulped in an instant. Despite such losses, and the morale-bursting effect of being under fire in the open (which rattled Argyll's highland archers) the Scottish juggernaut rolled forward, a bristling steel-tipped leviathan. Angus led with eight thousand spears and five guns; Arran followed with ten thousand, the cream of his army, and Huntly started with another eight thousand (although a number were already wavering and some had probably voted with their feet).

Somerset wasn't slow to work out the crisis he was facing; his carefully considered plans were evaporating in the fog of war. Dense as the ranks were, the Scots came on at an impressive pace. It would be a race to see who could get to the high ground of Fa'side Hill first. Somerset couldn't allow the Scots to win: this called for another hasty council of war. To curb the rush of pikes Somerset had to commit his cavalry, relying on shock and impact to slow them and to buy time to get his guns in action and his infantry into line.

One eyewitness who provided us with a comprehensive first-hand account was William Patten, Somerset's secretary. He could clearly see the Scots pike brigades, who

> ... stood at defence, shoulders nigh together, the fore-rank stooping low before their fellows behind them holding their pikes in both hands, the one end of the pike against the right foot, the other against the enemy's breast, so nigh as place and space might suffer. So thick were they that a bare finger should as easily pierce through the bristles of a hedgehog as any man encounter the front of the pikes.[54]

Both sides were bringing more and more guns into action; the field was already shrouded in a dense pall of acrid smoke, making command and control even more difficult. Cavalry attacking head on and unsupported had very little chance of breaking a pike formation and the Scots weren't overawed: 'Come here lounds [rascals]; come here tykes [dogs]; come here heretics,' they jeered.[55] Grey and Shelley's Bulleners would advance from the east while Vane with d'Arcy's Pensioners would come at them from the west. To make matters worse, the agricultural land over which they'd have to ride was 'a fallow field', with furrows lining towards the

English, the ground bisected by a ditch that both slowed momentum and impeded many riders, who became bogged down.

As the cavalry charged, artillery support was provided by guns drawn up on higher ground behind. This would never be the mad gallop of movies but was at best a sedate canter: mass and cohesion mattered more than speed. 'Herewith waxed it very hot,' Patten commented.[56] The pikes won. Horsemen were spitted on points, horses gored and brought down, a mass of human and equine corpses piling up (many of the heavy cavalry had left their horse armour with the baggage as they had not expected to fight, and now paid the price). Men and boys would dart from the phalanxes to hobble and hamstring horses and to cut the throats of riders. Steam rose like a cloud from the sweat, blood, entrails and excrement puddling the churned ground while the charnel house reek and satanic pall of gunsmoke added a furious top note.

Recoiling, losses heavy, the English cavalry stumbled back up the slope to the catcalls of their unshaken enemies. To the Scots it seemed the battle must be won and the field theirs. Somerset and Vane had a job to rally their riders and re-form on the flanks of the English infantry. However, though apparently victorious, the pikemen had stalled and were now being winnowed by continuing fire from Clinton's ships and Somerset's musketeers. No further advance was possible in the teeth of such a barrage; the Scots were hemmed in by the press of their dead. Many of the English cavalry had paid the ultimate price, including Edward Shelley and a slew of his 'Bulleners', but their sacrifice was not in vain. From a range of two hundred yards and less, English guns raked the massed files: arrows and bullets peppered their ranks.

Swooping like vultures, De Gamboa's lethal harquebusiers harassed their flanks. They couldn't advance but to stay put was to invite destruction, so the Scots attempted to withdraw – a difficult manoeuvre for pikemen. The phalanx shivered, stumbled and then, like a torrent, broke, pursued by jubilant cavalry. 'They fly, they fly,' the English exalted.[57] Their pikes, which had only a short while before dominated the fight, were left abandoned: 'The place they had stood like a wood of staves (pikes) strewed on the ground, as rushes in a chamber, impassable they lay so thick for either horse or man.'[58] Losses on the Scottish side were terrible; perhaps as many as ten thousand failed to reach the north bank of the Esk. Amongst the rank and file sprawled many of the nobility, but wily Angus evaded both death and capture and slipped away with the mass of fugitives streaming towards Dalkeith. Huntly, who was also Scotland's Lord Chancellor, was captured. English losses barely exceeded two hundred and fifty, mostly, as noted, from amongst the cavalry – the infantry got off far more lightly.

Pinkie was a momentous tactical victory but a strategic failure; the Scots had suffered another severe beating, but they soon bounced back

and Arran's credibility survived his running away. Somerset, however, felt he could now get on with his primary objective of turning the Scottish border into an extended outpost line. He wanted to bend hearts and minds with persuasive sharp swords, but it's a difficult trick and the costs of his venture were prohibitive. Wharton had got off to a good start in the west after his successful 'taking up' of Annandale, but in February 1548 it all went wrong for him: he was caught out in a well-staged ambush at Drumlanrig and suffered a humiliating near-defeat. Raging against his *assured* Scots who'd proved to be totally un-*assured*, he went so far as to hang some of his hostages. That didn't do too much for hearts and minds either.

Somerset, meanwhile, had established a post on Inchcolm Island in the Firth of Forth and had even pushed his line up to the Tay, taking over an *assured* castle at Broughty which, in theory, could control both the river and Dundee. Sir Andrew Dudley, Warwick's capable younger brother, was given command, but he soon discovered that he had been passed a poisoned chalice, a regular Fort Zinderneuf: men, materials, horses, food and ale were all in permanently short supply. Nonetheless, he saw off several sieges and was finally bolstered by a new, sheltering redoubt in modern style. Dudley kept hanging on by his fingernails. When he was finally relieved by Sir John Luttrell, who had held Inchcolm, I doubt he even spared a backward glance.

Eyemouth was already being fortified, Hume Castle was taken and ancient Roxburgh re-modelled. A new and impressive fort, state of the impromptu art, was thrown up at Haddington, big enough to house a garrison of two and a half thousand.[59] Somerset couldn't afford to keep the fleet in action so the ships were sent home, which vastly exacerbated his supply problem. His intention was that light cavalry stationed in his new bases could range freely and destructively whil reminding *assured* Scots where their loyalties lay. To do that they needed healthy horses, and unfed mounts don't stay healthy. Somerset had bitten off more than he could chew, and the spectre of the Scots receiving significant French assistance loomed closer in the early part of 1548. When the French did land they brought a good general, d'Esse, with plenty of men, guns and supplies. Their troops were all seasoned campaigners and they put heart into the Scots as well as boosting resources. Both sides still relied heavily on mercenaries; Pedro de Gamboa was still a player and each country imported ensigns (a double company, 300 and more strong) of German *Landsknecht*[60] who, tough customers as they were, didn't always rub along with their respective host nations.

D'Esse hammered away at the English forts but was generally seen off. Baulked militarily, he managed to achieve a real diplomatic coup. Arran persuaded the Scottish Parliament to ratify Henry II of France's proposal that Mary should marry his son, the four-year-old Dauphin, Francois.

The Governor's reward was a French dukedom – a real plum – while the Scots were happy to sacrifice their independence to France just to spite England. In August, Mary, aged five, sailed for France; any hope of reviving the Treaty of Greenwich sailed with her. Somerset's strategy had come unstuck; further fighting was now just an appendix to failure. Yet nobody was quite ready to give up. Grey, utterly exhausted, was succeeded by the Earl of Shrewsbury as Lord-Lieutenant in the North, who lifted an epic siege of Haddington. The new commander re-established a strong naval presence so that French ships could no longer ply with impunity. Some were sunk, more became prizes. Undeterred, d'Esse made a further attempt on Haddington, hoping to seize the place by a coup de main or *camisado* (surprise attack). He very nearly succeeded, but his failure left several hundred of his men dead in the ditches.[61]

Like two weary boxers locked in an exhausted embrace, the Franco-Scots and English stumbled on. The war was pointless yet infinitely bloody and merciless. The cruel English garrison at Ferniehurst were cut down wholesale by vengeful Scots whose bitter, hateful fury astonished even their allies.[62] Northumberland didn't escape destructive raids either, and Ford Castle was unsuccessfully besieged. Meanwhile, Somerset had other worries: there was unrest and rebellion in the south-west of England and an increasingly hostile Council who undermined his authority and finally wanted his head. Warwick, his rival and successor, inherited an unwinnable and hugely costly war. Like dominoes, the remaining English garrisons toppled, and what was left was finally abandoned as untenable. There was bad news from France, too, as Henry II threatened Boulogne. A treaty was needed and agreed: the 1551 Treaty of Norham. Both sides had really had enough and then the war – just like that – was over. This Rough Wooing had been the bloodiest episode in a long saga of bloody episodes and the stains would soak deep into the souls of both kingdoms. They're still there.

* * *

Ever versatile, during the war Sir Ralph Sadler became a soldier rather than diplomat; he was quartermaster for Lord Hertford during the brutal invasion of 1544. A universal fixer, he did well in his new assignment and was soon back again as QMG for the English army that fought and won at Pinkie three years later. Again, Sadler outlasted his master and even came through Bloody Mary's vengeful spree.

Elizabeth I soon found use for his more subtle skills when she debated whether to help Scottish Protestants oust the last partisans of the Auld Alliance, along with the French spears that were propping them up. Machiavelli would have been proud of the crepuscular logic Sir Ralph deployed to justify this meddling in August 1559:

Q: Whether it be meet that England should help the nobility and Protestants of Scotland to expel the French, or not? A(1): It is agreeable both to the law of God and nature, that every prince and publick state should defend itself, not only from perils presently seen but from dangers that be probably seen to come shortly after. A(2): Nature and reason teacheth every person, politick or other to use the same manner of defence that the adversary useth in offence.[63]

In short, there was every moral and practical justification for Elizabeth to support the Scottish Protestants. And this religious accord would, in due course, foster the Union of the Crowns.

In December 1560, the young and chronically unstable King of France died and his eighteen-year-old Scottish consort, Mary, found herself unpopular with her formidable mother-in-law, Catherine de Medici. The following year she returned to her native land, cold and impoverished. It was a poor substitute for cosmopolitan France. Mary had at least sufficient sense to ignore Huntly's dangerous overtures and make herself amenable to the Protestant clique, the Lords of the Congregation. She would not, however, agree to ratify the Treaty of Leith, which had ended hostilities with her adopted country, because a clause in the draft excluded Mary from the English succession. This was a potential prize she would not willingly relinquish.

I think it was George Macdonald Fraser who observed that wherever Mary went trouble was sure to follow. Her tenure in Scotland – no easy task, being the Catholic Queen of a now Protestant state – was not a happy one, and her final failure at Carberry Hill saw her incarcerated in Lochleven Castle. She was forced to abdicate in favour of her infant son who was very much *not* being raised as a subject of Rome. She broke out of gaol, but her short-lived comeback fell flat in the rout at Langside. Mary was on the run, and she ran to England – which surprised everybody.

When the runaway queen and a tiny band of adherents landed at Workington on 16 May 1568, nobody had any idea what to do with her. The plain fact was that she was toxic; most of Catholic Europe recognised Mary as the rightful queen of England, and Elizabeth as a heretic bastard. There was paranoia in the administration that she'd now be a talisman, a beacon for disaffected recusants in England. These fears were fully justified. Mary was met by Lord Scrope's deputy and escorted to Carlisle. Her status was uncertain; clearly she wasn't a prisoner – not quite – but nor was she exactly on a state visit, since she no longer had a kingdom to visit from. Her half-brother Moray, victor at Langside and now Regent, was moving rapidly to consolidate his position and was ready to cooperate fully with the English wardens.

Technically, her initial landfall placed her under the Earl of Northumberland's remit, and Simple Tom (as Percy was rather unkindly labelled) wasn't so simple that he didn't recognise a valuable pawn when one was thrust under his nose. Moreover, though not a Catholic, he was part of a general disgruntlement of northern gentry. Scrope cannily denied Northumberland's request to take charge of Mary, but at the same time his West March was far too close to the border for comfort, and Maxwell, still with the queen, had too many confederates just across the Solway. Mary was soon moved south to Tutbury. Meanwhile, her royal cousin wondered what to do with her. Mary wasn't – would never be – in irons, but she would never breathe free air again. That August, Elizabeth appointed Lord Hunsdon as East March Warden and he would prove a very sound choice. She would have need of him.

Thomas Percy, 7th Earl of Northumberland, was the son of Sir Thomas Percy who had lost his head in the clear up after the Pilgrimage of Grace (October 1536-February 1537). The stripping of the altars by Henry VIII had alienated many devout Catholics in the north and a lawyer, Robert Aske, became unofficial leader of a popular insurrection which began at Louth in Lincolnshire and soon spread to Yorkshire. This wasn't so much a revolution as a large-scale protest, but it was fully armed and followers came to number as many as thirty thousand. Initially, Northumberland and the borders weren't especially involved and Henry bought off the pilgrims with promises, secured their goodwill – then dealt with them once they had disarmed and dispersed.

Northumberland's Uncle Henry, the 6th Earl, was a rather dysfunctional character, an ex-boyfriend of Anne Boleyn. He managed to waste or alienate most of his vast patrimony before (to everyone's relief) dying in his thirties. One of the main beneficiaries of his largesse was Sir Reynold Carnaby of Halton, a proper Jack the Lad. There were no flies on Reynold: he abused Percy's generosity and participated enthusiastically in dismantling the abbeys, taking Hexham for himself.[64] (Sir John Forster was his son in law and I'm sure they got on famously.) Carpetbaggers make enemies and Carnaby had plenty. These included Percy's younger brothers, Sir Thomas and Ingram.

In October 1536 the brothers hosted a gathering at Alnwick, ostensibly to muster support for the Pilgrims but in fact to assemble a faction aimed at bringing the local upstart down. Heron of Chipchase (who felt cheated of the traditional office as Keeper of Tynedale, another of Carnaby's captures) was keen to help. So effective was the offensive that Sir Reynold felt obliged to hide behind Chillingham Castle's thick walls[65] and his people were roughed up at Stagshaw Fair. Sir Thomas Percy was no fan of the king, either, who had refused to recognise him as his brother's heir, despite being his nearest relative. For their part in the Pilgrimage of Grace, Thomas died a traitor's death at Tyburn in 1537 and Ingram went to gaol. Family resentment survived.

Lord Burghley, Queen Elizabeth's *eminence grise*, had no particular love for the Earl of Northumberland. Even though Percy opposed a suggested marriage between Mary and Thomas Howard, 4th Duke of Norfolk, he was already suspect and his abortive bid to grab Mary set alarm bells ringing.[66] If Tom was dull, his beautiful wife, Countess Anne, was the life and soul – but she was a convinced papist, the daughter of Henry Somerset, Earl of Worcester. His younger half-brother, Henry, had already earned a reputation as something of a *beau sabreur* in the endless run of cross-border skirmishes. Meantime, Moray and Hunsdon got on very well indeed. The Regent, who needed to keep control of his unsettled marches, found a willing and effective ally in Hunsdon. Moray's version of local justice was of the short, sharp shock variant, coming down hard on Liddesdale. This type of summary justice never produced any lasting calm, but levels of cross-border cooperation were at an all-time high.

By 1569 an unlikely conspiracy was brewing. Tom Percy was talking to Charles Neville, Earl of Westmorland. Now, Westmorland's countess, Jane, was a real firecracker, daughter of the Earl of Surrey who had been executed for treason in 1547, and a fervent Catholic. The third triumvir, Leonard Dacre ('Crookback' Leonard, that 'cankred suttil traitor') was motivated primarily by rage at being, as he saw it, cheated out of his Dacre inheritance at Naworth by the Howards (and they're still there). None of this unholy trinity was leadership material, but Mary was their catalyst and letters were sent to Madrid and to Rome seeking support.

These northern lords were not successors in title to Aske's pilgrims a generation before. Their grievances were more personal. They'd done well under Queen Mary I but felt marginalised under Elizabeth. If neither of the earls was a born general, many of their adherents were strongly motivated by ingrained loyalty to the old ways.[67] Their treason was born of perceived grudges rather than conviction, but we should remember that Elizabeth's version of Protestantism, the Church of England, was still an infant in comparison to the centuries of Rome. Besides, and though the Queen had confirmed Percy in his office as East March Warden, his appointment was fettered by so many restrictions that he gave it up and Lord Grey of Wilton, a southerner, took over. Percy had to endure the humiliation of the new warden lording it over his family seat at Alnwick.

Burghley was watching all three, but the administration seemed wrong-footed when their rebel flags were raised that November. Thomas Radcliffe, Earl of Sussex, the queen's representative in the north, perhaps fearful that his friendship with Norfolk might smear him, summoned the northern Earls to York, and on 9 October they duly appeared. Despite their fulsome declarations of loyalty, Sussex thought it wise to ensure that the major centres were put on alert and kept well supplied.[68] Queen Elizabeth had heard of this proposal – that Mary should be married to the Duke of Norfolk, which would enter her into the English polity – an

idea that even some Protestants found reasonable. The queen did not. It may be that a letter written by the Duke of Norfolk to Westmorland on 1 October begging him *not* to rebel was the catalyst; the duke was hoping he might marry the Scottish queen and create a powerful papist bloc, but he had lost his nerve by this point.

Sir Thomas Gargrave wrote to Burghley on 2 November:

> News came that the Duke had left the court and gone to Norfolk and that thereupon the Earls of Northumberland and Westmorland had caused their servants to take up their horses and be in readiness, whereupon the people imagined that they would assist the Duke ... There was another bruit [rumour] that the confederates minded to deliver the Scottish Queen from the custody of the Earl of Shrewsbury.[69]

Percy still bore the magic name and the dalesmen were happy to fall in with any cause that offered free licence. The rebels marched down to Durham and celebrated mass there, waving a two-fingered salute to Elizabeth: a cack-handed revival of the Pilgrimage of Grace. Mary was rapidly moved further south to Coventry while her northern adherents, holding Warkworth and Alnwick, wondered what to do next. For lack of any ideas, they settled for a siege of Barnard Castle.

Spanish aid was rumoured, but it never materialised: the rebels even sent a flying column to seize Hartlepool as a potential bridgehead. Meanwhile Hunsdon blamed their wives! Writing to Burghley on 26 November he sneered:

> I am sorry to hear of Westmorland's wilfulness in refusing to follow the advice of those who, for his house's sake, wish him well. The other [Northumberland] is very timorous and has meant twice or thrice to submit, but his wife encourages him to persevere and rides up and down with their army, so that the grey mare is the better horse.[70]

Moray, however, had his own marchers on a tight leash while Hunsdon, Sir John Forster and yes, Henry Percy, prepared a local counter-offensive. Lost castles were retaken and the rebels scattered after a skirmish at Chester le Street. The earls fled west. Naworth's gates were shut and Dacre wasn't inclined to hear anyone knocking. They panicked and went into the Scottish marches where fugitive Northumberland and his spirited lady found a very different level of accommodation, with betrayal and a traitor's death to follow. Younger brother Henry slipped effortlessly into his sudden inheritance.[71] Hunsdon was pretty scathing about the tardy response from the Queen's forces labouring up from the south: 'Others beat the bush and they have the birds.'[72]

Moray cooperated fully in the capture of Northumberland, though Westmorland escaped. The Earl of Sussex, arriving belatedly in the north with reinforcements, hanged as many rebels as he could find. So far so good, but in January 1570, Moray was 'taken out' by a sniper while riding through Linlithgow. With his strong hand now cold and still, a froth of trouble rose immediately to the surface. Mary's supporters in Scotland – and there were many – found an ally in Dacre, who'd kept out of the earl's folly but was still implicated. Scrope was after him, but Dacre prevaricated and managed to raise a substantial force from his own tenants with a promise of hundreds more from over the line. Combined, they could grip Carlisle in a vice; the warden didn't have sufficient manpower to hold it, provided of course, they could combine.

As before, Hunsdon and Forster came up trumps. The warden marched out of Berwick leading his garrison while Sir John raised as many riders as would follow him. Forster had charisma and courage and the names responded; besides, there would be loot. By dusk on 18/19 February they had marched as far as Hexham. Hunsdon could confront Dacre directly at Naworth or side-step to join forces with Scrope. He opted for the latter, but Dacre tried to block the road near the confluence of the little river Gelt and Hell Beck (well named), about four miles (6.5 kilometres) south of Brampton.

In a short, sharp fight, Hunsdon and Forster scattered the rebels. As the warden reported: 'In a heath where we were to pass a river (the Gelt) his foot gave the proudest charge upon my shot that I ever saw; whereupon having left Sir John Forster with five hundred horse for my back, I charged with the rest of my horse upon his foot and slew between three and four hundred.'[73] Dacre managed to escape and got away to the Spanish Netherlands, where he remained a nuisance until his death three years later. There weren't many mourners.

Though victory was won, it appeared only a respite; the Scottish marches were in turmoil. So, in the spring, Sussex launched a major *warden rode* to bang heads together. Seconded by both Hunsdon and Forster, this was a thorough job. Buccleuch and Ferniehurst, both leading Marians, were targeted; Hawick, Jedburgh and Kelso all took a hammering. Scrope carried on the good work in the west though Maxwell made him fight for it at Old Cockpole; this was a narrow English victory, abetted by the Armstrongs, who never let an opportunity slide by. Savage and unrelenting as such harrying would appear to the citizens of Hawick or Jedburgh, this was the last *chevauchée*, the curtain-call of the major warden raids. Mary's failure meant a Protestant Scotland with a Protestant king, which would eventually produce an outcome that nobody could, at that point, have foreseen.

Long before Bamburgh Castle, in a ruinous condition, came into the capable hands of William Lord Armstrong (who gave the castle its Olympian makeover) it belonged to the Forsters. Sir John had acquired the castle from the Crown in the middle of the sixteenth century and retired there after his tumultuous five decades as Warden of the Middle March. He was no Marshal Will Kane – he was much more a part of the problem than he was the cure. It could fairly be said that he understood the nature of the rampant criminality on his turf because he was the facilitator of most of it: more Mafioso than lawman. He took a cut on every act of thievery, and there were many. It was on his watch that a border truce day in July 1575 degenerated into a mass brawl with dozens dead, the Raid of the Reidswire (as described in Chapter Three).

Sir John was persuaded to retire in the mid-1590s, at an extraordinary age: he certainly made it past eighty and probably longer. His last years were very nearly as turbulent as the rest; a posse of assassins sought him out in 1597, even in his dotage, at Bamburgh, and only Lady Forster's quick thinking saved her husband's life. His descendants held the place for several generations. Dorothy Forster (1686-1767) became a romantic heroine of the doomed Jacobite Rising in 1715.

After Forster came Carey, and a greater contrast would be hard to imagine; it was something of a culture shock for the inhabitants of first the East and then Middle March in England. Robert Carey, born probably in 1560, was the tenth son of that tough old bruiser Sir Henry Carey, Lord Hunsdon, described as 'an honest stout-hearted man ... something of a braggart.'[74] Young Robert was well educated and spent an apprenticeship in diplomacy; he was sent on a number of high-level missions to the court of James VI. He campaigned with Essex in France, fought against the Armada and served as MP for Morpeth. A favourite of his aunt, the queen, he fell from grace after his marriage in 1593, which led to a stormy session with an angry *Gloriana* ... but silver-tongued as he clearly was, he managed to re-ingratiate himself into royal favour.

Lord Scrope, the unfortunate West March Warden, precious son of a very able father (to be humiliated in the Kinmont Will Armstrong debacle) was Robert's brother-in-law and secured him his first role as a border law enforcer. Even better, uniquely for the time, Carey left us a detailed memoir. He served his probation as warden in the East March before being moved to the Middle March, a much tougher assignment, hardly improved by Sir John's long and astonishingly corrupt tenure. It was in a dreadful mess and even Carey thought twice but finally acceded: 'I knew all things were out of order ... and that the thieves did domineer and do what they pleased and that the poor inhabitants were utterly disabled and overthrown.'[75]

It was a monumental task but Robert set to, moving his household and family into Alnwick Abbey, Forster's old place, and soon making his

presence felt. His internship in the west under Scrope had taught him some valuable lessons. It was indeed a 'stirring World' and a dangerous one. When stationed at Carlisle, agents brought news that a brace of fugitives were being abetted by a man called Greene whose tower was a bare five miles (8 kilometres) off. The suspect lived in a 'pretty' house with the old tower handily adjacent. Carey left in the early hours with twenty-five troopers, aiming to surprise the place at dawn.

Nice try ... but the Scots were too quick and reached the safety of the tower before they could be flushed out. Ominously, a lad was seen galloping off, and Carey's experienced deputy, Thomas Carleton (more on him later), warned him that the boy was off to raise reinforcements: the posse would soon have a major fight on their hands. That was a game two could play and Carey, on Carleton's advice, sent off for more troopers. Within a few hours, scores more riders and, finally, infantry from the Carlisle garrison arrived. Carey now had a combined force of hundreds. To take the tower, men got up onto the roof with ropes and grapnels, prised free some of the stone flags and a squad dropped down into the upper storey. The defenders saw the writing on the wall and gave up.[76]

Just as the Scots struck their colours and came out, a sizeable body of Scottish riders hove into view – perhaps as many as four hundred. The English West March lads were overjoyed: here was a prime opportunity to even a few outstanding scores: 'God hath put them into your hands that we may take revenge of them for much blood that they have spilt of ours.'[77] This was tricky, and Robert was half-inclined to let his men do their worst, but he opted instead for the judicious course, telling them to hold off. If the Scots backed down, they should let them go. This wasn't the decision his marchers were hoping for, but they held back, if with bad grace. The Scots took the hint and were off faster than Carey's messenger could speak. They had cause to be grateful for the young deputy's forbearance.

Inevitably, on his new patch (the Middle March) Liddesdale raiders were the prime offenders, but King James, who was already acquainted with Carey, was happy for him to pursue offenders over the border; the Scottish king had no love for his own thieves. When a particularly large raid struck, Carey sent a couple of hundred riders after them. Most simply took refuge in their towers, 'But one of the chief of them, being of more courage than the rest, got to horse and came pricking after them, crying out "what be he that durst avow that mighty work?" One of the company came to him with a spear and ran him through the body, leaving his spear broke in him, of which wound he died.'[78] The reivers got the point ... due notice had certainly been served. Things were changing.

The man killed was Sim of the Calfhill – a notorious Armstrong – and his kin vowed vengeance on the Ridleys, one of whom had run him

through so effectively. As good as their word, the dalesmen 'took up' the Ridleys settlement at 'Hartwessel' (Haltwhistle). The raid was anticipated and the villagers in their strong-houses, fully locked and loaded, blasted the reivers as they tried to fire the place. One marksman accounted for another leading Armstrong. Sim of Whittram, predictably, vowed that there would be revenge, and he could command a couple of hundred horsemen of his own. It was time for a final solution to the Liddesdale problem.

Carey's remedy was to take his own forty troopers, along with as many marchers as were up for it, into Liddesdale and effectively lay siege to fearsome Tarras Moss, that primeval swamp which had always been the reivers' last and hitherto impenetrable redoubt. But they had not reckoned on Carey, by now a superb border tactician, adept at fieldcraft. The result was the netting of a handspan of leading offenders, including two of Sim of Whitram's sons.[79] The warden had got the better of Liddesdale, which didn't happen often.

While he was serving in the East March, Carey had had to deal with his opposite number, Robert Ker of Cessford, a real throwback to the worst of the bad old days. One of his affinity was the notorious Geordie Bourne. This family weren't numerous, which was a blessing, but they made up for lack of numbers with widespread thuggery – and Geordie was the worst. Carey's riders caught up with the Bournes returning from a raid and shot dead Geordie's uncle while, after a stiff fight, capturing the man himself. His words echo those of the Liddesdale raider: 'After he was taken, his pride was such that he asked who it was durst avow that night's work.'[80]

He soon found out, and all of Cessford's huffing and puffing wasn't going to save Geordie from the noose. But here's where Carey did posterity a second great service: not only did he relate his story, but he told Geordie's as well. And this is it, the only actual recorded testimony from a reiver. We know a great deal of what was said and written *about* them, rather than information *from* them. Carey set out to talk to Geordie Bourne in person and recorded what he said. 'After supper about ten of the clock, I took one of my men's liveries and put it about me ... and came to the Provost Marshal's where Bourne was.'[81]

Bourne had no idea who he was talking to. He would assume that Carey was just an average trooper anxious to hear the story of the famous brigand's life before it ended. Bourne was happy to talk: a villain but no coward, he knew his time was short. He boasted 'that he had lain with above forty men's wives ... and that he had killed seven Englishmen with his own hands, cruelly murdering them.'[82] He'd spent his life 'whoring, drinking, stealing' and pursuing petty grudges. He did ask for a priest, however, not understanding that the very frankness of his confession cancelled any hope of clemency. The local gentry were appalled, not by

the hanging (which was a near everyday occurrence) but by Carey risking the humiliation of Cessford, who could make their lives intolerable. But the 'firebrand' had met his match and was forced to learn the lesson.

William Armstrong of Kinmont, known to history and to legend as 'Kinmont Willie', was a vicious ruffian with a record of lawlessness. From his tower at Morton Rigg on the fringe of the Debatable Lands, the wildest tract in the West March, he led regular raids across the border, lifting sheep, beasts and anything else that took his fancy. In the spring of 1596 he attended a truce at Kershopefoot on the Scottish side. After the formal business had finished, he rode, seemingly alone, along the north bank of the Liddel. On the far bank rode a squadron of English marchers. Safe in the knowledge that he was inviolate until sunrise the next day when the truce would expire, Will felt free to indulge in some less than genial banter with his less than friendly neighbours over the narrow waters. Salkeld, 'a gentleman of that west wardenry',[83] Lord Scrope's deputy, was leading.

Exactly what happened next is unclear: in all probability, the English, stung by this arrogant posturing and seeing their inveterate enemy so close found the moment too tempting and spurred across the Liddel Water to take the astonished reiver captive. A principal primary source, the Shawfield MS, tells us that: 'They brake a chase of more than 200 men out of the English train.'[84] What is certain is that he was carted within the fortress walls of Carlisle and incarcerated. Such an act, occurring as it did on a truce day, was considered an outrage, notwithstanding the nature and misdemeanours of the alleged victim: 'O have ye na heard o' the fause Sakelde?/ O have ye na heard o'the keen Lord Scrope?/ How they hae ta'en bauld Kinmont Willie/ On harribee to hang him up?'[85]

It's probable that Scrope was more embarrassed than elated. True, Will was a prize worth having, and well worth hanging, but given the truce it was never really on the warden's agenda. The arrest was illegal, and the law was the law, villain though he was. The warden couldn't flout such a powerful convention: it was one of the few slender threads that bound the marchers. Neither, on the other hand, was he minded to let the Armstrong loose. If nothing else he was a useful hostage to keep his nasty affinity in check. Scrope vaguely suggested that Will had broken his assurance on the day ... but he didn't specify how, and it did sound a rather specious justification. He knew full well that his people were in the wrong.[86]

Salkeld lodged his prisoner within the great castle, but not in the massive keep or any dark dungeon. It seems Will was comfortably housed and not unduly confined. Outrage there was and none was more outraged than Walter Scott of Buccleuch, at this point Keeper of Liddesdale. Now here was a force of nature: tough, efficient, brave and murderous, 'Bold' Buccleuch was the very model of everything a border official shouldn't

be. For a start, he didn't like prissy Scrope, and the dislike was entirely mutual. Kinmont's seizure was far more than a breach of protocol – it was a direct insult, a pointed two-fingered gesture aimed straight at him. This was personal.

Buccleuch began properly enough, sending official letters demanding that Will be set free. This was completely reasonable: the keeper was clearly in the right. The fact that Kinmont was probably a client, and under his far more unofficial protection, was irrelevant – for the moment anyway. He wrote in the first instance to Salkeld and then to Scrope. If the English Warden replied at all, it was in dismissive and suitably vague terms, probably similar to those he later used to explain himself to the Queen's Council (by no means on his side at that point).[87] However he actually worded any reply, it was perfectly clear that he was hanging on to his prisoner.

Protocol was now out of the window; it was a grudge match between Scrope and Buccleuch. Bad blood ran deep and Buccleuch certainly was addicted to the feud. Even aside from his differences with Scrope, he was at odds with the Tynedale Charltons (no strangers to a vendetta). A year earlier he had led a force of three hundred Teviotdale men on a raid; they had torched a Charlton steading but found nobody to kill. Returning a week later, he had murdered four, promising at the same time that 'he'd be back.'[88] So far, in the game with Scrope, he had behaved entirely correctly, and hearing nothing sensible from him he wrote next to Sir Robert Bowes, the English ambassador. Bowes was none too happy with Scrope either, and his letter made it plain he wanted Will released forthwith. The Warden ignored him, too.

Well, nobody could say Buccleuch hadn't played it by the book thus far, but thus far wasn't going anywhere, so other means would be employed. Force was the only remaining option and force was something Scott understood: but cutting up Charltons, while satisfying, wasn't in the same league as storming Carlisle Castle, which was still one of the strongest in the land. Any direct assault would need an army plus artillery and would be an outright act of war. King James would never allow it; he had his eyes on a far more glittering prize, and the fate of some border reprobate was neither here nor there.

An attack? No. But a raid … might that be possible? It would be very long odds indeed, unless of course it could be an inside job. On the upside, Buccleuch could easily find the right men, he had the experience and credibility to lead, along with the wit to plan carefully. Intelligence was the essential building block and given the numbers of Scots who traded freely in Carlisle it was easy to build up a detailed plan of the castle. Interestingly, an isolated postern gate offered possibilities.[89] 'And for such purpose the lord of Buccleuch, upon intelligence that the Castle of Carlisle where the prisoner was kept was surprisable and of the means,

by sending some persons of trust to view to view a postern gate and to measure the height of the wall very closely.'[90]

Ritchie Graham of Brackenhill was happy to play dishonest broker and provide introductions to Lance and Thomas Carleton. Now these were men after Buccleuch's heart: Thomas was a prominent and able border officer, land-sergeant of Gilsland and, in the words of MacDonald Fraser, 'crooked as a corkscrew',[91] related by marriage to the Grahams (a partner in his blackmail racket) and, ironically, distantly connected to Will himself. Lance was every bit as corrupt; neither brother had any love for Scrope. The meeting lasted for four productive hours and guaranteed Buccleuch the inside track he needed. It's almost possible to feel sorry for the English warden. For all his posturing, he was a babe in the woods compared to the talent now ranged against him: Buccleuch, Old Wat (Walter Scott) of Harden, Armstrongs, Grahams and now the Carletons. They were as distinguished a rogues' gallery as history ever produced.

As might be expected, the Grahams were key players; 'crooked as a corkscrew' doesn't do them justice. Not only were they facilitators, they had a material part to play. The raiders would have to cross Graham territory going both ways; their complicity effectively unlocked the frontier. That part of the border didn't belong to English or Scots – it was the sole province of Ritchie Graham and followers; if they were studiously looking the other way, any early warning system was disabled and the great fortress was shorn of its front line defence.

Sunday 13 April was the chosen date. The day before, Buccleuch had been at Langholm races, but not just for the sport: such meetings hosted more covert operations than CIA HQ at Langley, and that Saturday was a very busy one. Buccleuch was tying up loose ends and giving orders. He had arranged for some previously lifted Graham stock to be returned as a gesture of goodwill and as down-payment for services rendered and about to be rendered.

Eighty borderers would ride out against Carlisle on that night, four score men against the mightiest castle on the marches. This was high adventure. Villains they might have been, but this sheer dash and élan, this glorious hubris, seasoned by skill and experience, is the stuff of legend. At the same time, they were all professionals who knew full well what they were about. Scotts, Eliotts and Armstrongs, including Kinmont's four lads, were all in the saddle that night. A screen of scouts ranged in front – MacDonald Fraser supposes, correctly I think, that these were Armstrongs, ranged as a vanguard behind the prickers; next came the assault group with all the necessary ladders, grapnels etc, then the main body and a strong rear-guard.[92]

They moved with stealth rather than speed, using the cover of darkness to ford the Esk, frequently halting to close up and maintain cohesion. They only covered six miles, but they did so undetected; the

slightest giveaway would have been fatal. By the time they sighted the squat, menacing bulk of Carlisle from the northward side, first light was only a couple of hours off. It's likely that they forded the Eden a short distance below where the present bridge stands. The waters were frothing high and the dank night was clinging like a wet cloak – proper reiver weather: 'And passeth the water of Eden about two hours before day, at the Stoniebank beneath Carlisle Brig'.[93]

Nobody heard anything – perhaps the roaring of the spring wind drowned any noise, or perhaps the watchers were trying hard not to see or hear – and they reached the foot of the walls undetected. Probably just a chosen assault group went in, with the rest keeping watch, still in the saddle. Quite how they did get in is unclear. Maybe the postern was unlocked or had to be broken down, forced in some way. Ladders may have been used, probably were, but if so, somebody had their sums wrong as those they had carted with them proved too short.[94] Buccleuch knew from a female agent that Will was kept in a domestic building, west of the keep, with no close security. Whether he was in on the plot we can't say. The story that he had to be carried out still in chains is clearly untrue. It's quite possible that some of his hosts even helped him to the door: 'The prisoner was taken out of the house where he was kept, the which was known to the lord of Buccleuch, his sending a woman upon pretext the day before to visit the prisoner.'[95] Scrope seems to have had few supporters, even among his own men.

Will was soon on horseback and still there was no general alarm. Buccleuch had posted the bulk of his riders between the narrow postern and the West (Irish) Gate, ready to take on any posse that came tumbling out. None did. Only the attackers' trumpet, blaring briefly to summon the company together, disturbed the murky calm. Off they went. And that was that. If there was any pursuit, it was half-hearted at best and they were back over on the Scottish side a couple of hours after sunrise. Scrope, utterly humiliated, bleated that two of his troopers had been 'left for dead' and one of his servants roughed up,[96] but Buccleuch had clearly given orders that there was to be minimal violence and no opportunistic pilfering. This was a disciplined op, not retribution: 'All sore astonished stood Lord Scrope/ He stood still as rock of stane/ He scarcely dared to trew his eyes/ When thro' the water they had gane.'[97]

On 14 April Scrope wrote feverishly to Burghley. In a long exculpatory epistle, he blamed everyone but himself for the debacle. Buccleuch had apparently commanded five hundred riders and his 'proud attempt' was presented as some kind of full-scale attack, which stormed the postern 'speedily and quietly'. It was all the fault of the watch who were either asleep on duty or had bunked off to get out of the rain.[98] According to the Shawfield MS, 'The Queen of England, having notice sent to her of what was done, stormed not a little.'[99] I think we can accept the queen's

fury as fact because a diplomatic hurricane blew up: King James was suitably apologetic but was probably very far from being annoyed. Elizabeth wanted Buccleuch sent south to explain himself (along with Ker of Cessford, the other 'firebrand').[100]

After much procrastination, Buccleuch handed himself in to Sir William Selby, Master of the Ordnance at Berwick.[101] George Ridpath gives only a brief account of the raid but confirms, 'At last to gratify Elizabeth it was found necessary to commit Buccleuch a prisoner in St Andrews; and afterward to send him into England, where he did not continue long.'[102] A very light slap on the wrist and both hell-raisers were soon back on their own turf, but they'd seen the light and a map for the future with their own very reformed stances clearly marked.

As they spurred away to safety, Buccleuch's riders, his commando, might have felt rather chipper: they'd done a very good job, no bloodshed and Scrope had egg all over his outraged face. What they didn't understand, though their leader probably did, was that this was the last hurrah, the cowboy heroes riding off into the sunset (or in their case, a wet dawn) were cantering clear out of history. Many who rode with their dashing commander would be hanged by him later without a backward glance. Their present wasn't his future, and their time was almost up.

At the end of the American Civil War, the famous and pioneering photographer, Matthew Brady, who had chronicled the war with his striking images, laboriously captured on glass negatives, went bust. The nation had had its fill of war; images of the soulful dead scattered on battlefields went out of vogue. Many of his million glass negatives were acquired by gardeners as glazing for their greenhouses, and these priceless visions of a great nation torn by civil war literally faded away in the sunlight. The reivers were destined to go the same way. Their respective nations were jointly ashamed of them. Their images, so frighteningly vivid in their day, would fade away in the bright, strong light of a united realm. As with Brady's pictures, everyone had had enough.

Swords into Ploughshares

'Until I was put in prison, at least I had peace in the zone ... there is
no crime and no war there, you are not free but you are not robbed.'
I asked which way of life he preferred; repressive security or chaotic
liberty? He looked at me for a while and then laughed. 'You never find
this answer absolutely ... Life is the condition of the search between.'
My Afghan Diaries, Anthony Loyd

Robert Carey was in the saddle:

I returned and took horse between nine and ten o'clock, and that
night rode to Doncaster. The Friday night I came to my own house at
Witherington (Widdrington) and presently to order with my deputies
to see the borders kept in quiet, which they had much to do: and gave
order the next morning the King of Scotland should be proclaimed
King of England and at Morpeth and Alnwick. Very early on Sunday I
took horse for Edinburgh, and came to Norham about twelve at noon,
so that I might well have been with the King at supper time: but I got a
great fall by the way, and my horse with one of his heels gave me a great
blow on the head that made me shed much blood. It made me so weak
that I was forced to ride a soft pace after, so that the King was newly
gone to bed by the time that I knocked at the gate.[1]

D'Artagnan himself couldn't have done better. Robert Carey, now in his
early forties and more opportunist than diplomat, was determined to
be the one to bring the momentous news to James VI that Elizabeth I,
'Gloriana', was no more, and that as a result he was now also James I of
England. Tremendous tidings. Elizabeth had ruled for forty-five years –
few could remember any other sovereign – and she had attained near
deified status. Now she would be succeeded by a King of Scots. It was

the ultimate irony of the Border Wars – that after three centuries of kings of England seeking to annex Scotland, the final score was exactly the reverse. Nor was this a conquest won by force of arms, but a willing and sought-after Protestant succession – and Robert Cecil [2] had been a prime mover in this.

Carey had high hopes of his mission. No sooner was the queen cold than he had decided to ride at once, even though he didn't have any specific mandate: 'He (the comptroller) led me from thence (the Queen's Chamber) to the privy chamber, where all the council was assembled: there I was caught hold of, and assured I should not to Scotland, till their pleasures were better known.'[3] Well to heck with that; Robert knew a golden opportunity when he saw one – or thought he did – and he hit the saddle straight away.

On 26 March 1603, he brought the news that James had been waiting so long to hear, that his hopes of twenty years were to be fulfilled – a huge return on all the bribes he'd disbursed: 'I was quickly let in and carried up to the King's chamber. I kneeled by him and saluted him by his title of England, Scotland, France and Ireland.'[4] Now, the French reference was pushing it (every last toehold was long gone) but England would do very nicely. Well pleased, James made all the usual noises of condolence; after all, the Queen was Carey's aunt. He promised Carey ample reward (which was what he wanted to hear), and Carey made the point that his journey had been all down to his own initiative, and that the Council had tried to hold him back – just so the king knew who his friends were. Robert would be neither the first nor the last to find out that the gratitude of princes tends to fade.

So what did Robert Carey get from his ride? Well, rather less than he'd hoped for:

> Now I was to begin a new world: for by the King's coming to the crown I was to lose the best part of my living. For my office of wardenry ceased and I lost the pay of forty horse ... Most of the great ones in court envied my happiness when I heard I was sworn of the King's bedchamber: and in Scotland I had no acquaintance. I only relied on God and the King. The one never left me, the other shortly after his coming to London deceived my expectation, and adhered to those that sought my ruin.[5]

In fact, Carey's unauthorised ride cost him dear. He lost what friends he had in the administration and James had other concerns. It was through the capable conduct of his wife, Elizabeth Trevanion,[6] lady in waiting to Anne of Denmark, that he began to climb back up the ladder. She looked after the apparently backward Prince Charles (the future King Charles I), nurturing the weak and stammering boy; she taught him to walk and

talk. Carey became the boy's governor in 1605 and six years later his Master of the Robes. Five years on he was appointed Chamberlain and in 1622 was elevated to Baron Carey of Leppington. Four years after that he was created 1st Earl of Monmouth, dying a tolerably rich and revered elder statesman in 1639 when he was nearly eighty.[7]

James' progress south was a PR stroke of some genius. He'd had a long time to think about it, and here he was, a king of Scotland marching on London with garlands and cheers:

> The King proceeding by easy journeys and being from time to time stopped by the hospitality and fondness of his new subjects, spent a whole month on his journey from Berwick to London. Ten days after his arrival in the capital he issued a proclamation requiring all those guilty of the 'foul and insolent' outrages lately committed on the borders to submit themselves to his mercy before the 20th June on pain of being excluded from it forever.[8]

Just in case that wasn't plain enough, he published a second blast a couple of days later: 'In consequence of which the bounds possessed by the rebellious borderers, should no more be the "extremities" but "The Middle" and the inhabitants thereof reduced to a perfect obedience.'[9] This was at the heart of James's cherished project: there would be no more border. He was, for the first time in history, master of both realms; what had been the fringe was now the centre – the borderers would come to heel or face the consequences. What followed wouldn't be some warden's raid or even a judicial sweep; in modern terms it would amount to ethnic cleansing.

James VI of Scotland and I of England wasn't like his Stewart forbears. For one thing, he would lead a reasonably long life and die in his bed, having reigned for nearly half a century and never seen a battlefield. He was physically unprepossessing, notoriously mean and would recoil in terror at the sight of a drawn dagger, although Sir John Ramsay's knife had saved him from the Gowries.[10] He was horrified when Colquhoun widows presented their dead husbands' bloodied sarks after a fracas with MacGregors in Glen Fruin (though it was probably sheep's blood). He was utterly determined to eradicate the old and troublesome border and then impose law and order, at whatever cost to the inhabitants. It's hard to see how it might have been done more gently.

Further south, his English subjects soon began to tire of the new king's horde of Scottish carpetbaggers who flocked south in his wake, hungry for advancement and in search of streets paved with other people's gold.

The English 'soon began to treat the King and his countrymen with insolence and contempt'.[11] On this, even Papists and Puritans could agree.

King James was not to be deflected: 'The King in pursuance of his favourite purpose of extinguishing all memory of past hostilities between his kingdoms and if possible, of the places that had been the principal scene of these hostilities, prohibited the name of "Borders" any longer to be used, substituting in its place, that of the "Middle Shires"'[12] Well, reivers, you have been warned. He meant business:

> Soon after his arrival in London, he gave a commission to George Clifford Earl of Cumberland,[13] a nobleman who had acquired military fame in the wars of the late Queen; appointing him as Warden of the West and Middle Marches towards Scotland, with the most extensive powers and also Lieutenant-General of the Counties of Cumberland, Northumberland and Westmorland and of the town and county of Newcastle upon Tyne.[14]

That wasn't all: he was keeper of the upland Northumbrian dales, and governor of Carlisle. He could appoint deputies and mete out justice. His wages and those of his officers were guaranteed. All he didn't get initially was the East March and Berwick, where Sir John Carey was left in charge until the garrison was reduced.

Cumberland did not win universal acclaim. John Graham (there's a clue in the name) wrote in the early twentieth century about the tribulations endured under the earl's harsh governance observing that Cumberland 'was not one of those [favourites] upon whose shoulder the King hung with maudlin infatuation – but one in whom he discovered transcendent merits unobserved by the world at large.'[15] And on the Scottish side: 'At the end of July, Alexander, Lord Hume was appointed Justiciar and Lord-Lieutenant over the three Marches.'[16] He had plenipotentiary powers, a free and unfettered commission and a thousand merks (marks) a year in sterling by way of salary. I doubt anybody was surprised that Hume did so well: after all, his name had several centuries of form.

John Graham didn't much care for either of them: 'Their government was simply an organised system of plunder, unchecked, un-reprimanded and unpunished.'[17] Despite the writer's bias, there is much truth in this. James, initially at least, wasn't minded to ask too many questions, it was results that mattered. Men such as Cumberland and Hume were as much occupiers as pacifiers and both had an eye to the main chance. Regions like the Graham heartland of Eskdale, unprofitable in endemic war, had much more to offer in peacetime; it was lush, fertile ground, ripe for exploitation. If only those annoying inhabitants could be got out of the way ...

Who cared about the Grahams, anyway? They 'were represented as incorrigible criminals and oppressors and the very name of Graham was said to be a terror to all the country around.'[18] And indeed they were; it's easier to feel sorry for the Grahams if you hadn't encountered them. If you had, you might well be cheering for the carpetbaggers. Meanwhile, for the borderers themselves, the time of James's accession had seemed like business as usual: 'Upon the report of the Queen's death the east border broke forth into great unruliness, insomuch as many complaints came to the King thereof.'[19] Robert Carey was still recovering from his head injury sustained during his epic ride and had to leave matters in the hands of his underlings. It's unlikely that anyone on the frontier saw the tsunami approaching, or had the measure of the man who was about to stir the waves.

James has never enjoyed the kind of romantic aura that surrounds the very name of his foolish mother. George MacDonald Fraser (while admitting this might be harsh) picks up the general trend, describing him as 'a slobbering, goggling, pedantic pederast, stuffed with ill-digested scholarship, vain, cowardly and dishonest.'[20] He may indeed have been many of those things at times, but he was no fool; he was an arch-pragmatist and, above all, he understood his borders. None of his predecessors on the English throne, except perhaps Richard III, had greater experience of border affairs. He knew how the marches worked; his desire to bring order to the border was intense and genuine. And forget any mythic gloss … it needed doing.

There was an assumption – mere opportunism, perhaps – that all law (or such law as there was) on the border was suspended between the death of one sovereign and the proclamation of a successor. It was certainly a handy fiction, and in 1603 the riding names made the most of it. 'Ill-week', when a jolly good time was had by all except the victims, would be their last loud hurrah. Hutcheon Graham of Cargo took up North Cumberland, sweeping as far down as Penrith, driving off the Bishop of Carlisle's herds while that worthy cleric fumed impotently from his battlements at Rose Castle (the Bishop's official residence from 1230-2009, 1½ miles from Dalston).

Similar crimes were re-enacted across the wide sweep of the marches and on both sides of the line. Clearly, the reivers didn't get it: history had just overtaken them. The situation was unprecedented: they were up against one monarch, in Edinburgh and London, whose dearest project was their eradication. Bravado might be fun but they were really just underscoring their own death warrants. Ironically, it was James himself who was pulling off the greatest foray of all: he had bagged all of England and his hungry train held plenty of carpetbags. It would be English gold that did for the Steel Bonnets.

James's hopes were expressed in flowery, placatory terms: he wanted amity to break out amongst his Scottish and English subjects and

harmony to prevail. As the Venetian ambassador, the very worldly and cynical Giovanni Scaravelli observed; 'Such new and hopeful beginnings were mere wishful thinking, English and Scots would never be friends.'[21] James knew this, of course. Meanwhile, Cumberland's energetic deputy, the mercurial adventurer Sir Henry Leigh, was lucky to get out of a Graham ambush alive. It wouldn't all be one-sided.

Both Lieutenants-General had seasoned soldiers to lead their newly funded militias. Hume had Sir William Cranston; Cumberland chose Leigh. These were more *Einsatzgruppen* than UN peacekeepers. The old marches were a serious war zone. In no small degree they always had been, but now King James's main players were a team, not adversaries, and they weren't necessarily taking prisoners. Some of those gentlemen bandits experienced sudden and blinding epiphanies: Buccleuch, for example, recruited a force of two thousand light horsemen to serve in the Dutch wars[22] and became instantly zealous in his pursuit of domestic wrong-doers.

James was canny enough to realise he needed allies in his fight, and Scott's miraculous conversion earned him a peerage as 1st Lord Scott of Buccleuch in 1606. Kerr of Cessford, equally drenched in blood, went the same way and, already Lord Roxburghe by 1600, was raised to an earldom sixteen years later. Both did very well out of James; collaboration has its merits. Lord William Howard of Naworth, a son of the Duke of Norfolk who inherited the old Dacre lands by right of his wife and who was known from his celebrated baldric as 'Belted Will', became another enthusiastic supporter.

It would take James just four savage years, from 1603 to 1607, to establish the framework of success, with another three to consolidate. The Grahams would say that it was a case of creating a desolationt and calling it peace, and there was much of that, yet ultimately the bitter medicine went down and the patient recovered. In the early months of 1605, the king set up a Royal Commission to oversee pacification, with ten sitting members, drawn equally from both realms and based at Carlisle, nub of the border. Anybody who hoped this would just be another quick-fix judicial sweep or beefed-up warden's rode was wrong.

The list of sanctions was comprehensive:

- All iron yettes were to be removed from towers and peles.
- Weapons were banned, to be beaten into ploughshares.
- No man could own a horse worth more than £30 Scots – so working mounts only.
- Known past offenders were effectively tagged and had to report in; they couldn't leave their homes for longer than forty-eight hours without authorisation.

- The number of ale houses was to be reduced – even then the linkage between booze and banditry was noted.
- Only an eldest son could inherit, so estates would not continually be diminished by sub-division.
- Offenders – those who had offended or those who were thinking about it – could be lawfully transported.

Just in case anyone still hadn't got the message, Cranston, Hume's deputy, descended mob-handed on Dumfries where he hanged thirty-two Armstrongs, Johnsons and Batys.[23] Citizens of the town (no strangers to violence) turned on him, and his troop had to hack their way out, losing several mounts.[24] This breed of mercenary-cum-officer practised what was known, with usual gallows humour, as 'Jeddart Justice' – the suspect was first hanged then tried thereafter, so proceedings tended towards the cursory. Those who swung weren't innocent victims; most, if not all, were weighed down by more than their boots. Still, this was more terror than justice.

'Malefactors by the name of Graham' were a special mission for these commissioners. Of all the border names, they and the Armstrongs were most feared and hated ... and you can see why. A coroner's document of 1584 shows how some Grahams were killing others of the same name in a 'miserable family dispute about land', and there was also a long and bloody feud between the houses of Richard of Netherby and Fergus of Mote. The Grahams were never friends of authority. In 1596, when a Warden officer, assisted by ten Grahams and a bloodhound, overtook two Scottish cattle raiders that they had been chasing, the Grahams stood idly by while the thieves cut the officer down, then stole both horse and dog.

When Wattie, brother to Jock Graham of the Peartree, was on trial at Carlisle for horse-stealing, Jock kidnapped the sheriff's six-year-old son from outside the officer's home and used him as hostage to secure Wattie's release. In an attempt on the life of land-sergeant John Musgrave at Brampton, a group of Grahams set upon him and his followers with daggs (pistols) and tried to burn him alive in a house. In 1592, Lord Maxwell complained against the Grahams of Netherby and other of Lang Will's descendants in respect of their 'violent and masterful occupation' for thirty years past of Kirkandrews and Annandale, and twenty-five years of similar oppression and exploitation of five other named districts.

In 1600 Lord Scrope compiled a long charge-sheet of the name's crimes, of which MacDonald Fraser writes:

According to this, no fewer than sixty Grahams were outlaws, for murder, robbery and other crimes; they had despoiled above a dozen Cumbrian villages, sheltered felons, fought the Warden's troops, murdered witnesses, extorted money from their enemies, and in one

specific instance burned the house of one Hutcheon Hetherington to force him into the open so that they could cut him to pieces.[25]

It's a long list, much, much longer than this sample. These were bad people, even by the elastic standards of their fellow borderers.

The king, too, singled out the Grahams for special attention in his proclamation of 1603:

> Forasmuch as all our Subjects in the North parts, who have felt the smart of the spoils and outrages done upon them at our first entry into this Kingdome by divers Borderers, but specially by the *Greames,* cannot be ignorant what care we have had that punishment should be done upon the offenders, having for that purpose to our great charge, maintained both Forces to apprehend them, and Commissioners to try them according to the Law, by whose travail, namely of our cousin the Earl of Cumberland our Lieutenant here, with assistance of other Commissioners, things are brought to that point, that the Offenders (but specially the *Greames*) confess themselves to be no meet [fit] persons to live in those Countries, And therefore have humbly besought us that they might be removed to some other Parts, where with our gracious favour, they hope to live to become new men, and deserve our Mercy. Although we do confess that we have rather inclined to this course of Mercy, as a thing more agreeable to our Nature, then the taking of so much blood as would be shed if we should leave them to the just censure of the Law.[26]

This was justification for what we'd term 'ethnic cleansing' which earned a justifiably evil reputation during the Balkan Wars of the nineties: 'Ethnic cleansing is rendering an area ethnically homogenous by using force or intimidation to remove from a given area persons of another ethnic or religious group.'[27] Now, our Jacobethan ancestors, while they knew all about religious intolerance, weren't necessarily even aware of what we would called ethnicity. The Grahams weren't genetically different to anyone else around – but they were a distinct tribal group. In his 1993 article, *A Brief History of Ethnic Cleansing*, published in the magazine *Foreign Affairs*, Andrew Bell-Fialkoff also attempted a definition: 'The expulsion of an "undesirable" population from a given territory due to religious or ethnic discrimination, political, strategic or ideological considerations, or a combination of those.'[28] On that basis I think the attempted removal of the Grahams counts as much, say, as the Death March of the Cherokee; both were reprehensible. Except that the Native Americans' only real offence was being in the wrong place, at the wrong time and with the wrong skin tone, and if we're being brutally objective, the Grahams' retribution was long overdue. On 17 April 1605, one

hundred and fifty were conscripted into the Dutch garrisons; more were rounded up but they staged a successful mass-breakout from Carlisle. Many of these unwilling warriors deserted as quickly as they were recruited, and some slunk back pretty soon after: 'For a considerable time no real progress was made in clearing the country of the condemned clan. The escapes from prison and returns from banishment were more numerous than the arrests.'[29]

By now the Grahams, as born survivors, realised the game was changing radically and they needed to show some humility – which they duly did. They petitioned the king:

[T]hey, and others inhabiting within the bounds of Eske and Leven, being the borders of the realme of England against Scotland, are men brought up in ignorance, and not having had meanes to learne their due obedience to God, and your most excellent Majestie, of late, and immediately after the death of the Queen's most excellent Majestie, your Majestie's late dear sister, did disorderly and tumultuously assemble ourselves with all the warlike force and power that they could make, and being so disorderlie assembled, did invade the inlande part of the easte parte of the county of Cumberland, and spoiled many of your subjects of England with fire, sword, robbery, and reaving of their goods, and murthering and taking prisoners the persons of the same, which are misdemeanour; albeit we cannot excuse our ignorance, for that by the lawes of God we do knowe that all rebelling, reaving, and murthers are altogether forbidden, yet so it is, that some among us of evil and corrupt judgment did persuade us, that until your Majestie was a crowned kinge within the realme of England, that the law of the same kingdome did cease and was of no force, and that all acts and offences whatsoever done and committed in the meane tyme, were not by the common justice of this realme punishable by force, of the which malitious error put into our heads, as deceived men, and believing over reddy that grosse untruth, we did most injudiciously run upon your Majestie's inland subjectis, and did them many wronges, both by fyer, sword, and taking there goodes, in such sort as before we have acknowledged.[30]

Now, that's a *long* burst of grovelling ... but it was too little and too late.

That same Hutcheon Graham who had so taunted the Bishop of Carlisle saw his joke turn sour when he, with many others, was arrested. The list of charges he was facing was lengthy, going back to the springing of Kinmont Will and the murder of Sir John Carmichael. The year 1606 witnessed a new year's hanging spree and every gaol was bursting. James had wanted results, but even he began to feel a judicious tug away from overt connection to so much violent oppression. In January, he expressed a moue of concern, that his officers were using methods that 'savoured

of barbarism'[31] Of course, he wasn't all that concerned: Cranston was fully exonerated by the year's end and his robust defence was that any leniency now would smack of weakness and the borderers would take full advantage. It's hard to disagree.

Despite these barbarities, the Commissioners were still way behind on points and Graham survivors clung on tenaciously; exactly what they had been doing for three centuries. No truly final resolution had yet appeared, and then, 'In the midst of his perplexity James received a suggestion from one Sir Ralph Sidley to transport the whole remnant of the Eskdale outcasts to Ireland where Sidley reckoned he could, for a consideration, plant them upon certain land at his disposal in the County of Roscommon.'[32]

Now here was a gift! If helpful Sir Ralph could offer resettlement then so be it; to be sure, no one else was clamouring to have any Grahams foisted on them. It was only necessary for the good gentry of the west to come up with the funds. It's hard to say if Sidley was being genuinely philanthropic or if he just saw an opportunity. Some £300 was raised from donations – more of a levy really; James' commissioners were quick to lean on anyone who didn't cough up.[33] This might have been the making of a real settlement of the whole problem. Transportation would be radical ... but it was at least more humane than extinction. Once the name was expunged then 'their lands may be inhabited by others of good and honest conversation.'[34]

The king was already concerned at defections from the Dutch forts and wrote earnestly to his Commissioners on 24 June 1606: 'We wish all means to be used for the apprehension of the Grahams who have returned from the Cautionary Towns.[35] It appears that divers of the Grahams and other surnames were formerly planted in the Province of Connaught, where they have grown to be men of good desert and quality ... Sir Ralph Sidley is well able to plant thirty of forty families there.'[36]

In total, around fifty families were transported. If they expected to see any of the cash raised they'd be disappointed, though – being Grahams – not surprised. Their 'land' was waste; water was scarce, as indeed was labour, and what there was came dear. If Sidley had held out any real hopes, these were soon dashed: 'The condition of the outcasts having become so wholly desperate many of them fled rather than face starvation and by some means found their way home to the border to the surprise and vexation of the authorities.'[37]

Unsurprisingly, the native Irish hadn't taken to these newcomers, and the feeling was entirely mutual; borderers had served in Ireland before but hardly in peaceful roles. A few of those dumped there now made the best of it and signed on for local garrisons, the rest steadily began to defect. Legend has it that the passports they'd need to get back were easily faked and all in the name of 'Maharg' (Graham in reverse), which implies that customs officials were either really daft or easily bribed.

As late as 1614, James was still blasting out edicts stridently forbidding any to return. Much good did they do.

Ritchie Graham, son of his infamous father, was living at this time in Brackenhill Tower. The Earl of Cumberland tried to confiscate the place but he had overreached himself for once as young Ritchie was able to show good title; his estate had been bought fairly from Sir Thomas Dacre. Ritchie was sent to Ireland, but he soon came back and resumed residence keeping clear of the bad old ways. The lesson, it seems, had been learned. Brackenhill still stands: it's on the north bank of the River Lyne four miles west of Longtown.

Even more enterprising, James Graham pointedly walked to London (as he could no longer afford a horse) to press his claim for clemency directly on the king. James had many faults but he was no tyrant, and he gave this young man a job as Master of Horse to his favourite, the Duke of Buckingham. Honest toil proved more profitable than reiving and Graham prospered – so much so that Richard Graham was able to buy the estate of Netherby and Barony of Liddell from the Earl of Cumberland for cash, and he garnered a baronetcy in 1629. Sir Richard Graham of Esk would stay loyal to the Stuarts and would fight bravely at Edgehill for Charles I in October 1642, where he was badly wounded. Thenceforth good honest men and true, the Grahams never looked back.

George MacDonald Fraser points out that at the time he was writing, the Carlisle and Eden phone book was still crammed full of Grahams. Philip Walling, Cumbrian farmer, barrister and now author recalls a conversation he'd had with Graham of Netherby. The family had had to move out of the big house, which was sold, but Philip was told that they still owned peat-cutting rights on the Solway Marshes that had been theirs since they came to Cumberland in the reign of Henry IV, and the income was enough to pay Eton College fees for one laird's son in every generation.

* * *

It does seem that those in the west had it rougher than their contemporaries in Tynedale and Redesdale, who had been just as wild. The Redesdalers – Halls and Redes – didn't take too kindly to the kind of rough justice Leigh's officer Sir William Selby meted out, so they fought back vigorously enough for Leigh to think again. By 1606 the Commission itself had been streamlined, pared back as the new measures, however tough, appeared at least to be producing some results.

Needless to say, Liddesdale merited close attention. Armstrong of Mangerton and Whithaugh together with Martin Eliott all swung for their innumerable crimes; many towers were slighted (rendered

indefensible and partly demolished). In September 1606 alone, Hume, now elevated to Earl of Dunbar, hanged 140 suspects, with or without prior sentencing. Five years on and the good work still wasn't done, though Commissioners were claiming that everything was now in order ... but another 92 criminals were brought to book and just under half of them danced at the rope's end.[38]

It wasn't just the Grahams who faced transportation. Ulster was in need of settlers and it does seem that many borderers, fearful of persecution at home, saw this as a lesser evil. They and their ancestors were noted as tough soldierly types and a great number of them feature in subsequent annals of empire. Fighting was, after all, their metier, and the good news was that there was still plenty to be had. A company of Tynedale riders, captained by Andrew Grey, served in Bohemia (today's Czech Republic), and over three hundred more went off to Ireland under one of their Charlton heidmen.[39]

Criminality waned but it did not disappear; broken men, who were also known, like the later Covenanting light cavalry, as mosstroopers (and certainly at times the same men) rode as outlaw bands. Many still relied on their swords for resolving disputes: 'They expect no law but bang it out bravely, one and his kindred against the other and his; they will subject themselves to no justice but in an inhuman and barbarous manner, fight and kill one another.'[40]

Godfrey Watson concludes his own account with the tale of Willie Armstrong of Westburnflat. Will was something of a slow learner, so he failed to take on board that times had changed and reaved a dozen beasts from West Teviotdale. The law swiftly caught up with him and the posse sent him, with his accomplices, for trial at Selkirk Assizes. The verdict was never really in doubt and Will was sentenced to hang. By way of an appeal, he smashed free a heavy oak chair leg and brandished it aloft, calling on his team to fight their way clear, just like in the good old days. But the good old days were over, and none of his gang showed any inclination to try the odds. They preferred, stoically, to accept their fate and dangle. And so they did.[41]

Just to show that the grand old days weren't quite gone, that not all swords had been beaten into ploughshares, in the spring of 1627, 'Rattling, Roaring Willie' or William Henderson of Priesthaugh, fought 'Sweet Milk', 'Robert Rule' Elliott. Both had form and both had been drinking. Booze led to brawl and swords flickered in the spring air. Roaring Willie was perhaps less far gone and he did for Elliott. He went into hiding along Oxnam Water but, daftly, swaggered about at Jedburgh Rood Fair, overlooking the fact the deceased brawler was an Elliott and his name would be out for vengeance. Gilbert Elliott of Stobs tracked Henderson down and he found himself at the assizes on trial for his life. This time he was the loser and was hanged in December that year.

A thorn tree planted to mark the spot of the duel could still be seen in the early 1800s.[42]

This wasn't an isolated incident: Barty Milburn, of whom we read in Chapter Three, was still killing Scots during the reign of Charles II, and the year of the Long Pack incident was as late as 1723. But the era of endemic disorder and brutality was over. Later outlaws of the American West have been eulogised in countless movies: Butch and Sundance, John Wayne's *Shootist*,[43] together with their Depression era successors, Bonnie and Clyde. The Steel Bonnets received no elegiac tributes until Scott came along and re-wrote their history. Nor did they deserve any: their history was one of violence and savagery. Yes, they came from broken homelands – but it was mainly they themselves that did the breaking. They had no apologists and fewer mourners.

George Ridpath, writing over a century later, commented: 'The accession of James to the throne of England and both kingdoms thus devolving on one sovereign, was an event fruitful of blessings.'[44] Although I doubt whether any Armstrong or Graham accepted that the pogroms had been a good thing, 'The border which for many ages had been almost a scene of rapine and dissolution enjoyed, from this happy era, a quiet and order which they had never before experienced.'[45] This was written after the Act of Union, when Britain was busy forging a world empire and the ground had shifted immeasurably. One thing the riding names would certainly have understood – they wouldn't be missed.

12

The Barbarians Haven't Come

Because night has fallen and the barbarians haven't come
And some of our men just in from the border say
There are no barbarians any longer.

Now what's going to happen to us without barbarians?
Those people were a kind of solution.
'Waiting for the Barbarians', C.P. Cavafy

Jacobites, industrial boom and decline ... then, two world wars later, we entered the no-man's-land of the Cold War. The borders contributed Blue Streak, though it was more 'Beast from the East' when I last led a group there in 2018, so a good day for a band of students to visit RAF Spadeadam.[1] The range lies north of the River Irthing, across the strategic gap that marks the line between Northumberland and Cumbria. Once past Gilsland, the land rises beyond the twisting stream to the bleak moorland of Spadeadam Waste.[2] It's bleak, raw and untamed, where ancient history lies so close to the surface you can just about smell it.

Spadeadam. Now, *there's* a name ... It's northern and it's a frontier; the russet-tinted fell stretches north towards Bewcastle and the Debatable Lands. There's a lot of history here, much of it violent: the Three Hundred Years' War followed, far more recently and perhaps unexpectedly, by the Cold War. And it was cold when we made our journey; an arctic, knife-edged wind drove snow flurries into whipped furies.

In 1955, the Waste was chosen as the site for the UK's Intermediate Range Ballistic Missile Test Centre, the UK contribution to NATO and the Cold War (the original that is). Post 1945 we relied on the formidable 'V' Bombers[3] to deliver nuclear bombs, should we need to have them delivered. Politically, though, we wanted our very own deterrent – an

inter-continental ballistic missile (ICBM). We couldn't just buy these in wholesale from the US due to the restrictions imposed by the Atomic Energy Act of 1946 and besides, as a major power we felt entitled to our own branding.

During the spring of 1954 our American allies had proposed a joint venture: they would build an ICBM and we would construct a medium-range weapon of about 2000 miles (3700 kilometres) capability. That August, both powers agreed terms (the Wilson-Sandys Agreement) and the programme got underway. De Havilland Propellers won the contract to produce the kit, which would use liquid oxygen and kerosene. You could load up with kerosene cheap as chips and quite easily, but the sixty tonnes of liquid oxygen was far trickier: it had to be put in just before launching or it might (probably would) freeze up. The process took four and a half minutes, far, far too long. The missile was extremely vulnerable to a pre-emptive strike.

Rockets never did fly from Spadeadam; an actual test site was set up at Woomera in South Australia. The initial budget in 1955 was £50m, but within four years this had increased six-fold. Both the US and USSR were galloping way ahead of us and it was going to cost us £1.3bn to finish the job. Blue Streak got the chop in April 1960 and we bought in the US Skybolt system instead.[4]

If anyone's looking for a post-apocalyptic landscape or is considering a remake of of *Dr Strangelove*,[5] then Spadeadam's your ideal location: the Waste is bleak. The MoD road winds through commercial woodland to the RAF guardhouse and, once on the range itself, there's old Soviet gear, multiple tracked rocket launchers and anti-aircraft quads and trucks. The snouts of old 'Bloodhound'[6] missiles point at the sky. The engine testing area with its water reservoirs and squat, grey bunkers is an uncompromisingly brutalist complex ... they're the modern equivalent of peels or bastles, built for purpose and nowt else.

At Greymare Hills are the remains of two rocket-firing stands: massive, infinitely ornate, these imposingly ugly structures fit like the devil's mark into the fold of hills. They are redolent with menace; age has not diminished them. Nothing short of a fifty-megaton blast could hope to destroy them, and, as far as I'm aware, there's no such comparable site in the whole of NATO's demesne.

For once the enemy across the frowning Waste wasn't the Scots; thank heaven our reiver ancestors never had access to that level of firepower. If the final shot of the Great War was the first round of the Second, then the Cold War got started before the Second one ended. Habitually, on the cessation of hostilities Britain would massively scale down her armed

forces, but in 1945 (and for half a century afterwards) this didn't happen. Two generations of British servicemen and women, many doing their National Service, would be based on the North German Plain waiting for the war that didn't happen.

This war was fought by surrogates, but soldiers from the northern and border regiments would still be among those doing the fighting. My wife's late uncle, Ben Smith, was a 2nd Lieutenant in 1st Battalion Northumberland Fusiliers who took part in the battle of the Imjin during the Korean War, 22-25 April 1951. This was the bloodiest battle fought by British forces since 1945, after which Ben spent two years recovering in Japan; scraps of shrapnel would be working their way to the surface until he died in his late eighties. The Fusiliers, along with the 1st Battalion Glosters and 1st Royal Ulster Rifles, made up 29th Brigade, which bore the brunt of a huge Chinese offensive. The Northumbrians fought for eighty hours with this sole British Brigade fighting three full divisions. It cost them a quarter of their strength and the Glosters were overrun. They inflicted some 70,000 casualties on the enemy.[7]

Much later (June 1967) Corporal as he then was (later Major) Bertie Sexton was serving with 1 RNF in Aden, the notorious Crater. Northumbrians, perhaps more than others, would have cause to remember the time. Bertie is a native of Ashington; in his mid-teens his career options were to follow in the footsteps of one or other of his older brothers, either to join the army or to end up in gaol. He chose wisely and served until well into his sixties, finishing off as range officer at MoD Otterburn. He's probably the only officer of his rank who has LOVE and HATE tattooed on his knuckles – a memento of Ashington.

On 19 June 1967 the Fusiliers in Aden (or at least quite a few of them) were watching *Battle of the Bulge* with steely-eyed Robert Shaw playing a ruthlessly fanatical SS *Panzer* leader. I imagine they enjoyed it. I certainly did at about the same time, but I was in Byker. Their war became very real that night when disaffected soldiers from the South Arabian Army (SAA)[8] began randomly firing at British targets. The movie finished and it was back to Wellington Barracks and defending the lines. Previously, the SAA had been one of those colonial forces officered by Brits, but as we were leaving, control had been handed to Arab officers and the cadre was soon infiltrated by hard-line communists/nationalists.

Next morning it escalated. A supply unit was ambushed on the Queen Arwa Road with eight Royal Corps of Transport personnel killed. By 11am a 'state red' had been declared and the Fusiliers, tasked with the unenviable job of patrolling Crater, were in action. Lieutenant John Davis and his section did a run through behind the thick hide of an APC, the ubiquitous 'Pig'.[9] All clear, but their second sortie ran into improvised road blocks on the Queen Arwa Road, already garnished with British blood. There would soon be more. Davis, his wireless operator and two

riflemen left the vehicle to investigate and ran straight into heavy fire. The vehicle withdrew and got clear, apparently on his orders. The four left on the ground were never seen again.

When the firing began, Major Moncur with Sergeant Hoare and four riflemen scrambled into the major's soft-skinned LWB Landrover, followed by a second. They, too, only got as far as the damned road – smack into a storm of fire, with no protection whatsoever. Only Fusilier John Storey escaped the massacre: he holed up in some nearby flats where he took on the insurgents holding the police barracks. He was eventually captured, but he did return unharmed. No-one else did.[10]

Bertie Sexton also patrolled Crater District in a Ferret Mark 1/2 scout car.[11] Bertie was driving and Geordie was manning the Bren in the turret. Tensions were high, nerves were frayed and there wasn't a lot of goodwill towards the locals. Geordie was drawn tight as a bowstring. 'Now', barked Bertie, 'divvent use that f*****ng gun till I yells "fire" – gorrit?'

'Aye Corp, not till ye say so.'

Bertie was smoking a Woodbine in the driver's seat – probably against regulations but nobody was caring at that point. One pothole too many and Bertie's Woodie went flying onto his bone-dry overalls which immediately burst into flames.

'Christ, I'm on f*****ng FIRE,' he bellowed.

Geordie heard only the cry of 'fire' and he did, spraying .303 rounds around the crowded market they were approaching. Rounds kicked dust from ancient walls, the almighty crash reverberating; fruit was obliterated and people dived for cover. Geordie only stopped when he'd emptied the magazine and Bertie, who'd narrowly avoided his own immolation, managed to prevent him from reloading. Happily, there were no deaths.

An early manifestation of the Cold War was a form of early warning system or 'ROTOR', which resulted in the construction of a chain of radar stations studding the entire east coast of mainland Britain.[12] Where the threat was perceived to be greatest these were placed underground, and that at Troywood in Fife (1951), not quite in the borders of course,[13] is the largest survivor, now restored and open as a museum. With the collapse of the Soviet Bloc in the 1990s it seemed that the nuclear threat, Armageddon as promised by the underlying threat of Cold War, immediately retreated into history. Few, at that time, would have foreseen the events that occurred in New York on 11 September 2001. With the destruction of the Twin Towers our whole perception of the nature and direction of the current threat veered dramatically.

We've had plenty more atrocities since then, including the Manchester Arena Bombing on 22 May 2017 and the Borough Market attack on 3 June in that same year. But what effect has all of this had on the borders? While the border has mercifully been spared a major direct terrorist attack, Raoul Moat got far more air time locally than Osama bin Laden ever did. I did once have one of those daft Facebook arguments with a Scottish nationalist supporter who was of the view that if Scotland left the UK, then Scots would have nothing to fear from Daesh/Isis as long as Scotland kept clear of involvement in Iraq/Syria. I tried, but without success, to convince him that terrorism was unlikely to stop at Carter Bar …

Did we, up here, ever think that much about the Cold War? I don't think we did. And if we're honest, we're probably not that bothered by terrorist fears. Once, at the height of the IRA atrocities, I was briefly detained with a group of northerners, a mix of Scots and English, in Boston, Lincolnshire where our 'odd, Irish sounding accents' had sparked suspicion. Happily, we were spared incarceration.

It's a mistake that many southerners make (as in southern English … say from York/Leeds southwards as far as any Northumbrian is concerned) to believe that there are just Scots and English. That's wrong. We are the Northern English, distinctive and different from both Southerners *and* Scots. George MacDonald Fraser, writing half a century ago as an Anglo-Scot (as I am), asserts that the Scots and English are two of history's most dynamic races. Their partnership after 1707 forged the greatest trading empire the world has ever seen. The dazzling brilliance of the Scottish Enlightenment[14] gave birth to the Age of Reason, and then Britain spearheaded the Industrial Revolution while Scottish sailors like Cochrane[15] ensured Britannia did indeed rule the waves.

At the same time, our relationship has never been an easy one, 'and the marks show. The Scots are an extraordinarily proud people, with reason, as they are quick to point out and like most geniuses highly sensitive. Where England is concerned this sensitivity borders on neurosis.'[16] Three hundred years of war leaves scars, and those three centuries were unspeakably savage. The Scots had to fight hard for their independence and paid a fearful price to keep it. It was a magnificent achievement but again, as MacDonald Fraser points out, the Scots are cursed with residual fears of inferiority 'where this big, assertive neighbour is concerned',[17] This is not a criticism; England has a vastly bigger population and the wealth of these islands is heavily tilted southwards. We northerners are prone to the same insecurity. For most English, Scotland barely merits a cursory glance. It was often quipped in 2014 that if the Scottish independence vote had been held in England, then Nicola Sturgeon would already have her way.

I declare now that I'm an ardent unionist. Many of the more hysterical SNP supporters will be ready to send out the fiery cross, that ancient talisman summoning clans to the fight. My fellow author and neighbour, who was bold enough to criticise an SNP policy on Twitter, instantly received hundreds of electronic death threats, to the extent that we were ready to start building beacons and cleaning polearms, just in case.

'Old Scotswood Road must live again/ To carry further still its fame/ We're soon to have a celebration/ Let Tyneside rise in jubilation/ From Cruddas Park to Rye Hill/ We are determined, have the will/ That horrid slums we shall erase/ With surgeon's knife and then replace.'

This doggerel was the work of Thomas Daniel Smith (1915-1993), a better politician than poet who, before his fall, stood as a titan of the Left, of the new and progressive elite whose ethos had a significant impact during the heady years of the 1960s. With impeccable working-class credentials, T. Dan trained and worked as a painter and decorator, and despite his radical political beliefs he built up a chain of businesses, not necessarily on the back of quality workmanship. He avoided service in the Second World War as a conscientious objector, entering local politics in 1952. As a socialist he more resembled the parochial French version, an artisan of expressed views with a firm belief in self-determination rather than rigid orthodoxy, one who saw no conflict between radical philosophy and *petite bourgeois* capitalist enterprise. His rise in the party was meteoric and influential, and his dramatic (if Orwellian) vision of Newcastle was as sweeping as that of Grainger a century beforehand.

By the mid-1960s, as Labour under Harold Wilson finally toppled the long Conservative ascendancy, Smith dominated the local political skyline. Like Grainger, he understood the value and practice of showmanship: socialism through good PR. And it worked. Smith's dynamic new vision was in keeping with the iconoclastic spirit of the decade: new motorways would set a grid pattern, the Quayside (long since sunk into terminal disrepair) was to be re-vitalised. Eldon Square would be reborn and a central 'Cultural Plaza' created around the new Central Library. Thomas Faulkner records that 'Smith and his Associates ... were seeking what they saw as a clean, new, international image which they believed would dispel unfavourable industrial myths and attract new businesses.'

History has taken a dim view of Smith, whose career was to sink ingloriously in a mire of corruption barely a decade later. Unlike that of Grainger, his view wasn't based on a whiggish philosophy of prosperity through progress, but rather upon a utopian vision, funded by taxpayers, radical and, to a degree, totalitarian. Grainger invested in quality, Smith did not; he built fast, upwards and on the cheap – it was said that

'T. Dan Smith had an empire on which the concrete never set.' Again in line with the Gallic model of socialist endeavour, he was happy to profit from this vast expenditure by awarding lucrative contracts to his own web of companies. It was his relationship with Pontefract-based architect John Poulson (described as one who knew that everyone had a price and who possessed the knack of assessing the requisite scale of bribery accordingly) that brought him down.

Across the border region during the post war epoch, a primary economic factor has been the loss of its traditional industries. Tyneside, together with south-east Northumberland, has suffered from a terminal decline in mining, ship building and heavy engineering. The landscape has changed radically from my youth.

During the course of the nineteenth century, industrial growth on Tyneside changed entirely the character of Northumberland, or certainly the south-east region of the county. A largely agrarian economy gave was to coal mining and engineering. We saw how Newcastle had prospered on coal during the seventeenth and eighteenth centuries, but this expanded exponentially with the growth of engineering production. Steel, ship-building, and armaments boomed on a titanic scale, no dark satanic mills but mile upon mile of satanic weapons-building. Lord Armstrong, by the date of his death in 1900, was employing nearly 70,000 workers in Elswick and his guns kept the Union Jack flying over the empire. That has now all gone and the region went through decades of post-war decline and dereliction, 'largely disconnected from the decisive circuits of capital and the major growth mechanisms of contemporary capitalist economy.'[18] However, Newcastle has been reborn as a city of tourism and leisure, famous for its clamorous nightlife.

There are no pit-heaps anymore. The old Rising Sun colliery near where I used to live in Benton, which stood as a vast, ziggurat-like reminder of coal, is now a gently rising hill, more South Downs than *Germinal*. Woodhorn Colliery is a museum and archive on the fringes of Ashington, where for centuries the pit was just about the sole employer.

In 1984 Arthur Scargill, a would-be demagogue with an eye on the Labour leadership, launched an ill-judged and tactically flawed miners' strike. This created lasting bitterness, and split the Union. At the time, many in Northumberland already viewed the local Durham-based NUM leadership as despotic and corrupt.[19] The failure of the strike – and the victory of Margaret Thatcher – hastened the demise and now, as a casual visitor to the region, you'd never even know there'd been a mining industry. Over the last thirty years there's been a significant shift in the demographic, with large new estates of private housing catering

for a thriving commuter-belt around Newcastle. In the 2019 General Election, Labour lost control of Blyth – which you'd have said was as safe a red bastion as you'd find. One Twitter pundit of the shell-shocked Left lamented that the miners of '84 would be 'spinning in their graves'. Well, most of them aren't dead: they're around my age and a bit older. It was they who (at least in part) booted out the old regime.

Nonetheless, Newcastle enjoyed a major and glitzy renaissance during the thrusting eighties. The historic quayside was totally transformed into a shining leisure firmament, with new hotels, restaurants, bars and clubs. There wasn't much left in the way of industry, but the city's new lease of life was capped by the elegant curve of the Millennium Bridge. This brashness, and the place's reputation as a party capital, has a downside; the 'fat slag safari' of *Viz*[20] and unreal reality TV such as *Geordie Shore*, have reinforced the jaundiced view of Geordies as aggressive drink-fuelled yobbos.

On the Scottish side, the textile industry also went into a slow decline as man-made fibres came in after the war. In 1981 some 7,800 people were employed by the industry, but by the millennium this had declined by several thousand and many of the mills fell silent.[21] Not completely, however: a lot of them have been reborn as outlets for up-market woollen clothing, and tourism has become a big feature of the regional economy. Cumbria and The Lakes have long been very popular, with over 47 million visitors in 2018.[22] Northumberland welcomed a quarter of that number in 2019 but this was an annualised increase of eight per cent and the industry supports 15,000 jobs in the county.[23] The Scottish Borders have fared well, if less so, with some 3.3 million visitors in 2018.[24]

Heritage here is an important factor. The rise of interest in those old reiving names, in the early Christianity of Northumbria, in the evergreen romance of the Jacobites – they all fuel the growth in cultural tourism. The great coastal castles of Northumberland, along with the abbeys, castles and towers of the Scottish Marches, are prime and unequalled assets. And there are the battles. For a long time, military history was a rather poor relation, only of interest to old soldiers and anoraks. But battlefield tourism and archaeology are good news for tourist revenue: we've had significant interest at sites such as Flodden where there's been much excavation, at Carham, Homildon, Pinkie, Ancrum and now Otterburn. It would be hard to beat such epic historical panoramas as you get from Bamburgh, Tantallon, Hermitage, Gilnockie or Smailholm.

One stellar borderer heralding a new era was James Clark (1936-1968), who was born in Fife, although when he was a young lad his family moved to Duns. They were farmers but young James (Jim) was more interested in motor racing. It would lead to his early death, but also to enduring fame. He started driving in local hill-climbs and rallies before joining the local 'Border Reivers' team in 1958, moving from his

ageing Sunbeam Talbot onto D-Series Jaguars and Porsches. It was on Boxing Day of that year, behind the wheel of a Lotus Elite, that he came a close second in a GT race at Brand's Hatch.

From then on his rise to stardom was meteoric, making his F1 debut at the Dutch Grand Prix two years after his race at Brand's Hatch. In 1963 he won the World Championship. His list of achievements multiplied in the five years he had left; feat followed feat and he became a national hero – he was certainly one of mine. On 7 April 1968 he suffered fatal injuries in a smash at the Hockenheimring in West Germany. On the fourth lap, his Lotus 48 veered off the track and into the trees. He suffered a severe skull fracture and broken neck; he didn't even make it to hospital. The cause of the accident was never fully identified – it was possibly a blow-out. He is commemorated by a memorial at the site.

We're currently obsessed with ancestry and historic anniversaries, which has boded well for heritage tourism across the borders. Quite a number of clan societies have sprung up, all (as far as I'm aware) on the Scottish side: Clan Armstrong, Elliot and others. Fiona Armstrong, familiar from Border TV, has been particularly active in developing awareness of her own reiver forbears. Rory Stewart, Graham Robb and Dan Jackson have all published successful titles within the last three or four years and the tsunami of Great War commemoration 2014-2018 led to a huge surge in both interest in and research into men who served with the local regiments.

Despite this, the narrative history of the Anglo-Scottish border wars and the Steel Bonnets themselves is still not very widely known and hasn't really had the attention from fiction writers that such high drama and bitter conflict might otherwise have garnered. Susan Price's *Sterkarm Handshake*, Greig's atmospheric *When They Lay Bare* and his *Fair Helen* are all highly commended, as is P. F. Chisholm's series of novels (of which there are nine) starring Robert Carey – the real life *beau sabreur* of the marches and of my own not so humble offering, *Blood Divide*. I have to wonder how many inhabitants of today's borderland have read any of them. There's no doubt that general awareness of the region's history is far less alive here than it is in the Scottish Highlands, where tracing your clan ancestry has evolved into an industry.

In 2014 Scotland hosted 'The Homecoming' which I touched on previously, a great international festival of ancestry and belonging. I took a group of visitors to Bannockburn Battlefield Visitor Centre, the old (rather quirky) building having been expensively, and I thought rather tackily, made over.[25]

Yet check out the phone directories for Eden Valley or Liddesdale, Tynedale or Redesdale and they're still crammed with all the old names: Graham, Bell, Musgrave, Armstrong, Eliott, Crozier, Nixon, Charlton, Dodd, Robson, Milburn, Routledge, Hall and Reed ... Despite the best

efforts of successive border administrations they still survive and that, perhaps, is their real memorial. And it's the only one they're ever likely to get, aside from the tartan clocks (and no, the borderers never wore tartan; nor, for that matter, did Highlanders).

* * *

In September 2014, Scotland went to the polls in a referendum to decide whether or not the nation wished to remain as part of the UK. This was a passionate – not to say furious – debate, with occasional sparking undertones of racism from both sides. It was, however, nothing new. Scotland, and thus the Scottish side of the border, was an independent state until the Union of the Crowns in 1603 and did not fully merge governance for other 104 years. Even so, Scotland retained its own legal system, education provision and state religion. We've understood the immediate and cataclysmic effect 1603 had upon the old (and bad) way of life on the former Marches, but did that integrate the old troublesome borderland more firmly within the Scottish state ... or has the notion of being 'different' persisted?

Militarily, any notion of a return to full independence appears to have been crushed in the sleet at Culloden in April 1746. Even then, Jacobitism was very much a minority movement, rooted in dynastic ambition, not national sentiment. The borderers remained well-nigh indifferent. From the nineteenth century a different breed of nationalist movement began to arise, during what was a period of both change and division within Scotland. The Disruption of 1843[26] had profound civic, as well as religious, impact as the Church of Scotland split over issues of governance.

Spreading urbanisation and changes in land tenure produced new communities more aware of status than ever before, and social changes of the period produced a more highly educated population. Pressure for home rule grew, culminating in the creation of the Scottish Office in 1885. It is surely no coincidence that this is also the period when references to the Battle of Flodden as a symbol of a unified Scots identity started to emerge once more, this time in that most populist form, the broadsheet, or broadsides as they were known in Scotland. Amongst the many gems to be found in the holdings of the National Library of Scotland are a collection of these broadsides; they were popular bundles of news, fiction, songs and comment, passed round or pasted up on walls of inns and houses for all to read, debate and recite. And here we find Flodden, once more in the public consciousness as a symbol of courage, loss and the capacity for hope. *The Tragedy of Sir James the Rose* (1869) was a poetic tribute to a vocalist who could 'make us sigh for Scotia's wrongs 'an' Floddens day o' dool,'(1849).[27]

Some come from the *Poets Box* where, we are told, a list of popular readings and recitations is always to be had – including both *Edinburgh after Flodden* and a new method of promoting the rapid growth of whiskers! One of them holds out hope for the future, a nation and a people resurgent: 'Yet Scotland shall outlive thy stain, Dark Flodden Field; And distant lands shall sing their fame, Who die, but never yield. Here Scottish plumes and tartans wave, The foe will find thy sons as brave, As sires who filled the heroes' grave, on dark Flodden Field!'[28]

These effects may have been long term. Are the Scots a particularly independent and proud nation? Of course that is the case, but there is more. Historiographer Royal Christopher Smout summed it up rather nicely in a 1994 paper for *Scottish Affairs*. 'Think of identity as a set of concentric rings – family, kinship or clan connections, locality (I belong to Glasgow), nationality, state (in this case, Britain), Empire (while it existed) and finally, to a more amorphous cross-border affiliation (be it the United Nations or the EU).'[29]

Even beyond arguments about devolution or independence, Scotland has always been a nation wherein most would define themselves strongly as being both Scots *and* Britons. By contrast, this is something that's been missing until recently in English consciousness – witness the air of embarrassment about recent attempts to enshrine St George's Day as a national holiday. Almost as though somebody with a stiff upper lip were announcing, 'We don't talk about that sort of thing.'[30]

Smout points to history as a driver of identity, as in the case of Bavaria within Germany, Catalonia within Spain, or Scotland within Great Britain. He notes six key 'mythic' moments in Scots history, of which Flodden is one, which have come, collectively, to define both past and future:

> All the key myths involve clash with England or 'English' values; all but one are tragedies and defeats from the Scottish side; Scotland is, however, always Scotland the Brave: It is a tale operating to infuse a sense of Scottish pride with a concomitant sense of the inevitability of Scottish political failure.[31]

He ends with an interesting observation – that three hundred years has taught the Scots not to fear absorption into a wider political entity; that it is possible to retain what is unique about a nation even while participating in a wider alliance. The modern example he cites is the European Union.

Not that the Scots need any lessons in being European as well as themselves: the Auld Alliance owes much to the events culminating in Flodden. The Franco-Scottish alliance was not a new one, nor was the use of that alliance against the English. What did change in the early

sixteenth century was the way Scotland was caught up in France's European ambitions; she found herself standing with France against the combined forces of the Papacy, Spain, Venice and the Swiss. Some might say that this change was disastrous. It has to be admitted that from the outset the alliance was manipulated by the French in a cynical manner and Franco-Scottish collaboration on the border, as in 1385, was generally a chastening experience.[32]

In 1512, under a treaty extending the Auld Alliance, the peoples of Scotland and France effectively became nationals of each other's countries. It emphasises the importance of the relationship between the two. The Auld Alliance (actually a renewable treaty) had been in existence since before 1295 and was essentially a mutual protection pact, aimed at England. It had been renewed regularly since then, with each party agreeing to invade English territory if the other were at war with the enemy over the border. The 1512 codicil was not simply a gesture on the part of Louis XII; correspondence contained in *The Flodden Papers* makes it clear that France needed more than Scotland's willingness to act as a diversion while the real fight went on.[33]

In a letter to Robert Cockburn, the king of France noted an offer by the king of Scots to supply soldiers. 'Yes please,' was Louis's response; 'four thousand of your experienced men would be of considerable use in Italy.'[34] Scotsmen had served under the French kings during the Hundred Years' War and, as this correspondence notes, had formed a bodyguard to the kings of France since the reign of Charles VII. These served as volunteers rather than members of any expeditionary force. Manrent, that system of near-feudal relationships which allowed Scots to serve for an agreed 'leave of abence', was still very much in operation. It was notoriously difficult to persuade men contracted in this way to stay on once their term was finished.

Why was James IV so keen to venture abroad? Two reasons – or rather, two ambitions of the Scottish Crown – reflect his growing confidence about Scotland's place in Europe. First, James had long maintained the ideal of leading a crusade against the infidel: correspondence relayed through the French ambassador (Charles de Tocque, Seigneur de la Mothe) in April 1510 contains detailed discussion of James's proposals to act as Captain General of a new crusade to free the Holy Sepulchre and to contain the incursions of the Moors into Europe.[35] The second target was closer to home: the English throne. This was a possibility, because at this stage Henry VIII was without a male heir. Scotland may not have been a nation on the scale of France, but theirs was, to a limited extent, a relationship of true partners – not a weak state overly reliant upon a powerful one.

Maybe Flodden changed that. Scotland would never really again be in a position to invade. Albany could raise little enthusiasm and James

V's abortive attempt, which culminated in near farce at Solway Moss, underlined the difficulties. Even if she went on to make a fierce and finally successful defence of her own territory during the period of the 'Rough Wooing', this was essentially reactive and defensive in character. James V's daughter, Mary, might become queen of France, but as consort, rather than co-ruler. From 1513, Scotland was more involved with her neighbour than with Europe. The Reformation, first in England, then more gradually in Scotland, changed the dynamic more effectively than any military action, before or after. Nonetheless, that sense of looking outward, driven by the Scots diaspora and the totemic if largely mythic symbolism of the Auld Alliance, would retain potency. Recall 1990, when Glasgow won the title of European City of Culture. This award ushered in a period when commentators would routinely refer to the cosmopolitan and European nature of the Scots polity as if it were a commonplace that had, somehow, been overlooked for a while.

Scotland has a longer memory. In 1995, celebrations were held in both France and Scotland to mark the 700th anniversary of the Alliance. Much was made of the impact of French culture on Scottish architecture, law, language and cuisine. Many a wine merchant was quick to note that claret had long been the local wine of choice. Even after the Union of Parliaments with England in 1707, it continued to be smuggled into Scotland: 'It appears that Scots through the ages have sought to demonstrate their affinity with their French friends by toasting "the King over the water" with a fine drop of claret.'[36] And, of course, it was noted with glee that the promise of dual citizenship in both countries was only revoked by the French government in 1903.

In 1934 the Scottish National Party (SNP) came into being with the joining together of the National Party of Scotland and the Scottish Party. Winnie Ewing won the new party's first seat at Westminster in the 1967 Hamilton by-election. Twenty-two years on, and in a devolved Scottish Parliament, the SNP formed the second-largest party. After two terms in opposition, the party won control in 2007 but still as a minority government, not winning an outright majority until four years later. Though they slipped back in 2017, the most recent election saw Nicola Sturgeon make significant gains.

In 2014 the vote was a close-run thing; very possibly it was the intervention of Gordon Brown, a 'big beast' who spoke persuasively for a 'No Vote', that swung the day. Neither side had much to smile about; the campaign was frequently bad-tempered and embittered. Further, the result was close enough to allow nationalists grounds for future hope, especially after the Brexit vote in 2016. It seems voters were swayed by fears of adverse economic consequences: pragmatism, not passion.[37]

While the SNP just about cleaned up in 2019, the borders remained much less impressed: 'Three seats across the ITV Border region in the

south of Scotland are among the few the Tories have managed to retain ... So the thick Tory blue line north of the Border that goes from Portpatrick in the West to Eyemouth in the East remains, even if the majorities that delivered it are much thinner.'[38]

What, if anything, does this tell us about what might be defined as a 'Scottish Border character'? The vote was by no means clear cut, and many in the border shires clearly favour the independence route. We must always be wary of stereotypes; writers enjoy these, but actually putting your hand on anything resembling a 'border' character is very difficult and probably pointless. A Northumbrian is different from a Cumbrian, and someone from Dumfries & Galloway is different from both. Perhaps what these results do suggest is that, despite our centuries of brawling, borderers on both sides still feel distant from, and different to, their more cosmopolitan contemporaries.

I did hear some disquieting stuff on the English side of the line: that independence would awaken the old border rivalries. Even at a civilised dinner for some of the great and good near Kielder there was talk, and not all of it joshing, of re-arming the English marches. Drink-fuelled belligerence perhaps, but we only have to look at the terrible fate of the former Yugoslavia to see just how easily it can all go so terribly and bloodily wrong. Do I think it could happen here? No I don't, but re-drawing the line would have consequences. What these might be – how they might manifest themselves – I'm not quite sure. Anyone who tells you he is, will be lying.

Generally, and in terms of identifiable character, Dan Jackson and other good writers do stress the reputation Northumbrians in particular have for hard work, harder drinking and very hard fighting. The Northern and Border regiments of the British Army all have long banners trailing myriad battle honours and all have won more than their fair share of gallantry awards. It's not just here that history has been held to influence culture: authors like C. V. Wedgwood suggest that the biblical brutality of the Thirty Years' War conditioned the German character and influenced subsequent development of that notorious *Kultur* which produced the scale of casual atrocity witnessed in Belgium after August 1914.

Well, *we* had ten times as long as that to grow hard. Then we had several centuries, at least in Northumberland, to be toughened-up by heavy industry and mining. These demanded robust, resilient men, inured to cold and exhaustion, proofed against tragedy. The Hartley Pit Disaster, which occurred on 16 January 1862, cost the lives of 204 miners, including a distressing number of boys. This would equal the losses from any decent sized border scrap. It's the kind of death toll you'd expect a front-line battalion to suffer on 1 July 1916, and a close knit 'Pals' battalion at that.

There's a melancholy monument in Earsdon Churchyard to the victims; almost an entire generation of husbands and sons of working age were killed.[39] My paternal grandparents lived at 6 Churchways, just next to St Alban's Church, and I used to spend time wandering the graveyard. I always stopped beside the obelisk, noting that many of those remembered were my age or younger. Most war memorials carry far fewer names.

Many other writers, some 'real miners' like the marvellous Sid Chaplin, have chronicled life in the coalfields; it was dirty, hard, dangerous and unhealthy. What cultural resonances these miners took, if any, from their reiver heritage and given that many were immigrants, is uncertain. Yet my grandfather, his brothers and their generation, most of who had little formal education, did cherish their history; I certainly have much to thank them for. They were members of the ILP and were firm advocates of lifelong learning as a pathway to self-enrichment and social mobility. In terms of my father's generation and mine, it worked. I was the first in my family's history to go to university, an achievement that was trumpeted as a milestone.

Yet if there's one thing that characterises the more rural borderers, wherever you stand in the Marches, it was and remains their independence of spirit. Philip Walling, a former successful barrister and now more successful author, was born in Cumbria and while he lives and has lived for thirty odd years in Northumberland, he still sees himself as very much a Cumbrian. His ancestors were Norsemen and he sees this heritage as defining. He has never been an employee and cherishes his independence more than anything.

He sees 'Geordies' as being very different: physically immensely tough but lacking in free spirit. This could be the legacy of serving generations of powerful feudal magnates – the Percies, Nevilles, Douglases, Umfravilles et al – that fostered a spirit of proud subservience, of revering that level of leadership: 'no Prince but a Percy' and all that. Did this historical system of allegiance transfer to the mine owners (the Dukes of Northumberland being prominent in this as well), to industrial magnates like Lord Armstrong and others? Very possibly it did – feudalism morphing into capitalism. Recently, on a visit to Alnwick Castle archives, I saw the 'Flodden Roll': a list of names of those of Earl Percy's men who had served in the Flodden campaign. My family has, or is said to have had, an Alnwick connection, and the name 'John Sadler' featured on the list. A direct ancestor? Who knows? I'm saying he was!

Philip Walling's literary output has focused on our agricultural heritage, richly woven paeans of praise and belonging; he began his career as a Cumbrian farmer and has never severed the link. He stands very much for our agricultural heritage and refutes the orthodoxy of 're-wilders' such as George Monbiot and his vision of a landscape devoid

of husbandry. Years ago Philip described to me the pattern of land drainage on his farm in Cumbria, not far from Cockermouth. He traced the intricacy of these ancient channels back to an Iron Age field system. For two thousand years, generation after patient generation of farmers had followed the same course. I was impressed. Philip writes:

> I think my dislike of restraint comes more from my father's side of the family than the Armstrong or Scott lineage on my mother's side. He was a Norseman from a line long-settled in Westmorland. The Scott and Armstrong (in the West) were Brythonic tribes, no doubt impatient of coercion, but they do not fit easily into the narrative of Norse independence. The point about the Norse influence was that although they disliked being bossed about, they did know how to impose order based on the rule of law in a society. This, after all, is the only guarantee of freedom – not 'democracy' which inevitably leads to tyranny of one kind or another.
>
> The Norsemen could not have conquered and maintained kingdoms from Palestine to England via France, Sicily and the Kievan Rus, by force alone. Although extreme violence certainly underpinned their power, they had an instinctive dislike of unfairness and were prepared to eschew individual advantage if it contributed to the greater good. That's one of the reasons they wielded such moral authority and why their subjects were willing to submit to and eventually embrace their hegemony.
>
> I would argue that this moral authority was lacking in the Brythonic tribes that carved up the north of England and southern Scotland after Roman rule had ebbed away. So I do not accept that it is my Scott and Armstrong ancestors who have given me the legacy of a love of freedom and independence. While I crave freedom, it is not anarchy, which was created by the Border Wars. Freedom requires self-restraint, desire for truth and acceptance of a framework of common law to which every man adheres because he knows it to be a bulwark against tyranny on the one hand, and anarchy on the other. And he knows that the common law accords with every man's deepest understanding of justice. This, of course, has to be guaranteed by force, but it is not justified by force alone.

Those who dwell in the upland dales and county areas will inevitably be different to those living in the cities (few as these are). Indeed, urban dwellers still often view the dalesmen as hillbillies. Quite often they're right. I did at one time have a brother-in-law from Coquetdale who, even at the age of thirty, had never been to Newcastle and, when he was taken, found the experience altogether too much and came close to requiring sedation. On the Scottish side there aren't any really large population

centres to compare with Tyneside which, with its defining history of heavy industry, has evolved differently.

More than two decades ago women managed, after a stiff fight, to be included in the celebrated Common Riding, but the prejudices, strong at the time, have not gone away: in 2019 it was reported:

> Hawick Common Riding could lose thousands of pounds worth of funding following a series of complaints about behaviour towards women. They include claims that some female participants faced discrimination, derision and hostility at the event. ... complaints led to the withholding of a £9,300 grant from Scottish Borders Council. The row comes more than 20 years after two young women first defied convention and joined Hawick Common Riding.

'Venom' had been directed towards women riders and the leader's address referred only to 'gentlemen'. This manifest misogyny is a more unwelcome reminder of traditional attitudes.[40]

While lecturing during a World War Two exhibition at Woodhorn in 2009,[41] I was struck by how many complaints there were: 'Whey it's alreet t'talk aboot Ashington but what aboot Bedlington – it's always the same.' Geordies talk about belonging in the sense of an individual's roots – 'he belongs Blyth,' which means 'that's where he comes from,' and this is regarded as pretty much definitive. We remain more tribal than the southerners; for one thing there hasn't really been much mass-immigration since the days of the coalfields. If anything, the population – often the brightest and the best – have gravitated south.

One characteristic that does get mentioned time and again is *dourness*; not rudeness or xenophobia (though there is a bit of that at times), but a certain reserve and a generally laconic outlook. Borderers aren't given to emotional outbursts. Beverley Palin, one of a younger generation of Northumbrian pipers, is a lively exponent of the folk tradition. Her father, a retired railwayman for whom the adjective 'dour' was probably coined, once advised her over a morning cup of tea that one of her cherished band members had died suddenly. 'Bernie's deid.' That was the sum of poor Bernard's epitaph.

Beverley also remembers piping at a funeral. The widow was tiny and terrifying, swathed in bear-like black fur with an enormous black fur hat, surveying the proceedings from her wheelchair like Giles's formidable granny. She was accompanied by her daughter. Bev played the pipes to lead the coffin out, then walked ahead, piping, to the graveside. After the committal, Granny beckoned her daughter to push her to the foot of the grave. Slowly she extended a bony finger and in a manner reminiscent of one of Macbeth's witches, declaimed 'Look on yer faither! Look on

yer faither!' In the silence that followed she turned to the daughter (now looking on her faither).

'Ye'll hev te put yer tabs doon, hinny...'

Even Covid could dampen the traditional borderer's gallows humour:

Tae a virus

Twa months ago, we didna ken,
yer name or ocht aboot ye
But lots of things have changed since then,
I really must salute ye.

Yer spreading rate is quite intense,
yer feeding like a gannet;
Disruption caused, is so immense,
ye've shaken oor wee planet.

Corona used tae be a beer,
they garnished it wae limes,
But noo it's filled us awe wae fear
These days, are scary times.

Nae shakin hawns, or peckin lips,
it's whit they awe advise;
But scrub them weel, richt tae the tips,
that's how we'll awe survive.

Just stay inside, the hoose, ye bide
Nae sneakin oot for strolls,
Just check the lavvy every hoor
And stock-take yer loo rolls.[42]

Endnotes

Chapter 1

1. Steel of Aikwood, *Against Goliath* (London, Pan Macmillan 2008).
2. Interview with Graham Truman, formerly Captain in 3rd Battalion Light Infantry, September 2017, see also: http://news.bbc.co.uk/1/hi/world/europe/4632080.stm, accessed 28 March 2020.
3. Erected by the Berwickshire Naturalists in 1910.
4. Author of four volumes of *The Friday Books*.
5. Writing in the *Newcastle Journal* 2007.
6. Canon William Greenwell (1820-1918) was an Anglican clergyman, born in Durham, who excavated extensively, if overly-enthusiastically, throughout Northumberland.
7. Meaning the fort has a double ditch.
8. This was the Johnnie Armstrong Museum of Border Arms and Armour – sadly the collection appears to have been broken up.
9. Moat was on the run in July 2010 and finally shot himself after a six-hour stand-off. Paul Gascoigne convinced himself that they were somehow related.
10. *Little Jock Elliot,* Border Ballad.
11. See Moffat, A., *Arthur and the Lost Kingdoms* (Edinburgh, Birlinn 2012).
12. *Jamie Telfer,* Border Ballad.
13. *The Borderers* ran for 26 episodes on the BBC from December 1968 to March 1970.
14. 'Malcolm's Cross' still stands just east of Alnwick Castle Park, close to the line of the present A1.
15. Christopher Vane, interview 27 March 2020

Chapter 2

1. *Fortunes of War Trilogy* (London, Penguin/Random House 2014).

2. Sadler, D. J., & R. Serdiville, *The Great Siege of Newcastle 1644* (Stroud, The History Press 2011), p. 21.

3. Released 10 March 1971.

4. 1940-1982.

5. Sadler & Serdiville, *Little Book of Newcastle* (Stroud, History Press 2011), p. 171.

6. https://www.geologynorth.uk/southern-uplands/ accessed 9 March 2020.

7. 'Mosstroopers' can mean just bandits, but the name was applied to Scottish light cavalry during Cromwell's Dunbar campaign in 1650.

8. Robb, G., *The Debatable Land* (London, Picador 2018); traditionally this stretch of ground was ten miles (16 kilometres) from north to south, four and a half miles (6.4 kilometres) in width, bounded by the Liddel and Esk in the east and Sark in the west.

9. https://www.thefreelibrary.com/Customs+men+left+all+at+sea+as+Isaac+makes+his+getaway%3B+Local...-a0369123893, accessed 13 March 2020.

10. A March was supposedly the distance a man could cover in a day's march, more likely a day's ride, and even then, rather a long haul.

11. A magnificent span, built between 1847 and 1850, opened by Queen Victoria.

12. Tough, D. L. W., *Last Days of a Frontier* (Oxford, OUP 1928), p. 7.

13. NT8919; a suitably gruesome legends tells that the name was given after a pack-man slipped and the rope got caught around the stone and throttled him.

14. Tough, op. cit., p. 3.

15. Ibid

16. Ibid, p. 4.

17. Lindsay of Pitscottie *Chronicles of Scotland* Volume II (Edinburgh 1814), p. 307.

18. Percival (Percy) Reed was laird of Troughend and his neighbours the Halls set him up to be murdered and mutilated by the Croziers (see Chapter Ten).

19. Re-published by Red Fox Classics 2013.

20. Border clergy, those that were like Bernard Gilpin, tended to be on the robust side and were as prone to temptation as their flocks.

21. The Ottercops are crowned by a series of WWII emplacements guarding a radar station; has a real post-apocalyptic feel.

22. Source: English Heritage.

23. Tomlinson, W.W., *Comprehensive Guide to Northumberland* (Newcastle, Robinson 1863), p. 256.

24. Warkworth Hermitage is unique and enigmatic, a rock-hewn sepulchre which has been linked to the Templars, but then so have an awful lot of places. The riverside walk is enchanting.

25. Jackson, D., *The Northumbrians* (London, Hurst, 2019).

26. Newcastle upon Tyne did not become a city until 1882.

27. Sadler & Serdiville, *Little Book of Newcastle*, p. 17.

28. The L plan tower was just about the only building in Hawick to survive the Earl of Surrey's enthusiastic arson in 1570.

29. Beautifully located in Wilton Park to the west of the town.

30. Tough, p. 19.

31. *Fair Helen* (London, Quercus 2013).

32. Jedburgh Castle Gaol is now a museum.

33. Watson, G., *The Border Reivers* (Newcastle, Sandhill Press 1974), p. 141.

34. Ibid, p. 142.

35. Wade actually had his very own verse added to the National Anthem.

36. Willimoteswick remains as a fortified farmhouse, and still has a gritty, everyday feel to it.

37. Hexham Gaol is still open, at times, as a museum.

38. https://rowellsnorthumberland.wordpress.com/2016/07/11/ regality-of-hexhamshire/ accessed 11 March 2020.

39. Sitwell, Brigadier W., *The Border* (Newcastle, Andrew Reid 1927), p. 9.

40. Devine, D., *The North-West Frontier of Rome* (London Macdonald 1969), pp. 170-171.

41. Ruthwell lies on the Solway between Annan and Dumfries; the cross is probably eighth century.

42. Gavin Dunbar (c.1490-1547) was Archbishop of Glasgow, very well connected and no friend to Cardinal Beaton, whom he was prone to assaulting.

43. Published by Scholastic in 1998.

44. *Redgauntlet* published in 1824 is set in 1765, the last ghostly flicker of the Jacobite cause.

45. https://www.solwayfirthpartnership.co.uk/fisheries/haaf-net-fishing/, accessed 31 March 2020.

46. Skene, W. F., *Four Ancient Books of Wales* Volume I (Edinburgh, Edmonston and Douglas), p. 66.

47. Campbell, D. B., *Roman Auxiliary Forts 27 BC – 378 AD* (Oxford, Osprey 2009), p. 29.

48. Scott, *Minstrelsy* (London, Ward Lock & Co 1868), pp. 290 – 291.

49. MacDonald Fraser, G., *The Steel Bonnets* (London, Barrie & Jenkins 1971), p. 174.

50. Ibid, p. 176.

51. It was Sir John Forster who uncovered the first intimation of what would be 'The Enterprise of England' when his watchers detained an itinerant Scottish dentist or *dentatore* – purely routine, and the

fellow was kept in custody overnight. Forster examined the man's instruments and found he could unscrew the handle of one, and in the hollowed space discovered an encrypted message. The wily warden copied the cypher and then replaced the original and re-assembled the tool, letting the surgeon go on his way next day. The copy went down to Walsingham whose experts quickly cracked the code and gained the first clue as to what trouble was brewing by way of Spain.

52. MacDonald Fraser, op. cit., p. 178.

53. Despite the level of carnage, the Maxwell-Johnstone feud hasn't left the same lingering enmity as that between Campbell and MacDonald in the Highlands.

Chapter 3

1. http://www.borderreivers.co.uk/Border%20Stories/Poems%20 of%20Ogilvie.htm accessed 19 February, 2020.

2. Longshanks' brief siege and fearful sack of Berwick upon Tweed in that year was the first salvo, soon followed by many others (see Chapter Six).

3. The Battle of Solway Moss in November 1542, while less costly in terms of casualties, was an even worse humiliation than Flodden, the Scots army facing vastly inferior numbers simply fell apart (see Chapter Ten).

4. MacDonald Fraser, op. cit., p. 4.

5. *Shielings & Bastles* (HMSO 1970), p. 68.

6. MacDonald Fraser, op. cit., p. 4.

7. A 'grayne' is a unit within a wider affinity.

8. Sadler, D.J., *Border Fury* (London, Longmans 2004), p. 553

9. Gilnockie Tower has been extensively restored by a wonderfully eccentric descendant who, certainly until a few years ago and well into his eighties, was enthusiastically conducting groups of visitors. Johnny Armstrong himself never lived there; the present structure is, say, from half a century later.

10. Bothwell had been cut up by Little Jock Elliot of the Park, a notorious ruffian, as (to be fair) was the Earl. He'd cracked the reiver's thigh with a pistol shot but when he dismounted to finish his man off, the Elliot caught him with a sword blow to the skull.

11. Oswald died during the Battle of Masefield fought in August 641 or possibly the following year, defeated by an alliance of Penda and the Welsh Prince Cadwallon.

12. This was a gradual process rather than a planned and synchronised withdrawal as George MacDonald Fraser phrases it. *Steel Bonnets*, p. 15.

13. Dodds, J., *Bastles & Belligerents* (Newcastle Keepdale Press 1996), p. 270.
14. Wilson, A. N., *The Laird of Abbotsford* (Oxford, OUP 1980), p.11.
15. https://www.visitscotland.com/info/see-do/smailholm-tower-p252951, accessed 31 March 2020.
16. The slighting was carried out by order of Parliament in December 1567, after Queen Mary's debacle at Carberry Hill.
17. Agnes Randolph, Countess of Dunbar and March (c. 1312-1369).
18. Good, G. L. & Tabraham, C. J., (1981). 'Excavations at Threave Castle, Galloway, 1974-78' (PDF). *Medieval Archaeology* 25: 90–140.
19. Chris Tabraham's *Scotland's Castles* [revised] (London, Batsford 2005) is highly commended.
20. During February 1452, Douglas was summoned to appear at Stirling by James II where, safe conduct notwithstanding, he was hacked to death, a victim of the monarch's hatred for his line.
21. Fought near Langholm on 1 May 1455, the victor may well have been the Red (as opposed to the Black) Douglas, aided by Maxwells, Johnstones and Scotts. Of the three Douglas brothers on the losing side, only one escaped.
22. Mons Meg is still on display in Edinburgh Castle.
23. http://www.douglashistory.co.uk/history/Histories/Douglaslarder.htm, accessed 31 March 2020.
24. Wall Village, north of Hexham, even has a terrace of bastles.
25. It is just as common to find bastles in a group as singly.
26. Dodds, op. cit., p. 17.
27. Durham, K., *Border Reiver 1513-1603* (Osprey 'Warrior' Series, Oxford 2011), p. 44.
28. See Dodds, op. cit., p. 320.
29. Brown, P., *The Third Friday Book* (Newcastle, Bealls 1938), p. 19.
30. Dodds, op. cit., p. 336.
31. Ibid, p. 336.
32. Ibid
33. The celebrated 'Feast of Spurs'.
34. Sir John Carmichael, Keeper of Liddesdale, Forster's nemesis at the Reidswire was murdered by Armstrongs, 14 June 1600.
35. Watson, op. cit., p. 9.
36. MacDonald Fraser, op. cit., pp. 114-115.
37. Ibid, p. 116.
38. Watson, op. cit., p. 13.
39. Ibid, p. 14.
40. MacDonald Fraser, op. cit., p. 87.
41. The morion has a distinctive rounded skull with flared brim and high, raised comb.

42. MacDonald Fraser, op. cit., p.87.
43. Ibid, p. 89.
44. A backsword is one which is sharpened only along the leading edge and fashioned more for a cut than lunge; it's also cheap to produce.
45. *Raid of the Reidswire,* Border Ballad.
46. MacDonald Fraser, op. cit., p. 173.
47. Ibid, p. 162
48. *Raid of the Reidswire.*
49. Lord Francis Russell, when attending a subsequent Truce Day at Windygyle ten years later, was mysteriously gunned down by an unknown assailant; no culprit or proper motive for the crime was ever detected, see MacDonald Fraser, pp. 312-313.

Chapter 4

1. https://historicengland.org.uk/listing/the-list/list-entry/1018943, retrieved 20 November 2019.
2. A period in human history between the Upper Palaeolithic and Neolithic Ages, say 15,000-5,000 BC.
3. Oliver, N., *a History of Ancient Britain* (London, Weidenfeld & Nicolson 2010), p. 29.
4. MiD: 'Mention in Dispatches', a lower tier gallantry award.
5. Proc Soc Antiq Scot, 121 (1991), 1-3 Obituary George Jobey
6. *Iliad,* Book XVI' translated by W. H. D. Rouse (Edinburgh, Thomas Nelson & Sons 1938), p.p. 192–193.
7. See website: http://www.bronze-age-craft.com/
8. So named after a founder's hoard discovered in Ewart Park in Northumberland and is the twelfth in a sequence of industrial stages that cover the period 3000 BC to 600 BC: The Ewart Park phase dates from 800 to 700 BC.
9. Koch, J. T., in C. Gosden, S. Crawford & K. Ulmschneider *Celtic Art in Europe: Making Connections* (Oxford, Oxbow 2014), p. 9.
10. Oliver, op. cit., p. 155.
11. Ibid, p. 213.
12. Fields, N., *Alesia 52 BC* (Oxford, Osprey Campaign Series 2014), p. 9.
13. Tacitus, *Agricola* 'Complete Works of Tacitus' edited by Sara Bryant (London, Random House 1876. reprinted 1942), p. 11.
14. Roberts, A., *The Celts: Search for a Civilisation* (London, Heron Books 2015), p. 33.
15. Ibid, p. 142.
16. The name dates only from the eighteenth century, older maps refer to it by the name 'Dunpendyrlaw'.
17. The Votadini ruled from the Lothians, south to the Tyne.

18. Gododdin was the successor kingdom, covering much of the same ground.
19. Hunter-Blair, P., *Roman Britain & Early England* (Edinburgh, Thomas Nelson & Sons 1963), p. 157.
20. https://www.nms.ac.uk/national-museum-of-scotland/, accessed 15 May 2020.
21. https://historicengland.org.uk/listing/the-list/list-entry/1011397, accessed 15 May 2020.
22. https://historicengland.org.uk/listing/the-list/list-entry/1011397, accessed 15 May 2020.
23. Tacitus, *On Imperial Rome*, translated by M. Grant (Middlesex, Penguin 1956), XIV, 14-65.
24. Grant, M., *The Army of the Caesars* (London, Purnell 1974), p. xxii.
25. Josephus, *The Jewish War*, translated by H. St. J. Thackeray (London 1778), III, p. 102.
26. See Vegetius, *Epitome of Military Science*, translated by N. P. Milner, (Liverpool, Liverpool University Press 1996), I, 3.
27. Ibid, I, 1.
28. http://www.writersmugs.com/books/books.php?book=236&name=Rudyard_Kipling&title=Puck_of_Pook_s_Hill, accessed 15 May 2020.
29. Hunter Blair, op. cit., p. 53.
30. Tacitus's reference to a frontier line is the first such intimation; the idea of where the line, if any, might be drawn seems to have been rather woolly.
31. Agricola was the blue-eyed boy of the Flavian dynasty having steadfastly supported Vespasian during the anarchy and civil wars of AD 69.
32. The Stanegate ('Stone Road' in Northumbrian dialect), was an east/west highway linking Corbridge (*Corstopitum*) to Carlisle (*Luguvalium*).
33. Masters, J., *Bugles and a Tiger* (London, Weidenfeld & Nicholson 2002 edition), p. 17.
34. Ibid. The Tsar's vast armies were much feared though they performed poorly in the Crimea, with badly trained peasant conscripts, ill equipped and even worse led, the Bear began, for a while, to resemble a paper tiger.
35. Ibid, p. 17.
36. A Roman Mile – literally a thousand paces, was estimated to be equal to 1,617 yards (1,479 metres).
37. Originally published in 1954 by Oxford University Press.
38. Moved to GNM Hancock, April 2008.

39. Professor Brian Shefton, who died in 2012, had amassed a fabulous collection of Classical Greek artefacts, including some wondrous Corinthian helmets, and these were displayed in a secret little museum hidden in the depths of the Armstrong Building at Newcastle University, which he had set up in 1956 with a grant of £20 from the rector.

40. https://www.ncl.ac.uk/events/public-lectures/archive/item/themuseumofantiquitiesaretrospective.html, accessed 15 May 2020.

41. Collingwood Bruce, J., *Handbook to the Roman Wall* (Newcastle upon Tyne, Andrew Reid 1957), p.p. 87 – 93.

42. *Lorica Hamata* is mail armour as opposed to segmented plate *Lorica Segmentata*.

43. Professor Sir Ian Richmond (1902-1965) was the pre-eminent Roman scholar of his day, Professor of Roman Archaeology at Oxford.

44. Collingwood Bruce, op. cit, Introduction, p. viii.

45. Ibid, p. 109.

46. Ibid

47. The cult of Mithras was inspired by Iranian worship of the Zoroastrian Angelic Divinity (*yazata*) Mithra. The rites were popular among the Roman military from about the 1st to the 4th century AD.

48. Macdonald Fraser, op. cit., p. 15.

Chapter 5

1. 1958; directed by Richard Fleischer.

2. 1956; directed by Anthony Mann.

3. https://www.khm.uio.no/english/visit-us/viking-ship-museum/, accessed 2 June 2020.

4. Welsh triads and genealogies.

5. Higham, N. J., *the Kingdom of Northumbria 350–1100* (Stroud, Alan Sutton 1993), p. 82.

6. This battle isn't mentioned by Bede or in the *Anglo-Saxon Chronicle*.

7. *Anglo-Saxon Chronicle* [ASC] (London, George Bell & Sons 1880), Anno 525–560, p. 312.

8. Magnus Maximus also features in the Welsh sources as Prince Macsen; Ammianus Marcellinus, *The Later Roman Empire* (London, Penguin 1986), p. 417.

9. Possibly born towards the end of the fifth century, Thornton, David E. 'Urien Rheged' in *Oxford Dictionary of National Biography* (online edition; Oxford University Press doi:10.1093/ref:odnb/28016); his memory survives in a rather

strange retail centre outside Penrith; not sure he'd feel in any way flattered.

10. Principal source is Nennius, a Welsh scholar, his work first compiled in the ninth century.

11. Supposedly at Battleshield Haugh, north-west of Alwinton; see Sitwell, op. cit., pp. 197–198.

12. Aneirin is a sixth-century poet of the Welsh school and his *Gododdin* is part of that oral tradition; a first written version didn't appear till some 250 years after the events it describes.

13. Calgacus – 'The Swordsman'; purported leader of the Caledonian confederacy defeated by Agricola at Mons Graupius in 84 AD.

14. Venerable Bede's, *Ecclesiastical History of England* (London, George Bell & Sons 1880), Book I, chapter 1, pp. 5-6.

15. A seax, shortened version of scramasax, is a multi-purpose utility knife and back-up weapon common to all classes of society.

16. Uncovered in 1848 at Benty Grange Farm, West Derbyshire.

17. Near Woodbridge in Suffolk and first excavated in the nineteen-thirties.

18. Treece, H., & E. Oakeshott, *Fighting Men* (Leicester, Brockhampton Press 1963), p. 88.

19. Bede, Book I; chapter 34, p. 61.

20. Dunadd, a hugely evocative site, has always struck me as Scotland's version of Mycenae.

21. Hayes-McCoy, W. A., *Irish Battles* (Belfast, Appletree Press 2009), p. 52.

22. Bede, Book I; chapter 34, p. 61.

23. Ibid, Book II; chapter 2, p. 71.

24. Ibid, Book II; chapter 12, p. 93 & also *ASC* Anno 617- 627, p. 317.

25. Ibid, Book II; chapter 9, p. 83.

26. Brian Hope-Taylor (1923–2001), artist, archaeologist, teacher & broadcaster.

27. Heaney, S., *Beowulf* (London, Faber 1999). I was in the 2015 ITV series filmed in Weardale, though not many would be brave enough to admit that – it was pretty dire.

28. http://www.gefrin.com/gefrin/gefrin.html, accessed 2 June 2020.

29. Bede, Book II; chapter 16, p. 100.

30. Ibid, Book II; chapter 20, p. 106/*ASC* Anno 627–635, p. 318

31. Ibid, Book II; chapter 1, p. 108.

32. Ibid, Book III, chapter 1, p. 109.

33. Another unfinished epic was the independent film *Whiteblade* filmed near Bishop Auckland in 2015/2016 but it never made it onto the screen.

34. *ASC* Anno 627- 635 p. 318.

35. The 'Fyrd' comprised both a general levy and a 'select' element who were better trained and equipped.
36. Bede, Book III; Chapter 2, p. 110.
37. Ibid, Book III; Chapter 8, p. 123/*ASC* Anno 636-644, p. 319.
38. Probably somewhere near Leeds; Bede, Book III; Chapter 24, p. 151/*ASC* Anno 645-655, p. 320.
39. Released in 1966.
40. Released in 1972.
41. Bede, Book III; Chapter 3, p. 112.
42. Ibid, Book IV; Chapter 25, p. 223.
43. *ASC* Anno 677-685, p. 329.
44. Lynch, M., *Scotland a New History* (London, Pimlico 1992), p. 14.
45. Ibid, p. 19.
46. *Vita Sancta Wilfrithi* – he was Wilfrid's chanter and latterly biographer. (Cambridge, University Press 1985).
47. Bede, Book IV; Chapter 23, p. 223.
48. In 1899 he was canonised as Doctor of the Church St Bede the Venerable.
49. This land and the site are now in the care of the National Trust.
50. Pevsner N. & E. Williamson, *Durham* in the 'Buildings of England' (London, Penguin 1985), p.p. 340 – 341.
51. Adams, M., *King in the North* (London, Head of Zeus 2013).
52. https://www.tandfonline.com/doi/abs/10.1080/04580 63X.1994.10392215, accessed 1 June 2020.
53. *ASC* Anno 783-794, p. 342.
54. Ibid
55. Crumlin-Pedersen, O., *The Skuldelev Ships I* (Viking Ship Museum and the National Museum of Denmark 2002).
56. Ivar the Boneless – it's not certain what his name implies, possibly he may have suffered from some form of disability, or he may have been impotent, or simply this refers to his cunning; he was as slippery as a snake
57. Johnson, A., *Battle of Athelstaneford* in 'Battlefields Trust Magazine', volume 24, issue 3, Winter 2020, pp. 10 -13.
58. *ASC* Anno 861-868, p. 351.
59. *Ragnald of Corbridge,* Regia. Org, 31 March 2003, accessed 1 June 2020.
60. Howorth, H. H., *Ragnall Ivarson and Jarl Otir* ('English Historical Review' 26 101 1911), pp. 1-19.
61. https://www.scotsman.com/whats-on/arts-and-entertainment/ivar-boneless-and-brutal-viking-invasion-scotland-1460905, accessed 1 June 2020.
62. *ASC* Anno 924 -937, p. 375.
63. Ibid, Anno 937-941, p. 377.

64. Sitwell, op. cit., pp. 198-199.
65. *ASC* Anno 1054-1055, p. 432.
66. Ibid, Anno 1063-1065, p. 437.
67. Ibid, Anno 1066, p. 440.
68. Ibid, Anno 1068-1069, p. 446.
69. Ibid
70. Ibid, Anno 1071-1074, p. 453.
71. Ibid, Anno 1077-1080, p. 456.
72. A stone memorial still stands on the east side of the town. Legend asserts that the Scottish King was pierced through the eye by a Norman knight pretending to offer him the keys to the citadel and earned himself the name 'Pierce-Eye' – Percy in due course. A complete myth but an alluring one.

Chapter 6

1. https://www.nrscotland.gov.uk/Declaration, accessed 22 June 2020.
2. Fisher A., *William Wallace* (Edinburgh, John Donald 1986), p. 19.
3. 22 August wasn't a good date for kings: on that date Richard III was killed at Bosworth (1485) and Charles I unfurled his standard at Nottingham in 1642.
4. Lynch, op cit., p. 53.
5. Kinross, J., *Walking and Exploring the Battlefields of Britain* (London, David & Charles 1988), p. 48.
6. *Chronicles of Lanercost*: pp. 115-118. The chronicler may have exercised a degree of bias as the king seems generally not to have been noted for his alleged licentiousness, see Reid, N. H., (ed.) *Alexander III; the Historiography of a Myth* in 'Scotland in the Reign of Alexander III 1249-1286' (Edinburgh, John Donald 1990), p. 218.
7. *The Song of Lewes* (1264).
8. This was a much later addition to Longshank's CV.
9. Morris, M., *Edward I – a Great and Terrible King* (London, Random House 2008), p. 78.
10. Ibid, p. 241.
11. Ibid
12. The entire panel of jurors totalled over a hundred, with lengthy delays to allow aspirants to work up their claims – such delays also helped Edward consolidate his grip.
13. Bower, W., *Scotichronicon* (ed. D. E. R. Watt), (Edinburgh, John Donald 2012), Book XI, p. 183.
14. In that battle, he carried captured banners taken from the Montfortians during his earlier raid on Kenilworth.
15. *Scotichronicon* Book XI, p. 183.
16. These were new 'model' towns set out in a regular grid pattern, the best example still surviving is Monpazier.

17. *Scotichronicon* Book XI, p. 184.
18. Ridpath, Revd. G., *Border History of England & Scotland* (Berwick upon Tweed, C. Richardson 1776), p. 129.
19. *Bon besoigne fait qui de merde se delivrer.*
20. *The Wallace, Blind Harry* (ed. A. McKim, Michigan, Medieval Institute Publications 2003), Book ii. p. 281 & Ridpath, op. cit., p. 142.
21. *Scotichronicon* Book XI, p. 186.
22. Mackay, J., *Braveheart* (Edinburgh, Mainstream 1995), pp. 105-113; the unlucky woman was Marian Braidfute, daughter of Hugh Braidfute of Lamington.
23. Murray succumbed to injuries received at Stirling.
24. Ridpath, op. cit., p. 144.
25. Fisher, op. cit., p. 55.
26. Barrow, G. W. S., *Robert Bruce* (Los Angeles, University of California Press, 1965), pp. 206-208.
27. Ibid, pp. 275-276.
28. Ibid, p. 245.
29. Ibid, pp. 290-296.
30. Prestwich, M., *Armies and Warfare in the Middle Ages* (London, Yale University Press 1996), p. 58.
31. Lomas, R., *County of Conflict: Northumberland from Conquest to Civil War* (East Lothian, Tuckwell Press 1996), p. 58.
32. Barbour, J., *The Bruce* (Edinburgh, Canongate 2007), p. 94.
33. *Scotichronicon*, Book XIII, p. 211.
34. Lomas, op. cit. p. 41.
35. Ibid
36. Ibid, p. 42.
37. Ibid, p. 43.
38. Ibid, p. 43.
39. Ibid, p. 44.
40. Ridpath, op. cit, p. 148.
41. Bates, C. J., *History of Northumberland* (London, Elliott Stock 1895), p. 156.
42. Sadler, D. J., *Border Fury* (Harlow, Longmans/Pearson 2004), p. 148.
43. Ridpath, op. cit., p. 197.
44. Robson, R., *The Rise and Fall of the English Highland Clans* (Edinburgh, John Donald 1989), p. 34.
45. 'Barded' = caparisoned.
46. Sadler, op. cit., pp. 169-170.
47. *The True Chronicles of Jean le Bel* (translated by N. Bryant, Woodbridge, the Boydell Press 2011), Chapter X, p. 40.
48. Ibid

49. Ridpath, op. cit., p. 197.
50. Lynch, op. cit., pp. 128-131.
51. *Scotichronicon* Book XIII, p. 217.
52. Oman, Sir, C., *A History of the Art of War in the Middle Ages* Volume 2 (London, Greenhill 1924), p. 103.
53. Ridpath, op. cit., p. 209.
54. Oman, op. cit., p. 106.
55. Ibid
56. *The Original Chronicle of Andrew of Wyntoun,* ed. F. J. Amours (Scottish text Society, 1093–1914) VI, pp. 168-187.
57. *Jean le Bel,* Chapter LXXVI, p. 189.
58. *Scotichronicon* Book XIV, p. 229.
59. *Jean le Bel,* Chapter LXXVI, p. 189.
60. *Scotichronicon* Book XIV, p. 230.
61. *Wyntoun,* p. 187.
62. Baliol finally gave up in 1356 and assigned his right to Edward III who, by then, had clearly decided a captive David II was the better bet.
63. See *The Battle of Neville's Cross 1346* (eds. D. Rollaston & M. Prestwich in 'Studies in North-Eastern History', (Stamford, Shaun Tyas 1998).
64. Scottish chronicle accounts (Bower) give the date as 5 August.
65. *Scotichronicon* Book XIV, p. 256.
66. *Chronicles of Froissart* (Berners translation, ed. G. C. Macaulay, London, Macmillan & Co., 1924), Chapter CXL, p. 371.
67. Shakespeare: *King Henry IV First Part I.*
68. Lomas, op. cit. p. 69
69. Ibid, pp. 70-71.
70. Robson, op. cit., p. 34.
71. Ibid
72. Lomas, op. cit., p. 35.
73. Aydon Castle, rising entrancingly above the Cor Burn near Corbridge, is a fine example of successive waves of building, upgrading the defences.
74. Macdonald, A. J., *Border Bloodshed – Scotland and England at War 1369-1403* (East Linton, Tuckwell Press 2000), pp. 197-198.
75. Ibid, p. 200.
76. Loyd, A., *My War Gone by, I miss it so* (London, Atlantic 1999), pp. 152-153.
77. https://www.revitalisingredesdale.org.uk/
78. http://www.battlefieldstrust.com/

Chapter 7

1. The poem, by Felicity Lance – a pupil at Harbottle First School – was chosen by former Poet Laureate, Ted Hughes, as winner of a

national young writers competition in 1998. It is inscribed on the 'Sad Castle' Memorial Stone next to Harbottle Castle car park.

2. A glacial survivor and outstanding landmark with, behind it, a field of half cut millstones. It was also known as the Draag Stone, OS Ref NT921044 / Sheet 80.

3. This earlier siege was the inspiration for Scott's *Marmion*.

4. For more on the siege of Norham, refer to Sadler D. J. & R. Serdiville *The Battle of Flodden 1513* (Stroud, History Press 2013).

5. Known as 'The Anarchy', 1135-1154.

6. This proved ill-fated, as Charles effectively abandoned his ad hoc garrison to their fate on the withdrawal north after turning back at Derby, and Cumberland didn't do clemency.

7. See Morris, M., *Castle; A History of the Buildings that Shaped Medieval Britain* (London, 2012).

8. This model was funded by generous support from Heritage Lottery Fund and Northumberland National Park Authority.

9. 1147-1218.

10. The Siege of Berwick as discussed in Chapter Eight.

11. Initially there were only two marches; an east and west on both sides of the border.

12. Pevsner Sir N., J. Grundy, G. McCombie, P. Ryder & N. Welfare, *Northumberland* in *The Buildings of England* series (Penguin 1992), p. 303.

13. Ibid

14. Crow, J., *Harbottle Castle, Excavations and Survey 1997-1999* in 'Archaeology in Northumberland National Park', p. 246.

15. Percy Hedley, W., *Northumberland Families* Volume 1, (Society of Antiquaries of Newcastle upon Tyne, 1968), p. 208.

16. *NCH* XII. P. 81 & Percy Hedley, p. 209.

17. The Pipe Rolls are the annual Exchequer Accounts.

18. Percy Hedley, op. cit., p. 209.

19. Ibid

20. Crow, op cit. p. 246.

21. As recounted in Chapter Five, the Battle of Carham was a heavy defeat for the Northumbrians and casualties were very high among their clergy.

22. Robson, R., *The Rise and Fall of the English Highland Clans* (Edinburgh, John Donald 1989), pp. 4-5.

23. Ibid

24. Crow, op. cit., p. 246.

25. Ibid

26. Pevsner, op. cit., p. 302.

27. Berwick upon Tweed was finally and (for now) permanently taken by Richard of Gloucester in 1482.

28. Norham was held by the Prince Bishop, part of his North Durham holdings.
29. As mentioned, Malcolm was killed at Alnwick in 1093 and a stone marker still commemorates the spot.
30. Sadler, D. J., *Battle for Northumbria* (Newcastle, Bridge Studios 1988), pp. 54-56.
31. Robson, op. cit., p. 24.
32. From the metrical chronicle of Jordan Fantosme detailing the siege of Prudhoe, quoted in Percy Hedley, op. cit., p. 209.
33. Ibid
34. Ibid
35. The site is presently managed by Northumberland National Park Authority.
36. Percy Hedley, op. cit., p. 212.
37. Serjeanty = a form of feudal tenure whereby the render is in the form of a specific service.
38. Robson, op. cit., p. 11.
39. Ibid, p. 17.
40. Ibid
41. Percy Hedley, op. cit., p. 212.
42. Pevsner, op. cit., p. 302.
43. As before, 'Roaring Northerners', distinctly pejorative.
44. Crow, op. cit., p. 258.
45. Ibid, pp. 258-259.
46. An English mark at this time was worth 13s 4d.
47. Robson, op. cit., p. 10.
48. A carucate was the Danish equivalent of a hide, a parcel of land that could be ploughed by a single team – enough to support the tenant.
49. Robson, op. cit., p. 10.
50. A licence to crenellate or to fortify was necessary royal planning consent for undertaking defensive works.
51. Robson, op. cit., p. 11.
52. Ryder, P.F., *Harbottle Castle – A Short Historical and Descriptive Account* (February 1990).
53. Robson, p. 11.
54. Ryder, op. cit.
55. Robson, op. cit., p. 11.
56. Ibid, p. 19.
57. Ibid, p. 23.
58. Percy Hedley, op. cit., p. 212.
59. Robson, op. cit., p. 24.
60. As previously noted, the Treaty of Northampton appeared to fulfil all of Bruce's objectives but dodged the question of 'The Disinherited', storing up trouble for the future.

61. Bates, C.J. *History of Northumberland* (London, Elliot Stock 1895) p. 162.
62. A tun = around 250 gallons (1,137 litres).
63. Robson, op. cit., p. 27.
64. The battle, as mentioned, was one of the first 'longbow' victories.
65. Halidon Hill, again as discussed, was another resounding triumph for the English.
66. Neville's Cross, covered in the previous chapter, fought in October 1346, resulted in a major Scottish defeat and capture of David II.
67. Robson, op. cit., p. 38.
68. Ibid
69. Percy Hedley, op. cit., p. 214.
70. Ibid
71. Ibid, p. 212.
72. Robson, op. cit., p. 39.
73. Ibid, p. 40.
74. Percy Hedley, op. cit., p. 214.
75. Ibid
76. Ibid
77. Ibid, p. 215.
78. Hodgson, *Northumberland* Pt II Volume 1, pp. 48-58 & quoted in Robson, p. 53.
79. Percy Hedley, op. cit., p. 234.
80. *Arch Aeliana*, volume xiv, p. 14n.
81. Hist. BNC volume vi, p. 434.
82. First published in *The Daily Mail*, 21 December 2019.

Chapter 8

1. Griffiths, R. A., 'Local Rivalries and National Politics; the Percies, the Nevilles and the Duke of Exeter 1452-1455' in *Speculum* Volume XLIII 1968, p. 589.
2. Weiss, H., 'A Power in the North? The Percies in the Fifteenth Century' in *Historical Journal* 19, 2 1965, pp. 501-509.
3. Griffiths, op. cit., p. 589.
4. Ibid, p. 590.
5. Griffiths, op. cit., p. 592.
6. Ibid, p. 591.
7. Ibid, p. 592.
8. Ibid, p. 594.
9. Ibid
10. Ibid, p. 595.
11. Ibid
12. Ibid, p. 602.
13. Ibid, p. 603.

14. Ibid, p. 604.
15. Ibid, p. 605.
16. Ibid
17. Ross C., *Edward IV* (London, Eyre Methuen 1974), p. 28.
18. Ibid, p. 29.
19. Griffiths, op. cit., p. 608.
20. Ibid, p. 609.
21. Ibid, p. 610.
22. Ibid
23. Ibid, p. 611.
24. Ibid, p. 612.
25. Ibid, p. 613.
26. Ibid, p. 616.
27. Ibid, p. 620.
28. Ibid, p. 621.
29. Rot., Parl. 1st Edward IV 1461 Volume v folio, 477-478.
30. *Calendar of State Papers and Manuscripts existing in the Archives and Collections of Milan*, ed. and transl. by A.B. Hinds 1912 pp. 61-62.
31. Ibid, pp. 74-77.
32. Pollard, A. J., 'Characteristics of the Fifteenth Century North' in *Government Religion and Society in Northern England 1000–1700* ed. C. Appleby & P. Dalton (Stroud, Alan Sutton 1997), p. 131.
33. Hepple, L.W., *A History of Northumberland and Newcastle upon Tyne* (Newcastle upon Tyne, Phillimore 1976), pp. 14-15.
34. Pevsner, op. cit., pp. 135-136.
35. Ibid, pp. 155-156.
36. Ibid, pp. 258-259.
37. Charlesworth, D., 'Northumberland in the Early Years of Edward IV' in *Archaeologia Aeliana* (4th series 1953), p. 70.
38. Lynch, op. cit., pp. 146-151.
39. Lomas, op. cit., pp. 45-50.
40. Murray Kendall, P., *Warwick the Kingmaker* (London, Phoenix 2002), p. 86.
41. Ibid, pp. 202-203.
42. Ross, op. cit., p. 56.
43. Gillingham, J., *The Wars of the Roses* (London, Weidenfeld & Nicolson 1981), pp. 140-141.
44. *Scottish Exchequer Rolls*, vii Ramsay ii p. 290.
45. Gillingham, op cit., p. 141.
46. Ross, op. cit., p. 60.
47. Worcester *Annales* p. 470.
48. Ibid, p. 480.
49. *NCH* vol I p. 48.

50. Worcester *Annales* p. 480.
51. Paston Letters, no 464.
52. Ross, op. cit., pp. 62-63.
53. *Gregory's Chronicle* p. 219.
54. Ibid, p. 219.
55. Ibid, p. 220.
56. Ibid, p. 221.
57. *The Year Book de Termino Paschae 4 Edward IV* in Priory of Hexham, Surtees Society p. cviii gives Alnwick as the location but *NCH* Volume 1 p. 46 claims Bamburgh – the latter seems more likely being on the coast and closer to Scotland.
58. Ross, op. cit., p. 65.
59. *Gregory's Chronicle* p. 222.
60. *NCH* 1 p. 46.
61. Hicks, M. A., 'Edward IV, the Duke of Somerset and Lancastrian Loyalism in the North' in *Northern History* Volume xx p. 24.
62. Ibid, p. 25.
63. Ross, op. cit., pp. 51-52.
64. Hicks, op. cit., p. 31.
65. *Gregory's Chronicle* pp. 221-223.
66. Hicks, op. cit., p. 32.
67. Ibid, p. 33.
68. Ibid, p. 34.
69. *Fabyan's Chronicle* p. 683.
70. *Gregory's Chronicle* p. 224.
71. *Year Book of Edward IV* p. cviii.
72. Gillingham, op. cit., p. 180.
73. *Gregory's Chronicle* p. 224.
74. Ibid, p. 224.
75. Ibid, p. 224.
76. Ibid p. 224.
77. Ibid, p. 224.
78. Haigh, P., *The Military Campaigns of the Wars of the Roses* (Boston, Da Capo Press 1997), p. 80.
79. *Gregory's Chronicle* p. 224.
80. Boardman, A., *the Battle of Towton 1461* (Stroud, Alan Sutton 1996), p. 75.
81. Haigh, op. cit., p. 80.
82. Brenan, G., *The House of Percy* (England 1898), Volume 1, p. 93.
83. Gillingham op. cit., p. 152.
84. Ross, op cit., p. 56.
85. Ramsay Sir J. H., *Lancaster and York* (Oxford, Clarendon Press 1892), Volume II, p. 302
86. Paston Letters, no. 252.

87. Ramsay, op. cit., Volume II p. 302.
88. Ross, op. cit., p. 55.
89. Ibid p. 56.
90. *Gregory's Chronicle* p. 226.
91. *Fabyan's Chronicle* p. 654.
92. *Chronicles of London* ed. C.L. Kingsford Oxford 1905 p. 178.
93. Long, B., *The Castles of Northumberland.* (Newcastle upon Tyne, Harold Hill 1967), p. 76.
94. Lomas, op. cit., p. 136.
95. Ibid, pp. 154-155.
96. Boardman, op. cit., p. 38.
97. Charlesworth, op. cit., pp. 62.
98. *Gregory's Chronicle* p. 224.
99. Ibid, p. 232.
100. Charlesworth, op. cit., p. 63.
101. *Worcester's Chronicle* p. 779.
102. Ramsay, op. cit., volume II, p. 303.
103. Charlesworth, p. 64.
104. Haigh, op. cit., p. 84.
105. *Gregory's Chronicle* p. 224.
106. Ramsay, op. cit., Volume II, p. 303 n.
107. Ibid, p. 303.
108. *Warkworth's Chronicle* p. 4.
109. *Fabyan's Chronicle* p. 654.
110. *Chronicles of London* p. 178.
111. *Fabyan's Chronicle* p. 654.
112. *Gregory's Chronicle* p. 219.
113. 'Edward' is also listed in an inventory of 1475; the Master of the Ordnance, John Sturgeon, handed into store at Calais, 'divers parcels of the King's ordnance and artillery including a bumbartell called "The Edward"'. See Blackmore, op. cit., p. 33.
114. Bates, op. cit., p. 202.
115. *NCH* Volume I p. 47.
116. *Worcester's Chronicle* p. 280; the assumption may be based on a misreading of the Latin text: 'Radulfus Gray fugit de Hexham ante bellum inceptum ad castrum Bamburghe et post bellum de Hexham multi ex parte Regis Henrici fugerunt in eodem castro.' It is more probable the chronicler is describing Grey's flight as the battle began, rather than beforehand.
117. *NCH* Volume I, p. 48.
118. *Warkworth's Chronicle* pp. 37-39.
119. *NCH* Volume I, p. 48.
120. *Warkworth's Chronicle* pp. 37-39.
121. *NCH* Volume I, p. 49.

122. Sadler, D.J., *The Red Rose and the White* (Harlow, Longman/ Pearson 2010), p. 227.
123. Ibid, p. 226.
124. Ibid
125. Ibid, p. 229.
126. Watson, C., 'The Battle of Sauchieburn' (*Battlefield Trust Magazine*, Volume 24, Issue 4, spring 2020), pp. 9-11.

Chapter 9

1. For the visitor, refer to OS Landranger Map 75 and OS Explore Map 339, which show the field (NT895371 389596, 637112), its immediate environs and elements of the English flank march.
2. As noted previously, Norham was held by the Prince Bishop of Durham, part of his North Durham holdings.
3. *Letters and Papers, Foreign and Domestic, of Henry VIII, 1519–23* cited in 'Second to None: A History of Coldstream', Coldstream and District Local History Society, 2010, p. 38.
4. *Letters and Papers, Foreign and Domestic, Henry VIII*, Vol. 3 1519-1523, J. S. Brewis (ed.), 1867, pp. 1421-1422, accessed at: British History Online (http://www.british-history.ac.uk).
5. Cited in *Second to None: A History of Coldstream*, Coldstream and District Local History Society, 2010, p. 36.
6. Ibid
7. Ibid
8. *Letters and Papers, Foreign and Domestic, Henry VIII*, Vol. 3 1519-523 J. S. Brewis (ed.), 1867, accessed at: British History Online (http://www.british-history.ac.uk).
9. Sadler, D. J. & R.B. Serdiville, *Flodden 1513* (Stroud, History Press 2010), p. 110.
10. Ibid, p. 112.
11. Ibid, p. 114.
12. Ibid, p. 102.
13. A saker or saker falcon was medium-calibre artillery firing a 5.25 lb (2.7kg) ball; a demi-culverin was larger but of course smaller than a culverin.
14. Sadler & Serdiville, *Flodden* p. 117.
15. Ibid, p. 119.
16. Ibid
17. A. & J. Ferguson.
18. Ibid, p. 132.
19. Ibid, p. 134
20. Ibid, p. 141.
21. Ibid, p. 147.
22. Ibid

23. Ibid, pp. 149-150.

24. Ibid, p. 156.

25. Ibid, p. 169.

26. Ibid, p. 170.

27. Ibid, p. 180.

28. It appears that the ornate chest in which Queen Margaret stashed her silks was acquired at auction by a Coquetdale farmer and authenticated by NMS, where it currently resides.

29. Sadler & Serdiville, *Flodden* p. 211.

30. Ibid

31. Ibid

32. *'The history of Scotland: from 21 February, 1436 to March, 1565. In which are contained accounts of many remarkable passages altogether differing from our other historians; and many facts are related, either concealed by some, or omitted by others,* Robert Lindsay of Pitscottie (Baskett and Company, 1728), p. 113, http://books.google.co.uk, accessed 1 April 2020.

33. *The Baronetage of England, or the History of the English Baronets, and such Baronets of Scotland, as are of English families; with genealogical tables, and engravings of their armorial bearings,* Vol. 4, Revd. William Bethan, (1804), http://books.google.co.uk, accessed 1 April 2020.

34. *Rambles in Northumberland and on the Scottish border; interspersed with brief notices of interesting events in border history,* William Andrew (Chatton, Chapman and Hall, 1835), pp. 234-236, http://books.google.co.uk, accessed 1 April 2020.

35. *A Biographical Dictionary of Eminent Scotsmen in Four Volumes, vol. III* R. Chambers (ed.) 1835, Revised by T Thomson, (Blackie & Son, 1855), accessed at *http://www.archive.org/stream/biographicaldict04chamiala page/n7/mode/2up.*

36. Byrd, E., *Flowers of the Forest* (London, MacMillan, 1969).

37. *YouTube* Isla St Clair; *Flowers of the Forest,* http://www.youtube.com/watch?v=hqY79y-SCbA

38. Byrd, op. cit.

39. McNeil, E., *Flodden Field: A Novel* (London, Severn House 2007).

40. Nicholson, H., *Tom Fleck* (YouWriteon.com, 2011).

41. Orkney & Shetland weren't formerly annexed till the reign of Charles II in 1669.

42. *The History of Scotland,* Patrick Fraser Tyler, (William Tait, 1834), p. 90, accessed on Internet archive: *http://www.archive.org/stream/historyscotland18tytlgoog page/n115/mode/2up.*

43. Our Scotland – Scottish Politics Discussion Forum; *http://ourscotland.myfreeforum.org/archive/king-james-iv-personal-effects-helprequested__o_t__t_361.html.*

44. In the case of Culloden, battlefield archaeology has quite significantly altered our perceptions of both the area involved and of the action itself.
45. London, 1725.
46. The site was investigated in 2001 as part of the BBC series *Two Men in a Trench*.
47. Phillips, G., *The Anglo-Scottish Wars 1513-1550* (Woodbridge, Boydell Press 1999), pp. 33-34.
48. Ibid
49. James II, as noted, had been killed at the Siege of Roxburgh in 1461 when one of his own cannons blew up.
50. Philips, op. cit., p. 4.
51. Ibid
52. Ibid, p. 95.
53. Pegler, M., *Powder and Ball Small Arms* (Wilts. Crowood Press 1998), pp. 18-19.
54. Ibid

Chapter 10

1. Troughend still stands, just past Otterburn heading north on the A68. The present house is much later, dating from 1758.
2. Marsden J., *the Illustrated Border Ballads* (London, Macmillan 1990), pp. 36-37.
3. Ibid, p. 44; there are two version of this ballad, one of which was collected by James Telfer, schoolmaster at Saughtree, recited to him by an ancient besom called Kitty Hall.
4. Phillips, op. cit., p. 140.
5. Ibid
6. Ridpath, op. cit., p. 355.
7. Ibid, p. 358.
8. Ibid
9. Hall, E., *Chronicle* (London, J, Johnson 1809), p. 645.
10. Lisle started well but went bad, ending up as a desperado, for which he was eventually hanged.
11. Phillips, op. cit. p. 144.
12. Ibid, p. 145.
13. Standard drill for such raids was for the strike force to establish a forward operating base and send out mounted commandos to harvest the loot.
14. Phillips, op. cit., p. 46.
15. Ridpath, op. cit., p. 371.
16. 'Small' beer was an essential, as most water was unfit for drinking.
17. Phillips, op. cit., p. 150.
18. Ridpath, op. cit., p. 373.

19. Ibid
20. Phillips, op. cit., p. 151.
21. Ridpath, op. cit., p. 373.
22. *Hamilton Papers 1532-1543*, editor J. Bain (Edinburgh, Great Britain Register Office 1890) Vol. 1, p. xvi.
23. Phillips, op. cit., p.152.
24. *State Papers & Letters of Sir Ralph Sadler,* Editor A. Clifford, in three volumes (Edinburgh, Constable & Co 1809), Volume 1, p. 65
25. Hertford was plagued by a tricky younger brother, Tom Seymour, who had married Queen Katherine Parr; a witless chancer who soon paid the price.
26. Borland, Rev. R., *Border Raids & Reivers* (Glasgow, Thomas Fraser 1910), pp. 63-64.
27. Ibid p. 68.
28. Ridpath, op. cit., p. 231.
29. A handgun, lighter and handier than a musket, though shooting a smaller ball with lesser charge; something akin to a carbine.
30. Ridpath, op. cit., p. 381.
31. Borland, op. cit., p. 69.
32. Ibid
33. Beaton was murdered on 29 May 1546, his body mutilated and hung from a window.
34. These were Anne Boleyn and Katherine Howard.
35. Ridpath, op. cit., p. 385.
36. This was a new role which facilitated management of the army.
37. Phillips, op. cit., p. 185.
38. Cavalryman; half-armoured and armed with a lance.
39. A troop of gentlemen bodyguards raised by Henry VIII in 1509, remained as an office until 1834.
40. Patten, 'Expedition into Scotland etc' in *Tudor Tracts* edited by A. F. Pollard (London, Constable 1903), p. 45.
41. Ibid, p. 84.
42. Ibid, pp. 71-78.
43. Ibid, p. 90.
44. Ibid, p. 90 & Ridpath, op. cit., p. 385.
45. Ibid
46. Patten, op. cit., pp. 85-89.
47. Most of the ground now is built over; see http://www.battlefieldstrust.com/media/682.pdf, accessed 12 July 2020.
48. Ridpath, op. cit., p. 285.
49. Patten constantly refers to these as 'Irish', but they were likely Highlanders.
50. Ridpath, op. cit., p. 386 & Patten, op. cit., p. 102.

51. Ridpath, p. 385, wrongly reports Hume as being killed; see Patten, p. 102.

52. Patten, op. cit., p. 107 – known thereafter as 'Black Saturday'.

53. Ibid, p. 108.

54. Ibid, p. 115.

55. Ibid, p. 116.

56. Ibid, p. 112.

57. Ibid, p. 123 – he claims Arran was the first to bolt; this may be apocryphal.

58. Ibid

59. Roxburgh had been held by the English for decades during the fifteenth century.

60. German pike- or arquebus-armed mercenary soldier.

61. Phillips, op. cit., p. 240.

62. Ibid, p. 246.

63. *Sadler's State Papers*, op. cit., p. 377.

64. Lomas, op. cit., pp. 174-175.

65. Ibid, p. 175, Carnaby lost that office in 1539.

66. *The 1569 Rebellion*, Editor Sir Cuthbert Sharp, 1840 (Durham, J. Shotton 1975), p. xxi.

67. Richard Norton, one of Northumberland's affinity, had been born in 1498 and was out with the Pilgrimage of Grace thirty years before.

68. *1569 Rebellion*, op. cit., p. xxii.

69. Ibid, pp. xxi-xxii.

70. Ibid, p. xxiii.

71. Though he became 8th Earl, Harry later committed suicide in 1584, having been implicated in the Throckmorton Plot.

72. *1569 Rebellion*, op. cit., p. xxviii.

73. Ridpath, op. cit., p. 435.

74. Carey, R., *the Stirring World of Robert Carey* (Edinburgh, Constable & Co. 1808), p. 12

75. Ibid, p. 55.

76. Ibid, p. 37.

77. Ibid

78. Ibid, p. 57.

79. Ibid, p. 60.

80. Ibid, pp. 46-47.

81. Ibid, p. 48.

82. Ibid

83. 'The Shawfield Manuscript' as quoted in Walter Scott's *Minstrelsy of the Scottish Border*, p. 259.

84. Ibid, p. 260.

85. Ibid, p. 262.

86. MacDonald Fraser, op. cit., p. 330.

87. Ibid, p. 332.

88. Ibid, pp. 125-126.

89. Ibid, p. 338.

90. Shawfield MS, op. cit., p. 261.

91. MacDonald Fraser, op. cit., p. 335.

92. Ibid, p. 338.

93. Shawfield MS, op. cit., p. 261 – the source claims there were two hundred riders but this is too many.

94. Ibid

95. Ibid, p. 262, Will seems to have enjoyed privileges such as female company.

96. *CBP*, ii, 252, p. 121.

97. Marsden, op. cit., p. 175.

98. *CBP*, ii, 252, p. 121.

99. Shawfield MS, op. cit., p. 263.

100. Pease, H., *the Lord Wardens of the Marches of England and Scotland* (London, Constable 1913), p. 136.

101. Ibid

102. Ridpath, op. cit., p. 472.

Chapter 11

1. Carey, op. cit., pp. 66 – 67.

2. Robert Cecil, 1st Earl of Salisbury, son of Lord Burghley and a prime mover in the Union of the Crowns.

3. Carey, op. cit., p. 65.

4. Ibid, p. 67.

5. Ibid, p. 69.

6. She may have been the model for Old Dame Bob in *Jack & Jill*.

7. Carey's son inherited the title but it became extinct when he died childless.

8. Ridpath, op. cit., p. 483.

9. Ibid

10. James had cause to be thankful to one dagger-wielding page, John Ramsay, later knighted then raised to the peerage as 1st Earl of Holderness. Young John (he'd probably be in his late teens) used his finely crafted Canongate ballock knife in August 1600 to deal with the Earl of Gowrie, who had apparently lured James up to see his etchings. Whether this was attempted murder, kidnapping, or quite what, hasn't been established, but Ramsay's fast thinking and dexterity at arms ensured his advancement. I heard a tale that it was this same dagger that Ramsay lost in Paris a decade later, lifted when he'd passed out from drink by one Francois Ravaillac and used by him to murder Henry IV. I also thought the knife had come

back via purchase into the NMS collection, but a search failed to confirm this. It's still a good story.

11. Ridpath, op. cit., p. 483.

12. Ibid, p. 484.

13. Somewhat unfortunately, Henry Clifford Earl of Cumberland's grandson, Sir George Wharton, chose to fight a duel with Sir James Stuart. Both were well born and well connected courtiers and it's ironic that Clifford's grandson should decide to settle matters in the old-fashioned way: 'George Wharton was the first that fell/ Our Scotch Lord fell immediately/ They both did cry to him above/ To save their souls, for the boud [both] die[d]'; see *Minstrelsy* pp. 137-144.

14. Ridpath, op. cit., p. 483.

15. Graham, J., *Condition of the Border at the Union* (London, Routledge 1907), p. 124.

16. Ridpath, op. cit., p. 484.

17. Graham, op. cit., p. 125.

18. Ibid, p. 126.

19. Carey, op. cit., p. 63.

20. MacDonald Fraser, op. cit., p. 360.

21. Ibid p. 32.

22. Elizabeth I had been happy to support the Dutch rebels in their fight against Spain.

23. Baty = Beatty.

24. MacDonald Fraser, op. cit., p. 365.

25. https://www.pinterest.co.uk/haggishurler/grahams-of-the-border/, accessed 20 April 2020.

26. *By the King a proclamation for transplantation of the Greames*. England and Wales, Sovereign (1603-1625: James I), James I, King of England, 1566-1625; imprinted at London: by Robert Barker, Printer to the Kings most Excellent Majestie, Anno 1603.

27. United Nations definition.

28. https://www.history.com/topics/holocaust/ethnic-cleansing accessed 16 April 2020.

29. Graham, op. cit., p. 180.

30. https://electricscotland.com/webclans/families/grahams_esk.htm, accessed 17 April 2020.

31. MacDonald Fraser, op. cit., p. 368.

32. Graham, op. cit., p. 186.

33. MacDonald Fraser, op. cit., p. 371.

34. Tait, J., *Dick the Devil's Bairns: Breaking the Border Mafia* (tredition, 2019).

35. These were: Briel, Flushing and Fort Rammeken on Walcheren.

36. Graham, op. cit., p 186.

37. Ibid, p. 195.
38. Watson, op. cit., p. 194.
39. Ibid, p. 195.
40. 'Survey of Newcastle', Harleian Miscellany, vol. iii, quoted in 'Life of Gilpin' in *Ecclesiastical Biography: Or Lives of Eminent Men* (London, J. G. & F. Rivington 1839), p. 273.
41. Watson, op. cit., p. 196.
42. From *The Death of 'Sweet Milk'* by Paul Greville Hudson (1876-1960), Hawick Museum.
43. An adaption of the better book by Glendon Swarthout.
44. Ridpath, op. cit., p. 484.
45. Ibid

Chapter 12

1. http://www.weareexplore.org.uk/, accessed 24 March 2020.
2. Grid ref: NY 6339 7556.
3. These were the Vickers Valiant, Avro Vulcan and Handley Page Victor; only one Vulcan now remains airworthy.
4. See Boyes, J. (2013). 'The Blue Streak Underground Launcher' *Airfield Research Group Review* No 140 and 'Blue Streak Underground Launchers' *Royal Air Force Historical Society* Journal No. 58.
5. Directed by Stanley Kubrick, 1964.
6. Bristol Bloodhound, a ram-jet surface to air missile developed in the 1950s.
7. https://www.nam.ac.uk/explore/battle-imjin, accessed 23 March 2020.
8. The situation was exacerbated by the outcome of the Six-Day War; President Nasser of Egypt stirred up resentment on account of Britain's supposed support for Israel.
9. The Humber Pig was a lightly armoured enclosed truck which became a familiar sight throughout Northern Ireland during the Troubles.
10. http://britains-smallwars.com/campaigns/aden/page.php?art_url=aden-mutiny, accessed 23 March 2020.
11. Designed in 1949, the Ferret was a direct heir to the tradition of lightly armoured reconnaissance vehicles pioneered by the Daimler 'Dingo', which did good service during the Second World War. It was powered by a six-cylinder Rolls-Royce B60 engine with a pre-selector gearbox.
12. ROTOR was a post-war UK response to the perceived threat from Russian bombers and was largely based around war era radar stations, see www.thetimemachine.co.uk
13. https://secretbunker.co.uk/.

14. The Scottish Enlightenment was an astonishing outpouring of intellectual, artistic and scientific achievement, see Herman, A., *How the Scots Invented the Modern World – the True Story of How Western Europe's Poorest Nation Created our World and Everything in it* (London, Crown Publishing 2001).

15. Admiral Thomas Cochrane 10th Earl Dundonald, flag officer, mercenary and political figure, the only Nelsonian sea dog to live long enough to be photographed, and model for O'Brien's Jack Aubrey.

16. MacDonald Fraser, op. cit., p. 22.

17. Ibid

18. Hudson, R., *Re-thinking change in old industrial regions: reflecting on the experiences of North East England*, (Durham, Durham University Environment and planning A., 37 (4), 2005), pp. 581-596.

19. The bitterness remains potent in some communities.

20. *Viz* – a hugely popular adult comic first created by Chris Donald in 1979.

21. https://www.undiscoveredscotland.co.uk/areabord/index.html, accessed 26 March, 2020.

22. Source: Cumbria Tourism.

23. Source: Northumbria Tourist Board.

24. Source: Visit Scotland.

25. https://www.visitscotland.com/about/themed-years/, accessed 24 March 2020.

26. This was a major rift within the Church of Scotland, a mass walkout which resulted in the immediate establishment of the Free Church of Scotland.

27. *Letters and Papers, Foreign and Domestic, Henry VIII*, Vol. 3 1519-1523. J. S. Brewis (ed.), 1867, pp. 1421-1422, British History Online (http://www.british-history.ac.uk, accessed 26 March 2020.

28. Ibid

29. *Historical Tales of the Wars of Scotland and of the Border Raids, Forays and Conflicts*, (John Parker Lawson, 1839), p.367 accessed on Electric Scotland: http://www.electricscotland.com/history/wars/28BattleOfFlodden1513.pdf), accessed 25 March 2020.

30. Ibid

31. Ibid

32. Sadler & Serdiville, op. cit., p. 216.

33. Ibid, p. 217.

34. *Calendar of State Papers, Spain, Volume 2: 1509-1525* G. A. Bergenroth (ed.) 1866 pp.161-165; accessed 26 March 2020 British History Online: (http://www.british-history.ac.uk/report.aspx?compid=93622

35. *Accounts of the Treasurer of Scotland* 1473-1580, (Edinburgh, 13 vols, 1877-1978) 4 pp. xxiv 411-412 cited in 'Scotland in Renaissance Diplomacy', 1473-1603, Hiram Morgan, University College Cork, March 2008. http://www.ucc.ie/chronicon/scottishdiplomats/, accessed 25 March 2020.

36. *Flodden Papers, Diplomatic Correspondence between the Courts of France and Scotland, 1507-1517.* Marguerite Wood, (ed.), Printed at the University Press by T and A Constable Ltd for the Scottish Historical Society, Edinburgh, 1933.

37. https://www.open.edu/openlearn/people-politics-law/the-2014-scottish-independence-referendum-why-was-there-no-vote, accessed 25 March 2020.

38. https://www.itv.com/news/border/2019-12-13/ge2019-scotland-heads-into-uncharted-constitutional-waters/, accessed 25 March 2020.

39. The disaster spurred new legislation, introduced that August, requiring every pit from then on to have two shafts rather than one; the miners had been trapped underground when the only shaft became blocked.

40. https://www.bbc.co.uk/news/uk-scotland-south-scotland-49715159, accessed 25 March 2020.

41. For further details, visit: https://museumsnorthumberland.org.uk/woodhorn-museum/.

42. Willie Sinclair (March 2020) with thanks to Anne Telfer.

Glossary

'Auxilier' – member of Special Forces Home Guard Patrol

'Backsword' – a form of weapon with one sharpened cutting edge and the other flattened and blunt, primarily a horseman's weapon designed for the cut

'Barbican' – a form out defended outer gateway designed to shield the actual gate itself

'Bartizan' – a small corner turret projecting over the walls

'Bastion' – projection from the curtain wall of a fort usually at intersections to provide a wider firing platform and to allow defenders to enfilade (flanking fire) a section of the curtain

'Batter' – outward slope at the base of a masonry wall to add strength and frustrate mining efforts

'Battery' – a section of guns, may be mobile field artillery or a fixed defensive position within a defensive circuit

'Breast and back' – body armour comprising a front and rear plate section

'Breastwork' – defensive wall

'Broadsword' – a double edged blade intended for cut or thrust, becoming old-fashioned though many would do service, often with an enclosed or basket hilt

'Broken man [men]' – outlaw(s)

'Buff Coat' – a leather coat, long skirted and frequently with sleeves, fashioned from thick but pliant hide, replaced body armour for the cavalry

'Caliver' – a lighter form of musket, with greater barrel length than the cavalry carbine (see below)

'Cannon' – heavy gun throwing a 47-pound ball; a demi-cannon fired 27-pound ball; cannon-royal shot a massive 63-pound ball

'Captain' – the appointed guardian of an area, perhaps a more defensive role

'Carbine' – a short-barrelled musket used primarily by cavalry

'Case-shot' – Also referred to as canister this was a cylindrical shell case, usually tin, sealed in beeswax and caulked with wooden disks, wherein a quantity of balls were packed and filled with sawdust. A cartridge bag of powder was attached to the rear and, on firing the missile had the effect of a massive shotgun cartridge, very nasty

'Casement' – a bomb-proof chamber or vault within the defences

'Cleared' – innocent of charges made

'Commission of Array' – this was the ancient royal summons issued through the lords-lieutenants of the counties to raise militia forces, in the context of a civil war such an expedient was of dubious legality as clearly unsanctioned by Parliament

'Committee of Both Kingdoms' – this was brought into being as a consequence of two Parliamentary measures (16 February and 22 May 1644) to ensure close cooperation between the English and Scots, Cromwell, Manchester and Essex were all members of the Committee which sat at Derby House

'Constable' – a leader of tenantry group on demesne lands who could be mustered both for defence or offense.

'Cornet' – a pennant or standard and thus also the junior officer who carried it

'Corselet' – this refers to a pikeman's typical harness of breast and back, with tassets for the thighs

'Cuirassier' – these were heavy cavalry wearing three quarter harness, something of an anachronism, Sir Arthur Hesilrige's 'Lobsters' were the most famous example; as the wars progressed reliance upon armour decreased considerably

'Culverin' – a gun throwing a fifteen pound ball; mainly used in siege operations the guns weighed an average of 4,000 lbs. the lighter demi-culverin threw a nine pound ball and weighed some 3,600 lbs

'Dagg(s)' – Wheelock horseman's pistols, usually carried in saddle holsters

'Dragoon' – essentially mounted infantry, the name is likely derived from 'dragon' a form of carbine; their roles was to act as scouts and skirmishers and they could fight either mounted (rare) or dismounted

'Ensign' (or 'Ancient') – a junior commissioned officer of infantry who bears the flag from which the name derives

'Falcon' – light gun firing a 2¼-pound ball

'Falconet' – light gun throwing a 1¼-pound shot

'Field-works' – a system of improvised temporary defensive works employed by an army on the march or protecting an encampment

'Flintlock or 'firelock' – a more sophisticated ignition mechanism than match; the flint was held in a set of jaws, the cock which when released by the trigger, struck sparks from the steel frizzen and showered these into the pan which ignited the main charge

'Foot' – infantry

'Free Quarter' – troops paying for food and lodgings by a ticket system, requisitioning or outright theft in practice

'Fusil' – this was a form of light musket usually carried by gunners and latterly by officers, hence 'fusilier'

'Gabion' – wicker baskets filled with earth which formed handy building blocks for temporary works or sealing off a breach

'Glacis' – a sloped earthwork out from the covered way to provide for grazing fire from the curtain

'Grayne' – sept of a riding name

'Guns' – artillery

'Halberd' – a polearm, outdated in war but carried as a staff of rank by NCOs

'Harquebusier' – an archaic term describing the cavalryman armed with carbine, sword and brace of pistols, the latter sometimes still referred to as 'daggs'

'Heidman' – leader/chieftain of a riding name or grayne

'Horse' – cavalry

'Insight' – household goods and effects liable for plunder

'Land-Sergeant' – an officer responsible for a defined 'patch', subordinate to and appointed by the Warden

'Linstock' – a staff having a forked end to hold match – used for discharging cannon

'Lunette' – flanking walls added to a small redan (see below) to provide additional flanking protection and improved fire position; a 'demi-lune' is a crescent or half moon structure built projecting from the curtain to afford greater protection

'Magazine' – bomb proof vault where powder and shot are stored

'*Main Gauche*' – literally left hand; this was a form of dagger used in conjunction with the rapier

'Matchlock' – the standard infantry firearm, slow and cumbersome, prone to malfunction in wet or wind, it was nevertheless rugged and generally reliable. When the trigger was released the jaws lowered a length of lit cord 'match' into the exposed and primed pan which flashed through to the main charge, where the charge failed to ignite this was referred to a 'a flash in the pan'

'Matross' – a gunner's mate, doubled as a form of ad hoc infantry to protect the guns while on the march

'Meutriere' – or 'murder-hole', space between the curtain and corbelled-out battlements enabling defender to drop a variety of unpleasant things onto attackers at the base of the wall

'Minion' – gun shooting a 4-pound ball

'Morion' – infantry protective headgear, the morion was a conical helmet with curving protective brim and central ridged comb intended to deflect a downwards cut

'Mosstrooper' – an outlaw 'broken man' or in the later Civil Wars context irregular light cavalry

'Musket' – the term refers to any smooth-bored firearm, regardless of the form of lock, rifled barrels were extremely rare, though not unknown at this time

'Nolt' – cattle

'Ordnance' – artillery

'Pike' – a polearm with a shaft likely to be between twelve and eighteen feet in length, finished with a diamond-shaped head

'Plump Watch' – a tactical unit designed to keep watch for raiders

'Postern' ('Sally Port') – a small gateway set into the curtain allowing re-supply and deployment of defenders in localised attacks on besiegers

'Pricker' – mounted scout or forager

'Rapier' – a slender, long-bladed thrusting weapon, more likely to be owned by gentry; bespoke and more costly than a trooper's backsword

'Ravelin' – a large V shaped outwork, beyond the ditch or moat, intended to add protection to a particularly vulnerable point

'Redoubt' – a detached, square, polygonal or hexagonal earthwork or blockhouse

'Reiver' – one of the riding names of the border, a raider whose primary objective was cattle stealing

'Riding Name' – one of the primarily upland dales families on either and both sides of the border

'Robinet' – light field gun firing a 1¼-pound shot

'Rode' – raid

'Scarp' – inner wall of ditch or moat

'Sconce' – a small detached fort with projecting corner bastions

'Snap' – cold rations carried in a 'snapsack'

'Swine-Feather' – also known as Swedish feathers – a form of metal-shod stake that could be utilised to form an improvised barrier against an enemy

'tasset' – a section of plate armour hinged from the breastplate intended to afford protection to the upper thigh

'Tercio' – a Spanish term for the military formation, derived from the Swiss model which dominated renaissance warfare, developed into a more linear formation after the reforms of the Swede Gustavus Adolphus; essentially, a brigade

'Touch-hole' – the small diameter hole drilled through the top section of a gun barrel through which the linstock ignites the charge, fine powder was poured in a quill inserted into the touch-hole

'Train' – a column of guns on the move, the army marches accompanied or followed by the train

'Trained Bands' – local militia

'Wheel-lock' – more reliable and much more expensive than match this relied upon a circular metal spinning wheel wound up like a clock by key. When the trigger was released the wheel spun and the jaws lowered into contact and fitted with pyrites, showered sparks into the pan

Bibliography

Primary Sources

'An English Chronicle of the reigns of Richard II, Henry IV, Henry V and Henry VI' ed. J.S. Davies 1856

Anglo-Saxon Chronicle (London, George Bell & Sons 1880)

Bede, *Ecclesiastical History of England* (London, George Bell & Sons) 1880)

Benet J. 'John Benet's chronicle for the years 1400 to 1462' (ed. G.L. Hariss and M. A. Harriss) Camden Miscellany vol. XXIV London 1972

'Brut Chronicle' 2 vols. ed. F.W.D. Brie 1906

'Calendar of Fine Rolls: Edward IV; Edward V; Richard III, 1471 – 1485' London HMSO 1961

'Calendar of Patent Rolls, Edward IV 1467 – 1477, Edward IV, Edward V, Richard

III. 1476 – 1485' London 1899 – 1901

'Calendar of Documents relating to Scotland' vol. IV 1357 – 1509 (ed. J. Bain) London 1888

'Calendar of State Papers and Manuscripts existing in the Archives and Collections of Milan' ed. and transl. A.B. Hinds 1912

Chastellain G. 'Chronique des derniers Ducs de Bourgoyne' in Pantheon Literaire iv

'Chronicles of London' ed. C.L. Kingsford Oxford 1905

'Complaynt of Scotland written in 1548' Edinburgh 1801

'Croyland Abbey Chronicle' ed. H. T. Riley 1854

'The Croyland Chronicle Continuation 1459–1486' (ed. N. Prona and J. Cox) England 1986

The Cotton MS in the British Library

Davies R. 'York Records of the Fifteenth Century'

Edward Hall 'The Union of the Two Noble and Illustre Famelies of Lancastre and York, 1548

'English Historical Documents' vol. 5 1327 – 1484 (ed A.R. Myers) London 1969

'Froissart's Chronicles' ed. G. Brereton 1968

Grey's 'Chorographia' Newcastle upon Tyne 1649

Furnivall F.J. and H.W. Hales ed. 'Bishop Percy's Folio Manuscript' vol. 3 London 1868

Hammond P.W. and R. Horrox 'The Harleian Manuscripts' 4 vols. British Library Harleian Manuscripte 1979 – 1983

'Hearne's Fragment' in 'Chronicles of the White Rose' ed. J.A. Giles.1834

'Historie of the Arrivall of King Edward IV in England and the final Recoverye of his Kingdomes from Henry VI A.D. 1471 (ed. J. Bruce) Camden Soc. 1838

'Impartial History of the Town and County of Newcastle upon Tyne' 1801

John Warkworth 'A Chronicle of the First Thirteen Years of the Reign of Edward IV 1461 – 1474' ed. J.O. Halliwell C.S. Old Series x 1839

'Knyghthode and Bataile' (ed. R. Dyboski and Z.M. Arend) Early English Texts Society 1935

Mancini Dominic ed. C.A.J. Armstrong 'The Usurpation of Richard III' Oxford 1969, reprinted Gloucester 1984

Major, J., 'History of Greater Britain' $^{1}52^{1}$ Scottish History Society, 1892

'Monopoly of the Tyne' Society of Antiquaries of Newcastle upon Tyne 1978

More, Sir Thomas ed. R.S. Sylvester 'The History of Richard III' Complete Works vol. II Yale edition. 11 1963

'Northumberland Lay Subsidy Roll 1296' (Society of Antiquaries of Newcastle upon Tyne 1968

Phillip De Commynes 'The Memoirs of the Reign of Louis XI 1461–1463' transl. M. Jones 1972

'Plumpton Letters' ed. T. Stapleton Camden Society 1839

Polydore Vergil 'Three Books of Polydore Vergil's English History' ed. H. Ellis 1844

Robert Fabyan 'The New Chronicles of England and France' ed. H. Ellis London 1809

'Rose of Rouen' *Archaeologia* XXIX. p.p. 344–347

'Rotuli. Parliamentorum' ed. J. Strachey & others 6 vols. 1767–1777

Rous J. 'Historiae Regum Anglicae' (ed. T. Hearne) Oxford 1716

Rous J. 'The Rous Roll' ed. C. Ross and W. Courthope England 1980

'Sadler's State Papers' ed. A Clifford 3 vols. 1809

Scottish Exchequer Rolls vii Ramsay ii

'Shielings & Bastles' Royal Commission on Historic Monuments 1970

'Short English Chronicle' ed. J. Gairdner C.S. New Series xxviii 1880

Hans Talhoffer 'Manual of Swordfighting' transl. & ed. M. Rector facsimile edn. 2000

'The Household of Edward IV' ed. A.R. Myers 1959

'The Great Chronicle of London' ed. A.H. Thomas and I.D. Thornley London 1938

'The Paston Letters 1422–1509' ed. J. Gairdner 3 vols. 1872–1875

The Priory of Hexham' vol. i Surtees Soc. 1864

'The Stirring World of Robert Carey London 1808

'The Year Book de Termino Paschae 4 Edward IV' in Priory of Hexham, S.S. 1 1864

'Three Fifteenth Century Chronicles' ed. J. Gairdner Camden Soc. 1880

Waurin Jean de 'Recueil des Chroniques D'Angleterre' ed. W. Hardy & E.L.C.P. Hardy 1891

Whethamstede J. 'Registrum' in 'Registra quorandum Abbatum Monasterii S. Albani' 2 vols. ed. H. Riley Rolls Series 1872 – 1873

William Gregory's 'Chronicle of London' in Historical Collections of a Citizen of London in the Fifteenth Century ed. J. Gairdner C.C New Series xvii 1876

William of Worcester 'Annales Rerum Anglicarum' in Liber Niger Scaccarii ed. J. Hearne 2 vols. Oxford 1728

Blackett Family Records (NCRO, ZBK)

Chamberlain's accounts, Tyne & Wear Archives, TW 543/18

Christ ruling in midst of his enemies; or, Some first fruits of the Churches deliverance, budding forth out of the crosse and sufferings, [microform] and some remarkable deliverances of a twentie yeeres sufferer, and now a souldier of Jesus Christ; together, with Secretarie Windebanks letters to Sr. Jacob Ashley and the Maior of Newcastle, through which the violent prosecutions of the common adversaries to exile and banishment, are very transparent. Wherein also the reader shall find in severall passages, publike and particular, some notable encouragements to wade through difficulties for the advancing of the great designe of Christ, for setting up of His kingdome, and the ruine of Antichrist. By Lieutenant Colonel, John Fenwicke London (printed for Benjamin Allen in Pope's-head Alley, 1643)

Chorographia or a survey of Newcastle upon Tine, William Gray, (Newcastle: Printed by S.B, 1649)

Chorographia: Newcastle and Royalist Identity in the late 1640's, Jerome de Groot in 'The Seventeenth Century' vol. viii issue 1 (Manchester University Press, April, 2003). http://www.manchesteruniversitypress. co.uk/uploads/docs/180061.pdf

Delaval Family Records (NCRO, 1DE & 2DE)

A History of Northumberland issued under the direction of the Northumberland county history committee, vol. ix

The Parochial Chapelries of Earsdon and Horton, H. H. E. Craster, (Newcastle-upon-Tyne, Andrew Reid & Co., 1909)

History of Northumberland http://www.archive.org/stream/ historyofnorthum09nort/historyofnorthum09nort_djvu.txt

The Journal of Sir William Brererton 1635 in North Country Diaries, J C Hodgeson ed, (Surtees Society, 124, 1915)

A letter from the Corporation of Newcastle upon Tyne to the Mayor and Aldermen of Berwick *J Raine, Archaeologia Aeliana 1.2*

His Majesties Passing through the Scots Army, *(pamphlet, 1644)*

NCA Chamberlain's Accounts, 1642 – 45, Tyne & Wear Archives, TW543/27

Newcastle upon Tyne Record Series vol. 1 *Extracts from the Newcastle Council Minute Book 1639 – 1656* ed. M.H. Dodds (Newcastle-upon-Tyne: Northumberland Press, 1920)

Newcastle upon Tyne Record Series vol. 3 *The Register of Freemen of Newcastle upon Tyne from the Corporation, Guild and Admission Books chiefly of the Seventeenth Century,* M H Dodds (ed), Newcastle upon Tyne, 1923

Pedigrees Recorded at the Herald's Visitations of the County of Northumberland 1615 and 1666. R St George. Newcastle-upon-Tyne: Browne and Browne, 1891 http://www.archive.org/details/pedigreesrecorde00sainrich

Pedigrees recorded at the heralds' visitations of the counties of Cumberland and Westmorland: made by Richard St. George, Norry, king of arms in 1615, and by William Dugdale, Norry, king of arms in 1666 (1891?]) http://www.archive.org/details/pedigreesrecorde00sainrich

Diary of Mr. Robert Douglas when with the Scots Army in England (Edinburgh, 1833)

'Favver' *The Siege and Storming of Newcastle* (Newcastle upon Tyne, 1889)

Copies of Letters from Francis Anderson and Others (Richardson *Reprints*)

A True experimentall and exact relation upon that famous and renowned Siege of Newcastle, William Lithgow (Edinburgh: Printed by Robert Bryson, 1645).

The Visitation of Northumberland in 1615, R St George, George W. Marshall (ed). London, 1878

The Taking of Newcastle or Newes from the Army (Edinburgh, 1644) http://www.archive.org/details/pedigreesrecorde00sainrich

Women, Prophecy, and Authority in Early Stuart Puritanism, D R. Como, The Huntington Library Quarterly, Vol. 61, No. 2 (1998), pp. 203-222), Published by: University of California Press http://www.jstor.org/stable/3817798

A Continuance of Certain Special and Remarkable Passages No. 2, 03–10 January 1644

An Ordinance with Severall Propositions 1643 (Richardson, *Reprints*)

Andrews, G., *Acts of the High Commission Court within the Diocese of Durham* Surtees Society vol. 34 (1858)

Secondary Sources

Adams, M., *King in the North* (London, Head of Zeus 2013)

Allen, K., *the Wars of the Roses* (London, Jonathan Cape 1973)

Allmand, C., *Henry V* (London, Methuen 1992)

Arch Aeliana, vol. xiv

Allsop, B. & U. Clark, *Historic Architecture of Northumberland & Newcastle upon Tyne* (Northumberland, Oriel Press 1977)

Anderson-Graham, P., *Highways & Byways in Northumberland* (London, MacMillan 1920)

Archer, R.E.C., *Government and People in the Fifteenth Century* (Gloucs., Alan Sutton 1995)

Armstrong, P., *Dark Tales of Old Newcastle* (Newcastle upon Tyne, Newbridge Studios 1990)

Armstrong, R.B., *History of Liddesdale, Eskdale, Ewesdale, Wauchopedale & the Debatable Land* (Edinburgh, David Douglas 1883)

Ashley, M., *the English Civil War* (London, Thames & Hudson 1978)

Ashworth, N. & M. Pegg, *History of the British Coal Industry* (Oxford, OUP 1986)

Bagley, J.J., *Margaret of Anjou, Queen of England* (London, H. Jenkins 1948)

Bain, J., (ed.) *Calendar of Documents Relating to Scotland 1108 - 1509* (Scottish Records Office 1881 – 1884)

Banks, F.R., *Scottish Border Country* (London, Batsford 1951)

Barbour, R., *the Knight and Chivalry* (London, Sphere Books 1974)

Barr, J., *Border Papers* 2 vols. Eds: Revd. J. Stevenson and A. J. Crosbie (Edinburgh 1894)

Barriffe, W., *Militaries Discipline; or the Young Artilleryman* (6th edn. 1661)

Barrow, G.W.S., *Robert Bruce* (Edinburgh, University Press 1965)

__ *The Kingdom of the Scots* (Edinburgh, University Press 1973)

Bartlett, C., *the English Longbowman 1313 - 1515* (Oxford, Osprey 1995)

Bates, C.J., *History of Northumberland* (London, Elliot Stock 1895)

Bean, J.M.W., *the Estates of the Percy Family* (Oxford, Historical Series 1958)

Beckensall, S., *Life & Death in Prehistoric Northumberland* (Newcastle upon Tyne, Frank Graham 1976)

Bennett, H.S., *the Pastons and Their England* (Cambridge, University Press 1932)

Bingham, C., *the Stewart Kings of Scotland 1371 - 1603* (London, Weidenfeld & Nicolson 1974)

Blackmore, H. L., *the Armouries of the Tower of London - Ordnance* (HMSO 1976)

Blair, C., *European Armour* (London, Batsford 1958)

Boardman, A. V., *The Battle of Towton 1461* (Gloucs., Alan Sutton 1996)

__ *The Medieval Soldier in the Wars of the Roses* (Gloucs. Alan Sutton 1998)

__ *Hotspur* (Gloucs., Alan Sutton 2003)

Bogg, E., *the Border Country* (Newcastle upon Tyne, Mawson Swan & Morgan 1898)

Borland, Reverend R.R., *Border Raids & Reivers* (Dalbeattie, Thomas Fraser 1910)

Bourne, H., *The History of Newcastle upon Tyne; or the ancient and present state of that town* (Newcastle upon Tyne 1736)

Boyes, J. (2013) 'The Blue Streak Underground Launchers' *Airfield Research Group Review* No 140 and 'Blue Streak Underground Launchers' *Royal Air Force Historical Society Journal* No. 58.

Brand, J., *History of Newcastle upon Tyne* 2 volumes (London, H. White & Son 1789)

Breeze, D. J. & B. Dobson, *Hadrian's Wall* (4th edition, London, Penguin 2000)

Brenan, G., *the House of Percy* 2 vols. (London, Freemantle & Co 1898)

Brockett, J., *A Glossary of North Country Words* (Newcastle upon Tyne, T. & J. Dinsdale 1849)

Brooke, C., *Safe Sanctuaries* (Edinburgh, John Donald 2000)

Brown, M., *the Black Douglases* (Edinburgh, John Donald 1999)

Brown, P., *The Great Wall of Hadrian* (London, Heath Cranton 1932)

__ *The Friday Books* 4 vols. (Newcastle upon Tyne, Bealls 1934 – 1946)

Burne, Colonel A. H., *Battlefields of England* (London, Methuen 1950)

__ *More Battlefields of England* (London, Methuen 1952)

__ & P. Young, *The Great Civil War 1642–1646* (London, Eyre & Spottiswoode 1959)

Byrd, E., *Flowers of the Forest* (London, Macmillan 1969)

Caldwell, D. H., *the Scottish Armoury* (Edinburgh, John Donald 1979)

Camden, W., *Britain, or A Chorographicall Description of the Most Flourishing Kingdomes, England, Scotland and Ireland and the Ilands Adioyning, Out of the Depth of Antiquitie* (London 1610)

Campbell, D. B., *Siege Warfare in the Roman World 146 BC – AD 378* illustrated by Adam Hook (Osprey Elite series, 2005)

__ *Roman Auxiliary Forts 27 BC – 378 AD* (London, Osprey 2009)

Carpenter C., *the Wars of the Roses: Politics and the Constitution in England c.1437–1509* (Cambridge, University Press 2002)

Cathcart King, D. J., *Castellarium Anglicanum* volume 2 (New York, Kraus International 1983)

Chadwick, H. M., '*Early Scotland*' (Edinburgh, 1949; re-published Octagon Press 1974)

Chalmers, M. & W. Walker, '*The United Kingdom, Nuclear Weapons, and the Scottish Question*' in *the Non-proliferation Review* Spring 2002

Charlesworth, D., 'Northumberland in the Early Years of Edward 1V' in *Archaeologia Aeliana*,(4th Series 1953)

__ 'The Battle of Hexham' in *Archaeologia Aeliana* (4th Series 1952)

Charleton, R. J., *A History of Newcastle upon Tyne* (London, Walter Scott Publishing 1894)

Charlton, B., *Upper North Tynedale* (Northumberland, National Park Authority 1987)

Charlton, J., *Hidden Chains – the Slavery Business and North East England 1600–1865* (Newcastle upon Tyne, Tyne Bridge 2008)

Chesterton G. K., *A Short History of England* (London, Biblio-Bazaar, 2008)

Child, F. J., *The English and Scottish Popular Ballads* (New York, 1965), volume 1

Clark, P., *Where the Hills Meet the Sky* (Northumberland, Glen Graphics 2000)

Collingwood-Bruce, J., *Handbook to the Roman Wall* (XI edition, Newcastle, Andrew Reid 1957)

Colvin, H. M., D. R. Ransome & J. Summerson, *History of the King's Works* III 1485–1660 Part 1 (HMSO 1975)

Collins, R., & M. Symonds, *Hadrian's Wall 2009–2019* (Newcastle upon Tyne, Society of Antiquaries 2019)

Cowan, R., *Roman Legionary 58 BC–69 AD* illustrated by Angus Macbride (Osprey Men-at-Arms series, 2003)

Cook, D. R., *Lancastrians & Yorkists, The Wars of the Roses* (London, Longman 1984)

Corfe, T., *Riot: The Hexham Militia Riot 1761* (Northumberland, Hexham Community Partnership 2004)

Cross, R., & B. Charlton, *Then and Now – a Snapshot of Otterburn Training Area* (Defence Estates, 2004)

Crow, J., 'Harbottle Castle, Excavations and Survey 1997-1999' in *Archaeology in Northumberland National Park*

Crumlin-Pedersen, O., *The Skuldelev Ships I (Viking Ship Museum and the National Museum of Denmark 2002)*

Cunliffe, B., *The Ancient Celts* (London, Penguin 1999)

Davies, H., *A Walk along the Wall* (London, Frances Lincoln 1974)

Deary, T., *Dirty Little Imps – Stories from the DLI* (Durham, County Record Office 2004)

Dent, J. & R. McDonald, *Warfare & Fortifications in the Borders* (Newton St. Boswells, Scottish Borders Council 2000)

Devine, T.M., *The Scottish Nation 1700–2000* (London, Allen Lane 1999)

Dickinson, F., *the Reluctant Rebel* (Newcastle upon Tyne, Cresset Books 1996)

Divine, D., T*he North-West Frontier of Rome* (London, Macdonald & Co 1969)

Dixon, D.D., *Whittingham Vale* (Newcastle upon Tyne, Robert Redpath 1895)

__ *Upper North Coquetdale* (Newcastle upon Tyne, Robert Redpath, 1903)

Dixon, P.W., 'Fortified Houses on the Anglo-Scottish Border: A study of the Domestic Architecture of the Upland Area in its Social and Economic Context', PhD thesis (Oxford 1976)

Dockray, K.R., 'The Yorkshire Rebellions of 1469' in *The Ricardian* vol. 6, no. 82 (December 1983)

Dockray, K.R., *Chronicles of the Reign of Edward IV* (Gloucs., Alan Sutton 1983)

Dodds, J.F., *Bastions & Belligerents* (Newcastle upon Tyne, Keepdale 1996)

Drummond Gould, H., *Brave Borderland* (Edinburgh, Thomas Nelson 1936)

Ducklin, K., & J. Waller, *Sword Fighting* (London, Robert Hale 2001)

Duncan, A. A. M., '*Scotland, the Making of a Kingdom*' (Edinburgh, Oliver & Boyd 1975)

Durham, K., *Border Reiver 1513–1603* (Osprey 'Warrior' Series, London 2011)

__ *Strongholds of the Border Reivers* (Osprey 'Fortress' Series, London 2008)

Eddington, A., *Castles & Historic Houses of the Border* (Edinburgh, Oliver & Boyd 1926)

Elliot, G. F. S., *The Border Elliots and the Family of Minto* (Edinburgh, privately published 1897)

Ellis, J., *Eye Deep in Hell* (London, Crook Helm, 1976)

Eyre Todd, G., *Byways of the Old Scottish Border* (London, Macmillan 1913)

Falkus, G., *The Life and Times of Edward IV* (London, Weidenfeld & Nicolson 1981)

Ferguson, J., *The Flodden Helm and events linked to the death of Thomas Howard in 1524* (Berwick on Tweed, privately published 2009)

Fiorato, V., A Boylston & C. Knussel, (ed.) *Blood and Roses: The Archaeology of a Mass Grave from the Battle of Towton AD 1461* (Oxford, OUP 2000)

Forder, S., *The Romans in Scotland and the Battle of Mons Graupius* (Stroud, Amberley, 2019)

Foster, J., *Guns of the North-East Coast* (Barnsley, Pen & Sword 2004)

Frodsham, P. & P. Ryder, et al, 'Archaeology in Northumberland National Park' (York, *British Archaeology* 2004)

Furgol, E., *A Regimental History of the Covenanting Armies* (Edinburgh, John Donald 1990)

Gardiner, S.R., *History of the Great Civil War 1642–1649* (London, Longmans 1886–1891)

Gaunt, P., *The Cromwellian Gazetteer* (Gloucs., Tempus 1987)

Gerrard, C. M., P. Greaves, A. R. Millard R. Annis & A. Caffell, *Lost Lives, New Voices – Unlocking the Stories of the Scottish Soldiers from the Battle of Dunbar 1650* (Oxford, Oxbow Books 2018)

Gillingham, J., *The Wars of the Roses* (London, Weidenfeld & Nicolson 1981)

Goldsworthy, A., *The Complete Roman Army* (Phoenix Press, 2003)

__ *Roman Warfare* (Phoenix Press, 2007)

__ *Hadrian's Wall* (London, Profile 2018)

Good, G. L. & Tabraham, C. J. (1981). 'Excavations at Threave Castle, Galloway, 1974-78' (PDF). *Medieval Archaeology*.25: 90–140.

Graham, J., *Condition of the Border at the Union* (London, George Routledge 1907)

Grant, A., 'Richard III in Scotland' in *The North of England in the Reign of Richard III* (ed.) Pollard (London, St. Martin's Press 1996)

Grant, A., *Henry VII* (London, Methuen 1985)

Gravett, C., *Medieval Siege Warfare* (London, Osprey 1990)

Greig, A., *Fair Helen* (London, Quercus 2014)

Griffith, G., *The Viking Art of War* (London, Greenhill Books 1995)

Griffiths, R.A., 'Local Rivalries and National Politics: The Percies, the Nevilles and the Duke of Exeter 1452–1455' in *Speculum*, vol. XLIII (1968)

Griffiths, R. A., *the Reign of King Henry VI*' (Los Angeles, University of California Press 1981)

__ (ed.) *Patronage* in 'The Crown and the Provinces in Later Medieval England' (England 1981)

__ *King and Country: England and Wales in the Fifteenth Century* (Gloucs. Sutton 1991)

__ *The Making of the Tudor Dynasty* (Gloucs., Sutton 1985)

__ *Kings and Nobles in the Later Middle Ages* (Gloucs. Sutton 1986)

Gully, Reverend M., *Letters of C. J. Bates* (Kendal, Titus Wilson 1906)

Haigh, P.A., *The Military Campaigns of the Wars of the Roses* (Boston, Da Capo Press 1995)

Hallam, E., *The Plantagenet Encyclopedia* (London, Colour Library Direct 1990)

Hallam, E., (ed.) *The Chronicles of the Wars of the Roses* (London, Colour Library Direct 1988)

Hammond, P.W., *Richard III – Lordship Loyalty and Law* (England, Richard III & Yorkist History Trust 1986)

Harrison, W. J., *The Geology of Northumberland* (proof notes 1879)

Hartshorne, C. H., *Memoirs Illustrative of the History and Antiquities of Northumberland* volume 2, 'Feudal and Military Antiquities of Northumberland and the Scottish Borders' (London, Bell & Daldy 1852)

Hayes-McCoy, W. A., *Irish Battles* (Belfast, Appletree Press 2009)

Haythornthwaite, P., *The English Civil War 1642–1651* (London, Weidenfeld Military 1994)

Heald, H., *Magician of the North* (Carmathen, McNidder & Grace 2010)

Hearse, G. S., *The Tramways of Northumberland* (Durham, George S. Hearse 1961)

Heaney, S., *Beowulf* (London, Faber 1999)

Hepple, L. W., *A History of Northumberland and Newcastle upon Tyne* (Newcastle upon Tyne, Phillimore 1976)

Hermann, R., R. J. Crellin & M. Uckleman 'Bronze Age Combat' (Oxford, *British Archaeological Reports* 2020)

Hewitson, T. L., *Weekend Warriors from Tyne to Tweed* (Gloucs., Tempus 2006)

Hicks, M.A., 'Edward IV, The Duke of Somerset and Lancastrian Loyalism in the North' in *Northern History* (volume xx)

Higham, N. J., *the Kingdom of Northumbria 350–1100* (Gloucs., Alan Sutton 1993)

Hodges, C. C. & J. Gibson, *Hexham & its Abbey* (Northumberland, Hexham Abbey 1919)

Hogg, J., *Songs by the Ettrick Shepherd* (Edinburgh, William Blackwood 1831)

Hope Dodds M., ed., *A History of Northumberland* volume 15 (Newcastle upon Tyne, Northumberland County History Committee 1940)

Horrox, R., *Fifteenth Century Attitudes* (Cambridge, University Press 1994)

Horrox, R., *Richard III and the North* (Cambridge, University Press 1986)

Howell, R., *Newcastle upon Tyne and the Puritan Revolution: A Study of the Civil War in North England* (Oxford, University Press 1967)

Howitt, W., *Visits to Remarkable Places* 2 vols. (Philadelphia, Carey and Hart 1842)

Hudson, R., *Re-thinking change in old industrial regions: reflecting on the experiences of North East England* (Durham, Durham University Environment and planning A., 37 (4), 2005)

Hugill, R., *Castles and Peles of the English Border* (Newcastle upon Tyne, Frank Graham 1970)

Hunter Blair, C. H., 'Harbottle Castle' in *History of the Berwickshire Naturalists Club* xxviii (1932–1934)

__ *Mayors & Lord Mayors of Newcastle upon Tyne* (Newcastle upon Tyne, Society of Antiquaries 1940)

Hunter Blair, P., *Roman Britain & Early England* (Edinburgh, Thomas Nelson & Sons 1963)

Jackson, D., *The Northumbrians* (London, Hurst, 2019)

Kapelle, W.E., *The Norman Conquest of the North* (North Carolina, Croom Helm 1979)

Keegan, Sir J., *The Face of Battle* (London, Penguin 1976)

Keen, M., *English Society in the Later Middle Ages 1348–1500* (London, Penguin 1990)

__ ed., *Medieval Warfare – A History* (Oxford, OUP 1999)

Kendall, P. M., *Warwick the Kingmaker* (New York, W. W. Norton 1957)

Keppie, L., *The Making of the Roman Army from Republic to Empire* (Oklahoma, University of Oklahoma Press, 1998)

Kightly J., *Flodden and the Anglo-Scottish War of 1513* (London, Almark 1975)

Lander, J. R., *Crown and Nobility 1450–1509* (London, Edward Arnold 1976)

Lander, J. R., *The Limitations of English Monarchy in the later Middle Ages* (Canada, University of Toronto Press 1989)

Lang, J., *Stories of the Border Marches* (New York, Dodge 1916)

Leadman, A.D., *The Battle of Towton* Yorkshire Archaeological Journal vol. 10, (1889)

Leighton, Reverend A., *Wilson's Tales of the Borders* 8 volumes (Newcastle upon Tyne, Gall & Inglis [undated])

Loades, M., *Swords & Swordsmen* (Barnsley, Pen & Sword 2017)

Logan Mack, J., *the Border Line* (Edinburgh, Oliver & Boyd 1924)

Lomas, R., *North-East England in the Middle Ages* (Edinburgh, John Donald 1992)

__ *Northumberland – County of Conflict* (Edinburgh, Tuckwell Press 1996)

Long, B., *The Castles of Northumberland* (Newcastle upon Tyne, Harold Hill 1967)

Loyd, A., 'My Afghan Diaries' in Saturday London *Times* magazine, 2 May, 2020, p. 42

Lynch, M., *Scotland, A New History* (London, Pimlico 1992)

Macdonald, A. J., *Border Bloodshed* (Edinburgh, Tuckwell 2000)

Macdonald-Fraser, G., *The Steel Bonnets* (London, Barrie & Jenkins 1971)

Macdougall, N., *James III: A Political Study* (Edinburgh, John Donald 1982)

Mackenzie, E., *History of Northumberland* (Newcastle upon Tyne, Mackenzie & Dent 1825)

MacLauchlan, H., *Survey of the Roman Wall* (London, [imprint unknown] 1858)

__ *Old Roman Roads in Northumberland* (London, [imprint unknown; 1867)

McFarlane, K.B., *The Nobility of Late Medieval England* (Oxford, OUP 1975)

McFarlane, K.B., *England in the Fifteenth Century* (ed.) G.L. Harris, (London, Hambledon Press 1981)

McFarlane, K. B., 'The Wars of the Roses' in *Proceedings of the British Academy*, (50 1964)

McIvor, I., *A Fortified Frontier* (Gloucs., Tempus 2001)

McNamee, C., *The Wars of the Bruces: Scotland, England and Ireland* (Edinburgh, Birlinn 1997)

McNeil, E., *Flodden Field: A Novel* (London, Severn House 2007)

Mabbit, J., *Archaeology, Revolution and the End of the Medieval English Town: Fortification and Discourse in Seventeenth Century Newcastle upon Tyne* (Newcastle upon Tyne, Tyne Bridge 2010)

Manning, O., *Fortunes of War Trilogy* (London, Penguin/Random House 2014)

Marsden, J., *Northanhymbre Saga* (London, BCA 1992)

__ *Fury of the Norsemen* (New York, St. Martin's Press 1995)

__ *The Illustrated Border Ballads* (London, Macmillan 1990)

Maxwell-Irving, A., *The Border Towers of Scotland; the West March* (Stirling, Maxwell-Irving 2000)

Meade, D.M., *The Medieval Church in England* (England, Churchman 1988)

Meikle, M., *A British Frontier* (Edinburgh, Tuckwell 2004)

Middlebrook, S., 'Newcastle upon Tyne, its Growth and Achievement' (Newcastle upon Tyne, *Newcastle Chronicle & Journal* 1950)

Moat, D. D., *The North West Borderland* (Newcastle, Frank Graham 1973)

Moffat, A., *Arthur & the Lost Kingdoms* (Edinburgh, Birlinn 2012)

__ *The Borders* (Selkirk 2002)

__ & G. Rose *Tyneside; A History of Newcastle and Gateshead from Earliest Times* (Edinburgh 2009)

Morgan, A., *A Fine and Private Place, Jesmond Old Cemetery* (Newcastle upon Tyne, Tyne Bridge 2004)

Morris, M., *Castle; a History of the Buildings that Shaped Medieval Britain* (London, Random House 2012)

Moses, H., *The Fighting Bradfords* (Durham, County Durham Books, 2003)

Murray's Handbook for Travellers in Durham & Northumberland (London, John Murray 1890)

Murray Kendall, P., *Warwick the Kingmaker* (London, Phoenix 2002)

Myers, A. R., ed., *The Household of Edward IV: The Black Book and the Ordinance of 1478* (England, Manchester University Press 1959)

Nef, J. U., *The Rise of the British Coal Industry* (London, Routledge 1932)

Neillands, R., *The Hundred Years War* (London, Routledge 1990)

__ *The Wars of the Roses* (London, Routledge 1992)

Nicolle, D., *Medieval Warfare Source Book* (London, Brockhampton 1999)

Nicholson, H., *Tom Fleck* (YouWriteon.com, 2011)

Norman, A. V. B. and D. Pottinger, *English Weapons and Warfare 449–1660* (London, Dorset Press 1966)

Oakeshott, R. E., *A Knight and his Castle* (London, Dufour Editions 1996)

__ *A Knight and his Armour* (1999)

__ *A Knight and his Weapons* (1997)

__ *A Knight and his Horse* (1998)

Oliver, N., *A History of Ancient Britain* (London, Weidenfeld & Nicolson 2012)

Oliver, S., *Rambles in Northumberland and on the Scottish Border* (London, Chapman & Hall 1835)

Oman, Sir Charles, *The Art of War in the Middle Ages* vol. 2 (London, Greenhill 1924)

Osprey, New Vanguard 108, *English Civil War Artillery 1642 – 1651*

- Campaign 119, *Marston Moor 1644*
- Elite 25, *Soldiers of the English Civil War (1) Infantry*
- Elite 27, *Soldiers of the English Civil War (2) Cavalry*
- Fortress 9, *English Civil War Fortifications 1642–1651*
- Essential Histories 58, *The English Civil Wars 1642–1651*
- Men-at-Arms 14, *The English Civil War Armies*
- Men-at-Arms 331, *Scots Armies of the English Civil Wars*

Pearson, H., *Achtung Schweinehund* (London, Abacus 2008)

Pease, H., *The History of the Northumberland (Hussars) Yeomanry 1819–1923* (London, Constable 1924)

Pegler, M., *Powder and Ball Small Arms* (Wilts., Crowood Press 1998)

Percy Folio of Ballads and Romance edited by J. W. Hales and F. J. Furnival (London, De La Mare Press 1905–1910)

Percy, Bishop Thomas, *Reliques of Ancient English Poetry* edited by H. B. Wheatley (New York, Dover 1906)

Percy Hedley, W., *Northumberland Families* vol. 1 (Newcastle upon Tyne, Society of Antiquaries 1968)

Perry, R., *A Naturalist on Lindisfarne* (London, L. Drummond 1946)

Pevsner, N., & E. Williamson, *Durham* in *The Buildings of England* series (London, Penguin 1985)

__ & I. Richmond, *Northumberland* in *The Buildings of England* series (London, Penguin 1992)

__ & K. Cruft, J. Dunbar & R. Fawcett, *Borders* (London; Yale University Press 2006)

Phillips, G., *The Anglo-Scots Wars 151–1550* (Woodbridge, Boydell Press 1999)

Pitcairn, R., *Criminal Trials in Scotland 1488–1624* edited by William Tait (Edinburgh, the Maitland Club 1833)

Platt, W., *Stories of the Scottish Border* (London, Harrap 1919)

Pollard, A. J., 'Percies, Nevilles and the Wars of the Roses' in *History Today* (September 1992)

__ 'Characteristics of the Fifteenth Century North' in *Government, Religion and Society in Northern England 1000–1700* (ed.) C. Appleby and P. Dalton, (Oxford, OUP 1977)

__ *North-eastern England during the Wars of the Roses: War, Politics and Lay Society, 1450–1500* (Oxford, OUP 1990)

__ *The Wars of the Roses* (London, St. Martin's Press 1995)

__ *North of England in the Reign of Richard III* (Gloucs. Sutton 1996)

Prestwich, M., *Armies and Warfare in the Middle Ages* (Newhaven CT, Yale University Press 1996)

Price, S., *The Sterkarm Handshake* (Scholastic Press 1998)

Proceedings of the Society of Antiquaries of Newcastle upon Tyne volume IX

Ramsay, Sir J. H., *Lancaster and York* 2 vols. (Oxford, Clarendon Press 1892)

Ransome, C., 'The Battle of Towton' *English Historical Review* vol. 4, (1889)

Reid, S., *All the King's Armies – A Military History of the English Civil War 1642–1651* (Gloucs., History Press 2007)

Richardson, D., *the Swordmakers of Shotley Bridge* (Newcastle upon Tyne, Frank Graham 1973)

Richardson, M. A., *The local historian's table book, of remarkable occurrences, historical facts, traditions, legendary and descriptive ballads [&c.] connected with the counties of Newcastle upon Tyne, Northumberland and Durham* (London, J. R. Smith 1846)

Ridpath, G., *The Border History of England and Scotland* (Edinburgh, Mercat Press 1979)

Ritchie, C. I. A., 'Cumbrian Sleuth Hounds' in *Cumbria Lake District Life* Volume 35, No. 8, p. 474.

Robb, G., *The Debatable Land* (London, Picador 2018)

Robson, R., *Rise and Fall of the English Highland Clans: Tudor Responses to a Medieval Problem* (Edinburgh, John Donald 1989)

Rogers, Col. H. C. B., *Artillery through the Ages* (London, Military Book Society 1971)

Rollaston, D. & M. Prestwich, (eds) *The Battle of Neville's Cross 1346* (Lincolnshire, Studies in North Eastern History 1998)

Rose, A., *Kings in the North* (London, Phoenix 2002)

Ross C., *Edward IV* (London, Eyre Methuen 1974)

Royal Commission on Historic Monuments *Shielings and Bastles* (HMSO, 1970)

Ryder, P. F., *Harbottle Castle – a short historical and descriptive account* (Northumberland National Park Authority 1990)

Sadler, D. J., *Battle for Northumbria* (Newcastle upon Tyne, Bridge Studios 1988)

__ *War in the North – The Wars of the Roses in the North East of England 1461–1464* (England, Partizan Press 2000)

__ *Border Fury – The Three Hundred Years War* (London, Longmans 2004)

__ *The Red Rose & The White* (Harlow, Longman/Pearson 2010)

__ *The Field Gun Run* (London, Royal Military Tournament 2010)

__ & R. Serdiville, *Siege of Newcastle upon Tyne 1644* (Gloucs. History Press 2011)

__ & R. Serdiville, *Little Book of Newcastle upon Tyne* (Gloucs. History Press 2011)

__ & R. Serdiville, The Battle of Flodden 1513 (Gloucs. History Press 2013)

__ & A. Speirs the Battle of Hexham 1464 (Northumberland, Ergo Press 2007)

Saklatvala, B., *Arthur, Roman Britain's Last Champion* (Newton Abbot, David & Charles 1967)

Salter, V., *High Lives and Low Morals – the Duel that shook Stuart Society* (London, Pimlico 2000)

Sawyer, P., *Oxford Illustrated History of the Vikings* (Oxford, OUP 1997)

'Scotland's Secret Bunker 1951–1993; A Guide and History' (St. Andrews, *Scotland's Secret Bunker Guide* 2007).

Scott, Sir Walter, *Border Antiquities* 2 volumes (London, Longmans 1814)

__ *Minstrelsy of the Scottish Border (*London, Ward Lock 1892 edition)

Scofield, C. L., *the Life and Reign of Edward the Fourth* 2 vols. (London, Routledge 1967)

Second to None: A History of Coldstream (Coldstream and District Local History Society, 2010)

Seward, D., *Henry V as Warlord* (London, Sidgwick & Jackson 1987)

Seward, D., *Richard III – England's Black Legend* (London, Pegasus 2017)

Seward, D., *The Wars of the Roses* (London, Robinson 2013)

Seymour, W., *Battles in Britain* vol. 1, (London, Sidgwick & Jackson 1989)

Simons, E. N., *Reign of Edward IV* (New York, Barnes & Noble 1966)

Sinclair, Sir J., *General Report on the Agricultural State and Political Circumstance of Scotland* (Edinburgh, Constable & Co. 1814)

Sitwell, Brigadier W., *The Border* (Newcastle upon Tyne, Andrew Reid 1927)

Skene, W. F., *Four Ancient Books of Wales* volume I (Edinburgh, Edmonston and Douglas)

Smout, T. C., *History of the Scottish People* (London, Fontana 1969)

Smurthwaite, D., *the Ordnance Survey Guide to the Battlefields of Britain* (London, Michael Joseph 1984)

Society of Antiquaries of Newcastle upon Tyne *Pilgrimage of the Roman Wall June 26th July 1886* (South Shields 1886)

Spaven, M., *Fortress Scotland; a Guide to the Military Presence* (London, Pluto Press 1983)

Stewart, G., & J. Sheen, *Tyneside Scottish* (Barnsley, Pen & Sword 1999)

Stewart, R., *The Marches* (London, Jonathan Cape 2016)

Storey, R. L., *End of the House of Lancaster* (Gloucs., Sutton 1999)

Storey, R. L., 'The Wardens of the Marches of England towards Scotland 1377–1489' in *English Historical Review* (72: 1957)

Summerson, H., 'Carlisle and the English West March in the Late Middle Ages' in *The North of England in the Reign of Richard III* (Oxford, Wiley-Blackwell 1996)

Sykes, J., *Remarkable Events* 3 vols. (Berwick upon Tweed, Sykes 1866)

Tabraham, C. J., *Scotland's Castles* [revised] (London, Batsford 2005)

__ *Hermitage Castle* (Edinburgh, Historic Scotland 1996)

__ *Smailholm Tower* (Edinburgh, Historic Scotland 2007)

Tait, J., *Dick the Devil's Bairns: Breaking the Border Mafia* (Kindle version, Amazon media 2018)

Terry, C.S., *The Life and Campaigns of Alexander Leslie* (London, Longmans 1899)

__ *The Army of the Covenant* (two vols. Scottish History Society, 1917

__ 'The Scottish Campaign in Northumberland and Durham Between January and June 1644' in *Archaeologia Aeliana* New Series vol. xxi (1899)

Thrupp, S. L., *The problem of replacement Rates in Late Medieval English Population* ECHR 2nd Series (1965–1966)

Tomlinson, W. Weaver, *A Comprehensive Guide to Northumberland* (Newcastle upon Tyne, Robinson 1863)

__ *Sixteenth Century Life in Northumberland* (Newcastle upon Tyne, Robinson 1866)

Tough, D. L. W., *the Last Years of a Frontier* (Oxford, OUP 1928)

Tranter, N., *Fortalices & Early Mansions of Southern Scotland 1400–1650* (Edinburgh, Moray Press 1935)

Traquair, P., *Freedom's Sword: Scotland's Wars of Independence* (London, Harper Collins 1998)

Trevelyan, G. M., *A History of England* (London, Penguin 1975)

Treece, H., & E. Oakeshott, *Fighting Men* (Leicester, Brockhampton Press 1963

Tuck, A., *Border Warfare* (London, HMSO 1979)

__ *Crown and Nobility, 1272–1462* (New York, Barnes & Noble 1985)

Veitch, J., *History and Poetry of the Scottish Border* (Edinburgh, William Blackwood & sons 1893)

Wagner P. & S. Hand, *Medieval Sword and Shield* (California, Chivalry Bookshelf 2003)

Ward, S. G. P., *Faithful: The Story of the Durham Light Infantry* (London, Thomas Nelson & Sons 1969)

Warwicker, J., *Churchill's Underground Army* (Barnsley, Pen & Sword 2008)

Warner, P., *Sieges of the Middle Ages* (Barnsley, Pen & Sword 2005)

Watson, C., 'The Battle of Sauchieburn' (*Battlefield Trust Magazine*, volume 24, issue 4, Spring 2020)

Watson, G., *The Border Reivers* (Newcastle upon Tyne, Sandhill 1974)

Weiss, H., 'A Power in the North? The Percies in the Fifteenth Century' in *The Historical Journal* (1965)

Welford, R., *A History of Newcastle & Gateshead*, 3 volumes (London, Walter Scott 1884)

White, R., *History of the Battle of Otterburn 1388* (Newcastle upon Tyne, Emerson Charnley 1857)

Wilcox, P., *Rome's Enemies (2) Gallic and British Celts* illustrated by Angus McBride (Osprey Men-at-Arms series, 1985)

Williams, T., *The Viking Longship* (London, British Museum 2014)

__ *Viking Britain* (London, William Collins 2018)

Wills, F. A., *Fifty Weekend Walks Around Newcastle on Tyne* (London, Hodder & Stoughton 1951)

Wilson, A. N., *The Laird of Abbotsford* (Oxford, OUP 1980)

Wise, T., *Medieval Heraldry* (London, Osprey 2001)

Wise, T., *The Wars of the Roses* (London, Osprey 1983)

Woolgar, C. M., *The Great Household in late Medieval England* (London, Yale University Press 1999)

Wrightson, K., 'Continuity, Chance and Change; the Character of the Industrial Revolution in England: Elements of Identity; the Remaking of the North East' in *Northumberland, History and Identity* ed. R. Collis (Gloucs. Tempus 2007)

Index

About the Author

John Sadler has had a lifelong interest in military history. He now combines writing with lecturing in History at Newcastle University and working as a battlefield tour guide, living history interpreter, and heritage consultant. He has travelled extensively in Scandinavia and is thus familiar with all of the principal sites and saga/literary sources and is an acknowledged expert on the Viking art of war . He is the author of more than 40 books. He lives in mid-Northumberland.